THE OVER 50

INSURANCE SURVIVAL GUIDE

CYNTHIA DAVIDSON

HOW TO KNOW WHAT YOU NEED, GET WHAT YOU WANT AND AVOID RIP-OFFS

MERRITT PUBLISHING

A Division of The Merritt Company
Santa Monica, California

The Over 50 Insurance Survival Guide

First edition, 1994
Copyright © 1994 by Merritt Publishing, a division of The Merritt Company

Merritt Publishing
1661 Ninth Street
Santa Monica, California 90406

For a list of other publications or for more information, please call (800) 638-7597. In Alaska and Hawaii, please call (310) 450-7234.

Library of Congress Catalogue Card Number: 94-73594

Davidson, Cynthia
The Over 50 Insurance Survival Guide
How to know what you need, get what you want and avoid rip-offs.
Includes index.
Pages: 430

ISBN 1-56343-070-3
Printed in the United States of America.

Acknowledgements

In few other industries does the phrase "let the buyer beware" apply so well as it does to insurance. Not only is there a lack of information available for insurance consumers, but the information that is available can be quite biased by the information source (industry, government, consumer organization). Even government publications designed to simplify the insurance buying process tend to be either too complicated or overly simplified, too generic, too lacking in specific advice, and in the effort to be objective, too reluctant to name names.

Little is achieved if insurance agents alone know about the laws that require their fair dealing with older buyers of insurance. The Merritt Company has been publishing books to help educate those in the insurance industry for almost 40 years. We are certain that this information will be just as useful to insurance consumers.

This book would not have been possible without the help of the industry representatives who are trying to provide fair and ethical service to the senior market, the consumer representatives who are watching to see that they do, the government regulators who despite budget woes and conflicting priorities still scrutinize the ever-changing products and the attorneys who helped us demystify the legal cases we have summarized and who lent us their expertise to help others avoid the mistakes made by their clients.

Thanks in particular to:

John Mancini, National Association of Insurance Commissioners
Attorney Thomas L. Roberts of Englewood, Colorado,
Attorney Jack B. Winters, Jr. of San Diego, California,
Attorney William V. Evans of Douglas, Georgia,
Attorney H. Dennis Piercey of Salt Lake City, Utah,
John Davidson, West Virginia Insurance Department,
Warren Spruill, Virginia Insurance Department.

And special thanks to the Merritt editorial team (James Walsh, Tracy Sweet-Lovik and Donald Schlossman), without whose diligent research and excellent reporting this book would be half its size and one tenth its quality.

Cynthia Davidson

THE OVER 50 INSURANCE SURVIVAL GUIDE
TABLE OF CONTENTS

INTRODUCTION

At age 50, you may not consider yourself a "senior," but insurance company actuarial tables say you are. If you have any doubts, just try comparing the premiums on a new life insurance policy issued at age 35 and the same kind of policy issued at age 50. And the rates only get worse the older you get.

This book alerts you to the changes you should expect from age 50 forward, and prepares you for what lies ahead. It serves as a handbook of insurance advice for older Americans and is designed to help you make the best policy decisions: how your insurance needs have changed; what special considerations apply to your homeowners and automobile insurance; why and how to purchase life insurance; what you need to know about health insurance; whether you really need Medicare supplement or long-term care insurance; and whether your agent is telling you all you need to know.

It explains the insurance products available for seniors, what their real advantages and disadvantages are, and how to determine whether they are right for you. And it uses real case studies to illustrate important points.

You will learn where to get (and where not to get) good consumer information, how you are a potential victim, and how badly some insurance agents and brokers serve older clients.

Clearly, the ranks of the over-50 population in our society are growing in raw numbers and as a proportion of the overall population. This is partially due to the aging of the Baby Boom generation, and partially due to the fact that we are living longer.

Marketers call the 62 million Americans who are 50 and over the "golden market," because they control half the discretionary income (money that's left over after taxes are paid and basic living expenses are met) and three-quarters of the financial assets in the United States. And,

if predictions hold true, the numbers will increase considerably with time. In another year or two, the first of the Baby Boomers (those born between 1946 and 1964) will reach age 50. The over-50 group is one of the fastest growing in this country, exceeded only by two other groups—those 65 and over and those 85 and over.

Longevity Needs Better Planning

More people living to older ages means more people must stretch their retirement income to last longer (or delay retirement past age 65), keep their homes and assets protected longer, and make sure their health care coverage remains in force. If you retire at age 65 and live to age 100, you will be spending one third of your life without earned income. Longer life expectancy also means more admissions to nursing homes. Insurance plays a key part in addressing all of these concerns.

As people approach retirement, they usually need to rearrange budgets and priorities and make tough decisions about post-retirement finances. Often the various insurance policies they will need get only limited attention, and all too often, it's too little, too late.

Life, homeowners, auto and disability insurance may be the furthest things from your mind (except when premium payments are due). But you should review these things every year before you retire to ensure against excessively high costs, inadequate coverage, or creating a financial burden on your family members.

Understanding the coverages you already have in place is a critical first step in mastering your continuing insurance needs. You have many options, many legal rights, special legal protections, and plenty of modern, upgraded policies available to you, but first you must learn how to protect yourself. You just have to know what questions to ask, what benefits are the most important, how policy illustrations can be used to mislead you, and how much loss you can and cannot afford to accept.

Where You Stand Now

Older Americans have significant disposable income, especially since most already own their own homes and thus aren't strapped by large mortgage payments. Financial services, insurance and travel, in addition to health care, make up the bulk of senior spending, according to

the Dallas-based Senior Citizens Marketing Group, Inc. And when you add up your auto, homeowners, life, health, and supplemental insurance premiums, you might find insurance is one of your biggest expenses.

For this reason alone, you can expect to be hounded by insurance agents (and direct mail campaigns) that want to sell you insurance coverages that you may need, as well as coverages that you don't. Insurance companies have developed entire divisions specializing in retirement plans, Medicare supplement, and (especially) long-term care insurance. The long-term-care industry markets its services in every imaginable way—broadcast, print, direct mail, word-of-mouth and through referral networks consisting of physicians, attorneys, hospital discharge planners and social workers.

While some might argue that it is discriminatory to segregate older people from the general population and afford them special rights and protections under the law, public sentiment supports these protections as evidenced by our laws, court decisions, and the media.

Setting a definitive legal precedent for senior discounts, a movie ticket purchaser in California challenged a theater's right to offer senior citizen discounts and discounts for children, saying they were unfairly discriminatory and denied him equal protection under California's civil rights act. The courts held that the discount ticket policy was not arbitrary discrimination based on age. Charging different prices to children and senior citizens was found to be socially desirable; children and senior citizens are worthy of a discount because they generally have less discretionary disposable income and limited earning opportunities, and tend to be economically dependent (either upon fixed incomes or upon family members).

Support for Special Protections

State and federal legislation addresses the special needs of elderly citizens. Unlike other classifications such as race, sex, and national origin, all persons may benefit from age-based discounts during their lifetimes, first as children and then as senior citizens. Encouraging and enabling citizens to enjoy life and the benefits of our society as they age is considered a favored public policy.

The California civil code permits age restrictions for senior citizen housing where living accommodations are designed to meet the physical and social needs of seniors.

Studies have found that seniors with higher levels of income are more likely to have insurance than those with lower incomes, as are those who own homes as opposed to those who rent. With early retirements and corporate buyouts, many people over 50 are finding themselves with good-sized checks in their pockets and no investment experience. Legitimate—and illegitimate—financial advisers are waiting. And the potential for disastrous mistakes is great.

Marketers Target Seniors

In other words, welcome to your Golden Years—and hold on to your wallet. Seniors account for an estimated 30 percent of all financial scam victims. Telemarketing and direct mail ringleaders operate out of California, Texas, Nevada and Florida, selling insurance policies that benefit the insurer far more than the insured. Unethical insurance marketers sell seniors unnecessary and even duplicative policies, especially with regard to health insurance.

Florida, Illinois, Louisiana, North Carolina, Texas, and Washington are some of the states that make the financial exploitation of an older person a criminal offense. In Illinois, a person commits this offense when he stands in a position of trust and confidence with the older person and "knowingly and by deception or intimidation obtains control over the person's property with the intent to permanently deprive the person of the use, benefit, or possession of his property."

The Illinois statute classifies this crime as a felony, with the class of felony determined by the value of the property involved. The statute also clearly defines the terms "intimidation" and "deception" and explains who, exactly, "stands in a position of trust and confidence."

Intimidation is defined as communicating to an elderly person that he or she shall be deprived of food and nutrition, shelter, prescribed medication or medical care and treatment.

Deception means misrepresenting or concealing a material fact relating to contract terms, or to an existing or pre-existing condition of any of the property involved in the

contract. Also, deception includes using any misrepresentation, false pretense or false promise in order to induce, encourage or solicit the elderly person to enter into a contract.

Insurance agents act in a fiduciary capacity, which means they are bound to act in good faith with regard to the insured person. A fiduciary is in a position of trust and confidence with the insured.

In 1992, a California agent had his license revoked for selling 19 duplicative, unnecessary policies in a 2-year period to an elderly woman. The woman purchased seven long-term care policies, seven life insurance policies, four Medicare Supplement Insurance (Medigap) policies, and one cancer policy. The California Department of Insurance general standard for "overloading," is any more than two policies.

The woman paid out $40,000 in premiums to the agent, who made at least $20,000 in commissions. The sales stopped only after a relative who was appointed conservator noticed that large sums of money were being withdrawn from several bank accounts. Insurance Commissioner John Garamendi called this "the worst case of abuse of an insurance consumer ever imaginable."

Agent Report Cards: D –

In its June 1991 issue, *Consumer Reports* magazine examined agent conduct in sales interviews with senior prospects for insurance. Agents were given report cards grading their sales interviews with regard to clarity, honesty, thoroughness, length of presentation and knowledge of policy. The typical report card looked like this:

- Clarity of Presentation: D
- Honesty: F
- Thoroughness of Presentation: F
- Length of Interview: C –
- Product Knowledge: F

Sales interviews were characterized by misrepresentations of the policy, defamation of other insurers, and misrepresentations of competitor's policies. 75 percent of the agents observed did not explain the policies properly and didn't provide disclosure information for the policies they were attempting to sell in violation of state laws.

Only one agent did any type of fact-finding with regard to long-term care insurance, and learned that his prospect had only $10,000 in assets. This prospect was probably eligible for Medicaid to take care of nursing home expenses, but the agent persisted in trying to sell a long-term care policy which the individual did not need.

Other unethical conduct included agents failing to inform seniors that their premiums would increase, telling them that certain optional benefits were not available (when in fact they were) and a large amount of "bad mouthing" competing insurers.

Sometimes without intending to be dishonest, the agent simply does not understand the features of the policy he or she is selling and cannot accurately explain the benefits and exclusions. Or, the agent isn't aware of special discounts available to seniors: discounts that can make a big difference in the amount of premium you are paying.

Insolvent Insurers

Another potential risk is that the insurance company providing insurance coverages may fail. Unlike banks, which are federally insured, there is no government backing to insurance policy guarantees. If the insurance company becomes insolvent, the amount you eventually receive might be less than you think. When deciding where to invest your premium dollars, it's important that the company and your money will still be there when it comes time to withdraw your cash values or pay your beneficiaries your death benefit.

State insurance guaranty associations have been set up to provide some protection for policyholders, claimants, and beneficiaries from insurance company failures. Any insurance company wanting to do business in the state must become a member of the guaranty association, and is "assessed" to help pay for the association's expenses. Theoretically, if an insurance company goes out of business, its obligations are "spread out" among other similar insurance companies in the state.

However, when an insurance company becomes insolvent, there are limits to the amount for which the guaranty association will reimburse each insured. Usually, this amount is set at a maximum of $100,000 per policy (even if the face value of the policy is higher) and $300,000 per insured (regardless of the number of policies held or their

full face value). So don't count on guaranty funds to bail you out if your insurer fails.

An Environment Ready for Abuse

Abuses in the senior market are rampant. Harsh penalties are imposed on agents caught victimizing senior citizens, when they are caught. And no state law can completely protect the older consumer, nor assure the public that agents dealing in the senior market are true professionals.

The government, while noble in its intentions, ends up playing catch-up. Often, by the time regulators learn of an insurance con against the elderly, study it, investigate it, and go through the lengthy legislative process to regulate it, unethical agents are on to the next scam.

Special interest groups like the American Association of Retired Persons offer some help — but they also market insurance products of their own. So you have to take all information with a grain of skeptical salt.

Some Agents Will Lie to You

The organized cons are the smallest part of the problem. Agents commonly misrepresent policies, encourage prospects to lie on their applications, use misleading policy illustrations which promise unrealistic returns on investment, and pressure seniors into making too quick a decision. And because insurance is regulated at the state level, agents who are caught often just relocate to a new state and start the same thing all over again.

A Minnesota agent who sold endowment policies to senior citizens by misrepresenting the content of the plan, the rate of return and the liquidity of the investment, had his Minnesota license revoked in 1983. This agent then applied for, and received, nonresident licenses in 11 other states, and lied on each application saying that he had never had an insurance agent license revoked or been subject to any disciplinary action. North Dakota regulators learned about the Minnesota revocation quite by accident in 1988 while investigating the files of a life insurance company, and only then revoked the agent's nonresident license.

Usually regulators find out about insurance scams through complaints. In Virginia, complaints come in through the Consumer Services Division, Agents Inves-

tigative Department, or Agent Licensing Section. Warren Spruill, Director of Agency Licensing, recalls an agent who would take an application and then subsequently submit multiple applications from the same individual for other types of policies, without the applicant's knowledge, changing just small details such as the person's Social Security number, middle name, etc. The result was from three to nine contracts per person for Medicare supplement insurance, hospital indemnity, nursing home insurance, etc.

Unfortunately, this agent also convinced the applicants to sign authorizations for automatic premium payments from their bank accounts. By the time the banks notified the individuals they were overdrawn, the returned check penalties alone exceeded some of the individual's total monthly income.

Because most of the witnesses were confused about what they had purchased, and did not understand what had gone wrong, the Insurance Department settled for the agent's license. Believe it nor not, says Spruill, the insurance company protested that the Department of Insurance had intimidated their best producer into surrendering his license.

Although it is an unfair trade practice punishable by fines and loss of license for an agent to make derogatory or malicious statements about the competition, this is still a common way to sell insurance.

A retired schoolteacher in Tennesse told an agent trying to sell her a Medicare supplement insurance policy that she already had coverage. The agent then convinced her that her current insurer would not be in operation much longer and that once they went out of business, she and her husband would be left without medical insurance. Based on this, the couple purchased insurance from the agent. When she later learned that her current insurer was not going out of business, she requested that her premium be returned. Of course, the agent denied that he had misled her in any way. Luckily, she had not discontinued her original insurance policy. The agent's license was revoked.

Armed with Awareness

Many states have imposed special requirements for insurance products sold to seniors, which apply in addi-

tion to the legal protections afforded to all insurance consumers. Some, like California and North Carolina, require special training and education for agents selling to the senior market. Some states expand the "free look" period, the amount of time the insured has after purchasing insurance to change his or her mind and have the premium refunded. Most offer "senior counseling" programs to help older Americans with their insurance decision-making. (For more details, see the Resources Appendix.)

Replacement transactions (when one policy is replaced by another, similar policy) are of particular concern because of the potential for imposing new waiting periods, preexisting conditions limitations, and higher premiums on older insureds. The commissions payable on some replacement policies may be limited in order to discourage unnecessary replacements. State laws also require that the consumer be provided with disclosure notices concerning the risks of replacement and rights of applicants.

Specific policies designed principally for senior citizens, such as Medicare supplement insurance and long-term care insurance, are subject to special disclosure requirements in an effort to safeguard seniors' interests, give them access to balanced information before purchasing the insurance, and ensure their right to ethical treatment by insurance agents.

Other senior-specific insurance products have been standardized. Until recently, insurers offered dozens of different Medigap policies. But instead of fostering healthy competition, the result was chaos when the consumer tried to read through 20 or 30 policies that all described benefits in different ways.

Simplifying the Options

The sheer number of different, confusing Medicare supplement policies prompted the federal government in 1991 to restrict the kinds of Medicare supplement insurance policies to ten, period. The standardized policies make it possible to easily identify the benefits contained in the policy and make straight comparisons of premium prices, company reputation and service.

When the feds stiffened the law regarding Medicare supplement insurance policies, it helped weed out some of the unethical salespeople. But since the rapidly evolving

long-term care insurance products offer no such uniformity, many fear these agents have turned to long-term care insurance sales. Long term care insurance is being called the "new frontier" by insurance marketers.

Ultimately, no amount of government regulation can prevent fraud, let alone less-obvious forms of manipulation or abuse. Given the right information, you are in the best position to change the coverages you have into the best possible coverages for you, protect yourself from misleading policy illustrations and deceptive agents, and take advantage of the senior discounts, services, and legal protections available to you.

The goal of this book is to leave you informed and owning the types of coverage you need, so that when you submit an insurance claim, you receive an equitable settlement—and no surprises.

CHAPTER 1
BUYER'S GUIDE TO PERSONAL LINES INSURANCE

Your property/casualty insurance needs fall under the general heading of personal lines insurance. This includes risks—loss, damage or liability—involving any thing that you own.

The most basic kinds of personal lines insurance are homeowners and automobile coverage. We'll consider these issues in detail because they create most of the problems that people over age 50 face in personal insurance matters. More complex products include travel insurance, special theft insurance and personal liability insurance. We'll consider these, too—but in less detail.

Defining Appropriate Coverage

People over 50 have a growing need for asset protection—because they have more assets worth protecting. But professionals who work in the field say that insurance coverage spreads unevenly along income lines. More affluent seniors tend to be heavily-insured; less affluent ones tend to be under-insured. This discrepancy reflects the insurance market at large. It may have special meaning to people planning their lives around fixed incomes.

Personal Lines Insurance Center (PLIC), a subsidiary of ITT Hartford created specifically to market automobile and homeowners insurance directly to members of the American Association of Retired Persons (AARP), sees in great detail how these issues affect people.

"From our start-up in 1984, we have attracted 1.5 million policy holders, and our annual sales have grown to $900 million. While AARP is our only customer, it currently has 32 million members in the U.S., and this means that our growth prospects are enormous," says Hugh Martin, an ITT executive who helped developed PLIC. "Our customers can't, however, buy our product from their golfing buddy or their neighborhood broker. All of our sales and service is done directly by our employees without the help of local agents."

"We set a target to train each of our phone reps in all insurance transactions and products that a customer could possibly request," says Martin. "The trouble with this approach to service was that insurance is a state-regulated business with products and pricing unique to each state. We found that even those reps who had been with us three and four years felt they still had a lot to learn."

The people who buy their insurance through PLIC are well-informed and have specific questions they raise with phone reps. When a PLIC person can't answer a customer's questions, there's a significant chance that customer will seek out an agent face-to-face.

If you're over 50, you have good reason to be demanding about the personal lines insurance you buy. One reason stands out from the others—older people have better loss records than young ones. That means they make claims less often. They pose less of a risk under a home or auto policy.

Look for Senior Discounts

Because older people are better risks, several big insurance companies make premium discounts available to people smart enough and aggressive enough to ask for them.

Washington, D.C.-based GEICO Insurance takes a leading position in offering these breaks. Policyholders over 50 who are retired receive a discount of five to 25 percent on homeowner and automobile insurance premiums, depending on the policy. Retirees are loosely defined as people working fewer than 20 hours a week.

An additional ten percent off auto-premiums is given to older people willing to take an accredited defensive driving course (we discuss this in greater detail later).

The only downside: All of GEICO's auto discounts end at age 74[1].

Throughout the late 1980s, a number of other property/casualty insurance companies followed GEICO's lead. Farmers Insurance Group, lowered its homeowners rates around the country for policyholders age 50 and older.

[1]For more on GEICO's handling of auto rates for seniors, see p. 51.

around the country for policyholders age 50 and older. The move came on the heels of its auto insurance rate drop for 50-and-older policyholders.

State Farm also reduced its property/casualty rates for older people about the same time. "An improved loss experience with policyholders over 50 years of age led to the rate decreases," reported the Tulsa World in 1988, after Farmers cut auto and home rates for people over 50 in Oklahoma.

About the same time, Prudential Property and Casualty Insurance Company (PRUPAC) implemented a five percent premium discount for homeowners 55 or older in several key states.

According to a spokesman with PRUPAC's Eastern Regional Service Office in New York, "This program was designed to recognize the overall favorable loss experience of the mature homeowner. We're constantly striving to offer the best products at the most competitive price. This mature homeowner discount is just another example of that."

Low Loss Ratios

PRUPAC estimated that the senior discounts would apply to about 25 percent of its customers.

That low loss rate means a lot to insurance companies. One example: Colonial Penn Property/Casualty Insurance Group, which also specializes in selling insurance to seniors, had enjoyed two decades of strong performance when it decided in the early 1980s to expand beyond its traditional market. The expansion was a disaster. In 1991, New York-based Leucadia National Corp. purchased Colonial Penn and turned its focus back to selling property/casualty insurance to seniors.

Within a year, Standard & Poor's Corp. said it had increased its rating of the company's claims-paying ability to Triple-B-Plus. S&P said: "The rating is based on management's demonstrated commitment to running a low-cost operation, a re-emphasis on the group's traditional underwriting niche, and S&P's belief that loss reserve levels are adequate."

Most importantly, S&P said it "views this niche market favorably, because [people] over 50 have historically pro-

duced better underwriting results than younger insureds in the personal automobile market."

The personal lines section of this text examines the impact of aging on your homeowners and automobile insurance needs. It discusses the special property and liability exposures you face after age 50, and gives suggestions regarding coverages you may need to increase, decrease, purchase, or eliminate altogether.

It shows you where you may be eligible for special discounts and preferred rates. It teaches you how to read your policy to tell what is covered and what is excluded, how underinsuring your property can cost you at the time of a claim, and the best ways to fill your gaps in coverage. And it helps you assess whether your policy limits are sufficient and how to protect yourself against "inside" limits.

When you buy insurance, you enter into a contract with a much larger and more powerful entity than yourself: the insurance company. It only makes sense to be informed about the coverage you have purchased, understand your rights and responsibilities, and protect yourself from unnecessary losses. This becomes even more important as you get older and need to protect the assets you have accumulated.

CHAPTER 2
HOMEOWNERS INSURANCE

Homeowners insurance is designed not only to protect your home and your belongings against loss, but to protect you from liability for injuries to others, and liability for damage to the property of others. You may have bought homeowners insurance years ago when you first purchased your home and continued to renew it every year without thinking about it. Now is the time to think about it again, before a loss occurs that you can't afford.

In this section we discuss types of homeowners insurance available (including condominium and renters policies), what kinds of losses are covered and not covered, where problems arise with limits of liability (internal limits, exclusions, etc.) and some solutions to these problems.

The summaries of the coverages available may sound familiar, especially if you've ever filed a claim under your homeowners policy. We may end up reviewing some of the coverages and exclusions you already know about. Don't feel like you have to memorize your policy. It is more important to be able to read and use the policy in order to determine what is and is not covered. Sometimes you will have to read several parts of your policy (maybe more than once) to be sure you are correct. This is a normal part of determining coverage, not a sign that you don't understand the policy. It's a process your agent goes through, insurance companies go through, and the courts go through.

Analyzing Your Coverage

With any insurance policy, assessing the coverage you already have is the first step to determining what changes need to be made or what additional coverages you may need.

- Are you planning to sell your home and move to a condominium, apartment, or mobile home?

- Are you planning to transfer some or all or your interest in your home to your children?

- Are your policy limits sufficient to cover you in the event of a loss?

- Has your home increased or decreased in value?

- Have you accumulated jewelry, collections, fine art, or other valuables which aren't covered in full or are excluded entirely from your existing coverage?

- If you have a residence employee, do you know how he or she is covered by your homeowners policy?

If you're 50 years of age or older, it may pay to audit your homeowners coverage. This is especially true if you have recently become an empty nester, purchased a second home, increased the amount of travel you do, retired, or made other significant life changes.

Don't Skimp on Liability Coverage

Pay particular attention to issues involving liability. This coverage protects your assets against lawsuits. Review the liability limits of your insurance policies. In the past most of the personal liability risks you faced probably came—in some degree—from your business or work. For most people, homeowners insurance offers their main protection from non-work related personal liability. As you spend more time away from work, and as you accumulate more assets, your homeowners insurance policy assumes more importance as your primary liability coverage.

A standard homeowners policy provides $100,000 of liability insurance. For a nominal increase in your premium, you can increase your coverage to $300,000 or more.

A standard HO-3 policy with $100,000 in liability coverage that costs $745 annually (in 1994) cost only $8 more with a liability limit of $200,000. It cost only $15 more to increase the liability limit to $500,000. By any measurement, the added coverage is a good deal.

Remove your adult children from your policy if they no longer live at home. Many people continue coverage for their children for too long. There are a couple of advantages to removing adult children from your policy. First, you will no longer be liable for their accidents (and those of

their children). Second, they can buy the coverage that best meets their needs.

Liabilities created by children or grandchildren who live with older relatives make up a major portion of the home-owner insurance disputes that result in litigation. Especially problematic are situations where your relatives could be considered part of your "household", because they live in a house or apartment you own, or rent their living quarters from you.

You probably do not intend that the insurance on your home and belongings should be put up as collateral for the actions of your children or grandchildren. If a grandchild who rents your upstairs apartment causes injury to another person, is it fair that you could be held liable, just because you've purchased insurance on your home?

Your Household Defined

In the 1991 case *Howard Jacobs v. Fire Insurance Exchange*, the California Court of Appeal considered a typically sticky situation.

In November 1986, 18-year-old Luis Arreaga injured Howard Jacobs "by causing a truck to hit him." At the time, Luis lived in one unit of a duplex with his father and his stepmother, Connie Arreaga. Connie's grandmother, Erma Peterson, owned the duplex and lived in the other unit.

Erma was insured by a homeowners policy, issued by Fire Insurance Exchange, which provided liability coverage for Erma and for relatives or persons under age 21 "if permanent residents of [her] household."

The two units in Erma's duplex were separated by a solid wall. Each had a separate entrance, backyard, mailbox, kitchen, and bathroom. At the time of Jacobs' injury, Erma was living one unit, and Connie was living in the other with her husband (Luis's father), and Luis. Connie paid $250 per month rent to her grandmother, and helped her by preparing her daily medications, taking her to medical and dental appointments, and periodically checking to see how she was.

Jacobs, the injured party, made a claim with Fire Insurance for the limits of Erma's policy on the theory Luis was a resident of Erma's household. The insurance company denied the claim.

The trial court held that Luis was not a member of Erma's household. Jacobs appealed. He argued that the term "household" is ambiguous, and must therefore be interpreted in its broadest and most inclusive sense to provide coverage. The appeals court didn't agree:

"'Household' is not ambiguous. The policy provided liability coverage for Erma and her relatives and persons under age 21 if permanent residents of her household. [This concept] imposes two requirements. First, the person for whom coverage is sought must permanently reside with the named insured. Second, the person for whom coverage is sought must belong to the same household as the named insured. Luis and Erma did not live together as part of a group having permanent or domestic character. They did not share meals. Erma did not consider Luis to be in her household. Luis lived in a separate household and simply helped occasionally in caring for Erma. They belonged to separate households."

The court kept Jacobs away from the deep pockets of Erma's insurance policy.

An attorney for Howard Jacobs complains that rulings like this one hurt people who've already been injured. "Coverage is becoming more restrictive; the trend in the courts is toward being more restrictive," he says.

But, in liability contexts, the homeowner—you—should cheer when an insurance company fights tangential claims. And, as a person with assets to protect, you should feel the urge to prove this lawyer wrong.

Consistent Themes

Other states have defined the term "household" in different ways. But a few basic themes stay consistent.

In the Missouri case *Watt v. Mittelstadt*, a dog belonging to a policyholder's son and daughter-in-law attacked a child. The case went to court to determine whether the son and daughter-in-law were insured under the parents' policy, which provided coverage for relatives who were "residents of [the] household...."

The younger couple resided in a self-contained upstairs apartment of the parents' home. As rent, they paid a portion of the monthly utility costs and promised to maintain the property. The two couples only ate meals together on

holidays or special occasions. Any family decisions between the two couples were made independently. Each couple had separate income and paid its own expenses, and conducted all household chores and functions independently.

The trial court concluded there were two separate households and consequently held that the son and his wife were not insured under the parents' policy.

Affirming this decision, the Missouri Court of Appeals articulated what it considered to be an unambiguous definition of "household":

"…a collection of persons, whether related by consanguinity or affinity or not related at all but who live or reside together as a single group or unit which is of a permanent and domestic character, with one head, under one roof or within a single curtilage (walled area); who have a common subsistence and who direct their attention toward a common goal consisting of their mutual interest and happiness."

In the often-cited 1968 case *Wrigley v. Potomac Insurance Company*, a New York state appellate court ruled that definitions of "household" can shift, depending on the house being insured. This influences exposures you might face in a second house or condo.

The co-owners of the house in question resided in another state and only used the place less than a week each year. Grown relatives of the owners lived in the house full time. Although Potomac Insurance covered damage to the building after a fire, it refused coverage on the personal property of the relatives. It argued they were not members of the policyholder's household. The appellate court ruled that because the dwelling was insured as a secondary dwelling, the term "household" as used in that policy referred differently to that dwelling than to the primary dwelling of the named policyholders. If they had intended to cover their relatives' personal property (which they probably did not), they should have purchased different coverage.

Insuring Your Possessions

You can avoid major financial losses merely by understanding the coverage you already have, and then filling your gaps in coverage or taking other steps to protect your assets. While coverage to the building and other struc-

tures is provided on a replacement cost basis, personal property is insured for actual cash value, which means the policy pays the depreciated value, not the replacement cost.

If you've collected antiques or other valuable items, have them professionally appraised. You should also have coin, stamp and other types of valuable collections insured separately.

Ensuring Adequate Coverage

There's no household insurer who offers the best terms across the board. Many senior advocacy groups market or sell homeowners insurance. The AARP sells policies underwritten by The Hartford Insurance Company to its members.

The AARP/Hartford policies, unlike those of some competitors, do not cover mobile homes, farms or houseboats, though. This can be a problem for people who plan to buy things like mobile homes or boats for recreation or travel. If you're looking forward to that kind of activity, be prepared to insure your assets separately.

Most people insure their home with the insurance industry-standard Homeowners Special Form, or HO-3. This policy provides coverage for property damage to your home and personal property, and liability coverage in case you cause injury to another person or damage another person's property.

The policy also provides a kind of "no-fault" medical payments coverage for people who are injured in accidents in your home (and in some situations away from your home) regardless of who was at fault.

Financial advisers usually recommend that homeowners over age 50 buy an HO-3 policy and, if necessary, purchase extra coverage for their valuables.

The following are examples of the kinds of losses a homeowners policy is designed to cover:

- a severe windstorm loosens shingles on the roof, causing $1,800 damage;
- a neighbor stumbles on the broken corner of your front steps, and sues for $2,000 in medical bills;
- a fire in a kitchen trash basket spreads rapidly, doing $4,500 damage to the downstairs;

- lightning strikes your chimney, causing $400 damage.

The other major coverage provided is additional living expenses incurred when you must temporarily move to an apartment or motel because your home has been damaged. This coverage pays for expenses such as renting a hotel or other temporary housing, as well as meals.

Most people select the HO-3 because coverage of the dwelling and other structures is provided on what is known as an "open perils" basis. This means that all losses are covered unless excluded. (Open perils coverage used to be called all risk, but when courts began interpreting the term "all risk" as meaning that absolutely everything was covered, insurance companies quickly changed the terminology.)

Other homeowner policies available are the basic (HO-1) and broad (HO-2) forms. These are purchased less frequently because they provide coverage on a "named perils" basis, which means only causes of loss specifically named in the policy are covered. These policies tend to be less expensive than the HO-3, but they can leave you, the policy owner, with major gaps in your coverage. For example, HO-1 and HO-2 provide no coverage for theft. There are also special homeowners policies available for renters and for condominium or cooperative unit-owners, which differ from homeowners insurance.

Natural Disasters

In an open perils policy it is important to read the exclusions carefully in order to know where coverage has been eliminated. Common exclusions usually include damage caused by normal wear and tear, flood, sewer back-ups, tidal waves, earthquakes, landslides and war.

Insurance companies will look for a way to enforce exclusions when they have suspicions about a claim. Also, they can be slow to pay when property has been damaged during a natural disaster or catastrophe. No insurance company likes to admit this, but the number of disputes between insurers and policyholders almost always grow in the wake of earthquakes, hurricanes and big fires.

A number of homeowners over age 50 tangled with their carriers after the 1991 Oakland, California fires. Even more had done so in 1989, after Hurricane Hugo ravaged the coastal communities in the Southeast.

The South Carolina Court of Appeals considered a Hurricane Hugo claim in the 1994 decision *Brown and Brown v. C&S Real Estate Services, Inc.*

Douglas and Carol Brown had lived at their residence in Isle of Palms (on the coast near Charleston) since 1972. Mrs. Brown had purchased the house in 1967 for $14,750. According to Mrs. Brown, when she closed on the house, an agent of the bank told her that she was "well covered" in terms of insurance. At the time, flood and earthquake coverages were not available for the property.

The mortgage (issued by a corporate predecessor of C&S Real Estate) signed by Mrs. Brown provided that she had the responsibility for maintaining sufficient insurance. Nevertheless, the bank, on at least one occasion, procured additional insurance on the property using escrow funds included in the Browns' monthly mortgage payments.

Over the years, pursuant to an inflation clause in the policy, the amount of insurance was increased periodically to reflect the increased value of the insured property. The bank also added earthquake insurance in 1980.

The Browns did not request these changes in coverage, and claimed they relied on C&S to attend to their changing insurance needs. Over the years they made several claims on the policy and never experienced any problems.

When Hurricane Hugo hit the South Carolina coast in September of 1989, the Browns' home was completely destroyed. Only then did they learn that their home and contents were not, and never had been, covered by flood insurance.

A Bad Assumption of Coverage

Their insurance policy contained an exclusion—a fairly common one—for any loss resulting from water damage as a result of "flood, surface water, waves, tidal water, overflow of a body of water, or spray from any of these, whether or not driven by wind."

Mrs. Brown testified they were not aware of this exclusion because they did not receive a copy of the actual policy until after the hurricane.

With no insurance to replace their destroyed home, the

Browns sued C&S, seeking damages for its failure to procure adequate insurance on their real and personal properties.

The trial court found that the Browns failed to establish a duty on the part of C&S to add flood coverage to the policy. On appeal, the Browns argued that C&S had assumed the responsibility for ensuring their insurance coverage but admitted that they never talked to C&S about policy coverage and always relied on a third-party insurance servicing agency to answer their insurance questions.

The appeals court came down hard against the Browns. It ruled that the 1967 statements were insufficient to establish the assumption of a duty to procure flood insurance in the future. Also, "the maintenance of the escrow account by C&S and the payment of the insurance premiums therefrom pursuant to the agreement of the parties did not impose a duty on C&S to monitor the Browns' insurance coverage and adjust it according to the Browns' needs."

Finally the court stated that C&S, as a mortgage lender, had no fiduciary link with the Browns and, therefore, had no duty of care in its dealings with them.

Know Your Policy Exclusions

The Browns' case stresses the dangers of not understanding your coverage, not having a copy of your policy on hand to review, and most importantly, counting on anyone—a mortgage lender, a personal attorney, a financial adviser or an accountant—to make decisions about insurance coverage for you. In most cases, unless you've signed over power of attorney, these service-providers aren't obligated to think of you first. They can usually answer questions—but you have to ask the right questions.

Chief among these: What losses are excluded? The policy language defines which losses are covered and which are excluded. The Browns' insurance policy excluded loss resulting from water damage as a result of flooding. If they'd only taken the time to review their policy, or had an insurance agent review it for them, they could have taken steps to protect themselves.

Even though insurance experts describe the homeowners HO-3 form as an "open perils" policy, you should read the policy exclusions carefully. There are exclusions that

apply if your home is vacant or unoccupied, and exclusions for losses that are considered inevitable (wear and tear) or losses which are not accidental. The exclusions that cause policy owners the most aggravation in homeowners insurance have to do with liability exposures for:

- automobiles;
- watercraft and aircraft;
- recreational vehicles;
- rental property;
- business pursuits;
- professional activities.

Obviously, these exclusions involve a number of possessions and activities that seniors and people ready to retire consider. This doesn't mean you can't buy that boat or RV; it simply means you have to think about insuring them separately—and for liability as well as replacement cost.

When you read through the exclusions, it might seem that the insurance company is providing little coverage. A recreational vehicle you own is covered only while it is used on the insured location (so much for recreation). Coverage is provided for miscellaneous vehicles which are not subject to motor vehicle registration, and are not covered by automobile insurance. This would include golf carts, lawn mowers, motorized wheelchairs, and vehicles in storage. So, if you accidentally run over a fellow golfer in your golf cart, your homeowners policy provides coverage.

Boats Can Mean Trouble

Property coverage for watercraft, trailers, furnishings, equipment, and outboard engines or motors is limited to a maximum of $1,000 by the HO-3 policy. In general, the policy excludes all motorboats you own, and all sailboats you own that are 26 feet or more in length. Medical payments and personal liability are provided for the most part only on watercraft in storage. (It's pretty difficult for a boat that's in storage to cause bodily injury.) What the insurance company is telling you by restricting these coverages is that your homeowners policy is not the place to insure this kind of property.

You can see that the liability issues in these cases are often complex. And they often involve friends or family members.

The 1992 Florida case *Prudential Property and Casualty Insurance Company v. Cindy Bonnema and Patricia Casucci* considered a boating accident loss which was found to be excludable by the homeowners policy.

Donald and Cindy Bonnema had an HO-3 homeowners policy with Prudential. Cindy's mother, Patricia Casucci, was injured in an accident involving a boat Cindy was driving and sought damages from her daughter and son-in-law. Prudential denied the claim because of the family relationship and because Casucci lived with the Bonnemas. It cited the "family exclusion" provision of the homeowners policy. The Bonnemas and Casucci sued.

The trial court found that the policy language dealing with liability coverage and family exclusion was ambiguous. It sided with Casucci and the Bonnemas. Prudential appealed.

The policy defined "insured" as "you (the persons to whom the policy was issued)" and "residents of your household" including "your relatives." The relevant part of the exclusions section read: "Personal Liability: We do not cover bodily injury to you or any insured included in [the definition of insured]."

Hidden Exclusions

The Bonnemas argued that Prudential had intentionally disguised the exclusions in their policy. The term "family exclusion" didn't appear anywhere in the master policy; instead, the Florida Endorsement Booklet contained a family exclusion endorsement among a variety of other endorsements. Its index refers to the family exclusion endorsement as an "Amendatory Endorsement."

On appeal, the court ruled: "The documents constituting the policy contain language excluding coverage for Casucci's injuries….a policy's language, presentation, and/or organization can be designed intentionally to disguise coverages or exclusions. We do not find such a design in the instant case. While the title of the endorsement and the titles included in the index might have been more descriptive, the titles selected by the insurance company were not misleading."

Lora Dunlap, an attorney for Prudential, says that the case "was a family dispute, and the insurer got dragged into it." She says it was a good example of why insurance companies will aggressively exclude family members from liability claims.

The rationale behind family exclusions is that they prevent potentially collusive suits between family members who could scheme together to "profit" from a staged accident. In *Government Employees Insurance Company v. Fitzgibbon*, the same Florida court had warned that family exclusions "may come as an unpleasant surprise to the unwary." The prediction had been realized in the Bonnemas' case.

Dwelling Policies vs. Homeowners

You may choose to insure your property with a dwelling policy (the three major dwelling policies are commonly known as DP-1, DP-2, and DP-3). The major problem with a dwelling policy is that it does not automatically provide liability coverage, as homeowners insurance does. If you are trimming a tree on the property and a branch falls and damages a neighbor's house, no coverage is provided for the damage, even though you are legally liable for it. You would have to purchase supplemental liability coverage for this exposure.

Also, none of the dwelling policies provide any theft coverage. This would need to be added by special endorsement, for which you have to pay an additional premium.

Why purchase a dwelling policy at all? The major reason for purchasing a dwelling policy is for a house that you own but do not occupy. Another reason: in order to qualify for homeowners insurance, there must not be more than two family living units and no more than two boarders or roomers per family.

If you move to an apartment, condominium, senior community, or other residence, and you rent out your home or allow relatives to live in it, you will no longer be eligible for homeowners insurance on that property and will want to consider a dwelling policy special form (DP-3) with a personal liability endorsement and premises liability (non-owner occupied dwelling) endorsement. This would provide you with HO-3 type coverage for your home.

Another reason you may end up with a dwelling policy is if your home is old, or poorly maintained (for example, if the

plumbing or wiring does not meet current building standards), or you have a history of losses that is unacceptable, the insurance company may refuse to issue a homeowners policy and may offer you only dwelling coverage.

The Coinsurance Penalty

But how much coverage do you need? The policy limits which appear on the declarations page of your policy tell you the maximum amount of money your insurance company will pay for a covered loss.

A good rule to follow: insure your home for at least 80 percent of its replacement cost so that, after a loss, you are more likely to receive the full cost of your repair bills from your insurance company. Your policy limits should be increased whenever the value of your home increases or whenever you have made substantial improvements or additions to your home.

First, find out what your home's replacement cost is: what it would cost to rebuild your home at today's prices for materials and labor. One way to do this is to have an independent appraiser provide you with a written estimate. Then, increase your limits to at least 80 percent of the estimated replacement cost.

If you haven't insured your home at 80 percent of replacement cost, most losses will be settled at actual cash value or at a prorated value based on the amount of insurance you did purchase. This is called coinsurance, because you are forced to self-insure, or absorb part of the loss, and the insurance company gets to avoid part of the loss. And because it's stated clearly in the contract, there's no getting around it if you are underinsured.

The formula used by insurance companies to settle these losses is:

$$\text{DID/SHOULD} \times \text{AMOUNT OF LOSS}$$
$$= \$ \text{ PAID TO THE POLICYHOLDER}$$

If your home's replacement cost is $100,000, you should be carrying 80 percent or $80,000 worth of insurance. If, however, you only have $60,000 worth of coverage, you will be penalized for any loss you sustain, even small ones. The insurance company will pay for only a portion of the loss, rather than the full loss.

Suppose in this case you have a fire which causes $20,000 worth of structural damage to your home.

$$\frac{(DID=\$60,000/}{SHOULD=\$80,000)}$$
x $20,000 (amount of loss)

Only three-fourths of the loss, or $15,000, would be covered. You would have to absorb—or "self-insure"—the remainder. Also, the deductible amount would be subtracted from the amount to be paid.

While it might seem unfair for the insurance company to accept your premium payments for all this time and then penalize you when you have a loss, there is a reason for imposing the coinsurance penalty.

Doing so discourages people from underinsuring their property. If everyone were able to collect full recovery for their smaller, more frequent partial losses, there would be little reason to carry full coverage and reasonable policy limits, and insurance rates would be forced even higher for everyone.

If you have insured your home for 80 percent of replacement value, you avoid coinsurance penalties. Coverage is limited only by the policy limit and the deductible. If a $100,000 building insured at 80 percent is destroyed, the policy will pay the $80,000 policy limit. Any partial losses will be recovered without penalty, and are subject to the deductible only. So an $80,000 loss would be paid in full, minus the deductible.

Deductibles and Coverage Amounts

The standard deductible for homeowners policies is $250, but larger or smaller deductibles are permitted. Check the declarations page of your policy if you don't remember which you selected. The deductible, which applies on a per occurrence basis, affects property insurance losses (the dwelling, other structures, personal property, loss of use) but not liability losses. The intent of a deductible is to have the property owner assume responsibility for the smaller, more affordable losses that occur to property. If you increase your deductible, you will receive a premium discount, if you reduce your deductible, an additional premium will be charged.

The Supreme Court of South Carolina considered coverage amount issues in the 1994 decision *Robert*

Averill and Gerri Averill v. Preferred Mutual Insurance Company and Hover Insurance Agency, Inc.

The Averills purchased an insurance policy from Preferred Mutual against loss caused by fire while their new home was being constructed. Before construction was complete, the home was totally destroyed by fire. Preferred Mutual refused to pay the amount the Averills claimed they were due under the policy—so the couple sued.

The dispute focused on the amount to be used as the "value at date of completion" in order to calculate the amount of coverage available. Preferred Mutual claimed the value at date of completion was the total cost to construct the home—or $437,059. The Averills contended the value at date of completion was the liability limit in the policy—or $300,000.

Using this lower figure resulted in a greater amount of coverage, since it was the denominator in the policy's formula to determine the amount of insurance for a dwelling under construction.

The trial court sided with the Averills, saying that the "value at date of completion" did, in fact, equal the limit of liability—or $300,000. On appeal, Preferred Mutual argued that the definition of value didn't apply to a loss occurring while the home was under construction.

Enforcing the Policy Language

The state Supreme Court rejected the argument on two grounds. First, the policy's "Dwelling under Construction" endorsement expressly stated: "This insurance applies only to the dwelling or structure while under construction" and "all other provisions of this policy apply." Second, South Carolina insurance law stated: "No insurer doing business in this State may issue a fire insurance policy for more than the value stated in the policy or the value of the property to be insured. The amount of insurance must be fixed by the insurer and insured at or before the time of issuing the policy."

The court cited a decision it had made in the 1960s that construed state law to require that in a case of total loss by fire, recovery equals the full amount of insurance under the policy and not the "actual value" of the insured property.

While coverage to the building and other structures is provided on a replacement cost basis, personal property is insured on an actual cash value basis. If a sofa that would cost $800 to replace but is worth $400 because of depreciation is damaged by a covered cause of loss, the amount of reimbursement would be $400. Replacement cost coverage can be purchased for an additional premium.

Inside Limits on Your Personal Property

In a standard homeowners policy, coverage for your personal property is usually provided at 50 percent of the amount of insurance on the dwelling. For example, if you insure your home for $120,000, your policy automatically provides $60,000 of personal property (contents) coverage. This limit may be increased by endorsement and payment of additional premium.

This coverage applies to personal property you own or use anywhere in the world. The HO-3 policy limits coverage of personal property to named perils, so it is a good idea to attach HO-15 which broadens the coverage substantially to include open perils.

There are special limitations "inside" the personal property coverage limit, which if you don't protect yourself, can really hurt you at the time of a loss:

- $200 for money, bank notes, bullion, gold and silver other than goldware and silverware, platinum, coins and medals;
- $1,000 for securities, accounts, deeds, evidences of debt, letters of credit, notes other than bank notes, manuscripts, passports, tickets and stamps;
- $1,000 for watercraft including their trailers, furnishings, equipment and outboard motors;
- $1,000 for trailers not used with watercraft;
- $1,000 for loss by theft of jewelry, watches, furs, precious and semiprecious stones;
- $2,500 for loss by theft of pewterware and solid, hollow, or plated goldware and silverware, including trays, tea sets, trophies, and other items;
- $2,000 for loss by theft of firearms;

- $2,500 for property, on the residence premises, used for business purposes;

- $250 for property, away from the residence premises, used for business purposes;

- $1,000 for loss of portable electronic apparatus while in or upon a motor vehicle;

- $1,000 for loss of portable electronic apparatus while not in or upon a motor vehicle, but only if the loss occurs away from the residence premises and the apparatus is used for business purposes.

If your house was burglarized how would these special limits of coverage affect your recovery? You probably have acquired personal property over the years that is effectively excluded by these inside limits. You might have several individual pieces of jewelry each worth $1,000 or more. You might have silverware, firearms, a coin collection, a postage stamp collection, or a small outboard watercraft on a trailer in the garage. If you have more than $200 cash laying around, it isn't covered. If a fur coat worth $3,500 is stolen from your house, the most the insurance company will pay is $1,000.

These limitations apply "per occurrence," so if six months later, another fur coat is stolen from your house, the policy would pay another $1,000. However, after a few losses like that, the insurance company might take a hard look at your claims history and decide not to renew your coverage, or change your coverage to a dwelling policy and charge you a hefty premium for supplemental theft coverage. (Note that the limitation in this case is for theft; if the fur was destroyed in a fire it would be covered in full.)

First, Take Inventory

So how can you protect yourself from these exposures? First, you need to know what you need to protect. The best way to do this is to do a complete inventory of your personal property: home furnishings, carpeting, drapes, furniture, books, mirrors, china, silverware, pots and pans, clothing, linens, electronics, appliances, sports equipment, tools, etc. This is a big job, but you can get assistance (forms, etc.) from your insurance agent or company representative. Use a camera or video camera to record your inventory and keep the photos/video and inventory list off-site (in a safe deposit box, for example). Include as much detail as possible, including serial numbers from

your electronics and appliances. In case of a loss, you'll need proof of ownership to get your claim settled.

Update your inventory as you make additional purchases. Keep receipts indefinitely; you never know when you'll need to replace the property.

Personal Property Endorsements

Endorsements are additional coverages that can be attached to a standard policy (for additional premiums). Two endorsements are commonly used to expand coverage of personal property.

The Specific Scheduled Personal Property Endorsement (HO-61) provides broader coverage with no deductible, but requires you to schedule (or itemize) the specific items you want covered. This requires some initial effort on your part, but is more accurate and easier to adjust when you need to make changes.

The Increased Special Limits of Liability (HO-65) may be used to provide higher limits on an unscheduled basis. This should only be used when, for whatever reason, you cannot come up with a schedule of owned items. But be careful: unscheduled coverage, especially for items like jewelry, can be very expensive. And even with this endorsement, jewelry, watches, furs, precious and semi-precious stones are insured for loss by theft only up to $1,000 each.

Both the HO-61 and HO-65 endorsements can be further broadened by adding an endorsement which reimburses at replacement cost rather than actual cash value. However, the following property is not eligible for replacement cost coverage under this endorsement and would be settled at actual cash value: antiques, fine art, paintings, memorabilia, souvenirs, collectors items, articles that are not maintained in good or workable condition and articles that are outdated or obsolete and are stored or not being used.

Special Recovery Considerations

Another advantage to scheduling personal property is that scheduled personal property is not subject to the policy deductible. Recovery may be based on actual cash value, market value, repair or replacement cost or agreed value.

When you sustain a loss to a pair or set, the insurer has the right to either restore or replace the missing item, to restore the value of the pair or set or pay the difference between the property's actual cash value before and after the loss.

Suppose you own a complete set of four volumes of rare books. The value of the complete set is $400. However, collectors of rare books place a value of only $50 for single volumes. One volume of the set is destroyed in a fire covered by your homeowners policy. The insurer may either purchase a copy of the missing volume for $50 to complete your set, or pay you the $250 difference between the value of the set prior to the loss ($400) and the current value of the three remaining volumes ($150).

Insurers Like Master Policies

Insurance companies are reluctant to change their master policies issued in the various states because of fear of loss of the judicial interpretations of existing policies. They dread the prospect of beginning the judicial interpretation process for a new, separate policy in each state.

Therefore, master policies are usually kept intact and amended—as needed—by state-specific endorsements. (A rule of thumb: Unless you've requested it, the term "endorsement" usually involves an amendment that favors the insurance company.)

Because each state has its own court system and because judicial interpretations are binding only in the state in which the court has jurisdiction, insurance companies will usually issue packages of endorsements applicable to a state to meet the judicial interpretations and legislative and administrative requirements of that state.

If you're thinking about buying a vacation property in another state, be aware of these state-by-state differences. Eager insurance agents will sometimes say that a homeowners policy is the same from state to state. That's only partly true. Some states—especially the bigger ones—impose specific exclusions and terms via the endorsement packages.

Moving from place to place often complicates insurance issues. And this applies to more than just liability issues. If you travel, especially outside the United States, it is important for you to understand where your personal

property coverages start—and stop—with regard to your homeowners insurance policy.

Personal property coverage provided by the HO-3 form applies anywhere in the world. Personal property that belongs to others but is used by the policyholder is also covered anywhere in the world.

For example, the day before you leave for Italy, your camera breaks and you borrow your best friend's camera. While in Italy, your friend's camera is stolen. You are covered under your homeowners HO-3 form for this loss, subject to your deductible.

Property in Vacation Homes

Coverage for personal property that you usually keep at a residence, other than the "residence premises" (such as a vacation home you own) is limited to ten percent of the policy limit, or $1,000, whichever is greater. If you have $50,000 of personal property coverage on your homeowners policy, the most you could collect on a property loss in your weekend home would be $5,000. If you need or want more coverage, of course, you can buy it.

And coverage for personal property is excluded altogether if a loss caused by theft occurs at the other residence when you are not temporarily living there. If your cabin in the mountains is closed up over the winter, any theft loss occurring during the unoccupied months is excluded by your homeowners policy. (You may add coverage by endorsement or by purchasing a separate policy on the other residence.)

If you have a scheduled personal property endorsement, coverage applies worldwide as well. However, fine arts are only covered in the United States and Canada. For specific scheduled and unscheduled personal property coverage, or for higher limits, you should consider a personal articles floater or personal effects floater, which are discussed later in this text.

If the named policyholder or spouse dies, coverage continues for a legal representative or temporary custodian of the policyholder's property. All household members insured at the time of the named policyholder's death continue to be covered as long as they live at the residence premises and the policy is continued.

Transferring Home Ownership

Sometimes older people transfer their homes, in full or in part, to their children as gifts, for tax purposes or in preparation for becoming eligible for some state-funded health care programs. While your accountant or financial adviser might have solid reasons for recommending you do this, he or she may be unaware of the insurance implications.

The "conditions" section of a homeowners policy limits the amount of recovery to your "insurable interest" in the home. So even if you have a $100,000 policy, if you have transferred 50 percent of your ownership and retained a 50 percent interest in the home and you suffer a total loss, you will only be entitled to recover $50,000.

To avoid this you must name the other owner as an insured on your policy. Spouses are automatically covered, provided they live at the residence. A different joint owner who resides at the house would have to be shown on the declarations as a named insured, or, if the joint owner does not reside at the house, he or she could be added to the policy through an "Additional Insured" endorsement.

Something else to remember is that unlike life insurance policies, homeowners policies may not be assigned without the consent of the insurer. So if you transfer ownership of your home, you may not turn over the current insurance policy to the new owner without the written consent of the insurance company.

Subsidizing and Adult Child

Another risk that many people over 50 face without considering completely is the liability that occurs when they set up an adult child in a house or condo.

The Missouri Court of Appeals dealt with this kind of situation in the 1993 case *John Bewig v. State Farm Fire and Casualty Insurance Co.*

Bewig was a mail carrier who was bitten by a dog owned by Linda Hayden. He sued her for the injuries he suffered as a result of the bites. The two parties entered into a consent judgment in the amount of $10,000; Bewig agreed to seek payment solely from State Farm, which had insured the property's owner.

Bewig argued that Linda was a "real estate manager" of the property and therefore was insured under the owners' rental policy. The court stated that State Farm wasn't liable to cover the judgment. Bewig appealed.

The appeals court had to consider the various layers of the claim. At the time of the dog bite, Linda Hayden was living in a house owned by her father and several other relatives. The owners were the named insureds under a Rental Dwelling Insurance policy issued by State Farm, covering the dwelling in which Linda resided. Linda did not have renters insurance.

The Daughter's Status

In the policy, "insured" was defined to include the named insureds, any employee of the named insured while acting within the scope of that employment and "any person or organization while acting as real estate manager for the named insured."

Linda was responsible for obtaining additional tenants, for paying the utility bills and for either maintaining the premises or advising the owners of the need for repairs. The total rental for the premises was $500 per month, with Linda responsible for $100 of that amount and each of the other two tenants responsible for $200. Linda was employed full-time as a beautician and had never worked as a manager of real estate.

Melvin Hayden testified that part of the reduction in Linda's rent was because she was his daughter and he was giving her a break.

"The insurance is intended to protect the landlord and those acting in his behalf in regard to the property. It obviously does not protect employees or agents in their individual capacities unrelated to the landlord's interests," the appeals court concluded. "The record is totally silent of when the bite occurred, whether Linda was home, or the circumstances of the bite." Therefore, the court rejected Bewig's claim.

"This type of policy language expands coverage for rental property owners and managers. Here the daughter should have had her own rental policy. She wasn't a manager, and the owners' policy didn't apply to her," says one attorney involved in the case. "The parents were just looking to see if they could get some kind of insur-

ance coverage, because the daughter didn't ha'
own policy."

Douglas Salsbury, who represented Bewig, m
different—and more general—point. "The underlying
case was a negotiated settlement. It appears that there is a
trend among courts to treat these differently....they give
more scrutiny, make it harder for the plaintiff to prove the
case," he says. "They may think that the insurance com-
pany should have had a better chance to get into the mer-
its of the underlying [case], but the result is to accord
special treatment to the insurance company."

Often, people over 50 who've done well in the houses
they've owned will look to buying rental units as a safe
principle investment and steady revenue stream. Rental
properties do tend to be conservative investments—but
they create considerable liability exposures. In the Bewig
case, Melvin Hayden found out how troublesome this can
be. And it gets worse.

The Business Activities Exclusion

The main complication to protecting yourself from lia-
bilities created by rental properties is the business
activities exclusion of a homeowners policy. It's also a
compelling reason to purchase separate coverage for
rental policies.

The Wisconsin court of appeals dealt with business
activity exclusions in its 1993 decision *Charles J. Williams
v. State Farm Fire and Casualty Co.*

Charles Williams held two State Farm policies: a home-
owners policy and a personal liability umbrella policy
issued in 1971. The homeowners policy contained the
common exclusion for injury or damage arising out of
"business pursuits" and defined "business" as "a trade,
profession or occupation." The umbrella policy con-
tained similar language excluding business pursuits.

Williams was in a position to know about exclusions. A
certified public accountant, he was chairman of the
board of directors of Wisconsin Mutual Insurance
Company—and a former CEO of the company.

In 1979, Williams became a joint venturer in an apart-
ment building in Texas. Williams never inquired about
purchasing coverage from State Farm for the Texas
property (which was insured separately by another com-

pany). Williams's association with the apartment venture ended when the venture encountered financial difficulties and the building was repossessed by its creditors.

Sometime soon after, a serious accident, in which a woman died, occurred at the building. The dead woman's family sued Williams and his coinvestors, claiming that the accident was caused by negligence in repairing the building during their ownership.

Because there was no longer any underlying insurance in force on the property, Williams had to personally finance his defense of the action when State Farm refused to defend. Williams sued State Farm, seeking recovery of his defense expenses.

State Farm wanted the action dismissed, arguing that Williams's involvement in the apartment venture was a "business pursuit" which, under the two policies it had sold him, was specifically excluded from coverage. The trial court agreed. Williams appealed, raising the issue of whether the business pursuits exclusion applied to Williams's "passive investment" in the apartment enterprise.

Defining Business Pursuit

The court ruled in favor of State Farm. In 1978, the Wisconsin Supreme Court had examined the business pursuit exclusion in *Bertler v. Employers Insurance of Wausau.* In that case, an employee, who'd been struck by a forklift operated by a coworker, sued the coworker's homeowners liability insurer to recover his damages. The issue was whether the coworker's operation of the forklift in the course of his employment constituted a "business pursuit" within the meaning of the policy exclusion.

The court held that it did, concluding that homeowners and personal liability policies were never intended to provide coverage for the "hazards associated with regular income-producing activities...Business activities can be insured by other types of policies. Their exclusion from personal liability policies avoids areas requiring specialized underwriting, prevents unnecessary coverage overlaps, and helps keep premiums low."

The court then adopted a two-part test for the type of "business pursuit" covered by exclusions such as those

at issue in the Williams case: in order to constitute a business pursuit, there must be two elements: continuity of the business, and profit motive.

In the Williams case, the appeals court ruled that "he had invested in real estate in the past, and he invested in the Texas property on a continuing basis from 1979 until 1986, when the property was repossessed; for those seven years, he was exposed to liability as an owner of the commercial property. Nor is there any dispute that Williams became involved in the venture as a means of pursuing income and profit; the fact that the property eventually failed to be profitable is of no consequence."

Pleading Passive Investment

Williams argued that the business pursuits exclusion should be limited to activities undertaken in the policyholder's principal occupation as opposed to a mere "passive investment," such as his involvement in the Texas venture.

He argued that adopting the view that "any investment is a business and therefore excluded would arguably exclude from coverage any accident occurring at the insured's home," because home ownership necessarily includes both continuity and an expectation of appreciation or profit motive.

The court ruled that Williams's argument failed for at least two reasons. First, the primary motive for home ownership is shelter, not profit. Second, a policyholder's residence is expressly listed as the insured location in homeowners policies and most personal liability umbrella policies.

The business activity exclusion held. The insurance company didn't have to pay for Williams's defense against negligence charges stemming from the Texas apartment building. And it didn't have to cover any judgments or settlements.

Courts in other states have also held that, in situations similar to Williams's, the exclusion applied to those activities which are not the stated occupation of the policyholder.

A Rental Nightmare

You don't have to be involved in a multi-million dollar apartment partnership and major liability lawsuit to feel the sting of insurance problems on a rental property. Small situations can breed big troubles, too.

In the 1993 case *Farmers Insurance Company of Oregon v. Daniel Trutanich*, the Oregon court of appeals considered the case of an older landlord and a disastrous rental house.

In November 1988, Daniel Trutanich purchased a house and had it insured by Farmers with an open perils (HO-3 type) homeowners insurance policy. In June 1989, Trutanich moved to an apartment and rented part of the house to the Greshams. The Greshams lived in the house for approximately 45 days, and then found a new tenant, Pixler, who—with his children—began renting the house from Trutanich in August 1989.

In late September, Trutanich stopped by the house and found that Pixler had moved out. Entering the house, he noticed a strong odor. The smell was later determined to come from a methamphetamine lab in the lower level of the house.

Trutanich made a claim for damages to the house and his personal property caused by the methamphetamine operation. Farmers denied the claim on the ground that the insurance contract excluded coverage for "contamination."

The trial court decided in favor of Trutanich on the contamination issue and other issues Farmers raised. The jury returned a verdict awarding Trutanich over $38,000 for damage to his house, theft of personal property and lost rental income.

Exclusions Insurers Love

Farmers appealed, arguing that the contamination exclusion should apply to the losses to the house caused by a methamphetamine operation. The insurance policy covered "accidental direct physical loss" to the premises but excluded, among other things:"...direct or indirect loss from....Wear and tear; marring; deterioration; inherent vice; latent defect; mechanical breakdown;

rust; mold; wet or dry rot; contamination; smog; smoke from farm smudging or industrial operations; settling, cracking, shrinking, bulging or expansion of pavements, patios, foundations, walls, floors, roofs or ceiling; birds, vermin, rodents, insects or domestic animals."

This list stands out as a good example of the kinds of exclusions insurance companies like. Unfortunately for Farmers, an Oregon appeals court had recently ruled in the case *Largent v. State Farm*, that an almost identical list couldn't exclude damage caused by an illegal methamphetamine operation.

Farmers also argued that Trutanich's conduct in renting the house to a third party excluded his claims. First, the insurance company claimed that because the house was rented, it was not covered (remember that HO-3 policies require the owner to also be an occupant to qualify for coverage).

No Explicit Termination

However, an earlier court decision in Oregon held that "Under Oregon law, if an insurance company wishes to have a homeowner's policy terminate upon rental of his home, it must so provide explicitly and unambiguously in the policy of insurance, and that a mere statement in the policy that he is the owner and occupant is wholly insufficient for this purpose. Under any proper view of the law, a homeowner is entitled to be given specific and unequivocal notice in the insurance policy that his coverage will be forfeited upon his rental of his home so that if a death in the family or economic circumstances, or even just a desire to change his way of life, cause him to move from his home, he may make whatever other insurance arrangements are necessary to protect the asset which often represents all the remaining proceeds of a lifetime of labor."

Farmers tried to establish that renting the house to a third party fell under the policy definition of "business" and, therefore, limited the coverage available. However, the policy itself specifically provided for coverage for loss of use of "residence premises rented to others or held for rental." The trial court ruled that the house was covered, even though it was rented.

An attorney familiar with the case stressed the difference between policies written for homes people live in and

houses they rent. "A homeowners policy is designed to provide coverage for the person who owns the house. There are different policies for rental homes....If people want to be sure they are covered, they should look at their policy to avoid unwanted exclusions, or get a named-peril policy."

Robert Bonaparte, the attorney for Trutanich, saw things differently. "Homeowners policies are either all risk policies or named peril policies. But insurers are increasingly reluctant to use the term "all risk" because many risks are in fact excluded. Insurers now call such policies 'open peril'; or just use a generic name for example, HO-3 or DP-3, which are the homeowners or dwelling policy form numbers."

His advice to people buying policies for second homes that might be rented or lent to others: "Explore the coverage in detail with the broker (or insurer) and keep a careful written record of the conversation. Ask for brochures specifically describing the coverage provided including specific examples of covered events (especially with an all-risks policy). Be warned that brokers have a limited knowledge of how the courts will interpret the policies they sell."

The consensus: consider named-peril policies (such as HO-1 and HO-2) for a second house. Using this kind of policy takes a little more attention up front—but it makes coverage issues explicit. It also forces you to read the policy.

Residence Employees

Many older Americans rely on residence employees to help with home upkeep, shopping, personal care, etc. There are special limitations you should know about with regard to homeowners insurance coverage for residence employees.

A residence employee is defined in the HO-3 policy as "an employee of an 'insured' whose duties are related to the maintenance or use of the 'residence premises', including household or domestic services, or one who performs similar duties elsewhere not related to the "business' of an 'insured'." A gardener who comes to your house on a part-time basis, a full-time live-in maid, or a full-time caretaker, could all be considered residence employees. A caretaker from a pool service that services your pool, or a service representative working on a household appliance

such as a garbage disposal, would be considered an independent contractor and not a residence employee.

Medical payments coverage applies to bodily injury to a person off the insured location if caused by a residence employee in the course of employment by the policyholder. Medical payments coverage excludes bodily injury to the residence employee that occurs off the insured location and does not arise out of the person's employment by the policyholder.

Residence employee cases are almost always complicated. If you're considering a second career or doing work from your home, be scrupulous about bringing employees in to help.

The Hazards of Home-Based Business

In *Bruce Allen et al. v. Sentry Insurance et al.*, the Supreme Court of New Hampshire considered one such case.

Bruce and Debbie Allen operated Allen's Coal Company, Inc. from their home in Derry. Allen's Coal sells coal for fuel to customers in southern New Hampshire. The coal was stored in bulk and packaged at the Allens' residence and then delivered by truck to customers.

In December 1984, Sentry Insurance company issued a homeowners policy to Bruce and Debbie Allen which contained endorsements that extended coverage for the workers' compensation claims of residence employees and for the business use of the residence premises.

With the endorsements, the policy generally provided coverage for "all sums which the Insured shall become legally obligated to pay as damages because of bodily injury." The policy specifically excluded coverage for bodily injury "arising out of the ownership, maintenance, operation, use, loading or unloading of…any motor vehicle owned or operated by…any Insured." This motor vehicle exclusion, however, did not apply "to bodily injury to any residence employee arising out of and in the course of his employment by any Insured."

In August 1986, employee James O'Connell died from injuries sustained when Allen's Coal's delivery truck collided with another vehicle. O'Connell was a passenger in the truck being driven by Bruce Allen—the two were returning from a coal delivery.

Sentry delayed response to the Allens' inquiries about coverage after the accident. Eventually, Bruce Allen filed a suit for declaratory judgment against Sentry. The suit sought to establish that Sentry was obligated to provide coverage for liability arising from O'Connell's death.

Residence Employee Defined

The trial court ruled that O'Connell was a "residence employee" under the Allens' homeowners policy and, therefore, Sentry was obligated to provide coverage under the business use endorsement. The amount of the coverage: $300,000. Sentry appealed, arguing that O'Connell did not qualify as a "residence employee" under the applicable insurance policy.

The first question the state Supreme Court considered was whether James O'Connell was a "residence employee" as defined in the policy. Unless he qualified as a residence employee, coverage under the policy was excluded by the motor vehicle exclusion.

The policy defined a residence employee as "an employee of any Insured whose duties are in connection with the maintenance or use of the insured premises, including the performance of household or domestic services, or who performs elsewhere duties of a similar nature not in connection with any Insured's business."

Coverage Denied

O'Connell was not a residence employee under the policy's definition because he was not an employee of a policyholder. The homeowners policy unambiguously designated Bruce and Debbie Allen as the policy's named insureds. At the time of the accident, however, O'Connell was serving as an employee of Allen's Coal, which was not insured under the policy.

Despite the clear language of the policy designating Bruce and Debbie Allen as named insureds, they argued that the court should find coverage under the policy because "the Allens had a reasonable belief that liability coverage would be provided by Sentry for their coal business." The Allens had requested insurance for their business when they approached Sentry's agent about purchasing a policy, and Sentry's agent had reviewed Allen's Coal's existing business policy before issuing the homeowners policy that was in dispute.

After that meeting, the Allens decided that, because O'Connell did household chores as well as work for the company, he'd be covered by the business-related endorsements to the homeowners policy.

But the court didn't agree with this argument. "The expectation that Sentry would provide liability coverage for the business is certainly not the same as expecting Allen's Coal to receive all the benefits and coverage under a homeowners policy as a named insured," it ruled. "Without evidence of a reasonable expectation of specific coverage, we will not reform the unambiguous wording of the homeowners policy, and we conclude that Sentry is not obligated to provide coverage in this case."

Ask for Preferred Rates

Insurance companies offer a variety of preferred rates for such things as homes protected by smoke detectors, neighborhood watch programs, burglar alarms, and even fire resistant building materials. Multiple policy discounts of five to 15 percent are available if you place both your auto and homeowners coverages with the same insurer. Also, if you've kept your homeowners insurance with the same carrier for several years, you may receive a long-term policyholder discount of five to ten percent. Some insurance companies even offer a nonsmokers discount on homeowners insurance.

If you are age 55 or older and retired, you may qualify for a mature homeowners discount of up to ten percent. The assumption is that retired individuals spend more time at home, are better able to pinpoint hazards, and are better able to keep up with home maintenance.

As with all insurance policies, as soon as you've determined what your best coverage options are, be sure to shop around, and get prices from at least three different insurance companies or agents.

Your Rights During Policy Cancellation

If your insurer decides to cancel your homeowners policy, it must give you at least ten days notice if the policy has been in effect less than 60 days, or if you have failed to pay your premium. In all other cases, the insurer must give you at least 30 days notice before canceling or declining to renew your policy.

The 1988 case *Pennsylvania National Mutual v. Insurance Commissioner of the Commonwealth of Pennsylvania* dealt with issues of too-quick cancellation of a homeowners policy.

In May 1986, Mary Herron and her husband met with Kelly Moore, an insurance agent for Pennsylvania National, to purchase a homeowners insurance policy for their home. Moore told Herron that her home would be insured from the moment of payment.

Prior to the meeting, Herron had received notice from Commercial Union Insurance that her existing homeowners policy would be canceled because of two claims she'd made related to burglaries in 1984 and 1985. (Commercial Union later reversed its position and offered to renew the policy.)

A Problem of Renewal

Because of Moore's assurances, Herron didn't renew her policy with Commercial Union. She tendered a check for $204 in payment of a one-year premium and signed a policy application which was forwarded to Pennsylvania National by Moore.

On May 30, 1986, the Herron home was completely destroyed by fire. The next week, Moore's agency informed Mary Herron that her application for insurance coverage was being denied due to the 1985 burglary claim. As it turned out, she didn't have coverage at the time of fire.

Herron filed a complaint with the Pennsylvania Insurance Department. In January 1987, the Department concluded its investigation and determined that Pennsylvania National had violated the state's Insurance Consumer Protection Act. Pennsylvania National appealed to the Commission and, when that failed, sued in state court to have the decision overturned.

Pennsylvania National argued that Herron's application had been improperly completed and that Moore's agency didn't have the authority to promise coverage immediately (via what insurance companies call a "binder") in Herron's case.

The agency contract between Pennsylvania National and Moore's agency gave Moore authority to accept proposals for insurance contracts subject to restrictions

imposed by Pennsylvania National's written instructions. These restrictions included limiting coverage to an applicant who incurred more than a single loss in the immediate past three years—and that loss had to stem from natural causes beyond the applicant's control.

Herron's original policy application showed that although the section dealing with the binder was checked and dated, it had been altered with white-out and the no-binder section had been checked.

Looking for Loopholes

The insurance company argued that this alteration related to a loophole in the Consumer Protection Act: "Canceling any policy covering owner-occupied private residential properties [must include a 30-day notice] unless the policy was obtained through material misrepresentation, fraudulent statements, omissions or concealment of fact material to the acceptance of the risk...."

Based in part on Herron's testimony, the Commissioner concluded that the alteration to the application had occurred sometime after the meeting between the Herrons and Moore on May 22, 1986. The Insurance Department disbelieved that such an important item as binder of coverage had been altered prior to Herron's signature. It concluded that "any responsible agent would have prepared another application, or at least, obtained the applicant's initials approving the change."

Therefore, the loophole didn't apply and a contract of insurance existed as of May 22, the date of Herron's application and payment of premium.

Pennsylvania National made a second point: that other sections of the Act provided that the cancellation language didn't apply to policies in effect for less than sixty days. In fact, the relevant section read: "The period of 60 days...is intended to provide to insurers a reasonable period of time, if desired, to investigate thoroughly a particular risk while extending coverage during the period of investigation. An insurer may cancel the policy provided it gives at least 30 days notice of the termination and provided it gives notice no later than the sixtieth day."

The Commissioner determined that Pennsylvania National, by assuring Herron that coverage would be immediate and then taking the position that there was

no insurance policy in effect, failed to provide the required 30 day notice. The state court agreed.

Enforcing the Agent's Promise

"The record discloses that Moore twice assured Herron that she had coverage immediately upon payment of the premium. Moore [herself] testified that she assured Herron that she did not foresee a problem," it ruled. "Nothing in the record demonstrates that Moore explained to Herron the significance of an unbound application."

In its underwriting guidelines, Pennsylvania National listed the type of risks that agents were not authorized to bind. The type of risk that Herron presented wasn't included in that list.

"Nor is there any merit to the argument raised by Pennsylvania National that Moore did nothing that would have led Herron to believe that Moore had authority to bind Pennsylvania National, and that it was Herron's obligation to ascertain Moore's authority," the state court concluded. "Pennsylvania National is therefore liable for Moore's actions as she had apparent authority to bind coverage and did not communicate any limitation on her authority to Herron."

Assess an Agent's Authority

Because they pushed, the Herrons received coverage for their home, even though they had made two claims in the three years before applying for new coverage. This case also illustrates why you should be wary of assurances of coverage from agents; even though agents have certain authorities granted by the insurance company, the company doesn't always stand behind all of their promises.

Insurance companies cancel or refuse to renew policies for many reasons. While canceling a policy requires exceptional circumstances, insurance companies have wide latitude in choosing not to renew a policy that has expired. An insurer can simply decide to write fewer homeowners policies in your state, or it can decide that you have had a series of losses that make you an unacceptable risk.

You have the right to request in writing the reason for any policy cancellation or nonrenewal, and the insurer must respond in writing within a reasonable time.

It is illegal to cancel property insurance on the basis of the policyholder's age. However, an insurer may refuse to issue a policy because your home does not meet their underwriting standards; for example, you may have trouble buying a replacement value policy if your home's replacement value is much higher than its market value.

An insurer may refuse to issue you a homeowners policy if you have been convicted of arson within the last five years, have committed fraud or arson in an insurance claim, have had homeowners insurance canceled for failing to pay your premium, or have property taxes which have been overdue for two years or more.

Trouble Getting Coverage

If you are unable to obtain coverage through the standard market, your state may have a Fair Access to Insurance Requirements (FAIR) Plan or similar program which must provide you with coverage. However, this coverage is often more expensive and less comprehensive than that available through the standard market.

A market value or older homes form may be available which modifies the property coverages of homeowners insurance. This type of policy may be a good choice when the replacement cost of your older home is very high, but the market value is relatively low.. If the resale value of your home is low, a market value policy would allow you to insure your home for its lower market value rather than 80 percent of its higher replacement value.

The market value policy provides a practical amount of homeowners coverage for owners of such residences. There is no replacement cost provision and partial losses are paid in full, up to the policy limits, on an actual cash value basis. However, when a loss occurs, the insurer is not required to use the same quality of materials that are damaged, and if you sustain a total or near-total loss, you will probably not receive enough money to build another house of similar value.

Also, market value policies often restrict theft coverage (to something like $1,000 per occurrence), provide smaller amounts of personal property coverage, and remove optional property coverages such as increasing individual coverage limits.

When dealing with homeowners policies, it pays to be careful and firm. On average, people over 50 have more

assets than younger ones. This means they have more to protect—but it sometimes means they feel less inclined to fight for money. If you're not careful and firm, some insurance companies may even try to deny legitimate claims you make.

You Might Have to Fight

In the 1994 decision *Dominick Tomaselli et al. v. Transamerica Insurance Co.*, the California Court of Appeals considered the limits of how far an insurance company could go in denying a middle-aged couple's claim of gradual damages to their home.

Between 1977 and 1982, Dominick and Denise Tomaselli had homeowners insurance with Premier Insurance Company, an affiliate of Transamerica Insurance Company. From 1982 through 1987 they purchased homeowners insurance directly from Transamerica. The policies originally contained three relevant limitations on coverage:

- an exclusion for earth movement;
- a "prompt notice" requirement; and
- a requirement that suit on any claim be filed within one year of the loss.

In 1984 Transamerica added a fourth relevant limitation—endorsement number 14461, which excluded coverage for losses caused by "faulty or defective construction or compaction" even if another covered cause had contributed to the loss. This kind of exclusion came into vogue in the insurance industry during the 1980s, after a number of lawsuits had nullified exclusions by relating them to other, non-excluded factors.

In May 1987, the Tomasellis discovered a large crack in the concrete foundation beneath their house and submitted a claim for damages. Transamerica promptly sent out an adjuster, Joe Watanabe, who questioned Mrs. Tomaselli, examined the house for signs of damage and took photographs. He observed other signs of distress (primarily exterior stucco cracks, as well as a crack in the garage floor) which indicated there might be other problems.

Watanabe prepared and sent an "Advance Large Loss Notice" to his superiors. A week after the inspection, he prepared a "claim brief" which summarized the Tomasellis' claim. In it, Watanabe indicated there were

no "apparent" policy violations. The brief noted Mrs. Tomaselli stated she didn't understand the significance of the cracking in the garage slab and that the prior owner hadn't disclosed any soils problems. The brief concluded that (1) a soils engineer would undertake an investigation and (2) an "examination under oath" (hereafter "EUO") might be taken if warranted.

The same week, Watanabe sent the Tomasellis a "reservation of rights" letter. The letter specifically quoted the 14461 endorsement, the proof of loss clause and the "prompt notice" clause.

Questioning Time of Loss

Watanabe began questioning whether the Tomasellis were aware of the damage earlier than they claimed. He asked the soils engineer to try to determine when the damage first became manifest. He noted that the Tomasellis admitted seeing the crack in the garage slab "within the last year" but that they had "dismissed the crack since it was not inside the dwelling." Finally, he suggested that the Tomasellis were "excellent candidate[s] for an EUO."

On June 9, Watanabe referred the matter to the Law Offices of Barry Zalma for analysis and advice as to whether to deny the Tomasellis' claim.

On June 16, the initial soils report indicated that the problem was fill settlement, which appeared to have occurred over several years. It was probably an ongoing process since "patched areas inside the house [were] beginning to crack again." And, lastly, the Tomasellis said that they'd noticed some cracks in the floors and walls had worsened over several years. Watanabe believed that the statement about damage worsening over time conflicted with Mrs. Tomaselli's earlier report that the Tomasellis were unaware of any prior damage to the home, and mentioned the apparent discrepancy to the attorney.

The attorney from the Zalma law office assigned to handle the matter was Cynthia Hamilton. Hamilton told Watanabe that she needed more information from the soils engineer and the Tomasellis to evaluate and advise on the issue of when the cracking occurred and when the Tomasellis knew or should have known of damage. Her request to conduct an EUO was granted.

Examination Under Oath

Before the EUO took place, Mrs. Tomaselli discussed the procedure with Watanabe. He told her it was not necessary to have her attorney present, and that the EUO was merely a procedure to help settle the claim.

During the EUO, more detailed information about the Tomasellis' knowledge of progressive damage began to surface. They acknowledged that they knew there was a garage floor crack since 1980 and had noticed the patio separating and moving away from the house "a long, long time ago." However, they said they thought the problems were insignificant.

They also disclosed, for the first time, they had noticed defects in the bathroom. In 1979 when Mr. Tomaselli removed the bathroom carpet and replaced it with tile, he noticed a crack but thought nothing of it. A few years later, cracks in the tile forced them to replace it, and the tile setter told them cracking would be a recurring problem because there was a crack in the slab beneath the tile. Two weeks later, the crack indeed reappeared in the new tile.

The Tomasellis felt intimidated and badgered during the EUO. They were not asked about the alleged discrepancy between what they told Watanabe and what they said to the soils engineer.

Hamilton recommended that the claim be denied, based on the 14461 endorsement and the late notice of claim. She specifically concluded that the Tomasellis' EUO statements indicated they should have known that there was a problem. In fact, she felt the bathroom problems alone were enough to have placed them on notice.

Transamerica didn't investigate further because, based on the soils report (indicating a long-term progressive deterioration of the damage) and the EUO admissions (i.e., the recurring tile problem, the moving patio, the cracks worsening over time), "it was unlikely further investigation would have altered the coverage determination." Hamilton reaffirmed denial of the claim, and the Tomasellis sued.

The Tomasellis testified Watanabe never told them the purpose of the EUO was to explore possible policy viola-

tions. The Tomasellis' expert testified policyholders should be told they might want an attorney present; Watanabe's supervisor agreed it would have been improper for him to dissuade the Tomasellis from having an attorney present.

The jury decided in favor of the Tomasellis, and awarded contract damages of $260,000 and emotional distress damages totaling $500,000. In the punitive damages phase, the jury awarded $11.25 million. Transamerica appealed.

The appeals court set out the terms of the dispute: "The determination of bad faith in this case depended on an identification of inferences permissibly drawn from the facts. Transamerica claimed that its reliance on the one-year-suit clause was reasonable, given the facts revealed in the EUO; the evidence of other signs of long-standing distress; the statement Mr. and Mrs. Tomaselli each allegedly made to the geologist that 'the stress features have gradually worsened'; the statement of each in the proof of loss form that '[a]ll indications are that this problem has been ongoing since 1979-1980.'

A More Sinister View

"The inferences argued by the Tomasellis, however, painted a more sinister view: a scenario of an insurer searching for ways to avoid paying the claim. The Tomasellis claimed, and their expert testified, the investigation was inadequate.

"Even assuming Transamerica might have been justified in believing that the endorsement had been received by the Tomasellis, the jury could have found....both the handling and ultimate denial of this claim were unreasonable and in bad faith," the court concluded.

Even though it allowed almost $1 million in contract and emotional damages, the appeals court didn't allow the $11.25 million punitive award—which was most important to Transamerica. "There was nothing done which could be described as evil, criminal, recklessly indifferent to the rights of the insured, or with a vexatious intention to injure," the court concluded.

Some critics of the insurance industry allege that carriers have profiles of claims that they will challenge—even if the evidence suggests the claims are legitimate. The

Tomasellis—a middle-aged couple that hadn't had much experience with insurance claims—may have fit that profile.

"Transamerica refused to pay; they lied to their insureds...they used an EUO and said they didn't need an attorney," says Jack B. Winters, the attorney for the Tomasellis. He sees this as a pattern of behavior in insurance companies. "They have a definite system to uniformly deny claims. There should be a consumer relationship, but that isn't what happens."

Condominium Coverage

Either because of a reduced need for space, (children leave for college or move out) or because of a home's extra demands for maintenance, many older Americans change residences to a condominium, apartment or mobile home. Condominiums are also a common form of vacation residence. Whether you are considering a move to a condo to make your life easier or you're considering putting some money into a condo somewhere else, there will be insuance and liability issues that vary slightly from the traditional homeowners policies discussed above.

If you own a condominium, your owners association should have a master policy that covers property damage to the building structure (everything to the inside bare-wall) and common areas, as well as liability coverage for accidents that occur in the common areas. The master policy usually does not provide you with contents insurance (including paint, fixtures, carpet, plumbing, etc.) or liability coverage if someone is injured in your unit.

Also, while the master policy addresses the original installations and construction; the unit owner is most often responsible for all additions and improvements. It is a good idea to have a copy of the master policy and understand what it covers and does not cover before you buy your condominium policy.

Condominium Associations' master policies do not address individual owners' insurance needs. As a unit owner you should purchase an HO-6 homeowners policy, also known as the "Unit Owners Form." This is the policy most widely known as condominium insurance.

A "Contents Broad Form" or HO-4 type policy can also be used to cover personal property and liability exposures,

but the HO-6 is better designed to mesh with the joint coverage carried by the homeowners association.

Unit Owner's Responsibilities

The condominium form provides a limited type of dwelling coverage for owned structures which are not part of the residence, property that is the unit owner's responsibility under a property owners agreement, real property items exclusive to the unit (such as awnings, patios, and exterior glass), and alterations, appliances, fixtures, and improvements which are part of the residence building.

The best way to assess what building coverage you need is to refer to the master association bylaws, see which items are the responsibility of the unit owner, and insure for the replacement cost of those items.

Unlike homeowners insurance, the condominium form provides named perils coverage for the dwelling. An endorsement is available to broaden this to open perils coverage. A separate endorsement may be purchased to extend the personal property (contents) coverage to open perils, as well. Condominium policy exclusions are identical to the exclusions in the homeowners HO-3 form we analyzed in the homeowners chapter.

The primary coverage provided under condominium policies is personal property coverage (contents) insurance. The minimum amount of coverage is $6,000, and coverage can be written for any higher amount. The full limit applies to personal property owned or used by a policyholder anywhere in the world.

If you own a condominium which you rent to others, you need an HO-33 endorsement which adds theft coverage for your contents (except for jewelry, money, etc.) The reason you need this is because the policy form excludes theft when the residence premises is rented to others.

Loss assessment coverage is much more important in condominium coverage than homeowners coverage. Loss assessment concerns the policyholder's obligation to pay charges assessed by associations of property owners. If common areas or other collectively owned property are damaged, the association may finance the repairs by assessing each member for a share of the cost.

Insure Yourself Against Assessments

Loss assessment coverage is limited to $1,000 in home-
owners insurance, but increased limits are available by
endorsement (HO-35). It is advisable to purchase this
endorsement, as it is relatively inexpensive. Also, if you
have broadened your contents coverage to open perils by
attaching the special coverage endorsement, you have
also purchased "all risk" coverage for loss assessment.

An example: your owners association has an extermina-
tor spray the entire area but the exterminator uses a
faulty chemical which causes damage to walls, carpeting,
and furniture in the commonly owned recreation room.
The exterminator declares bankruptcy, goes out of busi-
ness and the association assesses each unit owner $1,000
for the damage. If you have not purchased the special
coverage endorsement, this loss assessment would not be
covered by your insurance, because the loss was not
caused by a named peril. However, if you bought the spe-
cial coverage endorsement, the loss assessment would be
covered.

A caveat: Even if you have purchased increased limits for
loss assessment, no additional coverage is provided for
assessments charged to you as a result of a deductible in
the master policy. Loss assessment coverage is also a con-
sideration in the liability section of your coverage. You
may be assessed by your association for your share in a
liability claim. The limit of liability here is also $1,000, but
increased limits may be added by endorsement.

Another important difference between condominium and
homeowners policies relates to loss of use. While a home-
owners policy will cover additional living expenses when
the home has been damaged, a condominium policy will
cover additional living expenses when the building con-
taining the residence premises has been damaged. For
example, a fire in one portion of your building does not
damage your unit, but still you must move out until the
damage to the rest of the building is repaired. Under a
unitowners policy, you would be able to collect for addi-
tional living expenses incurred during this period of time.

Other Homeowners Notes

If you live on a farm, you must have a farmowners policy
instead of a homeowners policy. Homeowners policies
exclude property used for farming purposes. Farm-

owners policies are specifically designed to cover the special needs of farms and ranches.

If you live in a flood-prone area you will probably need a flood insurance policy in addition to your homeowners policy. Flood insurance is available through the National Flood Insurance Program.

Earthquake coverage may be available from your present insurance company. It must be added to your policy and you need to pay an extra premium, but it might be worth it. The earthquake endorsement (HO 04 54) as adds earthquake as a covered peril, subject to a special deductible. In areas where the risk of earthquake is small, a two percent deductible might be applied to the limit of liability. In high risk areas, a ten percent or even 20 percent deductible might apply.

If you live in California, insurers are required to offer earthquake coverage at the time you purchase your homeowners or residential insurance policy. Also, even though "earth movement" is an exclusion in homeowners policies, if you add HO-15 to the HO-3 policy, which broadens coverage for personal property to open perils coverage, earthquake damage to personal property would be covered, and would only be subject to the smaller homeowners deductible rather than the larger earthquake coverage deductible.

Looking Back

To sum up the points made in this chapter:

- Don't assume homeowners policies you have had for years will cover every risk you face now. Read your policies again and reconsider what you need to insure.

- As you grow older, the purpose of a homeowners insurance policy shifts from replacing damaged or lost goods to protecting you against personal liability (liability policies will be considered in separate detail in chapter 4).

- Family members can create liability exposures. Be wary of the household you head—you can be held liable for the people who live under your roof.

- Second homes and rental units create special risks that the insurance industry covers with dwelling— as opposed to homeowners—insurance. In many

cases, named-peril policies serve your insurance needs for these properties.

- If you've accumulated valuable personal property, itemize it and attach the lists to your policy. Standard policies will limit the coverage you have for things—you may need to consider special riders or endorsements to cover specific valuables.

- Some of the things and activities older people enjoy most are specifically excluded from coverage under standard homeowners policies. Consider buying separate insurance for things like boats and RVs.

- Residence employees can pose complicated risks, especially if they do work for a home-based business. Keep them in your personal employ, don't pay them through business accounts or other non-household channels.

- Insurance companies are usually prohibited from cancelling or nonrenewing your policy or raising homeowners insurance rates based on your age, though they can raise rates for other reasons that reflect changes in your risk profile.

- Study all policy forms you get carefully.

- Some insurance companies will delay or scrutinize claims that older policyholders make. Be careful, articulate and firm when you make a claim on your homeowners policy.

CHAPTER 3
AUTOMOBILE INSURANCE

In many ways, auto insurance reflects the risk factors of aging as clearly as any kind of insurance. Regardless of age, auto insurance remains controversial because it's influenced by behavioral and demographic realities that some people would rather avoid.

But avoiding reality is silly. And it can be expensive. There are a number of tools available to people over 50 that can help reduce—or at least manage—auto insurance costs. If you use these tools and drive carefully, you should have no problem driving safely and cheaply for years to come.

The first thing to understand about auto coverage is how the insurance companies look at the risks that older drivers pose.

For most men and women, auto premiums actually drop a bit while they're in their 50s. The rate of accidents per mile driven is lower for people in the 40s and 50s than any other group. Insurance companies know this and respond accordingly. One example: State Farm says it reduces motorists' rates by ten percent when they reach age 50.

Relative Risks

Since older people tend to drive less and to avoid the most dangerous conditions (at night, during rush hour and in bad weather) fewer older people than teenagers die on the roads. That translates into lower insurance rates for older drivers than for even middle-aged drivers.

Consider these California Highway Patrol figures for 1989:

Age Group	% All Drivers	% Fatal Accidents	% Injury Accidents
20-to-24	10.6	17.6	16.6
60-to-64	4.9	2.9	2.6
over-65	11.2	7.3	5.6

Accident rates—and premiums—begin creeping up again when drivers reach 60; over age 75, the rate of fatal crashes per mile driven is even higher than it is for teenagers. "[People over 50] are high-risk drivers when they drive," says Allan Williams, who studies age and auto fatality at the Insurance Institute for Highway Safety. But their accident rates are lower mostly because they drive fewer miles and drive less frequently than other drivers.

A National Highway Traffic Safety Administration report found the nationwide "crash involvement" rate for the 16-to-19 age group is 28.6 accidents per million vehicle miles traveled. The rates drop markedly for the middle-age brackets; then they rise again in the senior range, reaching 6.4 for the 70-to-74 age group and 7.7 for the 75-to-79. Among the oldest drivers, the crash rates reach their highest levels—15.1 for the 80-to-84 group and 38.8 at ages 85 and older.

The AARP, which offers a driver safety training course for people over 50, stresses that the entire group—its target market—has more accidents per mile driven than any other age group. But some insurance industry professionals argue this is merely an attempt to spread risk.

Safe Driver Courses

The accident numbers for the oldest drivers skew perceptions among auto insurance risk analysts, who tend to characterize the entire population of over-65 drivers as "high risk." This means that drivers between 65 and 75, whose accident rates remain relatively close to drivers in the middle-age categories, subsidize the drivers over 75.

"A logical step would be to adjust premiums so that the oldest drivers paid much higher rates," says one risk analyst for a big multiline insurance company, who requested anonymity for his comments on this subject. "But that would effectively force people over 70—certainly over 75—off the roads. The political fallout from that would be huge. There wouldn't be an elected official in Florida who still had a job."

As with most insurance coverage, it is illegal to discriminate unfairly against a person because of age in the issuance, nonrenewal, or cancellation of an automobile insurance policy. If you feel an insurance company has rejected your application based on your age, you may

request in writing the reason for your denial of coverage, and the insurer has to respond in writing.

"They can still get around that, though," says Amy Johnson, counsel for the Illinois-based Public Insurance Council, which serves as an advocate for consumers on insurance issues. "It's illegal to refuse to renew a policy because of age, but the problem is, if you're an older driver and you lose your coverage for another reason, like making a claim, many companies refuse to write you another."

Limits on Rate Increases

Though individual insurance companies can set general rates, with the highest on young drivers who have statistically been proven greater accident risks, most states prohibit them from automatically increasing policy costs for drivers simply because they've passed their fiftieth or sixty-fifth birthdays.

The recent lawsuit most relevant to issues of auto insurance costs for people over 50 is the 1993 Maryland appeals case *GEICO et al. v. Insurance Commissioner.*

Prompted by complaints from drivers that their automobile insurance premiums were skyrocketing when they reached their sixty-fifth birthday, the Maryland Insurance Division reviewed the rate filings of certain insurers, including GEICO. The state was looking for any signs that the rates violated Maryland insurance law, which prohibited "excessive, inadequate, or unfairly discriminatory" insurance rates.

GEICO grouped auto risks by various classifications, including age. The age classifications included: 50 to 64, 65 to 74, and 75 and over. GEICO gave each of these age groups a specific rating classification factor, reflecting the company's applicable loss experiences. (The loss experience was based on risk indicators such as number and severity of accidents and the amount of paid claims.)

The risk rating increased as each group grew older. The rating for age group 65 to 74 was higher than that for age group 50 to 64.

Rate Factors for Auto Coverage

Maryland law set out the factors to be used by insurers in setting rates. First, insurers may give due consideration to past and projected loss experience, catastrophic haz-

ards, if any; past and projected expenses; contingencies; investment income from unearned premium reserve and reserve for losses; dividends, savings or unabsorbed premium deposits allowed or returned by insurers to their policyholders; and other relevant factors. Second, rates must not be excessive, inadequate, or unfairly discriminatory. Risks may be grouped by classifications for the establishment of rates and minimum premiums.

That language gave a lot of leeway to insurance companies. But a separate section, dealing with unfair trade practices, provided that motor vehicle insurance cannot be canceled or nonrenewed exclusively because of the age of the policy holder, and premiums may not be increased exclusively because the policyholder is over age 65.

Age-Based Rating Unfair

The Insurance Division ruled that, because GEICO's rates increased premiums for drivers as they turn 65— regardless of their driving records—it had violated state law. In September 1992, the state prohibited GEICO from using age-based rating factors in setting the premiums of individual drivers 65 years and older.

GEICO sued the Maryland Insurance Commissioner in state circuit court. The court supported the Commissioner's findings. GEICO appealed.

"A very long time ago, at 65 you got canceled. [Insurance companies] thought people over the age of 65 were bad risks," says Thomas Waxter, Jr., the Baltimore attorney who represented GEICO. "GEICO argued factually at age 65 the percentage of accidents and the severity of accidents increases. It goes up at age 50, and then spikes up at age 70. Insurance companies want each individual to bear their own exposure, and GEICO had the numbers to prove it."

The appeals court had to reconcile the two sections of state law. The section of the Maryland insurance code allowing rate structures that were actuarially sound became law three years before the section which prohibited insurers from raising premiums exclusively based on a driver's age beyond 65. The court stressed that the later "section expressly does not condition the prohibition against cancellation, nonrenewal, or the raising of rates on whether there is actuarial justification for it."

GEICO argued that the law was meant to protect senior citizens from arbitrary and unfounded prejudice, not to eliminate them altogether from the cost-based, actuarial decision-making applied to all age groups. Therefore, since its rates weren't "excessive, inadequate or unfairly discriminatory," they should be allowed.

No Increase at 65

The appeals court ruled, bluntly, that Maryland law "prohibits, absolutely, an insurer from increasing premiums of drivers 65 and older based solely on their age."

The appeals court built its opinion on a point GEICO conceded: A 64-year-old driver with the same driving history—good or bad—as a driver a year younger would immediately and automatically experience an increase in premiums when he or she reached age 65, while the younger driver's premiums would remain the same.

GEICO argued that the effect of this decision would be to establish an artificial cap on insurance rates for drivers over 65. The court told the company to take that issue up with the state legislature.

"This case didn't have a lot of discussion, they just said you can't do that...public policy. The court said when you retire, you shouldn't have your insurance go up. So, now most companies have flat rates...a 50 year old will subsidize the 65 year old. It accords special treatment to seniors," Waxter says. "But it wasn't passed to do that. It was originally passed to prevent cancellation."

Precedents Supporting Age-Based Rating

Trying to make its defense of actuarily sound rate structures, GEICO cited two legal decisions from other states that had allowed insurers more freedom to set rates.

In the 1983 Florida appeals court decision *State Department of Insurance v. Insurance Services Office*, the issue was a rule passed by the State Department of Insurance which was intended to implement a Florida statute prohibiting insurers from, "with respect to premiums charged for automobile insurance, unfairly discriminating solely on the basis of age, sex, marital status, or scholastic achievement."

The Florida court held that the rule was an invalid exercise of delegated authority. It reasoned that the legis-

lature obviously intended to permit discrimination based on age, sex, marital status, and scholastic achievement so long as this discrimination is not unfair or based solely on these factors. But the Department of Insurance, by promulgating its rule, went too far by prohibiting altogether the use of age, sex, marital status or scholastic achievement in the formulation of premiums or rate classifications.

The 1979 Louisiana decision *Insurance Services Office v. Commissioner of Insurance,* held that the use of age or sex as classifications in the establishment of rates, was not unfair discrimination on the basis of age and sex so long as there is a sound statistical basis for the classification. The statute at issue, however, did not prohibit the raising of rates solely on the basis of sex or age. It simply stated that risks may be grouped into reasonable classifications in order to establish rates and that these rates may be modified for individual risks as long as they are based on established standards which measure variations in hazards or expense provisions, or differences that have a probable effect upon losses or expenses.

But Louisiana's insurance law—like Maryland's—prohibited insurers from increasing, solely on the basis of age, the automobile insurance premiums for drivers age 65 and older. Ultimately, all the Louisiana case decided was that classifications on which insurance rates were predicated had to be reasonable and not unfairly discriminatory.

Premium Discounts

Some of the factors used to determine your premiums are out of your control, such as where you live, your age, gender, and marital status. Other factors are more within your control, such as your driving record, how many miles per year you drive, and what kind of car you drive.

Reductions in premium are commonly offered to non-smokers, to carpool drivers, to individuals with good safety records, to households insuring more than one car with the same insurance company, to people who don't use their automobile for commuting to work, to people who also buy homeowners or other types of insurance from the same company, and for vehicles with antitheft or safety features such as airbags or antilock brakes. Also, you

may be eligible for certain "mature driver" premium discounts.

More than half of all states require insurance companies who write automobile insurance to offer a premium reduction program for older adults who successfully complete a driver's safety course or defensive driving course. In most states the program applies to anyone 55 or older.

Qualified applicants generally need to have a clean driving record—no chargeable accidents or citations within the preceding three years. They must also have successfully completed an approved driver's safety course within the preceding three years and provide a certificate of course completion when applying for the discount. Most states require older drivers to successfully repeat the course every other or every third year in order to continue to qualify for the premium reduction. In most states, insurers may rescind the discount when a driver has received a moving violation or chargeable accident citation.

Since the AARP's program began in 1984, more than 3 million drivers have graduated. More than 500,000 were expected to take the course nationally during 1994. The program is not restricted to the elderly—anyone who's reached age 50 can attend and use the credits toward premium discounts.

Course advocates argued that such programs have already done much to focus on "the fact that there are many more safe and able older drivers out there than people realize," said Bob Watson, AARP's driver-education coordinator for California.

The results are promising. Students who pass a written exam receive a certificate good for reduced insurance rates. And Harris says that statistics kept by AARP's national headquarters show that successful students are 75 percent safer than before they began the program.

Physical Changes that Affect Driving

Don Harris, a retired insurance agent who teaches the AARP's "55 Alive" course in Tulsa, Oklahoma, says that some older drivers try to pretend they do not feel any effects of age behind the wheel. "We discuss the issue of age considerably in class. Some of the students are tough as nails when they start and then most mellow out."

Yet the fact remains that normal physical changes due to aging, such as changes in eyesight and hearing, adversely affect driving ability. Older drivers are more likely to have slower reflexes, be using prescription drugs, be more sensitive to glare, have reduced peripheral vision, and have trouble adapting to changes in lighting (both inside and outside of the vehicle).

An AARP publication notes: "Research shows that normal age-related physical changes begin to accelerate at age 55. Accidents per mile driven begin to increase at this same age."

Another study conducted by the NHTSA found that the most common accidents for older drivers involve turning, right-of-way and other intersection maneuvers. On average at interstate speeds, an older driver is about a second slower than younger drivers.

"As a group, we have more accidents per miles driven than younger or middle-aged persons. I think seniors today are more with it and are more perceptive as they get older when it comes to driving," says Len Quick, a 73-year-old Georgia-based instructor. Still, he adds that "Most [students] are amazed how much their reaction time has slipped."

This kind of training will likely become more and more the norm. Lawmakers, regulators and insurance companies are searching for ways to make older people better drivers.

The High-Risk Drivers Act, which the Senate passed in 1993, provides for a more detailed federal study of older drivers, who already face a variety of restrictions in some states.

Age-Based Renewal Regulations

In 1994, 16 states had age-based driver's license renewal regulations, but advocacy groups like the AARP consider them discriminatory. "As a general rule," says Ted Bobrow, an AARP auto insurance specialist, "we oppose age-based testing. It may be a good idea to test all drivers every year or every four years."

Proposed plans for reducing older drivers' accident rates include tighter relicensing rules to ensure that their vision or other capabilities haven't fallen below minimum levels. One example: New York law bans nighttime driving and use of limited access highways for those whose vision

has fallen below the minimum. And a road test may be required if police, a family member or a physician request it. But politicians, well aware that older people tend to be regular voters, are reluctant to endorse restrictions on their driving—just as they hesitate to force more specific rate breakdowns. Still, some automobile insurance agencies actively seek senior drivers as clients, said Jerry Johns, spokesman for Southwest Insurance Information Services, a public information organization for the property and casualty insurance industry.

The inevitable point: Older drivers may find themselves paying higher insurance rates. Johns insists that insurance company statistics "do not show that (the number of accidents) go up at any specific age," but the Texas Department of Insurance has specified three general driver-age categories: younger than 25, 25 to 65 and older than 65. And its data supports the general trend—the older drivers pose a comparatively high per-mile risk of accident.

Another factor that could affect your auto insurance premium is that not all states require or enforce mature driver discounts. In light of California Insurance Commissioner John Garamendi's promise to suspend auto insurance rate increases in 1991, 65-year-old Alex Baum was unpleasantly surprised when his insurance company—20th Century Insurance—sent him a bill that was 34 percent higher than it was the previous year.

"I called them and they told me that due to Proposition 103, they don't give an elderly discount any more," Baum, a driver in California since 1960, complained to the Los Angeles Times. "They said our premium had gone up because we didn't have enough years of driving experience...but when I tried to get into specifics they got very annoyed."

Policies for Older Drivers

You may find while shopping for automobile insurance that there are insurance companies reluctant to insure older drivers, as well as insurance companies that specialize in covering older drivers. The AARP offers a specialty program for drivers age 50 and older which will provide lifetime coverage, provided you have a reasonably good driving record and can qualify for initial coverage. You can only be dropped from this plan if you are arrested

for drunk driving, your license is revoked, or you fail to pay your premium.

The auto insurance plan—offered jointly by AARP and The Hartford—has high annual premiums and sur-charges levied after traffic violations or accidents. AARP sometimes assesses drivers in their seventies far more than those in their sixties.

AARP takes a particularly tough stance on accidents and traffic violations. If your car gets wrecked or you are caught speeding, you can expect to find a surcharge tacked on to your premiums for the next three years.

Room for Improvement

Even AARP staffers admit their automobile insurance plan could be improved. "There are significant numbers of people who could do better elsewhere," says Ron Hagen, AARP's director of insurance services.

When AARP started selling car insurance in the early 1980s, it aimed for premiums as much as ten percent below those of State Farm, the nation's largest auto insur-er. Today, AARP's premiums often rise well above that tar-get level. In one comparison, AARP charged 80 percent more than State Farm.

In a 1988 test, *Money* magazine asked five big insurers for the penalties they would impose on a retired 65-year-old married couple with a 1984 Buick Real Coupe and a 1982 Buick Skyhawk Limited Coupe if they were fined for driv-ing 15 miles per hour over the limit and if they filed an acci-dent claim during their first year as policyholders. AARP's surcharges were highest or second highest in all but one of the cases surveyed. If the couple filed an accident claim in Bellwood, Ill., they would see their AARP premiums rise 56 percent, compared with a four percent increase by State Farm. Add on a speeding conviction and that would raise their AARP premium another 26 percent. State Farm would not add that surcharge.

Basic Coverage

Robert Hunter, former president of the National Insur-ance Consumer Organization and currently Texas Insur-ance Commissioner, says poor drivers would probably pay less in their state's assigned-risk insurance plan than they would paying AARP's surcharge-heavy premiums.

"Guaranteed renewability at inaffordable prices is no guarantee at all," says Hunter.

If you are driving an older car with a low replacement value, you might want to drop your collision coverage in order to reduce your premium. However, if you cause an accident causing damage to your car, you would not be reimbursed at all for the vehicle, so you should only do this if you are willing to pay the entire cost to repair or replace your vehicle.

Another factor that affects the final premium charged is the size of the deductibles you select to apply to collision and comprehensive damages. (Comprehensive coverage is now commonly called "other than collision" coverage because policyholders forgot about their exclusions and thought "comprehensive" coverage meant all-inclusive coverage. When court interpretations began to agree, insurance companies changed the terminology, much as in homeowners insurance when the term "all-risk" was changed to "open perils".)

Liability Risks

Resist the temptation to minimize your limits of liability. The risk of injuring or killing another person is the largest risk you face when driving. You should consider carrying limits that are higher than those required by law, especially if you have a home or other assets to protect. If you cause an accident and are found to be liable, after the insurance company has paid the limits of the policy, you will have to pay any remaining damages out of your own pocket. The more you own, the more liability insurance you need.

You should also consider carrying increased limits for uninsured/underinsured motorists coverage. In the event you are in an accident with an uninsured driver, or a driver whose coverage is insufficient to pay the damages they are responsible for, your insurance company will step in and pay your additional costs.

Medical payments coverage is optional in some states, and if you do most of your driving alone and have good health insurance coverage you might decide not to buy it and avoid paying twice for similar coverage. However, if you often have nonfamily members in your car, you should keep your medical payments coverage because in the event of an accident, injuries to all passengers would

be covered. Passengers who are family members could collect under your health insurance policy, but nonfamily members would have to sue you for negligence to collect under your automobile liability insurance.

As with all insurance policies, don't assume all insurance companies will charge the same premium for similar coverage. As soon as you've determined what your best coverage options are, be sure to shop around, and get prices from a number of different insurance companies or different agents (at least three).

Auto Policy Territory

Most personal auto policies restrict the policy territory to the United States, its territories and possessions, Puerto Rico, and Canada. But when you drive your car into a state other than the one in which you live, and an accident occurs, even though you have coverage, settling a claim can be complicated because liability laws vary from state to state. The personal auto policy will automatically provide the minimum amounts and types of coverage needed in the other state. For example, suppose your home state does not have a no-fault auto insurance law, but you vacation in another state that requires no-fault coverage. If you have an accident in the no-fault state, your personal auto policy will provide the required no-fault benefits.

If you drive your car into Mexico you must have valid liability insurance from a Mexican insurer. If you do not and are involved in an accident in Mexico, you may be detained in jail, have your car impounded, and be subject to other penalties.

If when you travel, you have ever rented a car, you probably have been offered a collision damage waiver. If you're like everyone else, you wonder if you need it or not.

A collision damage waiver releases you from responsibility for damage to the rental car, provided you comply with the rental contract terms. If you decline the coverage and have an accident, you may be held responsible for the entire value of the car. But the collision damage waiver is an expensive way to buy collision insurance.

If you carry collision insurance on your own car and your policy also covers rented vehicles, it is safe to decline the collision damage waiver. Be sure to check with your insurance agent and make sure you have coverage beforehand.

Another way you may secure this coverage is through your credit card. Many credit card companies provide you with a collision damage waiver in return for using the card when you rent a car. Check with your credit card companies to see who offers this coverage.

When it comes to liability insurance, your own auto policy coverages protect you and your passengers in a rented car as well as in your own car.

Only private passenger type vehicles are eligible for coverage under the personal auto policy. To extend your medical payments, uninsured motorists, collision and other-than-collision coverage to motorhomes, motorcycles, golf carts, etc., you must endorse your auto policy with a Miscellaneous Type Vehicle Endorsement. Each insured vehicle is listed in a schedule which outlines the applicable coverages, limits of liability, and premium.

Liability for Your Family Members

In the chapter on homeowners insurance, we saw that family members can sometimes complicate the risk profiles of older policyholders. This holds equally true for auto insurance. If you've ever paid the premiums for family policies that include teenage drivers, you know this first-hand.

However, as families grow older and thoughts turn toward building and maintaining retirement funds, you need to think even more defensively. The Colorado case *Farmers Group, Inc., et al., v. R. Bruce Trimble* shows how even adult children can pose risks with cars.

In 1977, Mid-Century Insurance—a subsidiary of Farmers Group, Inc.—issued a homeowner's liability insurance policy to Bruce Trimble and his wife. In 1978, another Farmers unit issued an automobile liability insurance policy to Trimble.

The Farmers automobile liability policy contained a bodily injury liability limit of $50,000 per person. It also authorized Farmers to investigate and settle claims as it saw fit, and provided that Farmers had the right and duty to defend, at its own expense, suits against Trimble.

On November 6, 1978, Trimble's 19-year-old son, Douglas, drove Trimble's automobile onto the front yard of the residence of Robert Jensen, seriously injuring Jensen.

Trimble's son had had conflicts with Jensen, because Jensen had abused his dog. "So the son and a friend were going to do a wheelie through his front lawn with the car," says an attorney who was involved in the case. "Well, Jensen wakes up and hides behind the bushes when Trimble's son came back for the second pass at the yard. He jumps up from the bushes [to confront Trimble's son] and ends up getting dragged down the street. He was pretty seriously injured."

Trimble reported the incident to a Farmers agent, and the company immediately began an investigation.

On November 20, 1978, Farmers sent a letter to Douglas stating that the automobile policy's "intentional act exclusion" might deny coverage.

Settlement Offer Ignored

Shortly afterwards, Jensen offered to settle the case for $50,000—the policy limit of the automobile policy. Farmers rejected the offer, because it still had questions about the coverage under its policy. Farmers never informed Trimble or his son of Jensen's offer.

In March 1979, Jensen filed a civil action against Trimble, Douglas, and a third party asking for $200,000 compensatory and $200,000 exemplary damages.

In April 1979, Farmers selected an attorney to defend Trimble and his son against Jensen's claims. Trimble and Douglas were informed that they could retain private counsel, at their own expense, to protect their personal interests in case there was a judgment in excess of the policy limits and/or exemplary damages not covered by the policy. The letter also stated that it was not necessary for them to retain private counsel because the attorney retained by Farmers "will represent your personal interests without cost to you."

By June 1979, Farmers had reserved $50,000 in anticipation of the outcome of Jensen's lawsuit, and had estimated the value of Jensen's claims to be between $75,000 and $150,000.

However, when Jensen's attorney found out about the

Mid-Century homeowners policy, Jensen decided to forego the $50,000 settlement and try claimed $100,000 under the homeowners policy's liability coverage.

On November 12, 1979, Jensen's attorney informed the retained attorney and a Farmers agent that a recent court decision (*Douglass v. Hartford Insurance Co.*) established coverage by the homeowners policy for Jensen's claims. This letter was forwarded to Farmers, but not to Trimble.

In October 1980, Farmers and its affiliate companies sued Trimble, seeking to establish that the homeowners policy provided no coverage for Jensen's claims. Trimble hired an attorney and countersued Farmers.

In April 1981, Jensen's claims against Trimble were settled. Jensen received $50,000 under the Farmers policy and $12,000 under the Mid-Century policy. In connection with that settlement, Farmers' complaint against Trimble was dismissed as moot. Trimble's counterclaims against Farmers were not. The counterclaims sought compensatory and punitive damages allegedly caused by Farmers' mishandling of the claims.

Insurer's Negligence

Trimble charged that Farmers acted negligently by rejecting Jensen's settlement offers and by allowing Jensen to sue Trimble, thus exposing Trimble to the risk of a large, uninsured judgment. Trimble claimed economic loss incurred from having to employ an attorney. The appeals court concluded that the cost of hiring the attorney, if caused by Farmers' negligence, could be considered damages flowing from the failure of the insurer to exercise reasonable care in representing the policyholder in the course of litigation.

It cited the often-quoted 1970 Colorado decision *Aetna Casualty & Surety Co. v. Kornbluth*, which held: "An insurance carrier representing [a policyholder] pursuant to the requirements of an insurance contract must exercise reasonable care in fulfilling its duty of representation."

Trimble's second counterclaim alleged that although Farmers knew as early as November 1978 that it had no reasonable basis to rely upon the automobile insurance policy's intentional act exclusion to contest coverage, it still proceeded as though it might enforce the exclusion.

"When construed in Trimble's favor, this counterclaim states a claim for relief based upon the tort of bad faith breach of insurance contract. An insurance carrier may be liable to its policyholder for failure to exercise reasonable care in fulfilling its duty of representation," the court ruled. "Such liability is based upon traditional common law concepts of negligence, or an unintentional but unreasonable failure to discharge a duty owed to another."

Establishing Bad Faith

In order to prevail on a claim of bad faith breach of insurance contract, a policyholder must establish the absence of any reasonable basis for the alleged conduct. The appeals court said a jury would have to decide whether that was the case, and sent the case back to trial.

Farmers made the defense that evidence of intent, such as intentional misconduct, actual dishonesty, fraud, or concealment was a prerequisite to recovery on a claim of bad-faith in an insurance contract. This bounced the case up to the Colorado Supreme Court.

The high court rejected Farmers argument. "The duty of the insurer to act in good faith when dealing with its [policyholder] is characterized in many jurisdictions as a duty implied by law as a covenant of the insurance contract," it ruled, citing the 1973 California Supreme Court decision *Gruenberg v. Aetna. Gruenberg* states:

The duty to show good faith exist "whether the company is attending to the claims of third persons against the [policyholder] or the claims of the [policyholder] itself. Accordingly, when the insurer unreasonably and in bad faith withholds payment of the claim of its [policyholder], it is subject to liability in tort."

The Colorado court ruled that the basis for an insurer's duty of good faith and fair dealing is grounded on "the special nature of the insurance contract and the relationship which exists between the insurer and the insured."

It went even further:

"Particularly when handling claims of third persons, an insurance company stands in a position similar to that of a fiduciary. By virtue of the insurance contract, the

insurer retains the absolute right to control the defense of actions brought against the [policyholder]....

"Given the quasi-fiduciary nature of the insurance relationship, we are persuaded that the standard of conduct of an insurer in relation to its insured in a third party context must be characterized by general principles of negligence."

A Good Standard for Policyholders

The question of whether an insurer has breached its duties of good faith and fair dealing with a policyholder focuses on what the Colorado courts call "reasonableness under the circumstances."

"This is a very liberal standard favoring insureds. It is probably the most liberal, compared to other states who require either malice or the absence of any reasonable basis to delay or decline coverage," says Thomas L. Roberts, the attorney who represented Trimble in the lawsuit. The court allowed a bad faith claim based only on delay even though no judgment was entered against the insurers in excess of the policy limits. Recovery was allowed for all the worry, grief and turmoil caused. This was a very important result in this case because it made clear to insurers that ultimate payment does not erase their unreasonably dragging out the claim.

Indeed, the ruling created exacting terms on insurance companies. But it addressed precisely the sort of protection older policyholders seek most of all.

Uninsured/underinsured motorist coverages are a form of self-insurance. They allow you to protect yourself from genuine risks—the unknown risks that people in the car next to you pose. Don't skimp on this coverage. In the context of auto insurance, liability issues also focus on accidents involving other drivers who are uninsured or underinsured, making it important that you carry sufficient limits of coverage.

Understand the Insurance You Buy

The 1994 Ohio court of appeals decision *Lucas v. Liberty Mutual Insurance Company* dealt with uninsured/underinsured issues in a useful way.

In April 1988, Steven Lucas sustained serious injuries in a traffic accident, causing him to incur medical bills

alone in excess of $40,000. Other costs drove his total claim above $50,000. Lucas wasn't at fault in the accident, but the person who was didn't have insurance.

At the time of the accident, Lucas was insured under a policy issued by Liberty Mutual. The main issue that quickly emerged: the uninsured/underinsured limits contained in that policy.

After the accident, Liberty Mutual paid Lucas $50,000 pursuant to the uninsured/underinsured motorist coverage that was part of his auto policy.

Lucas took Liberty Mutual to court, arguing that, as a matter of law, Liberty Mutual owed him $100,000 uninsured/underinsured motorist coverage. Specifically, he claimed that he hadn't expressly rejected uninsured/underinsured coverage equal to the full amount of his coverage. Ohio law assumes consistent coverage limits in an auto policy unless the policyholder requests differently.

Choosing the Lowest Limits

Liberty Mutual claimed exactly that had happened. It argued that, at the time Lucas purchased the policy, he opted for the lowest uninsured/underinsured motorist coverage available—with limits of $15,000 and $30,000 per person and per accident respectively. He chose this amount by checking a box on a preprinted form entitled "Ohio Uninsured/Underinsured Motorist Coverage Option Form."

Lucas's insurance agent later informed him, however, that the coverage amounts he had chosen weren't available, and that the next lowest amount offered was $50,000/$100,000. According to Liberty Mutual, Lucas agreed to that amount, although he never signed a written application specifying his choice.

According to Lucas, the check mark for coverage that wasn't available rendered the whole endorsement useless. Thus, the uninsured motorist coverage defaulted back to the higher limits. He cited several cases in which people who had inaccurately or incompletely filed out endorsements for lower uninsured coverage won higher coverage.

Senior on a Fixed Budget

But Liberty Mutual's sales representative, Gregory Getzinger, testified in deposition that he offered Lucas coverage equal to his liability limits. "I recommended the same kind of limits for uninsured as bodily injury. Mr. Lucas reinforced the fact that he was a senior citizen and looking to stay within a fixed budget. And I explained to him the cost difference between the limits," Getzinger said. "He wanted to stay with the limits that he had from his previous policy, which was a Hartford company, which also had the 15/30 [limits]."

That was short-term wisdom and long-term folly.

The appeals court rejected Lucas's arguments about the way he signed the form. It cited a previous decision, concluding: "A separately signed provision in an insurance contract rejecting an equal amount of underinsured coverage was sufficient to constitute an express rejection of such coverage."

Lucas himself testified that he understood he was checking the lowest amount available. He said he did so to avoid the higher premiums:

"Q. So you initially requested the lowest limits you could get?

"A. Right, yes.

"Q. And why is it that you wanted the lowest limits?

"A. Economic reasons.

"Q. Premium payments?

"A. Yes."

The appeals court upheld Liberty Mutual's lower limit.

Pick Your Battles Wisely

An important point to remember when you're buying auto insurance: Like all coverage, this protection imposes certain conditions. Some people—driven by temperament or extreme circumstances—try to control how their cars are repaired after an accident.

It's better to take a more detached view. Buy car insurance that protects your assets and your well-being. Find a company that makes you comfortable you'll be treated in a manner you prefer. Then, if a claim has to be made, focus

on getting whatever's damaged fixed. Don't try to manage your insurance company through the claims process. The fruits of this kind of effort are usually meager.

The 1991 Ohio case *Henry Giovanni v. Swongers Service Center* proves this point.

In May 1989, Henry Giovanni's 1983 Buick Regal was involved in an automobile accident in Columbus, Ohio. Giovanni made arrangements to have his vehicle towed from the scene of the accident to Swongers Service Center for repairs. He notified his insurance carrier of the accident and of the location of his damaged car.

Giovanni chose Swongers's garage because it was approved by the American Automobile Association, of which he was a member, and because Swongers' garage offered a discount to senior citizens.

After the car was delivered to the Swongers Service Center, most of the dialogue concerning its repair was between the insurance carrier and the garage employees.

Giovanni was highly dissatisfied with the way the automobile operated after it was returned to him. He complained to Swongers on a number of occasions. Swongers attempted, at its own expense, to make the necessary corrections.

Among other things, Giovanni insisted that the trouble with the car stemmed from a defective ball joint. Swongers proceeded to replace the ball joint. However, this did not correct the problem, and Swongers, having exhausted its resources, referred the vehicle to Nelson's Frame and Body Shop, which discovered that the car had a bent brace. The bent brace was straightened, at Swongers' expense, and the problem was apparently corrected.

Giovanni sued Swongers, seeking $126.31. The trial court ruled in favor of the Swongers Service Center. Giovanni appealed.

A $126.31 Appeal

Giovanni's central objections centered around the ruling that his insurance company—not he—was the consumer of Swonger's services. In effect, the trial court had ruled that "Giovanni was entitled to no voice in the repair of his own damaged car."

Donald Cambert, the adjuster sent to inspect Giovanni's car, testified that Giovanni hired Swongers. He also said that Giovanni and not Swongers received the check from the insurance company for the damages.

The court ruled that "the purpose of Ohio law would be defeated if the owners of damaged automobiles were placed at the mercy of insurance adjusters and cooperative garages."

Giovanni also tried to claim damages for lost time due to the alleged misdiagnosis of his vehicle. But he failed to sustain his burden of proving any specific damages. He produced no documentation of his time loss, no receipts, and no reliable evidence of out-of-pocket expenses. "On the contrary, the record reveals that Swongers, while insisting that the real cause of the mechanical trouble with the car came from its high mileage and worn tires, nevertheless proceeded to pay for the ball joint and for straightening the bent brace," the court ruled.

Giovanni also claimed that Swongers hadn't refunded him its advertised senior citizen discount. The court agreed he should have it.

"Within the intention of the Consumer Sales Practices Act, the intervention of an insurance carrier does not alter the supplier-consumer relationship of a garage employed to do repairs and the owner of a damaged vehicle," the appeals court ruled, summing up the case. "But under such circumstances, the customer is required to prove some statutory or common law damage from such consumer transaction."

Because the court found that both sides had maintained good faith and the charges—though minor—weren't frivolous, both sides had to pay their own attorney fees. The net adjustment on appeal: the $58.31 that constituted Giovanni's discount.

Looking Back

The main points to remember from this chapter:

- Auto insurance is a losing game for people between 50 and 65. You're subsidizing the rates for drivers over 70. Advocacy groups don't make an issue of this imbalance because they see it just as the insurance companies do—as a logical spread of risk.

- Whenever they can, insurance companies use actuarial tables to defend higher insurance rates for older drivers. In some states, these arguments don't hold up against laws that prohibit raising rates for older drivers based solely on age.

- Because they can't base rate hikes solely on age, insurance companies try to find other actuarily-sound reasons for raising rates.

- Since you'll have a hard time changing the rules of the actuarial game, you do best to play by them. Various safe driver courses are available in most locations—and they usually include a premium discount (as much as 10 percent) upon completion.

- If you are driving an older car with a low replacement value, you can save on premiums by dropping your collision coverage. Raising your deductibles can also reduce your premium. But try not to minimize coverages like uninsured motorists and your maximum limits of liability; the more you own, the more liability insurance you need.

- Read through your policy to understand its limitations and exclusions. Find out whether your policy includes coverage for rental vehicles. If it does, it is safe to decline the collision insurance offered by car rental companies.

- What's true for homeowners insurance is true for auto insurance: Protect yourself. Insure against liabilities whenever you can. Don't cut corners on things like uninsured motorist coverage. That's counting on the insurance of every driver on the road—a bad bet and a big mistake.

- Be careful of the household members you carry on your auto insurance. This is another liability issue. It's also a situation where you practice some basic risk management—like not handing the car keys to a relative you can't trust.

- Don't look for auto insurance to give you complete justice in the wake of something as nerve-racking as an accident. Buy coverage that will fix what's broken in reasonable manner, make sure those things get fixed, but don't try to exact profound satisfaction from car insurance.

CHAPTER 4
OTHER FORMS OF PERSONAL COVERAGE

Once you've insured the place you live and the car your drive, your needs for personal lines insurance may turn very specific. Insurance companies sell dozens of products that protect you from different personal risks. In this chapter, we'll consider eight particular kinds of insurance: renters, mobile home, personal articles floaters, personal liability, credit, travel, reverse mortgages and pre-need funeral expense.

The way that insurance companies structure and market these personal coverages remains similar. If there's a personal property coverage you're considering that isn't covered here, you should still be able to apply most of the suggestions we make and conclusions we reach.

Renters Insurance

Many older people prefer to rent a home or—more often—an apartment for two reasons: it frees up capital and it creates fewer liability risk exposures. But, even if you rent a home or apartment, you still need "contents" coverage for your personal belongings, additional living expenses, and liability coverage if you are responsible for injury to another person or damage to another person's property.

Property and liability coverages provided by renters insurance are fundamentally the same as the homeowners coverages we discussed in an earlier chapter. Renters insurance is included here because the insurance needs for those who rent are generally different than they are for those who own a residence.

A Contents Broad Form, also known as a Tenants Policy, or HO-4 policy is designed to cover the exposures of renters. Coverage is provided for personal property and loss of use, but there is no coverage for the dwelling or other structures.

Sometimes long-term renters may decide to improve the property and invest in such things as permanent book-

shelves, expensive wallpaper, or new lighting fixtures. These would not be covered by the typical "contents" policy, but the tenants policy makes provision for these items under "additional coverages."

The additional coverages limit is ten percent of the total limit of liability for personal property. If you have a limit of $40,000 on personal property, and a fire destroys the inside of your apartment including additions you have just spent $8,000 to install, the most you will recover is $44,000: your policy limit plus ten percent. If that doesn't seem like enough coverage, you can buy more by adding an endorsement which gives you higher limits for building additions and alterations.

Mobile Home Insurance

Special mobile home owners policies are available that cover personal property and liability exposures as well as offering coverage similar to automobile insurance: collision and comprehensive. Mobile home policies are not standardized, so they might include coverage for awnings, porches, air conditioners, and other equipment you add after purchase, or these might be considered additional coverages for which you will be charged a higher premium.

Some big insurance companies will write mobile home insurance, usually as part of a package of coverages. But the market for this kind of insurance is dominated by a few niche players. Chief among these: Michigan-based Foremost Corp. of America. Foremost sells its insurance directly and through marketing agreements with groups like state mobile home owners associations and the AARP.

Mobile home insurance is the kind of niche product that insurance companies like to sell. It's a specific market with distinctive risks—but risks that share many characteristics with traditional auto insurance. And it's a concentrated market. AARP membership includes nearly 30 percent of the country's 5.4 million insurable mobile home owners.

Foremost has 12 million policy years of data on mobile homes, which it uses to define its customers, and 350 employees in a centralized claims department who handle 97 percent of its claims. The fruits of this focus have been rich. Foremost has shown underwriting profits in 33 of 37 years in its core products.

Mobile homes originated in the 1930s as temporary housing towed behind an automobile. During World War II, mobile home parks sprouted near war production plants. Because they were constructed of materials not necessary for the war effort, mobile homes were an ideal housing alternative. After the war, mobile homes continued to grow in popularity as low-cost housing.

Foremost began as a one-room operation insuring new mobile homes financed by a single bank. Ed Frey, the president of Michigan-based Union Bank Co., realized property insurance was needed in order for lending institutions to provide financing for this new segment of the housing market. The fledgling mobile home industry, however, was considered a poor risk by insurance companies. So Frey and a group of business associates formed Foremost to write mobile home policies.

Personal Articles Floaters

A personal articles floater (PAF) is specialized form of insurance that can be used to cover personal property on an itemized and scheduled basis. It is virtually identical to the "Scheduled Personal Property Endorsement" which may be attached to a homeowners policy, which lists specific classes of personal property along with a scheduled amount of insurance.

A PAF usually contains an itemized schedule listing insurable property such as jewelry, furs, cameras, musical instruments, silverware, golfer's equipment, fine arts, stamps, and coins. For each class of property covered, an amount of insurance must be shown and the article must be described. The coverage applies worldwide, except for fine arts coverage which only applies in the United States and Canada.

A personal articles floater is flexible and other classes of property may be included, such as watercraft. The PAF automatically provides coverage for some types of newly acquired property. The policyholder must report the objects within 30 days of acquisition (90 days for fine arts) and pay the additional premium.

The PAF provides open perils coverage for direct physical loss except loss caused by war, nuclear hazards, wear and tear, deterioration, inherent vice, and insects or vermin. Additional exclusions apply to specific classes of property such as musical instruments and fine arts. For example,

fine arts coverage does not include damage caused by repair, restoration, or retouching.

Fine arts are scheduled and insured on an agreed value basis. All other scheduled property is covered on an actual cash value basis. According to the PAF's loss settlement conditions, in the case of a loss, the insurer will pay the least of the following three amounts: the article's actual cash value at the time of the loss or damage, the amount for which the property could be repaired to its condition immediately prior to the loss, or the limit of insurance. So if your "priceless" antique porcelain doll which was damaged in a fire was recently appraised at $6,000, and you had it insured by a PAF for $5,000, but it would only take $1,000 to repair its damage, your insurance company will only issue you a check for $1,000.

Finding Precise Coverage

Other "floater" policies are available such as the personal property floater, personal effects floaters, and individual articles floaters, These are almost always written on an open perils basis, and commonly exclude losses from wear and tear, gradual deterioration, damage caused by animals and insects, and inherent vice (which refers to an item's natural tendency to decay).

The personal property floater provides all risk coverage on a worldwide basis for unscheduled personal property. The primary difference between the personal property floater and the personal articles floater is that the PPF covers unscheduled property while the PAF covers scheduled property.

Coverage for specific classes of property, such as money, securities, jewelry, watches, furs and other items of high value, is subject to special limits, just as they are under a homeowners policy. But these limits may be raised by attaching individual article floaters which show scheduled amounts of coverage.

The comprehensive coverage provided by the PPF is relatively expensive, and the form is designed for people who have significant amounts of personal property and travel extensively. Others probably would not be willing to pay the high premiums for worldwide all risk coverage.

Personal Liability Insurance

If you have assets that total $300,000 or more, you sh probably purchase additional liability insuranc means of an so-called "umbrella" policy. An umbrella icy protects you because its coverage takes effect when all your other liability limits have been exhausted by a large claim.

For example, if you have a $300,000 automobile liability limit and a $1 million umbrella policy, and you are found liable for an accident which incurs $600,000 in liability claims, your auto policy would pay $300,000 and the umbrella policy would pay the remaining $300,000. Without the umbrella liability policy you would be responsible for the remaining $300,000 out of your own pocket.

Because umbrella coverage only comes into play after other coverages are exhausted, a $1 million umbrella liability policy is less expensive than you might expect. One note: you will probably have to purchase your umbrella policy through the same insurance company that writes your automobile and/or homeowners policy, to help avoid legal disputes between companies at claims time. (If it's the same company, they have to pay, regardless of which policy provides coverage.)

All umbrella policies provide excess coverage over homeowners and automobile policies. Most provide some coverage for fire legal liability, water damage, employers liability, watercraft, contractual liability, and personal injury (although this last varies the most). Rarely do umbrellas give coverage for aircraft, professional liability, uninsured motorists coverage, or catastrophic medical expense.

Umbrella policies are particularly recommended for individuals travelling outside of the United States, because the coverage they provide applies worldwide.

True Umbrellas vs. Excess Policies

True umbrella liability policies increase the limits of the underlying policies, broaden the coverage provided by the underlying insurance (by covering some unusual claim situations not covered by the basic policies), and can pick up where the aggregate limits of the underlying policies leave off. The defense provisions require the insurer to join the underlying defense, defend retained claims, take

over the defense when the underlying policies are exhausted, and are usually payable in addition to the policy's limit of liability. An excess policy raises the limits of underlying insurance but provides no broadening of coverage.

Umbrella liability policies commonly exclude business pursuits, professional liability, liability assumed under contract (when you rent or borrow property), and intentional acts. Also, umbrella policies commonly exclude punitive damages (civil and criminal penalties), directors and officers liability, motor racing, motorcycles and recreational vehicles, and losses arising out of pollution, war, and nuclear energy.

Especially if you have a significant amount of assets to protect, an astute insurance agent will strongly recommend you purchase an umbrella policy. Your agent may go so far as to ask you sign off that even though it was recommended, you do not want to purchase umbrella coverage. You may think this an overly solicitous concern about protecting your assets, but in fact your agent is probably most concerned about protecting himself or herself.

Personal liability insurance (or, more accurately, the lack of it) is the eighth most common reason agents are sued for errors and omissions (insurance agent malpractice). The dangers for insurance agents are if they fail to check your underlying insurance, or if they switch your umbrella to lower limits without notifying you, the "gap" in your coverage may end up being paid by the agent's errors and omissions policy.

Unexpected Risks

The Texas Court of Appeals in Houston considered a complicated personal liability case (which also involved some homeowners issues) in its 1993 ruling *Jerry E. Chiles v. Chubb Lloyds Insurance Company*. The case turned on the divorce between a married couple in their fifties with some valuable assets to protect.

Chiles' wife Patti sued him for alleged intentional and negligent conduct that caused her physical pain and mental anguish. She sought damages from the personal liability rider to his homeowners policy with the Lloyds group.

The court rejected her negligence claims but allowed her claims of intentional infliction of emotional distress. The jury awarded her damages. Eventually, an appeals court rejected this award because of a pre-marital agreement between the Chileses.

But Jerry Chiles was left with some steep legal fees. He sued Lloyds to recoup them. Lloyds based its rejection of Chiles's legal bills on the fact that he hadn't informed it of the proceedings in a timely manner. The trial court found that Chiles had breached the policy's conditions and Lloyds therefore owed him no duty to defend or pay defense costs in the divorce suit. He appealed. The appeals court also found that Lloyds had no duty to provide a defense in this case.

Even if you buy personal liability riders to homeowner policies or separate liability packages, you might still be wary about exposures. James Liston, the attorney who represented Jerry Chiles, says that personal liability rulings in most states don't lead to consistent conclusions.

The Chiles case could possibly cause more litigation; this is still an open question in many states. It's common for insurance companies to try to use a notice provision to deny coverage. "The best thing I can say—the point from this case would be a clause in the policy can cover negligent conduct. Most people don't know this. It usually only comes up if they have an attorney, because the attorneys know this. To use this clause in the policy, attorneys will allege negligence to get into the policy language," Liston says.

If you want to use that policy clause, especially for the duty to defend, file a claim with the insurance company as soon as possible—so you trigger that duty to defend.

Insuring Business Activities

Another reason to consider buying liability separate from your homeowners policy: If you plan to work full or part-time during your retirement, you may face business exposures that probably would be excluded from your homeowners policy.

In the 1990 Minnesota appeals court case *Grossman v. American Family Mutual Insurance Co.*, members of a limited partnership were sued on several points relating to an apartment complex owned by the partnership. When the

limited partners turned to their personal liability insurers to cover the defense, the insurers denied coverage.

The *Grossman* court concluded that the business pursuits exclusions contained in personal policies precluded coverage for their limited partnership activities. Noting that the limited partners operated the apartment complex for profit, the court observed that "[p]remiums for homeowner's policies would be inflated unreasonably if the homeowner's insurance pool were required to assume risks attendant upon commercial ventures such as this."

Credit Insurance

One form of personal coverage that has gained growing consumer interest in the last five years is credit insurance. This insurance—which, technically, takes the form of either life insurance or disability insurance—often entails more flexible underwriting terms than traditional life policies.

Credit insurance is usually offered when you take an installment loan on a large purchase, such as an automobile, furniture, etc. The insurance pays off your consumer debt if you die, are disabled, or lose your job.

The purpose of credit disability coverage is to continue your loan installment payments when you are disabled due to accident or sickness. The creditor is the policy owner and the debtor (you) is the insured. Disability benefits equal to your indebtedness are paid directly to the creditor in the event that you are totally disabled, as defined in the policy. These benefits are usually paid on a monthly basis as long as the debt remains and you are totally disabled.

Credit insurance is a relatively expensive form of insurance, but it does relieve your family of debt obligations in the event of your death. Experts say that if you are in good health, always say "no" to credit life insurance, and if you are in poor health, always say "yes", because it may be the only kind of insurance you can get.

The catch is, credit insurance is usually only offered to those age 65 and under.

If, in order to approve your installment loan, your creditor requires credit life insurance, they cannot specify from which company or agent you may obtain the insurance. You may use existing life insurance (by assigning a policy

you already own) or purchase a different life insurance policy from another source.

Older people who have health problems or other circumstances that disqualify them from buying the most economical life insurance policies will sometimes borrow against assets they own—most often, their homes—and then buy credit insurance that will pay off the loan in the event of their death or disability.

Defending Your Right to Coverage

The 1992 Tennessee appeals court decision *Jackie Heatherly v. Peoples National Bank* considered a dispute over a credit policy that illustrates some of the problems these policies pose.

Jackie Heatherly had done business with Peoples National for a number of years and had an outstanding loan in December 1990. He wanted to renew his loan and also wanted to retain his credit life and disability insurance which he had carried on various installment loans for a number of years.

David Williams, a senior vice-president of the bank, assured Heatherly that he would be covered. His refinancing package was increased some $1370 to cover the costs of the premium of a credit disability policy with Mountain Life Insurance Co.

The next month, January 1991, Heatherly learned from his physician that he was totally disabled from working his job. The complicating factor: the doctor ruled that Heatherly's disability had begun in October.

Heatherly applied for disability benefits. However, Mountain Life had never issued a policy. Upon reviewing Heatherly's application, it had declined coverage because of Heatherly's prior physical condition.

About the same time, Heatherly also made a claim against Cherokee Insurance Company, which provided his disability insurance before the disability policy issued by it and made payments through the term of the policy. But this wouldn't cover the full obligation of Heatherly's refinancing.

When Heatherly learned that Mountain Life wouldn't cover his payments, he sued Peoples National and Mountain Life.

The court concluded that the bank, acting as an agent of Mountain Life, became Heatherly's insurer when it told him that he had disability coverage. The bank appealed.

"If there had been coverage under the Mountain Life policy, as it had been represented to Heatherly, would he be entitled to recover?" the appeals court wrote. "We think without question the answer to that question is in the negative."

Heatherly couldn't recover because the accident causing his disability had occurred before the policy was in force. So, the appeals court ruled, Peoples National shouldn't have to make payments that Mountain Life would not have had to.

Decisions Favor Insurance Companies

Courts tend to construe credit disability policies strictly in favor of insurance companies. Says one attorney involved in the case: "The court of appeal is very conservative, and they will reverse where they think it was a judgment call by the lower court."

On the other hand, some credit insurance companies will count on courts and laws working in their favor. The 1992 Illinois appeals court decision *Angela Verbaere and Peter Verbaere v. Life Investors Insurance Company of America* illustrates this other problem credit policies can pose.

In April 1978, Peter and Angela Verbaere borrowed $15,500 from the Community Bank of Homewood-Flossmoor to buy a motor home. They were required to obtain credit-life and credit-disability insurance to secure the loan and the premium for this insurance added another $4,391.95 to the borrowing.

As collateral for the loan, the bank took a second mortgage on the Verbaeres' residence and also a security interest in the motor home. The Verbaeres obtained credit-disability and credit-life insurance from three companies, one of which was Life Investors Insurance. The purpose of the insurance was to cover their indebtedness to the bank in the event of total disability or death.

Life Investors issued a certificate to the bank guaranteeing monthly payments of $125 for a maximum of ten years in the event that death or disability rendered the Verbaeres unable to make the loan payments.

In December 1978, Peter Verbaere suffered severe head injuries that left him totally and permanently disabled. Two of his credit insurance companies paid benefits under their policies in lump sums, reducing the amount of his indebtedness. Life Investors elected to remit proceeds in the monthly payments of $125. Life Investors paid the bank $125 per month from the time of the disability until October 1982.

In March 1982, the Verbaeres contracted to sell their home. In order to clear title, they needed to obtain a release of Community Bank's second mortgage. To do this, they agreed to substitute as collateral an amount of cash equal to the remaining balance on the motor home loan—$8,754.84.

In October 1982, on the sale of their home and attendant release of the second mortgage, Community Bank seized the Verbaeres' cash collateral to satisfy the motor home indebtedness. (In a separate lawsuit, the Illinois court found the bank's justification for seizing the collateral ill-founded. The bank then settled with the Verbaeres for a undisclosed amount.)

A Settlement Offer Comes Too Quickly

At the time Community Bank seized the money the Verbaeres had deposited as collateral, it notified Life Investors that the indebtedness had been paid off. The insurance company immediately discontinued paying the monthly disability benefits under the policy, without further investigation. The Verbaeres sued to collect the remaining proceeds.

Life Investors tried to get the Verbaeres' claims dismissed. The court rejected this, noting sarcastically: "Apparently ignoring the beneficiary provision in its own policy, Life Investors interposed a defense based on a cancellation provision, asserting that the bank's discharge of the motor home loan terminated the insurance. This position was rejected by the court...which held, as a matter of law, that plaintiffs were entitled to receive the full insurance benefits that had vested upon Peter Verbaeres' total disability."

Life Investors had declined to enter settlement negotiations with the Verbaeres until this point. Sensing a big loss in court, the insurance company indicated it would consider settlement, but only if the Verbaeres waived the

right to seek punitive sanctions under Illinois insurance law.

The court moved more quickly, finding Life Investors liable for the full value of the credit policy and assessing statutory sanctions for "vexatious and unreasonable" refusal to pay the Verbaeres' claim.

After Peter Verbaere's disability, Life Investors had elected to pay out the insurance benefits over time instead of in a lump sum. However, in choosing a pay out through installments, Life Investors was not free to treat the benefits as contingent upon anything other than the continuing disability of Peter Verbaere for the full ten years of coverage.

In short, the court concluded, Life Investors took advantage of the bank's mishandling of the Verbaeres' collateral to declare its own obligations at an end. In the meantime, the bank refused to admit any wrongdoing in using the Verbaeres' funds to pay off a loan that was never in default. The Verbaeres, caught in between, were left holding the debt.

In summing up its ruling for the Verbaeres, the appeals court took the opportunity to make an example of the insurance company:

"We do not understand why Life Investors—which underwrote the risk of disability, fixed the premium, and provided for a partial refund of the premium in the event of early discharge of the loan—appears to have difficulty understanding the nature of credit-disability insurance and its own clearly worded beneficiary provision.

"While the legal issues involved were not particularly complex, the insurance company spent at least $25,000 pursuing a policy defense that had no basis in fact, law, or logic."

The court finished the decision by awarding the Verbaeres' attorney the maximum fees he requested.

Reverse Mortgages

Another financial tool that a growing number of older people are using is the reverse mortgage. While this isn't technically insurance, many financial advisers package it with insurance—and the companies that write reverse mortgages peddle them as an insurance alternative.

Reverse mortgage loans provide senior citizen home-owners monthly, tax-free cash advances to supplement their current income. Repayment of the principal and interest is deferred for as long as the borrower remains in his or her home. In exchange, the homeowner conveys a deed of trust for equity in the home equal to the amount borrowed plus interest. The deed grants the lender the power of sale should the borrower default on his or her payment when it becomes due.

Reverse mortgages are typically restricted to owners age 62 or older who have fully paid off their mortgages but who now need supplementary income to make ends meet.

"Reverse mortgages are for the literally millions of people out there who fit the description of house-rich, cash-poor," says Ken Scholen, director of the National Center for Home Equity Conversion, a Minnesota-based non-profit organization that monitors the reverse mortgage field.

Some 12,000 private reverse loans have been written since the early 1980s. California-based Providential Corp., Kentucky-based Capital Holding Corp. and New Jersey-based American Homestead are among the largest-volume private originators.

The average borrower, according to Providential, is 76 years old, owns a $289,000 house, pledges $232,000 of it as collateral for the reverse mortgage and receives a $1,000-a-month payment. Younger home owners, with longer lifespans ahead of them, generally qualify for smaller payments. Older owners, and those with higher-value homes, qualify for larger payments.

Interest Rates Can Be Steep

During the course of the loan, the owner's debt steadily mounts, and the borrower is charged interest at a base monthly rate of 11.5 percent, the equivalent of an annual rate of 12.1 percent. Providential also charges borrowers origination fees that add another 0.3 percent to the rate.

On top of that, the firm adds an annual charge—essentially an insurance premium equal to 5.0 percent of the maximum loan balance. That tacks another 1.1 percent onto the loan's effective annual rate.

Average interest charges per year on "lifetime" loans reach 13.5 percent—a yield that lenders argue is neces-

sary to compensate investors for the risks of reverse mortgages.

"You don't want to be paying Mrs. Murphy her $1,000 ten years beyond the date your model said she'd be dead," says one federal official to the financial newspaper *Barrons*. "The whole pay-off to Providential and its investors is rolled up in the steady sales of houses in your portfolio. If you have a pool of Mrs. Murphys and you figured wrong on when you'd get paid on a whole lot of them, you're in trouble."

Debate over such risks came to the fore in July 1992, when the Securities and Exchange Commission ordered Providential to revise its accounting practices in two ways: to assume zero appreciation on all mortgaged homes in its portfolio, and to cease reporting accrued interest on the reverse loans as income until the underlying properties were actually sold and the proceeds disbursed.

In the wake of the SEC's order, Providential faced six different class-action suits by shareholders alleging securities violations. The suits charged that Providential should have anticipated the accounting standards set down by the SEC.

In the intervening months, Providential CEO William Texido enlisted the support of the AARP and other advocates of reverse mortgages to persuade the SEC to reconsider. Following a three-hour face-to-face meeting with AARP legislative analysts in September 1992, the SEC accountants changed their collective regulatory mind.

Veiled Policy Language

The U.S. District Court for the northern district of California considered reverse mortgages in its 1994 decision *Mary McCarthy, et al., v. Providential Corp., et al.*

Mary McCarthy, Perry and Eunice Williams, and Eda Kavin took out Providential's reverse mortgage loans. In February 1994, the plaintiffs filed a class action lawsuit against Providential alleging violations of the federal Truth in Lending Act. In April 1994, they amended their lawsuit to add the charge that Providential and its officers "systematically and fraudulently schemed to deny senior citizens of the equity in their homes" because of high interest rates.

The complaint also contained claims of fraud and deceit,

negligent misrepresentation, unlawful, unfair or fraudulent business practices and alleged violations of the California Consumers Legal Remedies Act.

Each of the reverse mortgage agreements consisted of a deed of trust, a loan agreement and a note. Providential issued other documents including a Truth in Lending Act disclosure statement and promotional materials. The deeds of trust entered into between Providential and each of the plaintiffs contained an arbitration clause.

McCarthy claimed that the arbitration provision was unenforceable because Providential failed to inform her that she was "waiving important rights by agreeing to arbitrate." She argued that Providential had a "compelling" duty to explain to senior citizens the consequences of the arbitration provision.

The arbitration clause in the deeds of trust executed between McCarthy and Providential was straightforward and clear: "Any controversy or claim arising out of or relating to the Loan Documents...shall be settled by binding arbitration under the jurisdiction of the American Arbitration Association in accordance with its Commercial Arbitration Rules."

Does It Take a Clairvoyant?

The court concluded that, contrary to McCarthy's assertions, it did not take a "clairvoyant" to understand the meaning of clause. "Regrettably, [McCarthy's] assumption of loans without understanding all of the terms of the contract may represent the norm and not the exception. This failure to inquire, however, will not shield [her] from obligations clearly and explicitly contained in the agreement," it ruled.

McCarthy also claimed that there was inequality of bargaining power between the parties—that she and the other borrowers were financially distressed, elderly and "unsophisticated" people with little knowledge about reverse mortgages. But the court didn't give this argument much credence: "While this may very well be true, inequality of bargaining power is not alone a sufficient basis upon which to show procedural unconscionability."

It ordered McCarthy's claims to proceed in arbitration and declined to certify a class action.

Like credit insurance, reverse mortgages usually work best as an alternative for people who can't get liquidity from life insurance policies or other investment vehicles. The fact remains that the terms of most reverse mortgages are steep. They are an expensive alternative to insurance.

Insuring Travel

Older travelers are more susceptible than average to problems that could cause a canceled or interrupted vacation. Those who can afford to lose what they've pre-paid, such as a relatively small initial deposit, won't need trip-interruption insurance (also called trip-cancellation insurance). But once you've turned over that final sum to the tour operator or cruise line and hefty cancellation penalties apply, you may well want to insure that amount.

Averaging $5.50 per $100 of coverage, trip-interruption insurance isn't cheap, and many senior travelers resist the added expense.

Yet every tour and cruise company can tell stories of uninsured travelers who lost thousands of dollars because a last-minute problem forced them to cancel a trip at a point they were no longer eligible for refunds.

"We suggest that travelers look at their vacations as if they were a tangible item like a car or a refrigerator that they would automatically cover under an automobile or home-owner's policy," says Stan Bosco, assistant director of consumer affairs of the American Society of Travel Agents.

Often a cruise line, tour operator or travel agent will sell policies to travelers directly. But it is not advisable to sign up without understanding the contingencies the policy covers and what it will and won't pay for. Policies offered by different companies may be very different, so it's a good idea to compare several of them and choose the one that meets your needs.

Some companies bundle trip interruption in a package with coverages you may not want, such as accidental death and dismemberment, baggage and flight insurance. Others let you pick and choose. For example, you could buy trip interruption only, or also insure yourself for medical expenses if you're going outside the United States, where Medicare does not apply.

The most important trip-interruption coverages are for death, illness or accident for you and your travel compa-

nion. Some policies include close family members or key business associates, too.

Coverage if You Can't Make the Trip

They also may cover additional contingencies that could interfere with a trip, such as jury duty or a subpoena, missing a flight, natural disasters, or a fire or flood that makes your home uninhabitable or makes it impossible for you to leave. You must decide which of these sorts of risks might apply to you and choose your policy accordingly.

Watch out for clauses that could deny a claim if you—or an otherwise covered travel companion, close family member or business associate—have a preexisting condition (you'll see lots more about preexisting conditions in the health section of this book).

One policy may not cover you for a medical problem if you received treatment or advice within 180 days of the date of coverage. Others ignore a preexisting condition if it was not treated within 60 days prior to coverage, or if it was controlled by prescription medications through that period.

All policies limit payments to the non-refundable portion of prepayments or additional out-of-pocket expenses. For example, they cover the difference between what you've paid a tour operator and the amount it refunds you.

Some policies add certain benefits to trip-interruption insurance, such as paying a nominal amount for replacement clothing and amenities should your luggage be temporarily lost (though they don't cover the lost luggage itself). They may pay the single supplement added to your bill if your companion is unable to take the trip or returns home early. In some cases, they may pick up the penalty for switching your flight to join the tour or cruise midway. Some include emergency medical transportation.

Coverage for the financial collapse of a tour operator, cruise line or airline has become more important than ever. Just because a tour operator belongs to a trade association with a consumer protection plan doesn't necessarily mean you'll get all your money back if the company closes its doors.

But be certain that a policy covers you in the case of a company's failure, default or service stoppage—not just a formal bankruptcy. And do not purchase travel insurance

directly from your tour operator or cruise line, even if it seems cheaper. The insurance is invalid if that company fails.

The American Society of Travel Agents offers what it calls a TRIP plan that covers agents in case any company with which they book you shuts its doors. Ask if your travel agent is participating in this program.

Insuring Your Personal Effects

A personal effects floater (PEF) is often used to insure the personal effects carried or worn by tourists and travelers. Clothing, cameras, and other portable personal property are covered. Coverage for jewelry, watches, and furs is limited to $100 per article. Vehicles, bicycles, currency, and travel tickets are not covered. PEF coverage applies worldwide but not at home.

A number of individual article floaters may be used to insure specific types of personal property for scheduled amounts. Separate floaters are available to insure bicycles, cameras, fine arts, golfer's equipment, jewelry and furs, musical instruments, stamp and coin collections, silverware, and other items. Individual floaters would be used instead of a personal articles floater when an individual's need to insure personal property was concentrated in one or two classes of property. When there is a need to insure multiple classes of property, it is more practical to purchase the PAF.

Pre-Need Funeral Insurance

As you grow older, you begin to think more about the specifics of how your affairs will be handled after you're gone. Thinking about death is difficult and leaves many people vulnerable to high-pressure salespeople and expensive insurance.

Don't let your legitimate desire to avoid being a burden on your family or friends turn you into a victim. As hard as it is, look at funeral insurance objectively.

The average cost of a traditional funeral is close to $3,000. One way to protect your family members from having to make difficult decisions about your funeral arrangements and costs at an emotional time, is to purchase a pre-paid funeral arrangement.

Essentially, pre-need policies entail payments—either lump sum or monthly—that buy coverage of specified funeral arrangements. These policies are often sold in bundles with other coverages.

One type of pre-need funeral plan is funded by life insurance or an annuity contract that has an increasing death benefit. The face amount usually equals the cost of the funeral you have selected, and is made payable to the funeral director (or a trust accessible to the funeral director), who usually is also the person selling you the policy. (This means the funeral director makes money by providing your funeral services and makes a commission from the insurance policy he or she sells you.) Excess funds left over after the costs of the funeral are paid may be payable to your survivors, or to the funeral director—check the contract to be sure.

One Market-Oriented Example

An example: In 1993, Provident American Corporation announced a pre-need funeral expense policy with a Retirement Deposit Fund rider followed early the next year by an annuity rider. Mitch Kalish, PAMCO president, said, "The final expense product, targeted at a slightly lower age bracket, provides funding for post-mortem expenses such as car and credit card debts. It supplements our pre-need funeral insurance."

Al Clemens, PAMCO CEO, said, "We are aggressively pursuing insurance products for the seniors market, which offers exceptional growth opportunities. One third of the population will be 65 or older by the year 2000. We will continue to add insurance products for seniors, including the introduction of dental insurance and home health care insurance in 1994."

As pre-need and/or pre-paid funeral arrangements become even bigger business than they already are, the opportunities for more mishandling, misuse and outright criminal activities will present themselves. You may learn that a plan you purchased in one state is inapplicable anywhere else. Often, survivors learn that the funeral arrangements that their husband, wife, mother, father, aunt or uncle made in good faith only cover the costs of the casket and vault. Other times, policyholders learn that the funeral home staff has set up a scam to divert funds and then skipped town.

Convenience Can Be Costly

Be wary of policies sold through funeral homes. Some funeral directors steer customers toward the most expensive funerals. One selling technique is to list the most expensive casket first and the least expensive last. This is designed to make the customer feel comfortable with a more expensive casket.

No matter how much you spend on a prepaid funeral— $2,000, $3,500, $5,000—make sure it's safe. Question the vendor—the sales representative, the funeral director—on just how the funds will be invested. Ask this every year when you receive the tax statement on the trust's earnings. Also, make sure that you have the right to change your mind. Contracts that cannot be canceled are sold, but you should avoid them.

Pre-need organizations, cemeteries, funeral homes and funeral directors, have been the subject of newspaper stories all across the country in the last several years—most of them negative.

An example: Funeral directors from all over Pennsylvania invested their prepaid funeral deposits with Mechem Financial Inc in the 1980s. The company received $9.2 million in prepaid funds from 250 funeral directors in Pennsylvania and Ohio during a three-year period. While it told funeral directors that funds would be invested in safe, secure investments, it actually invested in rare coins and diamonds and was diverted for personal use.

Mechem's president, according to court records, used prepaid funds for fur coats, jewelry, a Las Vegas trip and an addition to his home. The president is now in federal prison and the company is bankrupt; about $4 million in prepaid funeral funds is gone.

A hard irony: The funds never should have been invested with Mechem in the first place. A state law prohibited funeral homes from placing prepaid funds with investment firms. The law stated clearly that prepaid funeral funds should be deposited in banks.

Looking Back

The main points to remember when you're considering various specialized personal lines coverages:

- The risks you face will usually focus on the language in policies that deals with liability. Even when the special policy isn't explicitly related to liability, consider how it might apply.

- Specialized coverages are often dominated by insurance companies devoted to that niche—mobile home coverage and pre-need funeral coverage are two good examples. These specialty players can be good at what they do, but they can also be somewhat less trustworthy than big multiline companies. Talk to a good agent or the state insurance regulators where you live about which way a particular niche player leans.

- Many people use specialty insurance as an easy way to get the sort of life and disability coverage they can't other qualify to buy. The insurance companies know this and charge commensurately. Be wary of the terms of pay out and the conditions of coverage. Read the fine print.

- Because they operate on tighter profit margins, some niche insurance companies will resist paying claims more aggressively than big companies. Be prepared to fight for the benefits you're owed.

- State laws and regulations will usually apply in specific ways to specialized carriers. Before you sign a on to policy, talk to someone in the consumer division of state insurance department about the kind of insurance you're buying and the company that's selling it. To the extent they're relevant, use the cases we've explored here.

- If you have renters coverage, understand what your policy limits are, and whether improvements you make to the property are covered.

- Because mobile home owners policies are not standardized, read through the policy to see what is covered and what is excluded. When you shop around, you probably won't be comparing identical policies.

- Ask whether the kinds of property you own might be best covered by a personal articles floater or personal property floater. Because these tend to be expensive policies, be sure to get a number of different quotes.

If you have assets of $300,000 or more, ask about purchasing additional liability insurance in the form of an umbrella policy.

- If you are purchasing credit insurance, remember that the creditor cannot require that you buy the insurance from a particular company or agent. You have the right to assign an existing policy or purchase a new policy from another source.

- If you travel, consider purchasing travel insurance as well as a personal effects floater to cover the possessions you take with you.

- If you are considering pre-planning your funeral by purchasing a pre-paid funeral arrangement, read through the contract carefully and ask lots of questions, both of the agent and an outside party.

CHAPTER 5
BUYER'S GUIDE TO LIFE INSURANCE

About seven of ten adults have some form of life insurance. The usual model is that a person in their 20s or 30s purchases a life policy for a monthly premium that provides a death benefit in case of premature death. Insurance companies are able to offer relatively low premium rates provided the person is insurable.

However, the young married person just starting a family has dramatically different insurance needs than someone approaching retirement. As you age, some of your responsibilities decrease, and you may want to reduce or even eliminate some of your life insurance coverage.

Most life insurance is sold to protect against the risk of premature death—and the fear that survivors would suffer a loss of income and have unpaid debts to settle if the policyholder died. However, your needs in this context may have changed. If you made your insurance arrangements years ago, you should spend some time reevaluating your policies. The children you wanted to provide for are now self-sufficient, and you might need the extra retirement income available from your cash value policies more than your children need your death benefit.

There are also valid reasons to increase your life insurance protection as you age. If you have accumulated a large estate (more than $600,000), additional life insurance may be needed to provide funds for estate taxes. Or, you may have accumulated very little over the years in terms of an estate, and you may want to use life insurance to provide a cash inheritance. Some people start their first—or second—family later in life, or are raising grandchildren, and so may have minor dependents in mind when buying life insurance.

The Factors that Influence Cost

Life insurance policies are priced based on your mortality risk, or risk of dying, which is primarily based on your age at the time of application.

The good news: death rates in the United States have been falling, and life expectancy has been rising throughout this century. The falling death rate has led to falling rates for life insurance protection; as people live longer, the cost for life insurance becomes less expensive. The bad news: the older you get, the greater your chances of dying in any given year—and the higher the mortality charges for life insurance.

Age is not, however, the only factor used in the underwriting and pricing of life insurance. Decisions are usually based on a wide variety of criteria, including the applicant's health history, occupation, hobbies, and lifestyle. Life expectancy at older ages is now long enough so that insurance companies can develop and sell products to the senior market that can be profitable, even after policy, commission, and administrative costs are figured in.

The overall degree of risk presented by a particular applicant will determine whether an underwriter accepts the risk as a standard risk, accepts the risk as a nonstandard risk that requires an additional premium charge, or rejects the risk.

There are many different types of life insurance and each has its uses. This great diversity in life insurance products, features and options creates an equal diversity in the potential uses of life insurance in meeting consumer needs for security. Many individuals will purchase more than one policy during a lifetime, because insurance needs continually change.

This chapter explores the kinds of life insurance available, how your life insurance needs have changed over the years, what you can do with your existing policies, and how to determine whether you need additional life insurance.

Alternate Uses

Life insurance is used to fund estate and retirement vehicles such as trusts, and if you understand more about life insurance after reading this section, you will be better prepared to work with your financial planner, attorney,

and/or accountant in creating an estate plan that makes sense for you.

Unfortunately, so-called "anti-selection" is always going to be a problem. Even policyholders who meet all tangible tests of justification and character may have trouble getting a policy. Major reasons cited are the lack of underwriting experience for older insurance applicants and the variety and number of different abnormal blood or medical examination findings.

Many of these results are normal for older individuals and reflect a regular part of the aging process. None of the major companies that have published insurance manuals have anything built in for the senior market. As a result, seniors are often judged by the same standards that are applied to 35-year-olds.

Designing special products for people over 50—and people over 65—is part of the solution. Those of similar ages could go into their own mortality pool where experience is shared. Until this happens though, older people in the market to buy life insurance need to act carefully.

Watch Out for White Out

In West Virginia, an insurance agent was discovered selling life policies to people age 68 and over, and backdating the birth year on their applications by ten years. Thinking the applicant younger and more insurable, the insurance company issued the policies without question—until the first death claim. Benefits were denied based on material misrepresentation.

"This guy sold 20 or 30 policies like this before he was caught," says John Davidson, Director of Consumer Services. After investigating and finding that the agent had acted alone without the knowledge of the applicants, the Department of Insurance ordered the death claim paid. The insurer fired the agent, cancelled the other policies, and returned the premiums paid. The agent's license is in the process of being revoked.

In 1992, the U.S. Court of Appeals for the seventh circuit dealt with two related cases that involved the particular pressures life insurance salespeople put on older customers.

The first case, *United States of America v. Randall Coonce* involved a organized scheme to defraud older people. From 1983 to 1988, Randall Coonce ran a life insurance agency with offices in Charleston, Illinois and Indianapolis, Indiana. He sold life insurance and supervised sales agents in the Charleston and Indianapolis offices. Though he sold insurance for several companies, most of the policies he sold were from the Inter-state Assurance Company.

Since the early 1980s, Coonce had also been a serious gambler, betting heavily on sporting events. At first his bets were around $500 per game, but in 1984 his average wager escalated to between $3,000 and $4,000. In early 1986, Coonce was in serious financial difficulty as a result of substantial gambling debts. To pay these debts he began to convert clients' insurance premiums to his own use.

As a general rule, Inter-state required initial premium payments on life insurance policies to accompany the customer's application, and the policy was effective when the application and premium were received.

In some cases, however, it accepted applications without premiums, requiring payment when the approved policy was delivered to the customer. Applications processed in this way (known as C.O.D. policies) weren't effective until the receipt of the initial premium, after Inter-state had approved the application and sent a policy to the customer.

When customers sent their premium checks and applications to Coonce for delivery to Inter-state, he would deposit the check in his own account. Next, he would mark the application "C.O.D." without telling his client and send it to Inter-state.

Stealing from Peter to Pay Paul

When the application was approved and returned to Coonce for delivery to the customer, he would forward the premium payment. At first he made payments from his own account, having used the converted funds in the interim to pay his gambling debts. Later on he was unable to keep current on his debts, and he began to pay off the C.O.D. policies with more recent premiums he'd kept.

On some policies he took the money and never made any payment to Inter-state. Besides the C.O.D. policy scam, Coonce also collected annual premium payments from customers without Inter-state's knowledge or consent, depositing them into his own account.

During this same period, Coonce and his agents in Charleston and Indianapolis participated in a separate scheme to defraud senior citizens. Using a mailing list that Coonce had purchased from the National Association of Retired Persons (NARP), Coonce and his agents contacted elderly people and convinced them to buy expensive life insurance policies that they misrepresented as investment programs (this is illegal in most states).

Coonce specialized in selling a universal life insurance policy Inter-state called Flexlife II. The policy paid a benefit to the named beneficiary on the death of the policyholder and accumulated a cash value based on premiums paid. If a minimum ratio was maintained between the cash value of the policy and the death benefit that it provided, Flexlife II offered certain tax benefits for policyholders, including deferring income tax on the 9.5 percent interest earned on the cash value of the policy, the ability to borrow against the cash value of the policy tax-free, the ability to withdraw cash from the policy's cash value on a first in, first out basis, and a tax-free death benefit to the beneficiary.

Despite these benefits, Inter-state never authorized Flexlife II for sale as a pure investment program. This was true because the policies posed several significant risks: the older the policyholder, the higher the cost of the insurance—and the lower the return on the investment features of the policy. More importantly, the older the policyholder, the longer it would take for the policy to reach the "break-even" point—the point at which the cash value of the policy is equal to the amount of premiums paid. For most people in their seventies and eighties, the policy would never break even.

The Scheme Collapses

In January 1988, the house of cards Coonce had been building collapsed on itself. No matter what he did, he couldn't generate enough new business to hide the money he'd stolen in the past. Claims went unpaid and customers complained to Inter-state.

Coonce admitted his misdeeds regarding the C.O.D. policies to Inter-state, which cancelled his agent status and initiated civil proceedings, seeking to recover the premiums he had stolen to pay his debts.

Coonce realized that he might also face criminal charges and had his lawyer contact the United States Attorney to discuss the matter. After reviewing the case, the U.S. Attorney proposed a plea bargain requiring that Coonce admit that he had conspired with his sales agents to misrepresent insurance policies as investment programs for senior citizens.

Coonce denied having been part of a conspiracy or misrepresenting his products and refused the guilty plea offer. Within a few months, the government obtained a 36-count indictment against him. Faced with this, Coonce agreed to plead guilty to a four-count indictment alleging mail fraud but not conspiracy or misrepresentation. He also agreed to cooperate with the government in investigating other matters arising out of or related to his conduct.

The plea agreement stated that at sentencing Coonce could present evidence mitigating the seriousness of his offense and the government could present evidence in aggravation of his crime. The government prepared a pre-sentence report, which gave a detailed description of the entire scheme to defraud senior citizens through misrepresentation of the insurance policies as investments. The report revealed, among other things, that in 1985 the Illinois Department of Insurance had revoked Coonce's insurance license due to charges he had misrepresented insurance policies and engaged in fraudulent business activities. (He regained his license a year later by paying a fine and agreeing to abide by conditions designed to prevent future misrepresentations or fraud.)

Not a Criminal Enterprise

Coonce objected to the report and filed a motion to strike it from the court's record. He argued that he pled guilty to neither conspiracy nor misrepresentation—and thus these charges couldn't be considered in his sentencing.

The federal district court denied the motion. Coonce tried to withdraw his plea, but the court also denied that motion.

The court sentenced Coonce to three consecutive five-year terms to be followed by five years of probation. Coonce appealed, arguing that the trial court shouldn't have allowed the government to characterize his business a criminal enterprise and that the trial judge had a preconceived bias against the life insurance industry.

Coonce's claim that the trial judge was biased stemmed from an off-the-cuff comment. At one point during the sentencing, the trial judge said, "Anybody who knows anything about investments knows that [life insurance] is a bad investment."

The appeals court ruled that the judge had qualified his statement enough that he eliminated any bias. His qualifications prove instructive in their own right: "[Life insurance] provides an estate liquidity for estate planning purposes; but if you're looking to make money, don't buy insurance."

Other Cases Followed

While Coonce was facing 15 years in prison, one of his agents was going through similar trials in the same court. In fact, this second decision—*United States of America v. Kevin Stout*—puts life insurance risks in an even clearer light.

In 1986 and 1987, Stout, a licensed insurance agent, sold insurance through the Illinois office of Coonce & Associates. He obtained a number of the cards Coonce had purchased from NARP and contacted the persons named to sell them Flexlife II. Among the persons Stout sold the policies: Theo Bridges and Gladys Robinson.

Theo Bridges was a retired school teacher in her mid-seventies. In response to a mailing from the NARP, she returned one of the lead cards requesting more information about investment programs that offer tax benefits. The card found its way to Stout, who found his way to Bridges's house in March of 1987.

Stout described a program under which Bridges could earn 9 percent interest tax-free, and that would allow her to withdraw her money at any time. Bridges filled out an application, which she thought was the required paperwork for this investment, and gave Stout $1000 to get started.

Stout forwarded an application to Inter-state, which denied coverage. Stout told Bridges that she could still invest her money in an Flexlife II policy on her daughter. Bridges agreed, and her initial $1000 payment to Stout went toward the policy on her daughter. Of that amount, Stout received $500 as his commission. At the end of the first year Bridges owned it, this policy had a cash value of $437.

In October 1987, Bridges contacted Stout when a certificate of deposit she owned matured. She wanted to add the $16,500 to her investment with Inter-state. Instead, Stout used Bridges's money to purchase a policy from Pioneer Life Insurance Company, using information he had obtained from Bridges for the Inter-state policy. He had no personal information on her daughter, so he filled out the form with incorrect data. Then he forged both of their signatures, disguising his handwriting, and signed the application as a witness to the signatures of the two women.

Gladys Robinson, an 83-year old retired office worker, also filled out one of the NARP lead cards. Stout visited her in September 1987. He offered to sell her a tax-free investment that offered a 9.5 percent return. Having her interest piqued, Robinson gave Stout a check for $1000. Stout said nothing to her during this meeting about life insurance. Stout, however, did ask her some questions involving her health that she believed were related to the investment opportunity.

A month later, Robinson gave Stout an additional $4000 for this investment. For her $5000, Robinson purchased $41,916 worth of life insurance that after a year would have a cash value of only $654. Because of her age, her policy would never reach the break-even point.

After Coonce & Associates folded in early 1988, Bridges and Robinson got their money back from Inter-state. Stout was indicted for mail fraud.

A trial court found Stout guilty on four of five counts and sentenced him to 10 months imprisonment and 24 months probation. It also ordered him to pay restitution to the Pioneer Life Insurance Company. Stout appealed, arguing the government's case was legally flawed. The appeals court rejected all of his arguments.

The Need for Straight Talk

In the *Stout* decision, the court wrote in its first paragraph, "If, as a society, one of the criterion by which we are judged is how we treat our elderly, we can only hope that the facts of this case will be viewed as the exception rather than the norm."

Conscious of stories about villains like Coonce and Stout, most life insurance brokers and agents handle issues of aging with a kind of nervous hypercaution. Their sales pitches stress the threats of death and mortality to younger policyholders—but they shy away from blunt talk to older people.

That's unfortunate, because life insurance issues only get more complex—and need candid analysis—as people get older.

One specific point: As people get older, their medical records naturally get larger. And the medical information about you plays a leading role in determining whether you get coverage or not. Rather than allow a large file to create too negative an impact, the doctor should, if possible, highlight the individual's general health and prognosis.

Often, a doctor has ways of saying things in the attending physician's notes that may sound onerous, but a letter addressing this problem often puts things into perspective. Not all doctors are kind enough to do this, but many have their individual patient's welfare in mind and are happy to do so, if asked and if the purpose is explained.

Additional testing of the applicant by the doctor may be helpful, even if it doesn't change the doctor's therapy. When a kidney function test is abnormal, a confirmatory one drawn separately or a timed urine sample may help. If a treadmill test was abnormal, perhaps a thallium exam will lessen the overall apprehension about the risk.

Evaluate Your Existing Policies

Questions also revolve around the mechanics of existing policies. Suppose you purchased term insurance 19 years ago and it's about to expire. Or, you purchased a whole life insurance policy 25 years ago and have accumulated cash value you could be using now. You are wondering if rather than purchasing new life insurance, you should just reinstate a policy you allowed to lapse. The universal life policy you bought in the mid 1980s hasn't lived up to its

potential of 12 percent annual yield. You have just realized that the group life insurance provided by your employer stops when you retire, and you think you need additional protection. What do you do?

Dig out your current life policies; the original policy and application as well as any recent paperwork you've received (such as an annual statement reporting your current cash surrender value and total death benefit). You'll want to refer to them as you read on. Also, consider how your current life insurance can be put to use to help you achieve your financial goals, both short-term and long-term.

You have plenty of options: you may elect to replace one life insurance policy with another, "cash in" a cash value policy in return for a steady income, lend yourself money from a cash value policy, transfer ownership of a policy, change beneficiary designations, convert a cash value policy to reduced, paid-up insurance, or buy an altogether new policy that best fits your needs.

Life insurance, in its purest form, is designed to provide a cash benefit at the death of the insured person. Life insurance is the only financial services product which guarantees that a specific sum of money will be available at exactly the time it is needed. Bank savings accounts, mutual funds, stocks, bonds and other investments cannot make such a guarantee. The death of the policyholder creates an instant estate for the benefit of the individual's family (or other beneficiary).

Life insurance has many applications, but is mostly used to help individuals accomplish financial goals such as paying off a home mortgage, creating a college fund for children or grandchildren, accumulating money for retirement, paying estate taxes, providing income for a surviving spouse, providing an inheritance for children and grandchildren, and charitable giving.

Other Income Sources

In determining the amount and kind of insurance you need at this point in your life, consider other sources of income or benefits you have, or for which you may be eligible under other insurance plans, government programs (such as Social Security), and retirement plans (pensions, IRAs, Keoghs, etc.).

These other assets will help in determining the amount, and kind, of insurance necessary to meet current and future needs. You can request an estimate from Social Security of the amount you can expect to receive, based on what you have paid in. Some other sources of funds to be considered are:

- Medicare,
- Medicaid,
- Group retirement plans,
- Savings and investments,
- Other income (such as income from property rental and reverse mortgages),
- Annuities,
- Other insurance.

It's been estimated that you'll need 75 to 80 percent of your current income to maintain your lifestyle after retirement. This means that your Social Security benefits will have to be supplemented by income from other sources.

And some of the other benefits you are counting on might not be there when you need them. How confident are you that you will receive your full benefits from Social Security? The financial soundness of the Social Security System has been the source of controversy for some time. There is public concern that individuals working today will not be able to count on this system to provide them with retirement income.

When Congress first enacted Social Security, almost 20 workers were paying into the system for every one retired individual drawing out of it. Today, the ratio is only three-to-one, and decreasing.

When the current generation begins to retire, there may be only two workers paying in for each retired worker needing that income. In order to offset this trend, Social Security tax increases and benefit decreases were seen in the 1980s. Additional changes, such as increasing the normal retirement age from 65 to 67 or even 70, have become necessary. Considering the demographics of America's population, it seems safe to assume that government benefits will be decreased rather than increased.

Even today, Social Security benefits may not pay the retirement benefit a dependent spouse needs prior to age 65. It is important to remember that there is a period of time, called the blackout period, after a surviving spouse no longer receives survivor's benefits (after the youngest

child is no longer eligible) and before the he or she is eligible for retirement benefits.

The Role of Pension Plans

You may also be counting on retirement income from your employer's pension plan. However, depending on how your employer has set up the plan and where the money is invested, those retirement benefits may or may not be guaranteed. Poor investing has caused many a retirement plan to go bankrupt.

According to a much-cited 1985 study by the Mercer-Meidinger consulting firm, only about half of employers nationally provide added retirement benefits for workers who opt to stay on the job past age 65. The consultants also concluded that 213,000 older employees were forfeiting $450 million in yearly retirement benefits because employers improperly manage their pension funds.

The Mercer-Meidinger report was paid for by the AARP and later endorsed by the Senate Special Committee on Aging. The AARP contends that some employers and insurance companies are violating state and federal age-discrimination laws as well as federal pension-rights legislation.

"Employees over 65 suffer a substantial cut in compensation as a result of this practice," an AARP spokesman said at the time. "Many employees, working because their current pensions are insufficient to support retirement, will find the same inadequate pension at age 70."

Family Issues

Other issues usually focus on family and relations: Do you have a spouse? Your spouse may need more money if you die first, especially if you have any debts. Do your children need financial help? Adult children still can be named beneficiaries of your life insurance policy.

If you have accumulated an estate that is worth more than $600,000, you may want to purchase additional life insurance to provide enough cash to pay your estate taxes.

If you have a relatively small estate, you may want to purchase life insurance as a means of leaving an inheritance to your loved ones.

If you have any minor dependents, you will want to purchase life insurance for the same reasons a younger person needs it.

You also might use life insurance for charitable purposes. In accordance with tax laws, you may purchase a life insurance contract on your own life, pay the premiums and designate a charitable organization as the beneficiary; such as a church, school, hospital or similar organization. Generally, the premium you pay is tax deductible. Alternatively, you may make an irrevocable designation of the charity as your beneficiary on a life insurance policy you already own.

Buying New Life Insurance

Why buy individual coverage if you already have group insurance? Group life insurance provided by your employer generally ends when you retire or leave the company. By law in most states, any employee covered by a group life insurance plan must be allowed to convert to an individual permanent life policy upon termination of employment. Evidence of insurability cannot be required.

The conversion period is usually 30 or 31 days, and coverage is automatically in force during that period. Once that time period is up, you'll lose the chance to convert.

The conversion policy offered to a former member of an insured group is usually a "special" (meaning, not great) policy which is factored for a higher mortality cost, reduced cash value scale, reduced dividend scale (if any) and higher premium. If you want to replace this special policy with a better one, the insurance company will probably require medical underwriting and the agent who sells it to you will probably receive a commission on the sale.

Beware of Policy Illustrations

Insurance agents and companies are often criticized for using greatly exaggerated, inflated predictions of how much money you can accumulate with cash value life insurance and flexible policies. When you are looking at policy illustrations showing benefits or cash value over a period of years, pay close attention to the assumed rate of return. Is it realistic? Over the long term, a few percentage points of difference in the return can make a great deal of difference in the principal.

The National Association of Insurance Commissioners recently put aside a model regulation that restricted life insurance policy illustrations to only guaranteed cash values, guaranteed death benefits, and past performance. The NAIC is now considering a draft regulation which allows policy illustrations that include nonguaranteed elements. The nonguaranteed elements must be based on a "disciplined current scale" and accompanied by a disclaimer which states that the benefits are not guaranteed, the assumptions upon which they are based are subject to change, and that actual results may be more or less favorable than shown.

This watering down of a model regulation which may or may not be adopted by the states is not great news for insurance consumers. But as you can see, whenever anyone tries to restrict the use of policy illustrations in life insurance sales, agents and companies howl that it would be impossible to sell some products without showing buyers the benefits of cash value accumulation.

Even though agents and companies must say that projections are not guarantees, overly optimistic projections make impressive sales presentations, and can only lead to disappointment when actual results are less favorable. This is something to be especially aware of when considering any variable products. Your best bet is to ask to see policy illustrations with a wide range of rates of return before you get too excited about the future cash values of a policy.

**$2,000 Investment Over 30 Years
at Various Interest Rates**

$2,000 at 3% annually for 30 years = $ 4,855
$2,000 at 6% annually for 30 years = $11,487
$2,000 at 9% annually for 30 years = $26,535
$2,000 at 12% annually for 30 years = $59,920

In November 1994, New York Superintendent of Insurance Salavatore Curiale imposed a $500,000 fine on National Benefit Life Insurance Co. Curiale fined the company for submitting false training certificates for its agents and using policy illustrations that could mislead potential policyholders. Commenting on the case, Curiale said, "It is equally important that any sales material used

by an agent to sell a policy be clear and not misleading. We expect insurance companies to review all relevant sales materials and illustrations...."

When you fill out an application for life insurance, you will be questioned about your current health, health history, family history, etc. How you answer is critical to your acceptance or rejection, but if you do not answer honestly, and the insurer finds out within two years, your policy can be voided. After two years, the insurer can usually only void your policy for fraudulent misstatements you made in the application, and the burden of proof is on the insurer.

You will also be questioned about whether you have been rejected in any prior life insurance application, and about other life insurance policies you have in force. The insurance company wants to know if you have ever been "rated up" because of health problems, and will look for evidence of "overinsurance." People who suspect they have serious health problems are more likely to overinsure, or buy much more life insurance than they actually need.

A Case of Bogus Applications

The 1994 Georgia appeals court decision *Jennings v. Life Insurance Co. of Georgia* enforced the insurance company's right to protect itself from bogus applications.

> In 1990, both Annie Jennings and her husband applied for policies with Life Insurance Company of Georgia. Mary Salaam, a licensed practical nurse and the manager of a company administering paramedical examinations for life insurance applications, came to their home to perform the examinations required for the applications. Mrs. Jennings was blind, and Salaam verbally posed questions printed on a "statement to medical examiner" to both Mrs. Jennings and her husband and recorded their answers.

> About seven months later, in January 1991, Mr. Jennings died from cardiac arrest.

> It was undisputed that he had smoked for many years, although the number of cigarettes he smoked per day had declined in the last few years of his life. It was further uncontroverted that he suffered from asthma and diabetes, as well as high blood pressure.

> Life Insurance Co. of Georgia refused to pay benefits to

Annie Jennings, insisting that her husband had made "material misrepresentations" on his application. Annie Jennings sued.

She testified her husband told Salaam he suffered from the various conditions, and that she thought he told her he smoked. Although the statement indicated the applicant suffered from hypertension, it reflected negative answers to the questions inquiring whether the applicant had smoked cigarettes or had ever been treated for asthma or diabetes.

In an affidavit submitted in support of the insurer's motion for summary judgment, Salaam stated she had conducted more than 1,000 paramedical examinations for life insurance applications since 1983 and never asked an applicant to sign a blank form. She asserted it was her "regular and consistent practice in all cases" to read the entire statement to the applicant, record the applicant's answers, present the completed statement to the applicant to examine before signing, and sign it herself only after the applicant had reviewed and signed it. Because she would not have signed it otherwise, she knew that she returned the completed statement to Mr. Jennings for review and signature.

Misrepresentation Material to the Risk

In another affidavit, Tom Mills, senior underwriter for the insurer, stated that Mr. Jennings's undisclosed conditions were material to the risk, and had the company been informed of those conditions, it would not have issued the policy under the same terms and conditions.

The trial court issued a summary judgment in favor of the insurance company. Annie Jennings appealed.

While the appeals court allowed that "the evidence is in conflict regarding whether Jennings's husband told Salaam about all his medical conditions," it found this conflict immaterial. "Although Jennings did not remember that her husband signed the statement, the signed statement is in the record, and there is no suggestion either in the record or in briefs that it was forged," it concluded.

The cases cited by Jennings indicated only that recovery under a policy had been permitted despite material misrepresentations on the application where the applicant had been prevented from discovering the false answers

either by his own disability or by specific behavior on the part of the insurer's agent.

The appeals court didn't find this relevant, either: "The evidence in this case does not suggest that either of these circumstances was present here. No reason appears why Mr. Jennings could not have discovered, had he read the statement before signing it, that the answers on the statement were not the ones he allegedly gave Salaam." It affirmed the ruling for the insurance company.

If the amount of insurance for which you're applying is low enough to qualify as "non-medical" then no medical exam will be required, but you will still have to complete a health statement or medical questionnaire.

Most states have privacy protection laws to protect your rights to privacy with regard to the information you provide when applying for insurance. Often, insurers will conduct investigative reports on applicants for insurance, to gather information that is considered "material" to the risk of taking you on as a policyholder. These reports (consumer reports) include written, oral and other communication regarding your credit, character, reputation, or habits. Insurers will also use information gathered by consumer reporting agencies. If you are rejected based on the information contained in an investigative report, you have the right to access the information, challenge it, and request that corrections be made.

Written Notice of Practices

Regardless of the source of the information, the applicant for insurance must be given advance written notice of the insurer's practices regarding collection and use of personal information. This "Notice of Information Practices" generally provides the applicant with the following types of information:

- the kind of information to be collected;
- the sources of the information;
- the reason for obtaining the information;
- the types of persons from whom the information may be gathered;
- the persons to whom information may be disclosed without the applicant's prior authorization.

You may be asked to sign a disclosure authorization form, which allows your physician, hospitals, and other medi-

cal personnel to release medical information about you to the insurance company.

Naturally, it is the agent's responsibility to provide you with the disclosure notice and to obtain the necessary signatures. Generally this requirement is to be complied with at the time the application for insurance is initiated or at the time a claim is initiated.

One type of illegal encounter (and invasion of privacy) is the pretext interview, which is sometimes used to gather information. A pretext interview occurs when the party gathering information refuses to reveal their true identity, pretends to be someone else, or misrepresents the true purpose of the interview, which, in this case, may be to sell insurance. Pretext interviews may only be legally conducted when an insurer is conducting an investigation for suspected fraud or material misrepresentation.

In addition to providing your medical history when applying for life insurance, you may have to undergo a medical examination as part of the application process, especially if the amount of insurance you are applying for is large.

Paying the First Premium Up Front

Your agent will probably ask you to pay your first premium at the time of application. This is not just so the agent can be sure of a solid sale and can rush home and collect the commission on your policy. Life insurance coverage does not take effect until the initial premium has been paid. (In contract language this is known as agreement and consideration. The insurance companies agrees to provide coverage in return for due consideration, or your premium payment.) While there is always the chance that the insurance company will reject your application and return your premium, paying your premium at the time of application protects you if you die or become uninsurable between the date you sign the application and the date the policy is actually issued.

If you don't pay your premium at the time of application, and you become sick or uninsurable before the policy is delivered, you might not be covered. Most companies will require you to sign a statement when the policy is delivered that your health has not declined since you applied for the policy.

The influential U.S. Court of Appeals for the seventh circuit considered the issue in the 1994 decision *Deborah Anetsberger et al. v. Metropolitan Life Insurance Co.*

In the fall of 1991, Joseph Ryan, Sr., was 63 years old and suffering from emphysema. Because of Ryan's age and illness, his children expected his medical costs to be high. For these reasons, they decided to seek some form of life insurance for their father.

On September 13, 1991, Ryan and his adult children, Deborah Anetsberger, Margaret Lepine and Joseph Ryan, Jr., met with John Morreale, an insurance agent for Metropolitan, for the purpose of obtaining life insurance for Ryan.

Everyone present knew of Ryan's emphysema and poor health. During this meeting, Morreale completed an application form for a term insurance policy in the amount of $100,000 on behalf of Ryan. Deborah Anetsberger paid the first month premium of $107. Metropolitan subsequently cashed and deposited this check. As a matter of convenience, the parties agreed that Morreale would contact Deborah Anetsberger regarding any future questions on the policy.

Morreale told the Ryan family that coverage would go into effect after he signed the application and collected the first month's premium. After making this statement, Morreale handed Ryan a receipt for his daughter's check. Morreale did not inform the Ryan family that a medical examination would be required and did not say he was waiving any provisions of the receipt.

The Ryan children claimed that Morreale told them "If your father died right now, you would get $100,000." Morreale would later claim he couldn't remember whether he'd said this. However, he would separately say that he had said the policy was in effect as of September 13.

Look for Contradictions

At the top of the first page of the receipt, in a paragraph set off by different margins and in heavier type, Metropolitan stated:

"Please read both sides of this Receipt carefully. The Information It contains is Important to you. The maximum amount of coverage under this and all other

receipts will not be more than $500,000 for any person to be insured. The maximum period of coverage under this Receipt is 90 days. If a medical examination is required, no coverage [except for accidental death] will be provided until the examination has been completed."

Immediately below this paragraph the Receipt described the terms under which temporary insurance would take effect:

"Metropolitan will grant Temporary Insurance to each person to be insured if at least one month's premium is received on the date of the application and there is no material misrepresentation in the application....Coverage starts on the date of this Receipt. But, if a medical examination of a person to be insured is initially required by our underwriting rules, coverage on that person will not start until completion of the examination. If it is not completed within 90 days from the date of this Receipt, there will be no coverage. However, if a person to be insured dies from an accident within 30 days from the date of this Receipt and before the examination is completed, Temporary Insurance will be in effect if it has not already ended under the terms of this Receipt."

Morreale handed the Receipt containing this language to Ryan on September 13, 1991. Deborah Anetsberger did not read the Receipt until after her father died.

Medical Exam Required

Morreale met with Deborah Anetsberger on or about September 21, 1991, to discuss a policy that Anetsberger was interested in taking out on her own life. At this time Morreale informed her that Metropolitan underwriting rules required a medical examination on her father before Metropolitan would issue the policy. He did not make any statement regarding whether temporary insurance was in effect.

Anetsberger made an appointment for her father to undergo a physical. On the day the physical was scheduled, September 30, Ryan died of a heart attack before the physical was completed.

Four days later, Metropolitan denied Ryan's application on the grounds that the medical examination was not completed. In response, Ryan's children claimed the benefits under the alleged policy. Metropolitan rejected

this claim and returned the initial deposit of $107.

The children sued, claiming coverage based on Morreale's promise that it began when the application was completed and the first month's premium paid. They accused Metropolitan of breach of the Receipt and Temporary Agreement and a violation of Illinois law prohibiting vexatious and unreasonable delay in paying the insurance proceeds. The trial ruled for Metropolitan.

On appeal, the children claimed the trial court disregarded the intent of the parties and the ambiguities inherent in the Receipt when it held that temporary insurance never took effect. They argued that the court should have liberally construed the Receipt's language to find that temporary insurance began on September 13, 1991. They also claimed that Morreale's authority as an agent of Metropolitan waived the provisions contained in the Receipt.

The appeals court recognized a conflict in the law that applies to temporary insurance:

"On one hand the law seeks to protect the insured from being harmed as a result of ambiguities or misstatements contained in a policy drafted by the insurance company. On the other hand, courts must allow insurance companies to protect themselves from liability on uninsurable risks—risks that would be screened out during the underwriting process."

It ultimately concluded that Ryan, a 63 year-old man who had been suffering for years from emphysema, couldn't reasonably assume that he possessed immediate coverage without having to undergo a medical examination.

Be Careful of Where Premiums Go

Agents accept your premium payment in a fiduciary capacity, which means they are by law not allowed to mix your money with their own personal money. Agents get in trouble for doing this all the time.

A good way to protect yourself is never pay your premiums in cash and be suspicious of any agent that insists that your premiums be paid directly into his or her own personal account. Also, be sure you receive some proof of insurance from the insurance company within a reason-

able amount of time after paying your premium. This goes for any kind of insurance you buy.

Standard and Substandard Risks

A standard risk is an average risk acceptable to the insurance company. About 90 percent of policyholders qualify as standard risks. Substandard risks are risks which are acceptable, but have some negative characteristics not shared by standard risks, which usually means the premium will be higher. Sometimes the policy will be issued at "rated-up age" which means the premium is based on an age greater than the policyholder's actual age. The policy may be issued with a flat additional premium tacked on to the standard policy rate, or may be issued at the same premium as the standard rate but for a reduced face amount of insurance. Higher premiums may also be charged as a percentage increase (such as 125 percent of standard).

If You Have Trouble Getting Coverage

What should you do if you have health problems that make you uninsurable? You will be rejected by the insurance company when the insurer believes your policy cannot be profitable at a reasonable premium or with reasonable coverage modifications. If you are rejected based on information in an investigative report, you must be notified and given the name and address of the reporting company.

If your health problems are so severe that you are classified as "uninsurable," or even if new life insurance is just too expensive for you, it's good to know that some companies offer "guaranteed issue" life insurance. This insurance is available in smaller face amounts like $10,000. The full face amount is payable in the event of accidental death, but for death from natural causes the benefit is limited to the total of premiums paid plus interest, at least for the first few years of the policy. After that, the benefit equals the face amount. Guaranteed issue life insurance is a good solution for covering expenses such as funeral costs for otherwise "uninsurable" people.

The suicide clause of a life policy restricts the death benefit paid if you commit suicide within a certain period of time after policy issuance, usually two years. The death

benefit is usually reduced to just a refund of the total premiums paid.

One Unfortunate Exclusion

Sadly, suicide serves a good illustration of the sorts of exclusions insurance companies try to apply to life policies. The 1993 Utah court of appeals decision *Allison van der Heyde v. First Colony Life Insurance Co. et al.* sorted through some confusion.

In September 1983, American Agency Life Insurance Company issued Peter van der Heyde a whole life insurance policy with a face amount of $200,000. In September 1984, with the American Agency policy due for renewal, van der Heyde's insurance agent suggested he purchase a $200,000 life insurance policy from First Colony.

Van der Heyde, who was in his mid-fifties, submitted an application and First Colony issued coverage that month. Van der Heyde allowed the American Agency policy to lapse.

Although van der Heyde's agent had sold the American Agency policy to van der Heyde, he didn't mention that policy on the First Colony application. One of the answers in the application indicated that van der Heyde did not intend that the First Colony policy "replace or change any existing insurance."

The First Colony policy contained a suicide exclusion clause that stated, "If the Insured, while sane or insane, shall die by suicide within two years after the Date of Issue, the liability of the Company under this Policy shall be limited to an amount equal to the premiums paid."

In July 1986, approximately 22 months after the issuance of the First Colony policy, van der Heyde killed himself. First Colony refused to pay policy benefits to Mrs. van der Heyde because van der Heyde died by suicide within two years after the issuance of the policy.

Under Utah law, American Agency would have had to pay benefits under its policy, regardless of suicide, had that policy remained in effect.

Clarifying Continuation

In 1988, Mrs. van der Heyde sued First Colony, claiming that its policy was a continuation of the American Agency policy. Also, Mrs. van der Heyde claimed that First Colony shouldn't rely on suicide as a basis for denying benefits because its agent had failed to comply with the life insurance replacement regulations.

The trial court concluded that the First Colony policy was neither a continuation or replacement of the American Agency policy. Mrs. van der Heyde appealed, arguing that First Colony and its agent failed to comply with the Utah Insurance Department's Life Insurance Replacement Regulation 79-1 in the course of soliciting the First Colony policy.

Regulation 79-1 defined replacement as: "any transaction in which new life insurance is to be purchased, and it is known or should be known to the proposing agent, or to the proposing insurer if there is no agent, that by reason of such transaction, existing life insurance has been or is to be...lapsed, forfeited, surrendered, or otherwise terminated."

The issuance of any replacement policy not issued or offered for issuance in compliance with the terms of Regulation 79-1 is deemed to be both "injurious to the insuring public" and "an unfair and deceptive trade practice."

First Colony argued that it could rely on van der Heyde's answer in the application that replacement of insurance was not involved. But Regulation 79-1 explicitly did not permit the agent or insurer to rely solely on the application for insurance to determine whether the proposed policy was a replacement. It considered an agent's actions in light of all the information that was known or should have been known at the time the new policy was issued.

Additional Support for Coverage

The Utah court went further, citing the 1976 New York decision *Tannenbaum v. Provident Mutual Life*, which ruled: "A life insurance salesman, deriving his income from commissions earned on sales of life insurance, is motivated...by self-interest" to have the switch in policies take place.

The court ruled that "the record compels a conclusion that the First Colony policy was a replacement for the American policy:

"(1) [the agent] knew at the time he solicited the First Colony policy that he had previously sold the American policy to van der Heyde;

"(2) [the agent] contacted and solicited van der Heyde's purchase of the First Colony policy in September 1984, the annual renewal date for the American policy;

"(3) the American policy lapsed for nonpayment of the premium after the First Colony policy had been issued; and finally,

"(4) the policies had the same face amount.

"....[the agent] knew or should have known that the First Colony policy was a replacement policy subject to the requirements of Regulation 79-1. Thus, the trial court erred in concluding that the First Colony policy was not a replacement policy."

The First Colony agent, in his deposition testimony, said he had told van der Heyde about the effect of the suicide exclusion clause. The court didn't find such self-serving testimony credible and inferred that van der Heyde would not have permitted the American policy to lapse had he been given proper notice and comparison of the policies as required by Regulation 79-1."

It sent the case back to trial, but First Colony settled with Mrs. van der Heyde before the matter proceeded any further.

"The insurance company is supposed to inform the agent as to the effect of the law and policy provisions. But I'm not sure [that they do]. Agents make more on new policies than they do on old renewals, so there's some motivation [to deceive] there," says Dennis Piercey, the attorney for Allison van der Heyde. "In my opinion, they should just say if the suicide provision is past on one policy, then any later or second policy should be that way, too. Avoid all the disclosure business, and just carry it over."

Think Before Switching Policies

Extracting a general observation from the specifics of the van der Heyde case, Piercey says: "There is more to consider than just the language in the policy. There is value in

an old policy, so you really need to have a reason to change that outweighs the disadvantages. You can have a person in their 50's who has had insurance all their life, or at least their adult life, for maybe 30 years, and then they change. Suddenly they're not covered, and people don't understand this."

The incontestable clause of a life policy says that claims cannot be denied after a certain period of time (most often, two years) from the date of issue. This of course means that any policies you purchase new, or replace with newer policies, will be subject to new suicide and incontestability periods.

Time to Make Up Your Mind

With every new individual life insurance policy you buy, by law the insurance company must provide you with a "free look" period. From the date of policy delivery you have a period of time (usually ten to 30 days) to reconsider your decision to purchase the policy and change your mind without penalty. If you decide the policy does not meet your needs, you can surrender it to the insurer along with a written request for cancellation, and you must receive a complete refund of your premium. The policy will be considered void, as if it had never been issued.

The free look period gives you an opportunity to review the entire contract before you make the final decision to keep it. Always take advantage of your free look period, especially if you felt pressured during the sale of the policy and didn't feel you completely understood what you were purchasing. But be careful: some state courts rule strictly against consumers in free look disputes.

The Georgia court of appeals enforced the free look theory strictly—and against an insured senior—in its 1992 decision *Trulove v. Woodmen of the World Life Insurance Society.*

J.C. Trulove was a 74-year-old semi-retiree, still involved in the lumber and sawmill business. He met a Woodmen agent through a mutual friend. In August 1989, the agent came to Trulove's house in order to sell him supplemental Medicare insurance. He told Trulove that he also sold life insurance policies issued by Woodmen of the World through which money could also be invested with deferred taxation of the interest.

Later that month, Trulove signed an application for an

adjustable life certificate, which was subject to a physical examination to be performed on Trulove at Woodmen's expense. A week later Trulove gave the Woodmen agent a cashier's check in the amount of $10,000.

On October 18, the agent brought an adjustable life certificate to Trulove and he signed a certificate delivery receipt as well as a document referred to by Woodmen as a "free-standing" ratification form. It stated that the planned premium had been increased in order for the certificate to remain in force beyond the first year for adjustable life. This was prompted by Trulove's physical examination.

An Uncertain Date

The ratification form read, in relevant part:

"If this form is signed, this certificate immediately will be in force as of the certificate date shown on Page 2, or as of the date of the signing, whichever comes first. In any event, this form must be signed not later than October 28, 1989 and returned to the Payment Adjustment Section or the certificate will be cancelled." (The date was marked through and replaced with a handwritten date of "November 4.")

A copy of this ratification form was included in the certificate left with Trulove, but Trulove retained it unsigned.

Under the certificate, Trulove was insured through October 1, 1990. The certificate was returned to the agent on November 3, 1989, and Woodmen received Trulove's request to cancel it on November 6. Woodmen informed Trulove by letter that it could not cancel the certificate since the request was received after the ten-day review period, and the ratification was signed on October 18.

Page 1 of the certificate stated:

"TEN DAY RIGHT TO EXAMINE CERTIFICATE: All premiums paid will be returned if the member wants to cancel this certificate within ten days from the date it is received. To cancel the certificate, give it to the Woodmen representative who delivered it or send it to the Home Office."

This was referred to by Woodmen as the statutory ten-day "free look" period.

Question the Accuracy of Projections

The total annual planned premium and dues were stated as $4275.00, and the face amount was stated as $156,529 which "includes cash value." Included on both pages one and two were statements that the issue date was September 28, 1989. Included on page two was that the certificate date is October 1, 1989; the maturity date is October 1, 2016; the maximum initial surrender charge is $6261.16.

Woodmen stated in its letter that Trulove could "cash surrender" the certificate by completing and returning an enclosed form. He did not do that.

Trulove believed that the Woodmen agent was offering him an adjustable life certificate for a one-time premium payment of $100,000—and that the $10,000 cashier's check represented a deposit in the event he decided to purchase the certificate, rather than a premium payment. If he decided to purchase the certificate, he was to deliver an additional $90,000 to the Woodmen agent. Trulove also testified that the Woodmen agent represented to him that the ratification form related to an application for an increase in coverage from $156,529 to $200,000.

Based on the advice of his attorney, Trulove decided not to purchase the certificate. He notified the Woodmen agent of this after October 28 but before November 4, the interlined date on the ratification form.

However, Trulove admitted that he had signed various forms bearing his signature without reading them, instead placing trust in oral representations by the Woodmen agent. When Woodmen refused to refund all of his premium payment, Trulove sued.

The Verdict: Know What You're Signing

The trial court ruled for the insurance company, finding that the notice requirement was disclosed in bold print in plain English on the face of the policy. Trulove appealed.

The appeals court agreed with the lower court. "The policy for which Trulove signed a receipt on October 18 stated on its first page that he could cancel it within ten days of its receipt," it concluded. "The ratification form stated that the policy would be in force immediately if it

was signed, which it was. Trulove could not reasonably have been misled in these regards by the statement that it had to be signed no later than November 4 or would be cancelled by the insurer."

One of the attorneys representing Woodmen in this case says that its conclusion reiterates basic insurance-buying guidelines. "People don't realize how the law affects them. Especially with a complicated product like this. This is an investment product where you can get a better interest rate along with insurance. Consumers and insurance buyers [must] comply strictly with their policies....people should always consult a lawyer when buying a policy."

On the other hand, William Evans—who represented Trulove—argues that the decision reflects the political clout that insurance companies carry in most states.

"There was this sheet attached to the policy that said if it was not signed by a certain date, the application would be rejected. This was in the policy, but Mr. Trulove never signed it. We were both under the impression that until this document was signed, the policy would not go into force and effect," Evans says. "Insurers have been very successful in lobbying for laws that are good for them. It is very hard to go up against an insurance company. There's also a lot of motivation for agents [to mislead clients]. This agent admitted on the stand that Mr. Trulove would have only needed $7,000 for this kind of policy, but he told Mr. Trulove that he needed $10,000. This is because the agent wanted that commission."

Some states require the insurance company to give buyers over age 60 a financial review of the policy they are buying. The review shows your policy's premiums, death benefit, and cash values. You should receive a financial form if either of the following is true: Premiums for the policy, plus five percent interest, exceed the death benefit at some time during the first ten years, or death benefits are limited for some period (for example, the first two years of the policy).

Naming Your Beneficiary

The beneficiary is the person or interest to whom payment of your life insurance proceeds will be made upon your death. The beneficiary provision allows you to direct the payment to any person you choose. If no beneficiary is liv-

ing or chosen upon your death, proceeds will be paid to your estate.

You may designate a person or institution, such as a foundation or charity. You may name your estate, a corporation, a trust, or any other legal entity as a beneficiary. (However, for tax reasons, it is not advisable to name your estate as beneficiary.)

Most life insurance policies contain a revocable or changeable beneficiary designation. Irrevocable beneficiary designations, which are rare, cannot be changed without the consent of the beneficiary.

It is customary in life insurance contracts to specify a primary beneficiary and a contingent beneficiary. The primary beneficiary has first claim to the proceeds of the life insurance policy following the death of the policyholder. If the primary beneficiary dies before the policyholder, however, the contingent beneficiary is entitled to the benefits of the life insurance policy. If the primary beneficiary dies and there is no contingent beneficiary, the policy proceeds are automatically payable to the policyholder's estate.

In a family situation, a common primary and contingent designation is as follows: Mary Jane Smith, wife, and as contingent beneficiaries, all children, adopted or born of this marriage, to share equally.

It is also possible to designate a tertiary beneficiary. A tertiary beneficiary occupies the third level in the succession of beneficiaries and is entitled to receive the life insurance proceeds following the death of the policyholder, provided that both the primary and contingent (secondary) beneficiaries have died first.

After the death of the policyholder, the proceeds belong to the beneficiary, who then selects (or begins to receive your selection of) a settlement option. If a lump sum benefit is paid, the insurance company has no further obligation to the beneficiary. If an option other than a lump sum payment is selected, or an arrangement is made where benefits continue over a period of time, the beneficiary should then name his or her own beneficiary.

State Your Intentions Clearly

Careless wording of beneficiary designations can result in family disasters. Each year in courtroom litigation thou-

sands of hours are spent trying to sort out beneficiaries and heirs, all because of poorly worded beneficiary designations.

For example, if you just designate your "wife" (without specifically naming her) as the beneficiary, a problem may arise. If you have been married several times, does "wife" mean your current wife or the woman you were married to at the time the beneficiary was designated? Or does it apply to, perhaps, a different wife who is now caring for your minor children? Who was the intended beneficiary? Be sure to designate your beneficiaries by their full name to avoid misunderstanding.

Likewise if your "children" are designated as a class to receive your life insurance proceeds, it may be unclear whether you intend to include an adopted child in the disposition.

The insurer will make every effort to comply with your wishes, as long as they are clear. When the intention is not clear, the insurer must distribute the funds according to the apparent intent of the policyholder, or pay the funds into court and seek a judicial determination of the proper distribution.

The Cost of Confusion

In its 1991 decision *Claudette Taylor v. Dellona Johnson,* the Florida court of appeals dealt with a particularly messy issue of unclear beneficiary.

> Johnson's husband Kenneth had purchased a life insurance policy for $10,000 from John L. Alden Life Insurance Company in 1980. Sometime in 1976, Kenneth Johnson had initiated an extramarital affair with Taylor which lasted until he died of a heart attack in June 1986. Despite his relationship with Taylor, he continued to reside in the marital home with Dellona Johnson until his death.
>
> In the spring of 1983, Kenneth Johnson had changed the primary beneficiary designation to name Taylor in place of his wife, and the wife was listed as the first contingent beneficiary. The change in the primary beneficiary was recorded by John Alden Insurance on June 3, 1983. After the change, Dellona Johnson was falsely listed on the policy as "former wife" and Taylor as "fiancee."
>
> In August 1985, the policy value was increased to

$20,000. Premiums for the policy were paid by drafts from the Johnsons' joint checking account.

Dellona Johnson and Taylor both claimed the policy proceeds following the Kenneth Johnson's death. John Alden Insurance refused to pay either claim, instead transferring the funds to the court for distribution.

The Effect of Undue Influence

A bench trial ruled that Kenneth Johnson's designation of Taylor as primary beneficiary was the result of undue influence exercised by Taylor. The $20,000 in proceeds, plus interest, were awarded to Dellona Johnson. Taylor appealed.

Summing up its support of the initial ruling, the appeals court wrote: "The change in beneficiary designation occurred after the insured suffered a life-threatening heart attack, the prognosis for which was very poor...Taylor accompanied the insured to a research hospital in Philadelphia shortly before the beneficiary designation was changed....while Taylor claimed not to be familiar with the deceased's finances, the record shows that Taylor completed the deceased's State of Florida Retirement Benefit Computation form and used the deceased's credit card, and that the deceased gave her cash and paid many of her bills....the change in beneficiary designation from the wife to Taylor was witnessed by a long time friend of Taylor."

Against his professed wishes, the money went to Johnson's wife.

Different Types of Beneficiary

Older people often choose to name minor children as contingent beneficiaries under life insurance contracts. This is not a good idea. Insurance companies usually will not pay proceeds to a minor, since any release or settlement signed by a minor can be legally rejected by the minor when he or she attains legal age. It is necessary for a guardian to be appointed to receive the funds on behalf of the minor.

If a minor becomes eligible to receive life insurance proceeds due to the death of both parents, any of their estate left to the minor would have to be administered by a general guardian regardless of whether it includes life insur-

ance proceeds. Thus the life insurance proceeds would be paid to that guardian. Also, some people anticipate this problem by establishing a trust to administer the life insurance proceeds and all other property in the estate of the parents in the event that both parents die leaving minor children.

A trust is formed when the owner of property (the grantor) gives legal title of that property to another (the trustee) to be used for the benefit of a third individual (the trust beneficiary). This fiduciary relationship allows the trustee to manage the property in the trust for the benefit of the trust beneficiary only. The trustee legally must not benefit from the trust.

When a trust is designated as the beneficiary of a life insurance policy, the policy proceeds provide funds for the trust. Upon the death of the policyholder, the trustee administers the funds in accordance with the instructions set forth in the trust provisions.

While there are many benefits in naming a trust as beneficiary of an estate or a life insurance policy, particularly for minor children, there are drawbacks as well. A trustee will charge a fee for managing a trust. Also, the way trust property is managed is often left up to the trustee, leaving the trust beneficiary powerless to intervene if the trust is poorly managed. Also, the trustee may not provide resources for the trust beneficiary as he or she or even the grantor would have wanted; the trust beneficiary must request resources from the trustee, he or she cannot make free use of the property in the trust.

Inter Vivos Trust

An inter vivos trust is one that takes effect during the lifetime of the grantor (you). A testamentary trust is a trust created after the grantor's (your) death, according to the provisions of the grantor's (your) will.

You can name your estate as beneficiary, directing that policy proceeds be payable to your executors, administrators or assignees. Such a designation might be made in order to provide funds to pay estate taxes, expenses of past illness, funeral expenses, and any other debts outstanding prior to the settlement of the estate. Designating your estate as beneficiary aids in settling your estate by avoiding the need to sell other assets to pay these last expenses. However, it is not usually desirable to name

your estate as beneficiary because the insurance proceeds become assets of the estate and are subject to the claims of your creditors. This may not be what you had in mind. In addition, these proceeds increase the size of the estate and can increase the expenses, inheritance taxes and federal estate taxes involved in the administration and settlement of your estate.

Class Designation

In naming children as beneficiaries, a class designation is the best idea. Class designations should be used when individuals of a specific group (such as your children) are to share equally in your life insurance proceeds.

For example, if you designate your children as beneficiaries by naming each child specifically, other children might be accidentally excluded, especially if you failed to update your beneficiary provision to include children who joined the family since the original designation was made.

The wording of the class designation must carefully specify your intentions. "My children" will include children of other marriages or other unions, when in fact you might prefer to exclude both. In addition, this classification would exclude a posthumous child (born after the father's death) from receiving a portion of the proceeds.

If you wish to restrict your designation to the children of your present marriage, you might designate your present spouse "Carolyn Jones Bennett" as primary beneficiary and use the term "our children" or "children born of this marriage" as contingent beneficiaries. By using your spouse's name, followed by the designation "my wife," no question can arise as to your intent to have her as the primary beneficiary. Likewise, your intent to restrict the contingent beneficiaries to children of this marriage is clear.

Per capita and per stirpes designations are also used to benefit children. The per capita designation means "by heads," (individual) and per stirpes means "by stock" (family line or branch).

Under a per capita designation each surviving child shares equally in the death benefit.

PER CAPITA

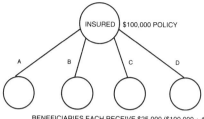

BENEFICIARIES EACH RECEIVE $25,000 ($100,000 ÷ 4)

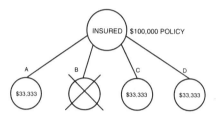

SURVIVING BENEFICIARIES EACH RECEIVE EQUAL SHARES OF
$33,000 ($100,000 ÷ 3)

Under a per stirpes designation each child, grandchild, or great grandchild, etc., moves up in a representative place of a deceased beneficiary. A per stirpes designation can become quite involved and it is important to know how the line of representation works because of the way courts interpret the per stirpes designation. The majority of courts hold that each child moves up to represent the closest relative (the parent). The child represents the deceased parent (insured), the grandchildren represent the child, great grandchildren represent the grandchildren, and so forth. We hope the following examples will help to clarify the per stirpes designation.

For illustration, consider these variations:

PER STIRPES

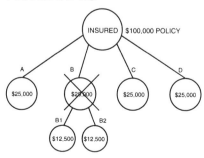

($100,000 ÷ 4) $25,000 EACH

IF B HAS PREDECEASED THE INSURED B1 & B2 WILL SHARE EQUALLY
B's BENEFIT

Mrs. Smith has three children, Faith, Hope, and Charity. At her death each child will share equally in the death benefit—one-third each.

If, at Mrs. Smith's death, Faith is no longer living and she has no dependents, Hope and Charity will share the death benefit equally—one-half each.

If, at Mrs. Smith's death Faith is no longer living but she is survived by two children, Jack and Jill (Mrs. Smith's grandchildren); Hope and Charity will each receive one-third of the benefit, and Faith's one-third will be divided equally between Jack and Jill—one-sixth each.

If, at Mrs. Smith's death, Faith (child) and both Jack and Jill (grandchildren) are also deceased, but Jack is survived by two children and Jill is survived by one child (Mrs. Smith's great grandchildren) Jill's child will get one-sixth benefit while, one-sixth of the benefit will be divided between Jack's two children—one-twelfth each.

If, of the three great grandchildren, one of Jack's children is dead at the time of the distribution and has left two children (Mrs. Smith's great great grandchildren) those two children are only entitled to share Jack's child's one-twelfth—the great grandchildren receive one-twenty-fourth each.

Although the preceding examples represent the majority finding, some courts have held that, for example, a grandchild can move up and share in the benefits on the same percentage basis as the original children.

Uniform Simultaneous Death Law

A problem arises when the policyholder and the primary beneficiary die simultaneously with no evidence as to who died first. Many states have adopted the Uniform Simultaneous Death Law. Under it, if there is no evidence as to who died first, the policy will be settled as though the policyholder survived the beneficiary.

Accordingly, the life insurance proceeds would be paid to the estate of the policyholder, not the estate of the beneficiary. Of course, if contingent beneficiaries are designated, the proceeds would be payable to them. Or if there is clear evidence that the beneficiary survived the policyholder, then the proceeds are payable to the beneficiary's estate.

Let's assume that John, the policyholder, has designated his wife, Jane, as primary beneficiary on a $100,000 whole life policy. John's children from a previous marriage are named as contingent beneficiaries. John and Jane are killed in an auto accident and it is determined that Jane survived John by 15 minutes. The insurance proceeds would be payable to Jane's estate and may not benefit the children.

In accordance with the Uniform Simultaneous Death Act, if it could not be determined that Jane survived John, then the proceeds are payable to the children as contingent beneficiaries. If the children were not designated as contingent beneficiaries, then the proceeds are payable to John's estate.

To avoid the problem of the primary beneficiary living for a very short time following the death of the policyholder and thus receiving the insurance proceeds, many policies will include a common disaster provision. This provision places a time element on the survival period of the primary beneficiary by stipulating that the primary beneficiary must survive the policyholder by a specified period of time such as 30, 60 or 90 days.

Thus, in the John and Jane example, if the policy contains a common disaster provision of 30 days and Jane only survived John by 15 minutes the proceeds are payable to the contingent beneficiaries.

Life Proceeds and Creditors

One of the unique features of life insurance is that the life insurance proceeds are exempt from the claims of the policyholder's creditors as long as there is a named beneficiary other than the policyholder's estate. Even the cash value of a life insurance policy is generally protected from creditors.

Although the life insurance contract is between the policyholder and the insurer, once that person has died, a contractual arrangement exists between the insurer and the beneficiary. The beneficiary may even sue the insurer if payment is not received upon proper proof of death.

The spendthrift clause is designed to protect the beneficiary from losing the life insurance proceeds to creditors, assigning the proceeds to others, or spending large sums recklessly. The spendthrift clause is not applicable to

lump sum settlements but is operative with settlement options. It only protects the portion of proceeds not yet paid (due, but still held by the insurer) from the claims of creditors to the extent permitted by law.

You would normally elect to include this provision at the time you apply for life insurance. As long as your proceeds are paid according to a settlement option where the insurer keeps the proceeds and sends a monthly payment to the beneficiary, then the amounts received by your beneficiary are exempt from the claims of the beneficiary's creditors.

This provision allows the insurer to select a beneficiary if the named beneficiaries cannot be found after a reasonable time. To facilitate the payment of the death proceeds, the insurer may select a beneficiary if this provision is in the policy. This provision is found most often in policies with small death benefits, such as industrial life insurance. The insurer would usually select someone who is in your family's immediate blood line (a brother, sister, aunt, uncle, etc.).

What to Tell Your Beneficiaries

Always let your beneficiaries know they are named in your life insurance, and where you keep your policy, so they know what to do in the event of your death. Inform your beneficiaries of any major changes you make to your policy. Keep the policy number and a current list of beneficiary names in a separate place, as well. Don't keep your policy in a safety deposit box or any other place where it might not be readily available in the event of your death.

Your beneficiaries also should be aware that it is not necessary to hire an attorney or pay anyone a fee in order to make a claim under a life insurance policy. All they need to do is contact your insurance agent or company and provide proof of your death.

Keep in mind that the guarantees associated with cash value life insurance (guaranteed cash value, death benefit, etc.) are made by the insurance company, and are not backed up by anything other than the insurer's financial solvency. There is no Federal Deposit Insurance Commission such as there is with your financial institution.

Policy Dividends

Life and health policies may be issued on either a nonparticipating or participating basis. Nonparticipating policies require you to pay a fixed premium and do not return dividends. Participating policies require you to pay a somewhat higher "gross" premium, but at the end of the year you are entitled to policy dividends.

Dividends represent the difference between the higher premium you paid and the actual cost of the policies to the company (or the lower premium you should have paid). Dividends are considered a return of excess premium, and are not taxable (however, interest earned on dividends, like all interest income, is taxable as income).

Dividends are never guaranteed. Agents trying to sell you a participating policy are not allowed to suggest that dividends are always paid, so beware of any agent who does (and report them to your state Insurance Department). The amount of the dividend depends on how profitable the insurance company has been based both on the decisions of its directors and trustees and the performance of its investments in the economy.

While premiums are usually lower for nonparticipating policies, so are cash values, interest amounts, and loan values. Also, you will not receive the higher dividends that a participating policyholder will receive when the insurance company has a great year.

When you purchase a participating policy you will be asked to select the way you would like to receive your policy dividends. The most frequently used options are:

- cash,
- application to Reduce Premium,
- accumulation at Interest,
- paid-up Additions,
- accelerated Endowment,
- paid-up Option,
- one-year Term Option.

Cash

Dividends are simply paid to you at the end of the year by check. Because of various expense factors used by the insurer, there is often no dividend available in the first year or two of the policy. The "excess premium" paid is used to cover expenses.

Application to Reduce Premium

You may use your dividends to pay part of the premium due at the time the dividend is declared. Usually if you select this option the premium notice will show the gross premium minus the dividend; and you just have to send a check for the net amount.

Accumulation at Interest

This option allows dividends to accumulate, with interest paid at a rate specified in the policy, compounded annually. Usually there is a guaranteed minimum interest rate. If the insurer earns more than the minimum, there may even be a payment of "excess interest" on the accumulations. You retain the right to withdraw the accumulations at any time.

Paid-Up Additions

You may apply your policy dividends to buy additional, paid-up insurance of the same type as the policy. These "dividend additions" or "paid-up adds" are actually small single premium policies generated from the dividend. No new policies are issued. The base policy is simply amended to reflect the additional paid-up values. Each of these additions will develop cash value. The face amount and the additions make up the total benefit at the time of your death. Should you surrender the policy for its cash value prior to that time, both the cash value of the policy and the additions would be paid.

The advantage of choosing this option at the time you apply for the policy is that the additional paid-up insurance will automatically be provided without requiring you to offer proof of insurability. If you decide to elect this option later, the company may require proof of insurability.

Accelerated Endowment

Dividends may be applied to convert the policy into an endowment, or in the case of endowment insurance, to shorten the endowment term. The usual methods are described below.

You can allow dividends to accumulate until they, together with the cash value, equal the face amount of the policy, at which time the face amount will be paid as an endowment.

Alternatively, the dividends may be used each year to shorten the endowment period. The effect is to change the policy each year by reducing its term. Under this option, a policy will mature more quickly because its cash value will reach the desired face amount of the insurance in a shorter period of time.

Paid-Up Option

This option actually allows you to pay the policy up early. For example, if you own a life insurance policy which will take 20 years to be fully paid up, and you apply this dividend option, you may pay up the policy in 16 or 17 years instead of 20. If you own a whole life contract, by applying your dividends in this manner, you could actually stop paying premiums earlier than age 100.

One-Year Term Option

With this option you use dividends to buy one-year term insurance, usually up to the amount of the cash value of the policy. If the option is selected after the time the policy is issued, evidence of insurability will usually be required. If the dividend amount is higher than the term premium, the excess may be paid as any other dividend option.

You would most likely use this option when there is an outstanding loan against the policy, to keep the total amount of insurance payable equal to the face amount. Otherwise, the outstanding loan balance will reduce the face amount when you die.

Looking Back

To sum up the points made in this chapter:

- Your sources of retirement income, benefits, and assets might include Social Security, Medicare, Medicaid, group retirement plans, savings and investments, insurance and annuities, and other income such as income from property rentals.

- Insurance companies have enough data on life expectancy to sell life insurance products for the mature market that are beneficial to both the company and the insured. Still, you need to be careful when buying new life insurance after age 50.

- The group life insurance coverage you have through work is "rented" coverage that stops when you stop working. But you may have the right to "convert" this group coverage into an individual policy when you retire.

- If you decide to replace an existing life insurance policy with a new one, remember you may have to undergo medical underwriting and may be subject to new waiting periods such as a two-year incontestability period and suicide clause.

- You will automatically have a 10 to 30 day "free look" period after you purchase a new life insurance policy to change your mind, write to request cancellation, and receive a complete premium refund.

- You have the right to designate your beneficiary(ies), and select how you would like to receive your policy dividends, if you are purchasing a participating policy.

- Review your current life insurance policies, as well as any recent annual reports you've received. Find out what your accumulated cash values are (if any).

- Review your beneficiary designations to be sure they are up to date and in accordance with your wishes. Have you named your beneficiaries in such a way that there can be no confusion after you die?

- Read through the conversion provisions of any group life insurance policies you have through your employment. Consider whether you will want to continue coverage after you stop working.

- When applying for new life insurance, be sure to answer the health questions on the application accurately and honestly. Make sure you receive the policy's outline of coverage and buyer's guide. And remember it's a good idea to pay your premium up front, but not directly to the insurance agent.

- Don't be misled by wildly optimistic policy illustrations. Ask to see a range of rates of returns. Also, beware of any agent that tells you that dividends on a participating life insurance policy are guaranteed.

CHAPTER 6
THE MECHANICS OF LIFE INSURANCE

Even though there are many different forms of life insurance policies, essentially all life policies are either term insurance or whole life insurance, or a combination of the two.

Pros and cons apply to every variation of life insurance. No single kind is best for all circumstances. Insurance industry veterans say the best kind of life insurance to have is "any policy that pays when you need it." As simple as it sounds, that's good advice.

Term Insurance

Term insurance provides pure insurance protection for a specific period of time, such as five, ten, or 20 years, or "to age 65." At the end of the term period, the policy expires with no accumulated cash value, and no benefits are payable. The death benefit is only paid if you die during the term period. Some define term insurance as "insurance that is actuarially designed to expire before you do."

The premiums on term insurance are generally low, but increase substantially as your age increases. For this reason, term insurance is most economical when purchased at a younger age and when the term is longer (i.e., 20 years or to age 65). Short-term renewable policies would initially be less expensive, but after middle age the renewal premiums begin to jump dramatically.

For example, in an annual renewable term insurance policy with a $100,000 death benefit, the annual premiums might look something like this:

$ 135/year age 35;

$ 410/year age 50;

$ 1,710/year age 65;

$ 4,625/year age 75;

$12,590/year age 85.

New term insurance is often unavailable after retirement age, although some insurance companies offer term up to age 70 or 80.

In decreasing term insurance, the face amount decreases but the premium remains level over the term period. This is most often used in mortgage insurance; where the policy is designed to provide exactly the unpaid balance of the mortgage upon the death of the policyholder. When the mortgage is paid off, the term policy expires and no benefit is provided. One advantage to decreasing term insurance is that it often allows the policy owner to convert the amount of remaining coverage into permanent insurance.

Most term policies are issued as renewable and convertible (R&C). A renewable term policy may be renewed at the end of the term for another term period without evidence of insurability. Thus, a one year renewable term policy expires after one year but is renewable for other one-year periods (of course, the premium will go up). A convertible term policy means you can convert to permanent insurance (such as whole life) without having to provide evidence of insurability. So perhaps the most important advantage to term policies is that they can preserve your insurability. However, the right to renew or convert is usually limited to a specific age. For example, a ten-year term policy may be convertible only through the eighth policy year, and could leave you "uninsurable" after the policy expires. This is one reason why it is important to periodically review your insurance policies.

The Importance of Insurability

Insurability is an important concept with all life insurance policies. It is much easier to have a life insurance policy issued when you are younger and in relatively good health, than it is after you have reached age 50 and/or have had some significant health problems. (Evidence of insurability is also critical in health insurance, as we'll see later.) If you apply for a new life insurance policy, you will most likely have to undergo a medical examination in order to "prove" your insurability. If your health is questionable, you may be declined for insurance coverage. Even if you are found eligible for insurance, you may be "rated up" to a much higher premium.

It might not sound like a good idea to purchase term insurance when it does not accumulate cash value, but there are some advantages. Term policies provide temporary protection at a low cost, allowing a person with a limited income to purchase more coverage than might otherwise be affordable. Investment gurus argue that you should "buy term and invest the difference," meaning that you purchase term insurance for a low premium cost and use the savings in premium to make long-range investments for retirement. Unfortunately, too many people end up just buying term and spending the difference.

Whole Life Insurance

Whole life insurance is the most common form of life insurance sold. These policies remain in force until you either die or reach age 100, as long as you pay the premium as scheduled. Also known as ordinary life, or permanent insurance, whole life is characterized by level premiums, level face amounts, guaranteed values, and a relatively high degree of safety.

Whole life insurance builds a living benefit through its guaranteed cash value element, enabling the policy owner to access this cash for emergencies, as a supplemental source of retirement income and for other needs.

Because whole life policies include both insurance and savings elements, they are often part of long-range financial planning. Many people like the level premiums associated with whole life insurance, since you always know what the cost of insurance will be and never need to worry about your monthly premium going up.

The element of risk to the insurance company is much different for a whole life policy than it is for something like an automobile policy. When an insurance company issues an auto policy, it hopes that the policyholder will be a safe driver and will never have an accident. When an insurance company issues a whole life policy, it knows it will someday be called upon to pay the claim.

For example, if you purchase a $100,000 whole life policy, your beneficiaries would receive the $100,000 death benefit whether you die one week, one year, or 50 years after the policy's effective date, as long as the policy remains in force.

Even though the cash value component of whole life is closely associated with the concept of, and often the main reason for buying life insurance, it may come as a surprise that the cash values accumulated actually have nothing to do with insurance. Your cash value is simply a low-yielding savings account based on the periodic contributions you have made by paying your premiums.

Historically, the rates of interest guaranteed by whole life policies have been low—three to four percent. But the principal is fully protected and the interest rates and future cash values are guaranteed by the insurance company. (Bear in mind there is no government backing to this guarantee, unlike savings accounts insured by the FDIC. If the insurance company closes its doors, the amount you will receive might be less than you think.)

Cash Value

Usually, in the first couple of years of the policy, the cash value is equal to zero because the insurance company deducts certain expenses (including your agent's sales commission). Over the life of the policy, there is a steady increase in the amount of the cash until at age 100, the cash value is exactly equal to the policy's face amount.

If you are fortunate enough to live to age 100, and own a $200,000 whole life policy, you'll get a $200,000 check for your birthday from your insurance company. (You're also not responsible for the premium payment at age 100, when the policy matures.)

Whole life policies don't need to be held until death or age 100 in order for benefits to be available. Your cash value is guaranteed, which means if you cancel (surrender) your policy after paying premiums for a number of years you will receive the cash value. If you do keep your policy in effect by paying premiums, you may access your cash value by borrowing it in the form of a policy loan.

Clearly, if you purchase a $100,000 policy at age 25, the fixed monthly premium you'd pay over the next 75 years to reach a $100,000 cash value by age 100 would be much lower than it would be if you purchase the policy at age 55 and have only about ten more income-producing years to accumulate the same amount of money.

However, state laws generally require that the benefits of an insurance policy must be "reasonable in relation to the

premiums charged." The way this is determined is by examining company loss ratios, or the amount of benefits that are eventually returned to policy holders as compared to the aggregate premiums earned. State regulators try to keep a close eye on the insurance premiums charged older policy holders. In regulating some senior health insurance products, many laws require minimum loss ratios of 65 to 75 percent.

Protecting Benefits for Seniors

In its 1990 decisions *Omega National Insurance Co. v. Dick Marquardt* and *American Council of Life Insurance v. Richard G. Marquardt,* the Supreme Court of Washington state ruled that certain small-value life policies usually written for seniors were inherently unfair.

In December 1988, the Washington Insurance Commissioner adopted a rule establishing a minimum ratio between death benefits and premiums that had to be maintained by life insurers, to assure that death benefits payable under a life insurance policy were reasonable in relation to premiums paid for the insurance.

In general, during its first ten years, life insurance covered by the rule had to provide benefits that equal or exceed the premiums paid so far, plus interest. The rule did not apply to policies that had a minimum death benefit of $25,000 or more.

A number of representatives from various insurance companies testified at public hearings and argued that the rule would have the effect of reducing the kinds of insurance available to the elderly, that less drastic regulation would solve the perceived problems, and that the rule exceeded the Commissioner's statutory grant of authority.

The Commissioner's response explained that the intent of the rule was to deal with small·life insurance policies issued to older buyers where high mortality rates and heavy expense loading combined to produce extremely unfair results.

The rule came in response to a history of complaints from senior citizens (and their children) made after realizing that the premiums already paid exceeded the face amount of the policies—and that the payments must continue to be paid until death if the beneficiary was to receive the full benefit.

"There was a problem in the small death benefits policies. The cost for expenses was extremely high, and this leads to a product where the amount of insurance exceeds the death benefit. Seniors have a legitimate desire to provide for their last expenses, but this isn't a good way to do it. It just costs too much," said one lawyer who works for the Washington Insurance Commissioner. "It was a whole life policy, a death benefit policy with a stable premium but a graded death benefit. The premium may remain level, but the benefit goes down if you live longer....some [insurance companies] designed it to where if you died within the first two or three years, you would just get your premiums back; or if you died four or five years or later, then you get the death benefit."

Under the targeted policies, unless the policy holder died within a small window of time, the premiums paid would exceed the benefits available. And, even if the policy holder died within that brief window period, the death benefit was often so small as to be virtually meaningless.

The Commissioner also said that "many policies endorsed by celebrities in mass-marketing plans were such a poor purchase that normal persons would have to be ill-informed, confused or deceived before they would buy such a plan."

Companies Challenge the Rules

Omega and Pierce National Life Insurance Company sued, arguing that the Commissioner's rule was unconstitutional and unfair. The American Council of Life Insurance and four other insurance companies filed similar actions. The cases were consolidated and proceeded to consider two basic issues.

Omega argued that statutes limiting the Commissioner's ability to set insurance rates effectively prohibit rules like the one in dispute. The appeals court focused on a conflict between the rate-making language and the authority granted to the Commissioner for combating unfair and deceptive practices. Ultimately, it concluded that the Commissioner had acted within his statutory authority in making the rule.

The insurance companies also argued that the rule violated substantive due process in that the "premium cap" violated the insurers' constitutional right to earn a reasonable return on their operations.

The appeals court disagreed. "Several persuasive reasons are advanced for the rule's classification of smaller and larger life insurance policies," it wrote. "The Commissioner argues that in policies under the purview of his new rule, it is the combination of high mortality rates together with heavy expense loading that produces the unfair results....because the unit expense costs on larger policies are less than on smaller policies, the relationship between premiums and benefits in larger policies tend to be more favorable to the consumer."

In a friend-of-the-court filing related to the case, the AARP argued the insurance companies lacked standing to assert the rights of the elderly.

One Senior's Story

The appeals court cited the earlier testimony of David Rodgers:

"About seven years ago, at age 69, I purchased an Omega National Life Insurance Company whole-life insurance funeral plan. By last year I had paid in accumulated premiums of $2,524.32 and realized that this already greatly exceeded the death benefit.

"...After having paid $2,524.32 of premiums over a 72-month period, I was advised that if I discontinued payments, my beneficiary would receive [less than that amount] in benefits; but if I immediately paid an additional $800 in premiums, I would have a reduced paid-up plan which would pay $1,940 at the time of my death. Thus, by paying a total of $3,324.32 in premiums, a $1,940 benefit would be paid when I die. This does not take into account interest I could have earned on my premiums had I left them in a savings account."

In sum, the appeals court supported the Insurance Commissioner's prohibition on the small-value life policies.

Endowments

Endowment insurance provides for the payment of the face amount to your beneficiary if you die during the endowment period (say, ten or 20 years). If you survive the endowment period, the face amount is usually payable to you.

The purpose of endowment insurance is to "force" you to save a specific sum of money over a period of time, and protect that savings by paying your beneficiary that sum if you die during the endowment period. Endowments provide the fastest accumulation of cash value, and are therefore the most expensive form of cash value insurance. If you are looking for maximum insurance protection at minimum cost, you should purchase term insurance or whole life insurance, not an endowment.

Modified Endowment Contracts

With single premium whole life policies, one single premium is paid up front to provide a guaranteed death benefit. The contract's guaranteed cash value grows on a tax-deferred basis. For example, a $175,000 premium might purchase a $500,000 death benefit, payable tax free to beneficiaries at the policyholder's death. Meanwhile, the cash value grows tax deferred. However, the federal government decided it was losing too much tax in certain contracts where the amount of the premium paid in is considered excessive.

In November 1988, Congress passed the Technical and Miscellaneous Revenue Act (TAMRA) which makes any withdrawal, loan, or collateralizing of the cash in these policies taxable. In fact, depending on the policy owner's age, the amount may be taxable and subject to a ten percent penalty (if withdrawn prior to age 59½).

In order to avoid the taxation and subsequent penalties, the policy owner must limit his or her investment according to the "seven pay test" established by the government, which limits the amount that may be paid into the policy during the first seven policy years. If you pay "too much" in premiums over the first seven years, or if you reduce the face amount of the policy, you may have created a modified endowment contract and you'll incur a tax liability. This information would be provided to you by the insurance company, and it is unlikely that you could form a modified endowment contract by accident.

This affects only policies purchased after 1988, so if your agent talked you into a single premium whole life policy before that, be sure to do something nice for him or her in return.

The modified endowment contract restrictions also apply to retirement income endowments and semi-endowments, where the amount payable upon survival (of the endowment period) is greater than the face amount, and the amount payable at death is the greater of the face amount or cash value.

Flexible Policies

While to some people, the level premiums, level face amounts, and fixed benefits associated with whole life insurance imply stability and safety, to others these features reflect inflexibility and missed investment opportunities. Insurance contracts offering guaranteed interest rates of four to six percent compared unfavorably to the extremely high interest rates experienced in the 1970s. Individuals who purchased whole life policies watched as their cash values were eroded by inflation.

To satisfy consumer demands for more flexibility in terms of premiums, face amounts, and investment objectives, the insurance industry developed flexible policies. The main types of flexible policies are adjustable life, universal life and variable life insurance.

Adjustable Life Insurance

Adjustable life is a policy which allows you to adjust the face amount, premium and length of protection without ever having to complete a new application or have another policy issued. (There is generally no investment risk with adjustable life insurance.)

For example, if at age 25, you feel you can afford to pay a $500 annual premium, it then becomes a matter of using this premium to purchase the type of insurance that will meet your needs. Let's assume you are married with three children and a large home mortgage and have no other life insurance. Based on the $500 premium, you might use all or most of that premium to purchase several hundred thousand dollars of term insurance.

In later years, you may adjust the premium, the face amount or the period of the death protection to meet current needs. For example, at age 50 you may be planning for retirement. The same $500 premium could now be used for some form of permanent insurance protection with guaranteed cash values. With adjustable life insurance, the temporary protection could be changed to per-

manent coverage and the death benefit (face amount) reduced due to your age and premium commitment.

If you make an adjustment in the policy which results in a higher death benefit, then proof of insurability may be required for the additional coverage.

Variable Life Insurance

Variable life insurance is a whole life policy designed to protect you and your beneficiaries from losing life insurance values due to inflation.

Variable life insurance has a guaranteed death benefit, but the cash values depend on equity (investment) performance. If investment performance is poor, you run the risk of having your cash value decrease or be lost altogether. You assume the investment risk, but have the potential for excellent growth in cash value through potentially high interest rates and protection against inflation.

Historically, during periods of inflation, the stock market has kept pace by increasing in value. In recognition of this fact, the insurers have established separate accounts which consist primarily of a portfolio of common stock and other securities-based investments. Premiums paid for variable life insurance contracts are placed in the insurer's separate account.

An insurer's general account is an investment portfolio used by the insurance company for investing its premium income. It consists of safe, conservative, guaranteed investments, such as real estate and mortgages. Funds which are invested for policyholders or annuitants who hold variable contracts must be held in a separate account.

In accordance with the Investment Company Act of 1940, the separate account funding a variable contract (whether it be a variable life policy or variable annuity) must be registered with the Securities and Exchange Commission (SEC) as an investment company. Most often the separate account will be registered as a unit investment trust (UIT). As a UIT, the separate account management will purchase and hold assets (common stock and other securities) for the benefit of plan participants.

Comparison of Traditional Life Insurance Forms and Variable Life Insurance

	Scheduled Premium VL	Whole Life	Flexible Premium VL	Universal Life
Death Benefit	Guaranteed minimum death benefit	Guaranteed death benefit	Not guaranteed	Guaranteed and flexible
Premium	Fixed	Fixed	Flexible	Flexible
Cash Value	Not guaranteed	Guaranteed	Not guaranteed	Guaranteed
Risk	The insured	The insurer	The insured	The insurer
Performance	Based on Separate Account	Based on General Account	Based on Separate Account	Based on General Account
Laws	State and Federal	State	State and Federal	State

Investment Risks

If the portfolio of securities performs well then the separate account performs well and the variable contract, backed by the separate account, will also do well. Thus, it can be said, that the performance of the variable contract depends on the performance of the separate account. Due to this fact, there is investment risk to the policyholder or annuitant since there is no guarantee of principal, interest or investment income associated with the separate account. The securities held in the separate account are valued each business day at the close of the New York Stock Exchange.

Due to the element of investment risk, the federal government considers variable contracts to be securities subject to regulation by the Securities and Exchange Commission (SEC), the National Association of Securities Dealers (NASD) and other federal bodies. Federal laws require that you have a mandatory 45 day free-look provision

from the date you apply for the policy. Also, variable life policy owners have voting rights (one vote for each $100 of cash value), and must be permitted to convert to traditional whole life insurance within 24 months of policy issuance.

Variable life insurance is also regulated by state insurance departments as an insurance product. Agents selling variable life products must be registered with the NASD by passing the appropriate licensing exam (usually Series 6 or Series 7), and must also be licensed on a state level to sell life insurance. If your life insurance agent is not licensed to sell variable products, you may be missing out on some important investment options.

Variable Life Policies Differ

There are basically two types of variable life insurance: scheduled premium variable life and flexible premium variable life.

Scheduled premium variable life requires a periodic level premium be paid to keep the policy in force. Because a specific premium will be paid, this type of variable life provides a guaranteed minimum death benefit equal to the initial face amount of the policy. An additional death benefit may be paid depending on the performance of the policy's separate account. However, the policy owner is guaranteed a minimum death benefit regardless of the performance of the separate account.

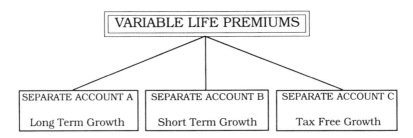

The cash value of the scheduled premium variable life policy is not guaranteed. The values depend completely upon the performance of the separate account. Because of this, cash value loans are usually limited to 75 percent of the policy's available cash value. In most other respects, the scheduled premium variable life contract is very similar to traditional whole life.

Scheduled Premium Variable Life Policy

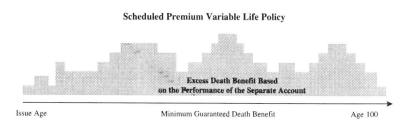

Excess Death Benefit Based
on the Performance of the Separate Account

Issue Age Minimum Guaranteed Death Benefit Age 100

Flexible premium variable life is basically variable universal life (described below). It provides the flexibility of universal life and the hedge against inflation of variable life. Although, flexible premium variable life may provide a minimum guaranteed death benefit, most often there is no guarantee of death benefit or cash values.

The performance of the policy is solely based on the performance of the separate account. There is usually no guaranteed death benefit because policyholders are allowed to pay flexible premium amounts each month. It is impossible to provide a guaranteed death benefit when the amount of premium to be paid is unknown. Thus, the principal difference between scheduled and flexible premium variable life is the method and amount of premiums paid.

	SCHEDULED PREMIUM VARIABLE LIFE	FLEXIBLE PREMIUM VARIABLE LIFE
PREMIUM	Scheduled	Flexible
DEATH BENEFIT	Minimum Guaranteed	Usually Not Guaranteed
CASH VALUE	Not Guaranteed	Not Guaranteed
RISK	The Insured	The Insured
PERFORMANCE	Based on the Separate Account	Based on the Separate Account

Universal Life Insurance

Universal life policies are incredibly flexible. Premium payments can be skipped, you can increase or decrease the face amount, lengthen or shorten the protection period, increase or decrease the premiums, change the premium paying period, and contribute or withdraw lump sums. Like variable life, universal life insurance is more risky for you, because the principal is at risk as well as the interest or dividends earned on the principal.

Universal life is basically a whole life policy divided into its two components—death protection and cash value. The death protection takes the form of one-year renewable term insurance and the cash value account earns current interest rates.

For example, assume that your universal life premium is $1,000 annually for $100,000 of coverage. When the premium is paid, an amount necessary to provide one-year renewable term coverage is used to cover the death protection element of the policy. The balance is "deposited" into the cash account where it earns interest, at rates more competitive and more current than the guaranteed interest rates associated with whole life.

There are two interest rates "inside" a universal life policy — the current year guaranteed rate and the contract rate. The current guaranteed rate is the annual rate which reflects current market conditions and can change every year. The contract rate is the minimum interest rate which the policy guarantees will be paid.

For example, the policy's guaranteed rate may be five percent. This amount would be credited to the cash account, even if the current year's rate fell below five percent.

When you sign up for a universal life policy, you will be asked to select "Option A" where the cash value is incorporated as part of the death benefit, or "Option B" where the cash value is paid in addition to the death benefit. Over time, Option A is the one that will yield the highest cash value, and is most likely your best choice.

Many universal life policies also permit a partial withdrawal or surrender from the cash account. This is not treated as a loan. A partial surrender is not subject to any interest, but will reduce the total cash value in the account.

Universal life sales were popular in the 1980s, but have fallen along with interest rates, and many people have gone back to the "safety" of guaranteed cash values by buying whole life insurance.

Whole life insurance sales are much more profitable to insurance companies than sales of flexible policies. While this idea may appeal to you, don't forget you are taking on investment risk when you buy variable policies.

Universal Policies Continue to Sell

Many insurance companies still champion universal life and create new products based on it. In a 1991 story that appeared in an insurance industry trade magazine, executives at Missouri-based Kansas City Life said they wanted to make universal life insurance easy for seniors to buy—easy, in the sense that it could be issued on a non-medical basis.

The company designed a universal plan for people ages 50 to 80 that allowed policies with specified amounts of $10,000 to $24,999 to be issued on a non-medical basis, as long as the policyholder has been "seen" by a physician within the last 36 months. The purpose of the non-med approach was so that seniors don't have to go through a medical exam in order to get lower-limit insurance. Kansas City Life kept the non-medical limit to face amounts of $25,000 or less in order to target buyers who needed minor boosts in their coverage. The policy was designed to appeal to those who want life insurance for final expense

needs—this would be a more-reputable version of pre-need funeral insurance.

The death benefit could be increased or decreased at any time. Optional riders: term insurance for spouse and children, cost of living, accidental death benefit and disability continuance of insurance (this waives the cost-of-insurance and other expenses of the policy if the insured person is disabled).

The policy, called "Protector 50," was approved quickly by most states. It carried a 15-year back-end load (load refers to how the insurance company recoups its administrative expenses). At current interest rates, the policy earned 8.0 percent—and had a guaranteed minimum interest rate of 4.5 percent. The net policy loan interest rate was 2.5 percent, but starting in year 11, policy owners can borrow the accumulated interest at zero net cost.

A Good Example of a Bad Practice

The Minnesota court of appeals considered a shady use of universal life insurance in its 1991 decision *In re: Insurance Agents' Licenses of David Kane and Michael Pohl.*

David Kane had been licensed for over 25 years as an insurance agent in Minnesota. In late 1986, Kane formed Financial Benefits, a managing general agency for insurance companies.

In 1987, Kane approached Western States Life Insurance Company about marketing a product called the "Senior Security Policy," (SSP) which Kane had been successfully marketing for another insurance company. SSP was a universal life insurance policy targeted for senior citizens. Policy costs include service charges of 7.5 percent of each premium, monthly policy fees of $4.50 and monthly mortality charges.

Kane and Financial Benefits entered into a managing general agent agreement with Western States, which provided that Kane would recruit, train, and supervise sales agents. The agents signed independent contractor agreements with Western States; there were no written contracts between the agents and either Kane or Financial Benefits.

Kane recruited Michael Pohl, who'd been licensed in Minnesota since 1984, as an agent to sell SSP for Western States. Pohl signed the independent contractor agreement with Western States.

During 1988, Pohl sold 29 SSPs to Minnesota senior citizens. The sales were initiated by a general mailing of "lead materials" to senior citizens. Although the lead materials mentioned insurance, they also referred in large type to "Federal Estate Tax Information."

After receiving responses from the lead materials, Pohl called on prospective clients in their homes and used the sales presentation he had learned at Kane's seminar. The written materials Pohl used in his presentation had been approved by Western States—they emphasized federal estate taxes and estate planning. Life insurance was not mentioned until page 47 of the materials.

The written materials included documents referring to state inheritance taxes and federal estate taxes and costs. Pohl was aware that Minnesota did not have a state inheritance tax. In addition, the materials did not reflect application of unified credit laws, so estate taxes were indicated as payable for small estates. Pohl knew at the time of each sale that none of his clients had a current estate tax liability.

No Explanation of Costs

When Pohl received an application for an SSP, he left behind with the client a brochure explaining the 7.5 percent premium deduction, the $4.50 policy fee deduction and the mortality cost deduction. Pohl did not explain these costs in his initial presentation.

In the summer of 1988, the Minnesota Department of Insurance became concerned about the marketing and sale of SSPs. After discussing its concerns with Western States and contacting some of Pohl's clients, the Department mailed a letter to 29 Western States policyholders. The letter stated that "numerous phone calls" had been received by individuals "evidencing considerable misunderstanding with respect to the content and/or structure of [SSP] policies."

Sensing they were probably in trouble with the regulators, Western States also mailed a letter to the 29 policyholders, offering them the opportunity to return their SSPs for a full refund if they did not understand the costs involved. Several of the policyholders chose the refund.

The Insurance Department proceeded with disciplinary actions against Kane and Pohl, alleging violations of state guidelines for the sale of life insurance. An administrative law judge heard testimony by several experts as well as 11 of Pohl's policyholders who had subsequently requested refunds. At the close of the hearing, the judge found that Kane, Pohl and Financial Benefits had misrepresented SSPs and misled prospective purchasers into believing that they were buying "savings" or "investment plans."

Seven senior citizens had testified at the hearing that they were not told or did not know about the policy charges. Four testified that they believed all of their premiums would earn interest.

The judge also found that Pohl failed to reveal the insurance policy costs until after the purchases had been made and that the sales materials Pohl used were false and misleading because they implied that, if the senior citizens didn't purchase the SSPs, they would be subject to state inheritance and federal estate taxes.

The Insurance Department revoked the insurance licenses of Kane, Pohl and Financial Benefits. They appealed, arguing that Pohl was an independent contractor for Western States—rather than an agent of Kane and Financial Benefits.

But Kane had the authority from Western States to supervise Pohl and other agents. Pohl testified that someone from Kane's office witnessed about a dozen of his sales presentations. Kane testified that a sales manager went with Pohl for a week and reported that Pohl had done a good job. Finally, Kane's managing general agent contract with Western States consistently referred to the "GA's agents." This contract also provided that Kane would hold Western States harmless for Pohl's acts.

For these reasons, the appeals court concluded that the Insurance Department had been right to find an agency relationship existed between Pohl and Financial Benefits. It upheld essentially all of the regulators' conclusions, citing Minnesota Department of Insurance rules that provide:

"It is unfair and deceptive to use the terms 'investment,' 'investment plan,' 'expansion plan,' 'profit,' 'profit-sharing,' and other similar terms in connection with life insurance policies,...in a context or under such circum-

stances or conditions as to have a capacity or tendency to mislead a purchaser or prospective purchaser of such policy or contract to believe that he will receive, or that it is possible that he will receive, something other than a life insurance policy...."

The appeals court upheld the administrative law judge's findings, though it did recommend reducing the penalties against Kane and Pohl from license revocation to temporary suspension and an agreement to refrain from using misleading marketing materials.

Variable Universal Life

Variable universal life insurance is a combination of variable life insurance and universal life insurance. It offers what are considered the best features of both products.

The policy is variable in that the benefits vary according to the investments backing the contract. Many companies allow you to choose the type of investments you want, and will often permit you to switch from one investment to another. Eligible investments include stocks, bonds, mutual funds, precious metals, diamonds, real estate in various forms, stamps, coins, or art objects.

The policy is universal in that it offers flexible premium, an adjustable benefit, term or endowment insurance, and tax-deferred savings.

The flexible premium feature allows you to choose the amount of your premium payment. The life insurance benefit will be whatever the premium paid will purchase.

The adjustable feature allows the policyholder to change the amount of life insurance in force. The premium payment will then become the amount needed to provide that benefit. The premium payment amount, or the benefit amount, or both, depend on the performance of the stock portfolio backing the contract.

The term feature provides the policyholder with adequate life insurance protection at a low cost. The endowment feature provides retirement income, or funds for the children's education. It also provides the policyholder with money to get started in business. Only the funds which exceed the total amount of premium paid is taxable as income, and only at the time that the funds are actually withdrawn.

Your Rights in Life Policies

Ownership Rights

The owner of a life insurance policy is entitled to certain valuable rights. These include the right to assign or transfer the policy, and the right to select and change the payment schedule, beneficiary and settlement option. The owner also has the right to receive cash values and dividends and the right to borrow from the cash values. As previously discussed the owner and the policyholder may be two different parties, something to consider when assigning ownership of your policy to someone else.

Grace Period

You have a grace period of 30 or 31 days from the premium due date in which to make a premium payment. During the grace period coverage continues in force. This is to protect your beneficiaries if you happen to die during this period since the death benefit remains payable. Any premium due to cover the grace period extension would be deducted from the final settlement. The purpose of this provision is to protect you from unintentionally allowing your policy to lapse. Without this provision, if your payment was even one day late, benefits could be denied and technically you might have to furnish evidence of insurability to continue coverage.

Incontestability

In this clause, the insurance company agrees not to deny a claim for payment of benefits based on any error, concealment, misstatement or even fraud, on your part after the policy has been in effect a certain length of time, usually two years.

This makes the insurance contract a little different from other types of contracts. Usually, if a fraudulent contract has been enacted, it may be voided or canceled at any time. The incontestable period limits the period of time in which the insurer may contest the insurance contract as to any misrepresentations or fraud on your part. One of the dangers of purchasing new life insurance, or replacing an older policy with a newer policy, is that you will be subject to a new incontestability period.

Entire Contract and Representations

This clause says the policy, together with the attached application, constitutes the entire contract. This provi-

sion limits the use of evidence other than the contract and the attached application in any test of the contract's validity.

In addition, this provision specifies that the agent cannot alter or change the policy. Only insurance company officers have the authority to change or amend the insurance contract. Beware of any agent who offers to modify your policy language, change your beneficiaries, or extend the amount of time you have to pay your premiums. Policy changes or modifications must be in writing, signed and acknowledged by you, and signed by a company official (*not* your agent). These signed and witnessed changes are attached to your policy and become part of the legal contract between you and the insurer.

Policy Change Provision (Conversion Option)

Your policy may contain a provision which permits you to exchange a policy for another type of policy form. This exchange is usually made from one policy type to another policy form with the same face amount.

If the exchange is to a policy with a higher premium, then you just have to pay the higher premium and no proof of insurability would be required. If the exchange is to a policy form with a lower premium, then proof of insurability may be required to protect the insurance company.

For example, if Charlie discovers that he only has six months to live, then he might decide to exchange his higher premium whole life contract for one-year term insurance with the same face amount but a lower premium. The insurer's risk has increased while its premium income has decreased. Thus, Charlie will have to prove insurability.

Your Life Insurance Company's Rights

Medical Examinations and Autopsy

Some life insurance policies include a provision giving the insurer the right at its own expense to conduct a medical examination of the policyholder as often as reasonably required when a claim is pending, and to make an autopsy in case of death (where not forbidden by law). This can come as a shock (and outrage) to family members who are unaware of this provision when, for example, the insurance company insists on conducting an autopsy.

Policy Modifications

The insurance company, and only the insurance company, has the right to make or approve modifications or changes in your policy, or any agreement in connection with the policy (such as changes in the beneficiaries, face amount, or additional coverage). Changes must be in writing and must be endorsed on or attached to the policy and include the signature of a specified officer or officers of the company. Some modification clauses also specifically state that no agent has the right to waive policy provisions, make alterations or agreements, extend the time for payments of premiums, or make any promise which is not already contained in the policy.

Options for Policies You Already Own

Depending on the kinds of life insurance policies you already own, you may want to cash in a policy in return for a regular monthly income, convert the policy to another form of insurance, take a policy loan on the cash value, assign ownership of a policy to a third party, make changes in beneficiary designations, and/or replace one policy with another.

Most of these options apply to forms of permanent life insurance such as whole life. If you own term policies your options are more limited; you might be able to convert to a form of permanent insurance, or you might just keep paying the premium and keep the extra protection until the end of the term period.

Life policies with cash value have nonforfeiture provisions designed to protect you against losing all your benefits when you stop paying premiums. If a policy has no cash value (such as term insurance), then there are no nonforfeiture values.

The following are common nonforfeiture options in cash value policies.

Cash Surrender Value

The cash value of a life insurance policy is the amount you are entitled to when the policy is surrendered before maturity. The minimum cash value is determined by a formula established by law. A portion of each premium paid is allocated to the policy reserve which is a fixed liability of the insurance company. The balance of the pre-

mium is used to cover certain expenses (acquisition costs, administrative expenses, agents' commission, etc). In the early years of the policy (the first two or three), all of the premium is used for the reserve requirement and other liabilities and expenses. The life insurance contract is a heavily loaded with these expenses in the beginning; thus, there is no cash value in the early years of the policy.

Usually by about the third year of the policy, these initial expenses are covered and the policy's guaranteed cash value begins to grow. As the cash value grows, the nonforfeiture values grow, too. You may elect to "cash in" the policy, or surrender it for its available cash. The longer the policy is in force, the higher is the cash surrender or loan value and the higher are the other nonforfeiture values.

Extended Term Insurance

If you fail to select a nonforfeiture option, the company will usually apply your cash surrender value (plus dividends and interest, minus any outstanding loans) to issue term insurance in the same face amount as your current policy, for however long the cash value will pay the new policy premium. It is obviously to the insurance company's advantage to do this; changing your permanent contract to a temporary (term) contract.

However, unlike the cash surrender option which leaves you with no life insurance, this option provides you with the full face amount of the policy for a specified period of time and of course, no further premium payments are required.

Reduced Paid-Up Insurance

In this situation, the cash value of the policy is used as a single premium to provide life insurance on the same plan as the current policy itself, for as large an amount as the cash value will purchase at your current age. The purchase is on a single premium basis and the insurance purchased is fully paid up. You end up with the same plan of insurance but in a reduced face amount. As a "new" single premium policy, this reduced paid up contract will also begin to grow in cash value over the life of the policy.

Under the paid-up option, a reduced amount of insurance remains in force for the duration of the policy period. Under the extended term option, the full amount remains in force for a reduced amount of time.

Sample Table of Guaranteed Nonforfeiture Values

End of Policy Year	Cash Surrender Or Loan Value	Reduced Paid-Up Insurance	Extended Term Insurance Years	Days
1	$.00	$ 0	0	0
2	.00	0	0	0
3	641.00	3,658	2	169
4	1,632.00	8,927	5	312
5	2,659.00	13,944	8	246
6	3,727.00	18,741	11	4
7	4,832.00	23,304	12	316
8	5,978.00	27,656	14	116
9	7,165.00	31,803	15	174
10	8,395.00	35,759	16	146
11	9,657.00	39,483	17	40
12	10,965.00	43,042	17	236
13	12,320.00	46,442	18	18
14	13,727.00	49,705	18	123
15	15,183.00	52,822	18	197
16	16,691.00	55,807	18	244
17	18,251.00	58,666	18	268
18	19,860.00	61,397	18	271
19	21,519.00	64,010	18	256
20	23,225.00	66,506	18	222
25	31,461.00	75,080	17	29
27	34,993.00	77,940	16	124
30	40,464.00	81,688	15	59
35	49,800.00	86,687	13	42

Automatic Premium Loan

Although not part of the policy's nonforfeiture values or options, the automatic premium loan (APL) option or provision is discussed here because it too is related to the policy's available cash value.

This option, which you would usually select at the time you apply for new life insurance, provides that in case of a possible policy lapse, the premium will be automatically paid from the contract's guaranteed cash value. This option protects you from unintentionally allowing your

policy to lapse. There is no charge for this option as the premium is being paid by the policy's cash value.

Of course, since this the automatic premium loan depends on guaranteed cash values, it is not available with term insurance as term does not have cash value.

Reinstatement

If you have allowed a policy to lapse by not paying the premium, you may have three to five years to apply for reinstatement of your policy.

Usually you will have to request reinstatement in writing, submit evidence of continued insurability, and pay all back premiums plus interest. In addition, any outstanding loans or other indebtedness against the policy will have to be paid.

The insurer can decline your request for reinstatement if you cannot prove insurability. Any statements made on the reinstatement application are subject to a new incontestable period (usually two years). Normally, the reinstatement request will be approved.

Why reinstate an older, lapsed policy? If it has not been in force for some time, you might think it is better to simply purchase a new policy rather than pay back premiums plus interest to reinstate a lapsed policy. However, there are several reasons for considering reinstatement. These include:

- the lapsed policy may have more liberal policy provisions;

- the older policy may offer lower interest rates on policy loans;

- suicide and incontestable clauses probably will no longer apply if the policy is three years old or older;

- the lapsed policy probably has a lower premium than a new policy.

This last point is especially true if you purchased the lapsed policy ten or 15 years ago. Instead of paying premiums for a new policy which will be based on your current age, you can reinstate the lapsed policy at the rate you were charged when the policy was originally issued.

Taking Out a Policy Loan

After a cash value policy has been in force for a specified period of time (usually three years), it must contain cash value which you are entitled to borrow. You may use this money as you would money in a savings account, but you are responsible for paying interest (typically, six to eight percent).

Why do you have to pay interest if you are lending money to yourself? The cash value accumulation the insurance company has guaranteed to you depends on the interest your money earns while being held by the insurer. If you have withdrawn cash value, the insurance company can only meet its obligation to you by charging you interest. The amount of money which may be borrowed is the current cash value less any outstanding and unpaid policy loans.

If the loan amount and interest due are not paid, these amounts will be deducted from the death benefit if you die before the loan is repaid.

Joe requests a $5,000 policy loan against the cash value accumulated in a $100,000 whole life policy, and then dies before repaying the loan. At the time of death interest in the amount of $125 had accrued on the loan. The beneficiary would therefore receive a death benefit of $94,875

Most of the time, after the policy has been in effect a certain number of years, if you fail to repay the loan or pay the interest, the policy cannot be voided until the total amount of the loan plus interest equals or exceeds the policy's cash value, and even then the insurer must mail you 30 days notice of pending cancellation and give you a chance to repay the loan and keep the policy in force.

The insurer has the right to defer your loan request for up to six months unless the reason for the loan is to pay premiums due.

Even if you have to pay interest, when you take a policy loan, any income tax is deferred to a later date, and if death occurs before the loan is paid back, no tax is due at all.

Assigning the Policy to Another Person

As the owner of a life insurance policy you are entitled to certain valuable rights. One of these is the right to assign

or transfer the policy to another person. You can transfer or assign all or any portion of the rights of ownership of an insurance policy to another person. This can be accomplished by sending a written request to the insurance company.

There are two types of assignment. Absolute assignment gives the assignee every right in the policy you possessed before the assignment—all "incidents of ownership" are transferred. Any assignment is subject to debts owed to the insurance company. Upon the completion of an absolute assignment, you retain no ownership interest whatsoever.

A more limited type of assignment, collateral assignment, is used to provide security (collateral) for a transaction such as a loan. For example, you may make a collateral assignment of your life policy as security for a loan. In this case, only some of your ownership rights are transferred, usually temporarily. Once the obligation is satisfied, full ownership reverts back to you. During the assignment period, you retain the right to designate the beneficiary of the policy, but you could not cash in the policy or otherwise impair the security arrangement of the collateral assignment.

Often, assigning ownership to a third party offers a tax advantage. Life insurance death benefits are generally received by the beneficiary free of federal income tax but the proceeds are included in your gross estate for federal estate tax purposes. If you do not own the policy on your life, then the proceeds would not be included in your estate, thereby reducing the federal estate tax liability.

You may also have considered exchanging your life insurance policy in return for an immediate, reduced cash amount. Viatical companies surfaced in the 1980s, offering discounted, cash amounts of, say $75,000 in return for a policy with a $100,000 death benefit. While it might be tempting to assign your policy in such a manner, especially in the event of a catastrophic illness, such assignments can be to your extreme disadvantage (especially with regard to taxation). Usually your insurance company can offer you better terms through accelerated benefit products. Accelerated benefits allow the prepayment of your death benefits if, for example, you have been diagnosed with a terminal illness.

Changing Beneficiary Designations

Almost all life insurance beneficiary designations are revocable or changeable unless you have specifically given up that right.

An irrevocable beneficiary designation cannot be changed without the consent of the beneficiary. These are rare, but might be used when a court orders a husband in a divorce settlement to continue payment on an insurance policy on his own life, with an irrevocable beneficiary designation on behalf of his wife (the primary beneficiary), and his children (the contingent beneficiaries).

In order to change your beneficiary, the insurance company may just require a written notice so it can record the change in its records. Or, the insurance company may require that you mail in your written request along with the policy, so that the change is made directly to the policy.

There are many reasons to change beneficiary designations you made earlier in life. Couples get divorced, remarry, and sometimes beneficiaries die before you do. Failing to change your beneficiary designations when major changes occur can lead to unintended results.

Consider this scenario:

When Ted and Jane married, they took out life insurance policies and each spouse was named as the beneficiary under the policy on the other spouse's life. When they divorced a few years later, there was no legal need to change the beneficiary on these policies. Both remarried and Jane changed her policy to show her new husband as the beneficiary, but Ted failed to do so. If Ted dies, his ex-wife Jane is entitled to his life insurance proceeds and Ted's current wife would not receive any benefit.

Preferably, there would be a change in ownership rights, or beneficiary designations, or both, or the policies will be surrendered when a marriage terminates. If there are children from the marriage, ownership rights might be transferred to the children or the children may be designated as new beneficiaries. If there are no children, the policies would probably be surrendered, because people generally don't continue to pay life insurance premiums when financial and emotional interest in an insured person has ceased.

As you can see, it is important to keep beneficiary designations up-to-date as situations change. It is also important to understand the rights associated with a beneficiary designation, and how the type of designation made may affect the payment of life insurance proceeds.

A beneficiary is not required to have an insurable interest, but often does. A person is presumed to have an insurable interest in his or her own life, and in the life of a close blood relative or a spouse. Insurable interest can also be based on a financial loss that will take place if an insured person dies. For life insurance, insurable interest must exist at the time of the application for insurance, but it need not exist at the time of the policyholder's death. There is no need to change a beneficiary designation if the original family relationship changes, but you may want to anyway.

If you decide to change your beneficiary, be sure to read the section on the importance of clearly naming beneficiaries. The wording you use in your written request is critical, and if not done carefully, you can accidentally disinherit your loved ones. Your insurance agent can help you with the wording.

Understanding Settlement Options

Your policy's benefits will be paid to your beneficiary or beneficiaries upon your death, or to you if you surrender a cash value policy or survive an endowment period. Who makes the choice? You do.

Actually, you may designate the settlement mode, or you may leave the decision to your beneficiary. If you haven't made a choice prior to your death, the beneficiary will be allowed to choose. In any case, you should fully understand all the settlement modes before making your decision. Usually, once you decide and benefit payments begin, no changes are possible.

The usual life insurance policy is written as an agreement to pay a stated sum in cash on the death of the policyholder. However, beneficiaries often prefer a stream of future payments rather than a large lump sum of money. Similarly, if you retire and decide to cash in your policy, you probably would like a steady, guaranteed income rather than a lump sum of cash.

Although other options may be available, the five most frequently used settlement options are:

- interest only,
- fixed-period installments,
- fixed-amount installments,
- life income,
- joint and survivor.

Selecting a settlement option frees you from investment concerns. If a beneficiary elects a lump sum settlement of the death benefit, then he or she must decide how to use or invest the money. In essence, by electing a settlement option other than a lump sum, the beneficiary is trusting in the expertise and knowledge of the insurance company to administer these proceeds and provide some form of income.

Another advantage of settlement options is the fact that any of the options will guarantee a greater return than simply taking the face amount of the policy. A $100,000 policy will generate a greater death benefit than $100,000 if these proceeds, consisting of principal and interest, are paid to a beneficiary over a period of time. For example, if a beneficiary elected an interest only option, he or she would receive interest payments over a period of time and then possibly at some future date, the principal. This could result in a total sum of money many times greater than just the face amount of the policy.

One other note: if benefits come due while there is a loan against the policy, the loan plus any accrued interest will be deducted from the pay out.

Interest Only

Under this option, the proceeds are held by the insurance company, and the interest earned on the proceeds is paid to your beneficiary at least annually. The minimum interest rate that will be paid is guaranteed in the policy. Usually the policy also provides that if the company earns interest in excess of the minimum guaranteed, it will pay excess interest on the proceeds, usually on an installment basis.

You may specify that no part of the principal is ever to be paid to the beneficiary but that it will be paid to a con-

tingent beneficiary on the death of the primary beneficiary, or to your estate.

On the other hand, you may specify that the beneficiary may withdraw the principal in whole or in part or elect another option in the policy. You may also specify that the proceeds will remain on an interest only basis for a stated period of time or to a stated date and then be paid in cash or under one of the other options.

Fixed-Period Installments

This option is also referred to as "installments certain" and the "time option." The proceeds are retained by the insurer and paid in equal installments over a specified period of months or years. Payments are made up of both principal and interest, and continue without regard to the length of life of the primary beneficiary. If the primary beneficiary dies, they are continued to the contingent beneficiary as long as the payments last. If no contingent beneficiary is surviving, or none were named, the commuted value (an amount reflecting the current value of a number of payments) of the remaining payments is paid to the estate of the last beneficiary. The amount of each installment will be increased by any excess interest earned.

Fixed-Amount Installments

This option is also known as the "amount option" and sometimes, "principal and interest to exhaustion." It calls for the payment of a fixed, periodic (annual, semiannual, quarterly, monthly) benefit of a predetermined amount until the proceeds (principal and interest) are exhausted. The size of each installment determines the duration of the payments in contrast to the fixed-period option where the length of the income period selected determines the size of the installment. Excess interest will increase the duration rather than the size of the installment. Fractional amounts are paid in full with the last full installment.

Life Income

Under the life income option, the proceeds are retained by the insurer and paid in equal installments (monthly, quarterly, semiannually, or annually) as long as the beneficiary lives, even if the total paid exceeds the amount of principal plus interest. When a life income only option is elected, there is no refund when the beneficiary dies even if only one installment has been paid. Beneficiaries who

do not live to draw all their proceeds make it possible to continue payments to those who outlive their proceeds and the interest earned on them. The benefits are calculated on a basis of the beneficiary's life expectancy at the time payments begin. The older the beneficiary at the beginning of the payment period the larger the payments will be.

When this option is used to settle a death claim, the face value becomes the principal. When it is used to provide income for a living policyholder, the cash or endowment value becomes the principal.

The greatest risk with a "life income only" option is that premature death will end all benefits, even if only a small portion of the principal has been received, and any principal which has not been paid out will be lost. To reduce or eliminate this risk, many recipients want to have payments guaranteed for a specified period of time. This can be arranged by electing a life income with period certain option.

Under this option, the benefits are guaranteed for a "period certain" (usually five, ten, or 20 years). If the primary recipient dies before the end of the period certain, benefits will continue to be paid to another person for the remainder of the period certain (or the commuted value may be paid to the estate of the policyholder or last beneficiary to die). If the original recipient lives beyond the period certain, the benefit payments continue for as long as he or she lives. However, the longer the period certain, the smaller the benefit payments.

Joint and Survivor

Some policies contain a joint and survivor option. Most companies that do not include it in the contract will grant it as a special settlement agreement. This option can be used to provide for two beneficiaries upon the death of the policyholder. Under this mode of settlement, two beneficiaries receive the proceeds of a life insurance policy. When the first beneficiary dies, the second beneficiary (if he or she is still living) continues to receive the proceeds of the policy, in installments, for his or her lifetime (or for a specified period).

The option can also be written as "joint and two-thirds" survivor, "joint and one-half" survivor, or with other reduced installment methods. Under the "joint and two-thirds" survivor option, the income for the survivor of the

two recipients is two-thirds of the amount paid while both were still alive.

Survivorship Issues

Survivorship has become a key issue in estate planning for most married couples in their fifties or older. It directs tax liabilities on the second death by keeping assets out of the estate of the first to die. Because it spreads the mortality risk over two lives, the cost for this insurance is substantially lower than the cost of providing the same coverage on either one of the two lives.

Second-to-die policies cost significantly less than those for conventional whole life insurance or individual term life insurance. The proceeds become available at the second death when liquidity concerns or other financial needs may become pressing as a result of estate tax and estate settlement costs.

Usually, the costs of this kind of insurance are much less than the three most common alternatives: liquidating assets that may subject the estate to income tax; a forced sale of prime holdings under fire-sale terms; and borrowing funds and then paying back principal plus interest.

Second-to-die insurance is a long-term instrument. Therefore, it is critical to consider the financial wherewithal of insurance companies when reviewing their offering literature.

Some companies in this market make projections that have little or no basis in reality. Some companies that sell second-to-die insurance illustrate interest credits which, with no explanation, start at one rate and then increase in later years. Others assume mortality costs will remain completely flat beyond age 85 on the theory that 95-year-olds die at the same rate as 85-year-olds. Yet others assume continuing improvement of their current actual mortality experience (i.e., people will stop dying so quickly).

How Life Insurance Rates Are Made

There are three primary components to an insurance projection:rate of dividends to be credited as earnings to the policy; mortality risk rate charged based on death assumptions; and expense rate charge for costs of administering the policy.

Each component must be analyzed individually. Although these components appear straightforward, their pattern varies from company to company.

In evaluating the companies, you should consider the degree that the insurer's assumptions vary from its experience. Also, be aware that these policies—like most that appeal to older people—concentrate certain kinds of risks.

Buyers of second-to-die policies are usually older than most other insurance purchasers. The policy size is, by the nature of the need, much larger. Performance of the policy depends on so many factors outside the purchaser's control that the more departures from the assumptions that can be evaluated, the better. The ability of a product to withstand a downturn in interest, increased mortality, or an early death will determine the product's quality.

Extra quality costs money up front. But the lack of quality has a cost that will be paid at a later date, possibly at a time when the damage cannot be reversed. If your goal is to retain family wealth accumulated over a long term and to care for surviving heirs, you should consider a higher premium a reasonable cost.

Remember: the annual premium is not the policy's cost. You can't know a policy cost until the death claim is paid or the policy is surrendered. So the comparison between a policy that has a low premium and one that has a higher premium depends on the death benefit that develops and on how long that premium has to be paid, as well as what happens if interest rates drop or mortality experience changes adversely over the life of the policy.

Vanishing Premiums

Most people think the feature of a vanishing premium is attractive. They like the fact that at some future point, the internal build-up of values will offset the annual premium resulting in no more out-of-pocket payments. But most people have never really considered the true reason it is so attractive.

A vanishing premium is possible because there are dividends. A major component in the dividend is the return of investment income in excess of what is guaranteed by the

contract. In other words, if there's no excess interest, the premium will never vanish.

A procedure used by some insurers to accelerate the point at which the premium vanishes is to pay the premium by borrowing against the cash values. However, the internal borrowing may not be apparent in a projection. A way to spot internal borrowing is to compare guaranteed cash value with actual cash value. Because the internal borrowing will have reduced the actual cash values, they will be lower than the guaranteed amount. If you see that, request an expanded projection that considers all borrowings.

There are companies that make aggressive projections using the current dividend scale and the assumption that both policyholders live forever. Unfortunately, that's only true in the world of projections. You should demand real-life assumptions by requesting projections that show how the contract operates when the first death occurs in years one, five and ten.

In addition to knowing whether the insurer is capable of delivering a check at the second death, it is important to recognize additional characteristics of the second-to-die policy:

- In the event of a divorce, what happens to a policy that insures both husband and wife?

- In the event of a repeal of the Unlimited Marital Deduction or a substantial decrease in estate tax rates, what happens to a policy that insures both husband and wife?

- Does the insurance company pay the same dividend interest rate to all policy owners regardless of when the policy was purchased? Or does the company throw old policyholders to the wolves in the race for sales volume?

- Does every policyholder who buys today automatically become an old policy owner at some point?

If a second-to-die policy needs to be changed to a single life policy, or if the property must be distributed in a divorce, the only option is surrender of the contract. There is no tax-free exchange available, because there can be no "like to like" exchange. If the policy is surrendered, there is either a gain or a loss; gain means taxes will be due. If new insurance is needed, the policyholder will have to

requalify at attained age and health. At best, purchasers will have to pay a higher premium because they're older, and have to pay acquisition costs again. At worst, they won't be able to buy life insurance.

Some second-to-die policies have a so-called "Split Option" feature. This permits a policy to be split into two individual policies, retroactive to date of issue. But not all companies have the same provisions in event of divorce or changes in the estate tax law.

Settlement Arrangements

Many policies are written with no provision for any special arrangements in the settlement of proceeds. However, many companies will permit other settlement arrangements. Special settlement arrangements are sometimes desirable in order to accomplish the estate planning objectives of some policyholders, and insurance companies will cooperate with almost any arrangement that is reasonable. Whatever plan is selected, however, it must be structured so it can be administered by the insurance company according to proper actuarial principles. In other words, any installments received under the special arrangement must be the actuarial equivalent of the other settlement options available under the contract.

Insurance companies often have rules to avoid arrangements which are uneconomical to administer. For example, a company may require a minimum of $1,000 or $2,000 in order to offer a settlement option. If the amount is smaller, they may just issue a check for the lump sum. The company may also prescribe minimum installments payable and may set a time limit for holding proceeds at interest, such as for the lifetime of the primary beneficiary or contingent beneficiary.

Relevant Life Insurance Policy Riders

A life insurance policy rider is an addition to the contract that either adds benefits or takes them away (usually resulting in a premium reduction). There are good reasons to select certain riders when you first buy a policy, and to add riders later as they become available or make sense in light of your changing insurance profile. The function of riders in life insurance is identical to that of endorsements in homeowners and automobile insurance.

Just as riders enhance the value of insurance products for clients, they also add value for companies and agents. By offering riders, companies gain additional sales options-options that will help them keep existing business in force. And agents, in designing insurance programs for their clients, are not restricted by rigid product offerings. Taken together, these enhancements combine to serve the client, the company and the agents.

Middle-aged people in their peak earning years think ahead toward retirement and must plan a future stream of income and a financial strategy to fight inflation. Retired people, who need asset liquidity, insure themselves against costly liability, catastrophic illness and tax burdens on their estates.

Permanent insurance offers comprehensive insurance protection and accumulation of equity. But while permanent life insurance may be desirable as part of most people's financial portfolios, riders are the vehicle that enable agents to offer highly tailored insurance programs, making permanent life insurance a better overall value.

Advances in information technology have encouraged insurance companies to bring new riders to market by allowing them to process increasingly complex transactions and policy features. By using computer illustrations, agents demonstrate the benefits of riders to clients in a way that was unimaginable 10 years ago. This new processing capability has increased policyholders' awareness of riders and has made riders a more important part of insurance programs.

Riders offer individual policyholders increased coverage, increased flexibility and more balanced coverage. The development of new riders builds on several traditional functions.

Increased Coverage

Riders that expand a policy's coverage generally come in two varieties: those that add other covered people (OCI riders), or those that increase the policy face amount.

OCI riders, like family riders, have been around for a long time. But term OCI riders now feature level premiums, making family coverage more attractive and cost-effective.

For families who make a long-term commitment to a policy, or need extra protection for a fixed period of time, level-premium OCI riders provide extra coverage, while stabilizing the cost of the base policy. Riders that increase an insurance policy's face amount are also available in new varieties.

A new type of term rider, usually called a decreasing-term rider, provides an increased face amount on a base whole life policy. The rider brings the coverage of the base policy up to a target face amount.

Let's say it doubles the face amount. Then, as the dividends of the base whole life policy are used to purchase paid-up additions and increase the amount of permanent insurance, the amount of additional insurance provided by the term rider steadily declines. Such a rider is useful when a customer needs a large amount of insurance but that amount of permanent insurance is out of the customer's price range.

Easier Gifting

Another type of rider, introduced a few years ago, allows the policy to accept additional premium deposits. This rider can meet the requirements of a gifting program by an individual or a trust and/or the cash-flow requirements of the premium payer. It achieves this through additional underwriting at the time of the purchase of the original policy, permitting the face amount of the policy to grow as these additional deposits are made into the contract. This rider creates valuable investment as well as insurance planning opportunities.

Estate Planning

Consider what can occur should an investment or sale of property result in an increased influx of cash flow for a few years. During this time, the policyholder can make additional deposits into the rider and accumulate enough values to offset the premium after the third or fourth year. The policyholder not only realizes increased death benefits in the earlier years, but the rates of return on cash values can be very attractive.

Another rider that offers flexible coverage is the survivorship rider, which shapes a whole life policy into a second-to-die policy. At the death of the policyholder, the designated beneficiary has the option of using the proceeds

from the original life policy to purchase a premium-paying policy on his or her own life. If the beneficiary decides to do this, then the new policy is underwritten back to the same date on which the original policy was issued. The face amount of the second policy is usually variable and can be from one to five times the face amount of the original policy.

A package of two whole life policies with survivorship riders can be structured to compete on a cost basis with a comparable second-to-die policy and can offer more flexibility at the first death. The beneficiary gains liquidity at the first death, because he or she can choose either a death benefit or a new policy. If the couple's financial needs change, a whole life policy might be better able to meet new financial challenges than a survivorship policy.

Long-Term Care Coverage

One area in which insurance companies are using new riders to offer balanced coverage is to provide accelerated death benefits (also known as living needs benefits) for many long-term care needs. These early benefits can be paid out either for nursing home care, or as cash benefits directly to policyholders who have been diagnosed as having a terminal illness. (Long-term care insurance will be discussed in greater detail in Chapter 11.)

According to a recent survey by the American Council of Life Insurance, 70 companies were offering some type of accelerated death benefit product as of October 1990, and almost 90 percent of those products had come on the market since January 1988.

An overwhelming majority—88 percent—of these accelerated benefits provisions, including long-term care and catastrophic and terminal illnesses, come in the form of policy riders, the ACLI notes. Less than 12 percent of accelerated benefits provisions are included as base policy provisions. Many of these accelerated benefits riders fill the need for a separate long-term care or catastrophic care plan, saving the policyholder money as well as providing the many benefits of permanent insurance.

This type of rider may be a separate benefit requiring payment of additional premium, or may be part of the life policy, where long-term care benefits paid out reduce the life insurance death benefit and cash value.

These benefits are usually provided without being taxed and without an early withdrawal penalty, because the payment of the death claim is imminent. Many insurers have added this rider to existing policies, at the option of the policyholder, without charging any additional premium.

Guaranteed Insurability

Although we might be too late with this advice, whenever you purchase a life insurance policy with cash value component, you should try to attach the "guaranteed insurability" rider. This way you will have the opportunity to purchase additional amounts of insurance at regular intervals without having to provide evidence of insurability.

As you get older, this may be one of the only ways to increase the amounts of life insurance you own, especially if you have developed health problems along the way. Regular option dates occur on policy anniversaries at ages 25, 28, 31, 34, 37, and 40. In addition, marriage and the birth of children between the ages of 25 and 40 also trigger additional options. It is unusual to have option dates past age 40. When you try to increase amounts of coverage after age 40, you may have to prove that your are insurable, and go through medical underwriting again.

Cost of Living Adjustments

During the high inflation years of the 1970s, policyholders became concerned that the face amounts of policies purchased would not be adequate to cover family expenses by the time the death benefit was paid. The cost of living rider changes the face amount of the policy each year by a stated percentage, such as five percent. This amount is compounded annually.

The cost of living rider may either increase or decrease the face amount of the policy, depending on that year's cost of living. There are limits on the amount the face amount can be decreased, however.

Waiver of Premium

This rider provides that if you become totally disabled, your life insurance policy premiums will be waived for the duration of your disability. This rider usually expires

when you turn 65 (which is of course when you would probably need it most). However, if a total disability occurred prior to age 65, the premiums are waived for the duration of the disability.

There is a six month waiting period before the rider's benefits are payable. This means that you must be totally disabled for six months (some insurers only require three months) and then future premiums will be waived for the duration of the disability. Once the six month waiting period has been satisfied, any premiums paid during the waiting period will also be refunded to you. This rider adds a small additional premium, usually about $1 per year per thousand dollars of insurance, and is well worth it.

Another version of this rider, Waiver of Premium with Disability Income, will pay a weekly or monthly disability income benefit in addition to waiving the life insurance premiums. This rider is somewhat more expensive.

Tax Implications of Life Insurance

Life insurance proceeds represent a great deal of money, often the bulk of a policyholder's estate, so tax considerations become very important.

Generally, life insurance proceeds are received federal income tax free if taken in a lump sum death benefit. However, life insurance proceeds are included in the deceased's gross estate for federal estate tax purposes.

If the insured person does not own the policy (if it has been assigned), then the proceeds would not be included in that person's estate—thereby possibly reducing the federal estate tax liability. The policyholder must have an insurable interest in the insured person. Life insurance proceeds are also subject to inclusion in the deceased's estate for federal estate tax purposes if the estate was the named beneficiary.

Whether the life insurance proceeds will actually be taxed in accordance with federal estate tax laws will depend on the deceased's estate situation. There are deductions and exemptions which may be applied to adjust a person's estate for tax purposes. Other estate planning techniques such as the use of trusts and gifts can also reduce the size of a person's taxable estate. The main point is that regardless of the tax consequences, the life insurance proceeds are included in the estate.

If the life insurance proceeds are taken other than in a lump sum by the beneficiary, part of the proceeds received will be tax free and part will be taxable. The basic concept is that the principal (the face amount) is returned tax free. However, the installment received is part principal and part interest. Therefore, the interest portion of the installment is taxable. All interest is taxable as income.

Life insurance proceeds may not be exempt from income taxes if the benefit payment results from a transfer for value. If the benefits are transferred under a beneficiary designation to a person in exchange for valuable consideration (whether it be money, an exchange of policies, or a promise to perform services), the proceeds would be taxable as income. This section of the tax laws is designed to prevent a tax exemption for benefits which are purchased from another party, since the intent of the transaction would be to exchange something of value for tax-free income.

Consider the following example:

A couple wants to fund their estate tax liability with a survivorship policy held in an irrevocable trust. In examining the illustration for the survivorship policy, the agent notices that the premium for the survivorship policy exceeds the couple's gift tax exclusion. The goal then is to reduce the policy premium while maintaining adequate funding for the estate tax liability. There are at least two ways to accomplish this goal.

One way is to change the base policy from a survivorship policy to a whole life policy and add a survivorship rider. The beneficiary's option to purchase an individual policy of a multiple of the face amount of the first policy allows the policyholder to carry less insurance at the start, reducing the premiums.

Another way to accomplish the same objective is to add a decreasing-term rider to the existing survivorship policy, which will also reduce the face amount of the base permanent insurance. Either of these options should help reduce premiums to within the couple's gift tax limit, while providing adequate coverage for the estate tax liability.

Taxation under the transfer of value rules does not apply to an assignment of benefits as collateral security, because a lender has every right to secure the interest in the unpaid balance of a loan. Nor does it apply to transfers

between a policyholder and an insured person, transfers to a partner of an insured person, transfers to a corporation in which the insured person is an officer or stockholder, or transfers of interest made as a gift (where no exchange of value occurs).

Taxes on Surrender Value

If a policyholder surrenders the policy for its cash value, some of the cash value received may be subject to ordinary income tax if it exceeds the sum of the premiums paid for the policy.

For example, Mary cash surrenders her whole life policy and receives $5,000. Total premiums paid into the policy were $4,700. Mary owes federal income tax on $300.

In accordance with section 1035(a) of the Internal Revenue Code, certain exchanges of insurance policies (and annuities) may occur as nontaxable exchanges. Generally, if a policyholder exchanges a life policy for another life policy with the same insured person and beneficiary and a gain is realized, it will not be taxed under section 1035(a). This same concept applies to exchanges involving annuities and other life insurance products.

For example, if you have a life insurance policy that you have paid $200,000 into in premiums, and its cash value is $350,000, the excess is taxable unless you transfer the accumulations from one contract to another. A life contract can be exchanged for another life policy, an annuity, or an endowment. An endowment contract can be exchanged for an annuity or an endowment, and an annuity contract can be exchanged only for another annuity contract, all without incurring taxes.

Premiums paid for life insurance are generally not tax deductible. For individuals, they are considered a personal expense and are not deductible.

Dividends are considered to be a return of excess premium paid by the policyholder. They are not included as income for tax purposes. However, interest earned on dividends and accumulated by the insurer or paid to the policyholder is taxable in the year received.

Looking Back

These are the major points discussed in this chapter. Keep them in mind any time you talk to a life insurance salesperson:

- Most kinds of life insurance are based on term insurance, whole life insurance, or both. Term insurance provides pure insurance protection for a specific period of time, after which it expires with no cash value. The cost of term insurance increases substantially after middle age. Whole life insurance is characterized by level premiums, guaranteed cash values, and death protection, but its values can be eroded by inflation.

- Flexible policies such as adjustable life, variable life, and universal life, were developed to offer more attractive growth opportunities. These policies pose a greater risk, since neither principal nor interest are guaranteed. Variable contracts are regulated both at the state and federal level.

- You have ownership rights, and perhaps a conversion option, and are protected by the policy's grace period, incontestability clause, entire contract clause, reinstatement clause, and automatic premium loan provision.

- You have the option to surrender cash value life insurance for cash, extended term insurance, or paid-up insurance, or to take a policy loan. You also may have the right to designate how your policy's benefits will be paid out to your beneficiaries.

- In reviewing your life insurance policies, it is important to understand your rights and responsibilities as a policy owner. Have your agent review all the coverages and limitations of any new policy you are considering. Let your agent know you understand how replacement of a cash value policy can work against you.

- Ask about life insurance policy riders that may have become available since you last talked to your agent. You may be able to add long-term care coverage, cost of living adjustments, or a rider which waives your premium when you are disabled.

CHAPTER 7
ANNUITIES

Strictly speaking, annuities are not life insurance. But a basic understanding of the types of annuity policies available is a good idea because they are sold by insurance companies and life insurance agents, as well as by financial institutions.

Confusion reigns in this market. An example: the National Association of Life Underwriters expressed "grave concern" over the results of a 1994 survey released by the AARP and the North American Securities Administrators Association showing that the vast majority of older consumers were unaware that annuities and investment products sold by banks are not federally insured.

"The fact that 86 percent of bank customers don't understand that annuities are not protected by FDIC only underscores the wisdom of our nation's long-standing policy of separating banking and insurance," said NALU President Robert L. Tedoldi. "In their enthusiasm to generate additional fee income, the banks are using their government-conferred franchise insurance to persuade consumers to purchase annuities, which are not federally insured."

Tedoldi said he was particularly concerned by survey findings which indicate that banks have aggressively marketed uninsured investment products to older Americans. "When a bank trades on its reputation in the community as safe place for savings in order to sell mutual funds, annuities and other financial products which are not backed by FDIC, consumer confusion is inevitable," he said.

Costly Misunderstanding

Tedoldi said the fact that over half of those who purchased an annuity at a bank think the purchase was FDIC-insured "is an alarming indication that meaningful con-

sumer disclosure may ultimately prove ineffective to prevent confusion and misunderstanding."

The basic function of an annuity is to systematically liquidate a principal sum over a specified period of time. An annuity contract provides for a series of periodic payments that begin on a specific date (such as the annuitant reaching a stated age) or a contingent date (such as the death of another person), and continue for the duration of a person's life or for a fixed period. Usually, but not always, an annuity guarantees a lifetime income for the recipient.

The annuitant is the person on whose life the annuity policy has been issued. As is the case with life insurance, the owner of the contract may or may not be the annuitant. In most cases, the annuitant is the intended recipient of the annuity payments.

Depending on the type of annuity and the method of benefit payment selected, a beneficiary may also be named in an annuity contract. In such cases, annuity payments may continue after the death of the annuitant for the lifetime of the beneficiary or for a specified number of years.

While life insurance is primarily designed to protect the policyholder against premature death, an annuity is designed to protect the annuitant against the risk of living too long and possibly outliving his or her financial resources during retirement. Thus, most often, the primary purpose of an annuity is to provide retirement income.

Annuities may be purchased on an individual basis to help solve individual retirement needs. In this case, the annuitant is the owner of the annuity. Often, annuities are purchased on a group basis covering a number of annuitants typically in an employer-employee situation. Group annuities are often used to fund an employer-sponsored retirement plan, with the employer as the contract owner.

Be Careful of Salespeople

Some questionable brokers and agents are attracted to the annuity market because of the large amounts of cash involved, and the opportunities for skimming of this cash for personal use. In the 1991 decision *United States of America v. William Kilroy,* the U.S. District Court for the District of Columbia dealt with a striking scam.

In March 1990, a federal grand jury returned a 13-count indictment against William Kilroy, an insurance broker, charging him with multiple offenses in connection with his alleged embezzlement of approximately $573,000 from two pension plans of which he was the administrator from mid-1981 to mid-1985.

According to the indictment, Kilroy stole the money he was supposed to send to the Hartford Insurance Company to pay the premiums for the annuities that funded the plans for the benefit of staff and contract employees of the National Council of Senior Citizens (NCSC) in the District of Columbia.

Kilroy was a protege of one Louis Ostrer, a disbarred New York insurance broker and convicted felon, in whose office Kilroy began his insurance career in 1959 at the age of 18. After Ostrer lost his own license he did business through Kilroy, who would write the coverage and split the commissions with Ostrer. Ostrer, who dealt with "the people who controlled the unions," according to Kilroy, continued to refer business to Kilroy even after Kilroy left his employ and moved from New York to Maryland to open his own office in 1976.

Two Scams at One Time

During roughly the same period covered by the D.C. indictment, Kilroy was also under investigation by an organized crime strike force of the U.S. Department of Justice in Las Vegas, Nevada, in connection with labor union corruption in general, and, specifically, Kilroy's suspected sale of fraudulent insurance coverage to a culinary workers' union local welfare and pension fund.

In the Las Vegas venture, Kilroy ostensibly procured fiduciary liability "insurance coverage" for the union from a bogus carrier, splitting the commissions with Ostrer. Ostrer denied any knowledge of Kilroy's relationship with NCSC, and had nothing to do with his appointment as the plans' administrator. (He was, in fact, in federal prison from February 1981 to February 1989.)

Kilroy was indicted in Las Vegas in March 1985, and surrendered to the Baltimore F.B.I. field office immediately. Shortly thereafter his attorneys began negotiations for his cooperation.

Exposing the Scam

The premise of the Las Vegas investigation was that the culinary workers' union had been infiltrated by organized crime and that Ostrer conspired with the organized crime figures who controlled it, paying kickbacks from the premiums paid for the illusory insurance placed by Kilroy.

Kilroy agreed to cooperate in return for immunity for all he revealed. He testified for the government against others indicted in Las Vegas, and ultimately received just probation on his felony conviction.

About the same time the Las Vegas prosecution was getting underway, NCSC's comptroller ordered an audit of Kilroy's handling of NCSC's pension plan accounts by a private CPA. Kilroy explained to the auditor that NCSC's premium payments were made payable to his company, Nationwide Family Plans, Inc., and that he would then remit the annuity premiums due to Hartford by checks drawn on his own company accounts.

Kilroy didn't reveal the shortages in the payments he had made to Hartford, but within a week the auditor became aware that Hartford had received considerably less than Kilroy was supposed to have remitted. NCSC proceeded with criminal charges.

Kilroy moved to dismiss the 1990 District of Columbia indictment, claiming "unconscionable delay" in presenting evidence to a grand jury after first acquiring knowledge of his crime against NCSC. He had confessed to the F.B.I. in August of 1985, following his plea agreement in Las Vegas.

"The Department of Justice completed its review in early 1990, and the case was presented to a grand jury for indictment a month or two later," the appeals court ruled. "The investigative process leading up to indictment may have been desultory, and the government not altogether candid with Kilroy about it, but he has not shown it to have been done as slowly as it was for any purpose of getting an upper hand in this case."

The appeals court concluded that there was enough evidence untainted by the Las Vegas Strike Force's promise of immunity.

The Uses of Annuities

Why do these investment vehicles attract such colorful crooks? Because they involve a lot of cash. Annuities are primarily used as retirement vehicles due to their guarantee of income for life. During the accumulation period, the investment income realized on payments made are tax deferred until taken at retirement. If you die during the accumulation period, the money accumulated will be paid to a survivor. A common illustration is the annual premium retirement annuity contract, where the total accumulation is calculated based on an annual premium, an assumed interest rate and retirement age (usually 65).

During the accumulation period, the annuity contract may be quite flexible in that you may choose to make payments or not make payments. In addition, you have withdrawal options where the money accumulated can be withdrawn totally, or in part, during the accumulation period.

Annuities may be used to fund individual retirement accounts (IRAs), in which case premium payments may be tax deductible, but there are more restrictions on withdrawals (including tax penalties for withdrawals before age 59½).

Although most commonly used to build retirement funds, annuities may be used for many other purposes where there is a need to accumulate funds over a period of time and/or to provide periodic payments for a specific need. For example, annuities may be used to accumulate funds for children's education.

Another common use for an annuity is to liquidate large cash settlements such as lawsuits or lottery winnings. These large sums of money can be used to purchase a single payment annuity and thus provide you with a guaranteed lifetime income.

You Don't Have to Prove Insurability

Occasionally, an annuity may be used when an individual is uninsurable. Applicants for annuities do not have to prove insurability since the risk involved is outliving your retirement resources by living too long. If for example, a business owner is uninsurable and needs to provide cash

for funding a business agreement, an annuity might be an alternative method for funding the business obligation.

There are two principal types of annuities: fixed and variable. A fixed annuity is a fully guaranteed contract. Principal, interest and the amount of the benefit payments are guaranteed. Fixed annuity payments are considered part of the insurer's general account assets, the conservative investment portfolio used by the insurance company for investing premium income. There are two levels of guaranteed interest; current and minimum. The current guarantee reflects current interest rates and is guaranteed at the beginning of each calendar year. The policy will also have a minimum guaranteed interest rate, such as three percent or four percent, which will be paid even if the current rate falls below the policy's guaranteed rate.

A variable annuity, like variable life insurance, is designed to provide a hedge against inflation through investments in a separate account of the insurer consisting primarily of common stock. A variable annuity is not a fully guaranteed contract. However, both a fixed and variable annuity guarantee expenses and mortality. This means that any expense deductions made by the insurance company are guaranteed not to exceed a specific amount or percentage of the payments you make. The guarantee of mortality means annuity benefits will be paid for life.

Occasionally, an annuitant may decide that it is in his or her best interests to purchase an annuity which offers some guarantees but also offers protection against inflation. This type of annuity is usually identified as a combination or balanced annuity. It is a combination of a fixed and variable annuity.

COMPARISON
FIXED AND VARIABLE ANNUITIES

	Fixed Annuity	**Variable Annuity**
Issued by	Insurance Company	Insurance Company
Purpose	Guaranteed retirement income	Retirement income and a hedge against inflation
Performance	The General Account	The Separate Account
Principal	Guaranteed	Not Guaranteed
Interest	Guaranteed	Not Guaranteed
Payout Amount	Guaranteed	Not Guaranteed
Expenses	Guaranteed	Guaranteed
Mortality	Guaranteed	Guaranteed
Regulated by	State Insurance Dept.	State Insurance Dept. & the SEC
Investment Risk	The Insurer	The annuitant

Like life insurance policies, annuity contracts may include nonforfeiture values to protect you from a loss of benefits if you stop making the required periodic payments, and surrender charges, or penalties for "cashing in" the annuity early.

Method of Premium Payment

A single premium or single payment annuity is purchased by making one lump sum payment. For example, a life insurance policy could be cashed in at the date of retirement and the cash value used to buy a single premium annuity.

PERIODIC PAYMENT ANNUITY

Annual Premium: $1,000 Retirement Age: 65

Interest Rate: 8.75%

	Premium	Male, Age 35	Male, Age 65
Age 35	$1,000	$ 1,089	
Age 36	1,000	2,273	
Age 37	1,000	3,561	
Age 38	1,000	4,961	
Age 39	1,000	6,484	
Age 40	1,000	8,140	
Age 41	1,000	9,941	
Age 42	1,000	11,890	
Age 43	1,000	14,030	
Age 44	1,000	16,346	
Age 45	1,000	18,866	
Age 46	1,000	21,605	
Age 47	1,000	24,585	
Age 48	1,000	27,825	
Age 49	1,000	31,348	
Age 50	1,000	35,180	$ 1,089
Age 51	1,000	39,347	2,273
Age 52	1,000	43,879	3,561
Age 53	1,000	48,807	4,961
Age 54	1,000	54,166	6,484
Age 65	1,000	$141,667	$31,348

SINGLE PAYMENT ANNUITY

Single Deposit of $10,000 Retirement Age: 65

Interest Rate: 8.75%

	Male, Age 35	Male, Age 50
Age 35	$ 10,000	
Age 40	15,229	
Age 45	23,165	
Age 50	35,235	$10,000
Age 55	53,594	15,229
Age 60	81,520	23,165
Age 65	123,997	53,594

A periodic premium or periodic payment annuity consists of a series of periodic payments over a period of time. These payments may be made annually, semi-annually, quarterly or monthly; however, periodic payments are not mandatory. Often, this type of purchase may be identified as a flexible premium annuity in that the frequency and amount of these payments are flexible.

An annuity can further be described in terms of when the benefit payments to the annuitant will begin. Benefits may be immediate or they may be deferred until a later date.

THE ANNUITY PROCESS

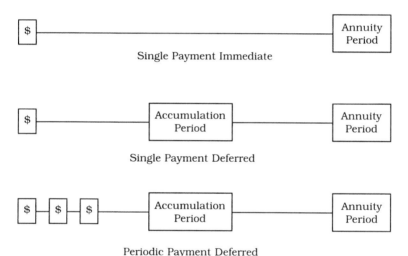

Single Payment Immediate

Single Payment Deferred

Periodic Payment Deferred

If an annuitant purchases an annuity with a single payment, the benefits may begin immediately or they may be deferred. This is known as a single payment immediate, or single payment deferred annuity. If the annuity is purchased with a series of periodic payments, then the benefits will be deferred until all payments have been made. This is known as a periodic payment deferred annuity.

Periods of Time

There are two periods of time associated with an annuity; the accumulation period and the annuity or benefit period. The accumulation period is the "putting in" time. It is that period during which you make contributions or payments to the annuity. A unique feature of this period of time is the fact that the interest paid on the amounts contributed will grow tax deferred. The interest earned will be taxed but not until you begin to receive the benefits.

The annuity period is the "taking out" time. This is the period following the accumulation of the annuitant's payments (principal and interest) during which annuity benefits are received.

Generally, when you decide to take money from the annuity (the annuity period), an annuity option will be selected, just as you would select a settlement option in life insurance. It is not unusual for you to select your annuity option at the time of application. Thus, if you purchased a single payment deferred straight life annuity, you own an annuity, purchased with a single payment, which will provide a pay out for life. Even if an annuity option is elected at the time of purchase, it may (and probably will) be changed at the annuity period to reflect the annuitant's needs at retirement.

Types of Annuity Pay-Outs

The amount of money available during the annuity period is determined by the annuity option selected, the amount of money accumulated by the annuitant and the life expectancy of the annuitant. Annuity options include the following types.

A *Life Only (straight life) option* provides for the payment of annuity benefits for the life of the annuitant only, with no further payment following the death of the annuitant. There is a risk in that if you die shortly after benefits begin, the insurer keeps the balance of the unpaid benefits.

However, this option will pay the highest amount of monthly income to the annuitant because it is based only on life expectancy, with no further payments due after your death.

A *Refund Annuity option* will pay annuity benefits for life but if you die too soon after the annuity period begins, there may be a refund of undistributed principal or cost of the annuity. This option assures you that at least the full purchase price of the annuity will be paid out to someone. Depending on when your death occurs, there may or may not be a refund.

If you live well beyond your average life expectancy, then all of your investment in the annuity will have been paid and thus there would be no refund. But if you die just a few years after retiring, then a refund of the total payments made, less any distributed amounts, would be made to your survivor. This refund may be in the form of continued monthly installments (an installment refund annuity) or it may be in one lump sum (a cash refund annuity), whichever you have elected.

Life with Period Certain is basically a straight life annuity with an extra guarantee for a certain period of time. This option provides for the payment of annuity benefits for life but if death occurs within the period certain, annuity payments will be continued to a survivor for the balance of the period certain.

The period certain can be for just about any length of time—five, ten or twenty years. Most often, the period selected is ten years because ten years is approximately the average life expectancy of a male who retires at age 65.

Thus, if Archie, the annuitant, retires at age 65 and selects life with ten years certain and dies at age 70, his survivor, or beneficiary, will continue to receive the monthly annuity payments for the balance of the period certain (five more years).

The Joint-Survivor Option

The *Joint-Survivor option* provides benefits for the life of the annuitant and the life of the survivor. A stated monthly amount is paid to you, and upon your death, the same or a lesser amount is paid for the lifetime of the survivor. The joint-survivor option is usually classified as a joint and

100 percent survivor, joint and two-thirds survivor or joint and 50 percent survivor.

For example, if the annuitant was receiving $1,000 monthly under a joint and 50 percent survivor option, the survivor would receive $500 (50 percent of $1,000) upon the death of the annuitant.

JOINT AND 50% SURVIVOR

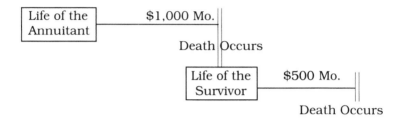

The joint-survivor annuity option should be distinguished from a joint life annuity, which covers two or more annuitants and provides monthly income to each annuitant until one of them dies. Following the first annuitant's death, all income benefits cease.

The above mentioned annuity options all have one concept in common: they guarantee an income for the life of the annuitant. Some of them may also provide continued payments following the death of the annuitant.

The Annuity Certain Option

An *annuity certain* is not an option which guarantees a lifetime income. It does provide an income for a guaranteed period of time whether you are alive or not. The guaranteed period could be five, ten, 15 or 20 years. If you outlive the guaranteed period, the annuity payments cease. If you die during the guaranteed period, the payments continue to the survivor until the guaranteed period of time ends.

10 YEAR ANNUITY CERTAIN

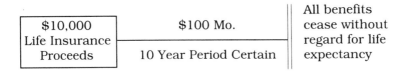

$10,000 Life Insurance Proceeds	$100 Mo.	All benefits cease without regard for life expectancy
	10 Year Period Certain	

A temporary annuity provides annuity payments for a specified period of time (such as five years or ten years), or until the death of the annuitant—whichever occurs first. A temporary annuity does not necessarily guarantee payment for life or the specified period of time. Unlike other forms of life annuities, there is no guarantee that an annuitant will receive payments for life because payments end when the specified period expires. Unlike an annuity certain, the period of time for a temporary annuity is not guaranteed and could be terminated by early death. The key concept is that the earlier event will terminate benefits.

For example, Sandra purchases a ten-year temporary annuity to distribute an inheritance in monthly installments. If Sandra dies three months into the annuity period, all benefits stop. If Sandra lives for 20 years, all annuity payments stop at the end of the tenth year.

Calculating Interest

Premiums or payments made during the accumulation period earn a guaranteed return on a tax-deferred basis. There are two ways to calculate guaranteed interest paid on these contributions.

The current purchase rate reflects the current interest rates relevant to current economic conditions. This rate is guaranteed at the beginning of each calendar year, and could fluctuate from year to year. Increasing or decreasing interest rates will mirror present investment, banking, and market rates available in the marketplace.

The guaranteed purchase rate is the "minimum" interest rate that is guaranteed for the life of the contract. This will be a fairly modest amount such as four to five percent. This is the minimum return which will be paid even if the current annual rate falls below the guaranteed rate.

Thus, deferred annuities guarantee a minimum interest rate which contributions will earn. Since the guaranteed rate is less than prevailing interest rates, the insurer will often credit excess interest on the contract.

Excess interest is calculated based on how much the insurer has earned through its investments. If the insurer considers all of its invested reserves and net investment earnings over a relatively long period of time, the interest rate calculation is said to be made based on the portfolio method. If the insurer instead considers portions of its invested reserves over a shorter period of time the interest rate calculation is based on the tier method.

Variable Annuities

The primary purpose of the variable annuity is to provide a hedge against inflation. To achieve this, the insurer invests the annuity premiums or payments in its separate account consisting primarily of a portfolio of common stock (this was discussed earlier in the section on variable life insurance). Because the annuitant's investment in the variable annuity is placed in a portfolio of common stock, there is investment risk. Of course, investing in a variable annuity gives you the opportunity to preserve the purchasing power of your retirement dollars.

As evidence of your participation in the separate account, units of the trust are issued. This is very similar to shares of a mutual fund which are issued to mutual fund investors. During the accumulation period, these units are identified as accumulation units. Both the number of the units and the value of these units will vary in accordance with the amount of premium payments made and the subsequent performance of the separate account.

For example, Jan invests $100 per month in her variable annuity. On the day the insurer received her $100 payment, the value of an accumulation unit was $10. Thus, Jan is credited with ten additional accumulation units.

When the annuitant reaches the annuity period, these accumulation units are converted to annuity units. The number of annuity units remains constant. No further money is being contributed to the annuity, thus, there is no further increase in the number of annuity units. However, the value of the annuity units will vary in accordance with the daily performance of the separate account. Accordingly, during the annuity period, benefit checks

will vary depending on the value of the annuity units at the time the monthly check is issued.

There are few guarantees associated with a variable annuity. The variable annuity contract will guarantee that expenses chargeable to the annuity will not exceed a specific amount or percentage. In addition, the policy will also guarantee mortality which means a benefit check will be received for the life of the annuitant. However, the variable annuity does not guarantee the amount of the benefits at retirement nor does it guarantee principal or interest.

Regulation of Variable Annuities

As the court cases in this chapter show, considerable controversy has raged over the regulatory issue of whether a variable annuity is really an insurance product or an equity investment. Both the federal Securities and Exchange Commission (SEC) and state Insurance Departments regulate variable annuities. They are considered securities and have to comply with federal securities laws and regulations with certain limited exemptions. Regulation by state Insurance Departments includes licensing companies and agents to sell variable annuities and approving variable annuity contracts.

Due to this dual regulation, to sell variable annuities (and variable life products), an agent must pass a test and be registered with the National Association of Securities Dealers (NASD). In addition, the agent must also be licensed to sell life insurance by the state. Some states also have specific variable contract requirements which require a separate variable contracts license in addition to the other licenses.

The pivotal legal precedent relating to annuities came in the 1986 decision *Beverly Otto v. Variable Annuity Life Insurance Co. et al.*, written by the seventh circuit U.S. Court of Appeals.

Variable Annuity Life Insurance Company (VALIC) marketed annuities and other financial products which qualified for tax-exempt status under section 403(b) of the Internal Revenue Code. Typically, VALIC would enter into a "group unit purchase contract" with a tax-exempt organization—such as a public school or college—under which the organization permitted VALIC to offer its various annuity plans to the organization's employees.

If an employee chose to participate in one of VALIC's plans, he or she would direct the employer to contribute a portion of his or her salary (up to a maximum determined by law) to purchase an annuity.

VALIC offered both fixed and variable annuities. Under both plans, the principal and any return accumulated over the life of the contract. At the end of the contract, the employee could withdraw the accumulated monies or use them to purchase another annuity from VALIC.

Under the fixed annuity, VALIC guaranteed the principal and an interest rate of four percent per year for the first ten years and 3½ percent thereafter. "Excess" interest over the guaranteed rate was paid to fixed annuity participants at the discretion of VALIC. Funds were held in VALIC's unsegregated general account and invested primarily in long-term debt-type instruments such as mortgages and bonds.

Under the variable annuity, neither the principal nor the rate of return was guaranteed; both fluctuated with VALIC's investment performance. Funds were placed in a separate account, segregated from VALIC's general assets. The separate account's funds were invested in a diversified portfolio of common stocks and other equity-type investments.

Otto purchased a fixed annuity from VALIC in 1975. In August 1982, she brought a class action on behalf of herself and all Illinois investors who participated in VALIC's fixed annuity plan between October 17, 1975 and August 2, 1982. She alleged violations of the Securities Exchange Act of 1934, the Employee Retirement Income Security Act of 1974 (ERISA) and the Racketeer Influenced and Corrupt Organizations Act (RICO).

The Banding Method

Specifically, she claimed that VALIC failed to disclose the manner in which interest was calculated under the fixed annuity plan—specifically, that it used the "banding" or "new money" method for crediting "excess" interest to the fixed annuity account.

Under the banding method, the current rate of excess interest was paid only on deposits made during the current period. All prior contributions continued to earn the rates of interest declared during the periods in which those contributions were made.

Otto also claimed that VALIC failed to disclose the method by which a participant in the fixed annuity plan could maximize his or her rate of return. According to Otto, an employee could earn the current rate of interest by transferring funds from the fixed account into a variable account for 120 days and then transferring them back into the fixed account.

The Court of Appeals held—among other things—that the fixed annuity was not an insurance product but an investment contract and was not exempt from federal securities laws; and the annuity was not an employee pension benefit plan established or maintained by the employer and was not subject to ERISA requirements.

The Securities Act of 1933 exempts "[a]ny insurance or endowment policy or annuity contract or optional annuity contract" issued by a corporation subject to supervision by the appropriate insurance regulatory authority.

An Earlier Precedent

In its 1959 decision *S.E.C. v. Variable Annuity Life Insurance Co.* (*VALIC I*), the Supreme Court considered whether a variable annuity was a security or insurance. The Court discussed the characteristics distinguishing the variable annuity from the traditional fixed annuity. Generally, the funds underlying the fixed annuity are invested according to conservative standards, and the fixed annuity pays a specified and definite amount to the annuitant. In contrast, the variable annuity's funds are invested primarily in common stocks and other equities, and the variable annuity's benefits vary with the success of the company's investment experience. The holder of a variable annuity, therefore, is not able to depend upon the annuity's paying a fixed return.

The insurance company in *VALIC I* stressed that, as with all insurance, the company assumed the mortality risks under both the variable and the fixed annuity plans. Yet the Court found this characteristic alone an insufficient basis for considering a variable annuity to be insurance. Insurance, according to the Court, "involves some investment risk-taking on the part of the company" and "a guarantee that at least some fraction of the benefits will be payable in fixed amounts."

An annuity contract that did not guarantee a fixed return thus places all of the investment risk on the policyholder and none on the company. Because there was "no true underwriting of risks," the *VALIC I* Court concluded that the variable annuity was a security.

Unlike that earlier case, the fixed annuity plan in Otto's case appealed to potential participants on the usual insurance bases of stability and security. VALIC promoted the fixed annuity as a long-term accumulation of funds for retirement through compound interest. Contributions were mingled with the company's general assets and invested primarily in debt-type securities.

Regardless of the investment success of VALIC's general account, VALIC was required to pay a guaranteed rate of interest on all fixed annuity contributions of four percent during the first ten years and 3.5 percent thereafter. "Although this was a low rate of return, it was not so low that we can say it placed the investment risk on the policyholder in a way substantial enough to make the fixed annuity a security," the appeals court ruled.

The appeals court allowed Otto's first claim, dealing with VALIC's fixed annuity under federal securities law, to stand but rejected her others.

Group Annuities

The seventh circuit Court of Appeals had previously considered whether a "group deposit administration annuity contract" constituted a security or insurance in the 1983 case *Peoria Union Stock Yards Co. v. Penn Mutual Life Insurance Co.*

Under the contract at issue in Peoria Union, the employer contributed annually to a deposit account at Penn Mutual to fund a defined-benefit retirement plan for its employees. When an employee retired, the employer could purchase the annuity from the insurance company with a portion of the funds on deposit or it could withdraw funds and purchase the annuity for its employee from another insurance company.

The income available to fund the employer's obligations to its employees fluctuated with the investment experience of Penn Mutual. Penn Mutual guaranteed interest on the employer's contributions made during the first three years of the contract at a rate declining from 7.5

percent the first year to 3.5 percent the third year. Although there was no guarantee of interest after the first three years, any interest earned by the deposit account beyond the interest guarantee was credited to the deposit account.

This court observed that the insurance company actually served as an investment agency and permitted the pension plan to share in the company's investment experience. It concluded that during the accumulation phase the annuity plan was an investment contract.

The High Court Examines a Deferred Annuity

In the 1967 decision *S.E.C. v. United Benefit Life Insurance Co.*, the U.S. Supreme Court explored the distinction between a security product and insurance in considering a deferred annuity plan.

Under United Benefit's "Flexible Fund" annuity program, the purchaser's premiums less a deduction for expenses (the net premium), and any money earned from investing the premiums, were held in a Flexible Fund Account, which United maintained separately from its other funds.

The purchaser was entitled to withdraw the "cash value" of the policy before maturity. The "cash value" was equal to the higher of two amounts: the purchaser's proportional share of the fund or the "net premium guarantee," which was measured by a gradually increasing percentage of the purchaser's net premiums, from 50 percent of net premiums in the first year to 100 percent after ten years.

At maturity, the purchaser had the option of either receiving the cash value of the policy or converting that interest into a life annuity. But was this insurance or an investment vechicle?

The test to determine whether an instrument is an investment contract, according to the Court, "is what character the instrument is given in commerce by the terms of the offer, the plan of distribution, and the economic inducements held out to the prospect."

The Court noted that the Flexible Fund completely reversed the role of the insurer during the accumulation period. Instead of offering the inducements typical for insurance, such as "stability" and "security," United

proposed to serve as an investment agency and promised the policyholder "growth."

Although the minimum guarantee reduced the investment risk of the annuity purchaser, the Court pointed out that there was a "basic difference between a contract which to some degree is insured and a contract of insurance." It ruled that the guarantee would have to be higher in order to qualify as insurance.

Variable annuities may be purchased in the same way as fixed annuities—single premium immediate or deferred and periodic payment deferred contracts. Also, variable annuities include a variable premium feature, known as a flexible premium deferred annuity (FPDA) contract. Variable annuities offer the same annuity options for settlement of the contract as fixed annuities, and both are primarily used as retirement vehicles.

Tax Implications of Annuities

When an endowment or annuity begins to pay out, part of the payment is taxable and part is not. The non-taxable portion is the expected return of the principal paid in. The taxable portion is the actual amount of payment minus that expected return of the principal paid in. Since these amounts would be difficult to calculate, the IRS makes up tax tables for this purpose.

By definition, cost base is money which has already been taxed. Tax base is money which is yet to be taxed. A person investing $1,000 in an annuity is investing $1,000 cost base. Any interest earned is tax base, but the taxes are deferred during the accumulation period.

The taxation of annuity contracts is based upon an exclusion ratio. The exclusion ratio is the relationship of the total investment in the contract (cost base) to the total expected return under the contract (calculated based on average life expectancy tables). This ratio (expressed in a percentage) shows how much of each annuity payment is taxable, and how much is excluded from taxation.

Once an annuitant recovers his or her cost base during the annuity period, the total payments received will be taxed at ordinary income tax rates.

If an annuitant dies and the balance of a guaranteed amount is paid to a beneficiary, the payment is not taxable as income until the investment in the contract has been

received tax free (the amount received by the beneficiary is added to the tax free amounts received by the annuitant, and only any amount which exceeds the total amounts paid in will be taxable).

If an annuitant dies and payments continue to a surviving annuitant under a joint and survivor annuity, the same percentage that was excluded from taxes before the first annuitant's death will continue to be excluded.

Looking Back

These are the major points made in this chapter:

- Annuities involve large sums of cash which are liquidated over a period of time, providing an income to the annuitant. Confusion abounds in the annuity market, and so do scams against older people.

- The duration and amount of benefits depends on the annuity options selected. In the case of variable annuities, these also depend on the performance of the insurance company's investments.

- Understand the ins and outs of your annuity contract, especially when your benefit payments will begin and in what amount they will be payable.

CHAPTER 8
HEALTH INSURANCE

According to the Alliance for Aging Research, by 2010 the 65-plus population will account for $1.9 trillion in health-care costs, about half of all such costs in the nation.

Over the past decade the average age of people who have coronary bypass surgery has jumped from 55 to 61. Thousands of patients in their 70s have undergone the operation—which usually costs about $25,000. When surgeons began to master the art of transplanting hearts two decades ago they limited the procedure to patients under 50. Now they sometimes sew hearts into people in their 60s. A transplant costs $75,000 to $140,000. As with coronary bypasses, Medicare pays the bill for those over 65.

Medicare subsidizes dialysis for more than 100,000 people, half of them over 60, at a cost of more than $2 billion a year.

Geriatrician Meghan Gerety, associate director of the Veterans Affairs Department's Geriatric Research, Education and Clinical Center, says that 10 million older people will require care in the home by 2040. One reason why: The cost of Alzheimer's disease to society now is about $100 billion a year in medical care, nursing-home costs and paid care. And that's not factoring in the loss of productivity of caregivers—usually younger family members.

"The epidemic that is coming in Alzheimer's is not even being discussed," says physician and researcher Dr. David Espino, director of the division of geriatrics in the family practice department, the University of Texas Health Science Center at San Antonio. 14 million people may have the disease by 2040.

The future has arrived and is available for viewing in Florida, where 18 percent of the residents are over 65. That's what the elderly population of the whole U.S. will amount to in 30 years; it's 12 percent now. Those over 65 now con-

sume about one-third of the federal budget, including Social Security. A third of the $55-billion-a-year budget for Medicaid goes to those over 65, primarily to support them in nursing homes.

Daniel Callahan of the Hastings Center, a New York-based bioethical think tank argues there should be a generally agreed-on age (probably around 80) that would serve as an automatic cutoff point for aggressive life-saving medical treatment.

The Potential of Medical Rationing

In his book, *Setting Limits: Medical Goals in an Aging Society,* Callahan makes a harsh case for medical rationing. While you may object to this kind of scheme, you should probably think about what it means for your health coverage that people are even proposing it. The continuing rise in U.S. outlays on health care makes some sort of rationing inevitable, and an age-based cutoff of life-extending measures may be the first approach considered.

Medical and scientific research, Callahan argues, constantly uncovers new—and usually expensive—technologies to prolong life. Add to this the rapidly growing numbers of older people, and you begin to see one reason the nation's medical outlays grow beyond society's ability to pay.

The specter of cost-saving, health-care rationing for the elderly conjures up enormous ethical issues for society.

Medical ethicist Miguel Bedolla says: "Rationing has always existed, except it is based on how much money you have or if you have insurance. But, they are doing that England, where after 55 you no longer have the right to have an angioplasty. I'm afraid of any rationing that puts a price on lives."

According to a recent report by the Families USA Foundation, older Americans pay a startlingly higher portion of their incomes for health care today than they did in 1961, four years before Medicare was created. Thirty-one years ago, out-of-pocket health care costs consumed 10.6 percent of seniors' income. Last year, the figure was 17.1 percent.

For these reasons—and others—having adequate health insurance is perhaps the greatest insurance concern for seniors. As we age, we are more likely to have health problems and tend to use the health care system more frequently. Also, many retirees are living on a fixed income and face increasing health care costs. A major illness, or even a prolonged minor illness, can have serious financial consequences if you do not have the right health coverage.

The Importance of Health Benefits

In *Patricia S. Trupo v. Board of Review and Liberty Mutual Insurance, Co.*, the New Jersey courts were faced with deciding whether someone who was "forced" into early retirement because she was afraid to lose her health insurance coverage was entitled to unemployment compensation benefits.

Trupo worked as an office assistant for Liberty Mutual from February 22, 1982 until her retirement on February 28, 1992 at age 61. In November 1991, Trupo, along with other employees, was offered an early retirement package which included: the addition of five years to her age or work history which would increase her pension benefits; company-paid medical benefits until age 65, when she would qualify for Medicare; and payment of $700 per month until age 62, when she would be entitled to Social Security benefits.

At her administrative hearing, Trupo admitted that she was not told she definitely would be laid off if she did not accept the retirement package, and that she knew that Liberty had not decided as to which employees would be laid off or which employees would be transferred to other vacant positions within the company.

Trupo testified that she would have preferred to continue to work, but she feared if she was laid off she would become medically uninsured. But if she had declined the early retirement and continued her employment, she feared she would be terminated because she had the least seniority in her 14-employee department. After considering her options, Trupo believed she had no choice but to accept the early retirement, and therefore should not be disqualified from receiving unemployment compensation benefits.

In Massachusetts, courts have found that if a claimant reasonably believes that he will be terminated if he does not accept an early retirement plan, his leaving work will not be viewed as voluntary (*White v. Dir. of Division of Employment Security*). In this case the claimant with only six years seniority elected to take an early retirement after he heard a rumor of an impending layoff if the work force were not reduced by early retirement.

In explaining his decision to accept an early retirement proposal, White testified, "I could see that I would be laid off." He took the incentive rather than accepting a layoff. The court concluded that if the claimant believed this layoff was imminent and if that belief was reasonable, a finding was required that the claimant did not leave his employment voluntarily.

A Standard of Unemployment Compensation

New Jersey statutes provide that a person is disqualified for unemployment compensation benefits when he or she leaves work "voluntarily without good cause." But the courts have construed good cause to include "cause sufficient to justify an employee's voluntarily leaving the ranks of the employed and joining the ranks of the unemployed" and "when an individual voluntarily leaves a job under the pressure of circumstances which may reasonably be viewed as having compelled him to do so.

Good cause for voluntarily terminating employment was found in the case of a music therapist at Ancora State Psychiatric Hospital who expressed fear of physical harm by hospital patients, and in the case of a worker who had been threatened with physical violence by a co-worker, and they were not disqualified from receiving unemployment compensation benefits.

In the *Trupo* case, the issue raised was: "Does a 61-year-old woman, who is the head of her household and who holds a position of office clerical assistant without seniority at her place of employment and who fears an impending job layoff, have any realistic option when offered an early retirement incentive with full medical coverage other than to accept early retirement?"

The court agreed that her choice was either to accept the offered retirement proposal or continue her employment experiencing a daily fear that she would be laid off. The court also stated that the daily fear of a future employ-

ment layoff having no relation to work performance and which would cause the loss of all medical insurance, could engender as great a fear in an employee, subjectively, as the fear expressed by the employees described above.

The Ohio case *Mason v. Board of Review*, involved the claims of ten former employees of TRW, which sold its corporate business to a successor company. Employees aged 55 and older were given the option of working for the successor or taking early retirement and receiving a benefit package that included payment of 75 percent of health insurance costs for retirees and their dependents. Those who chose employment with the successor corporation would be ineligible for the former employer's health insurance benefits upon retirement. The claimants in Mason chose early retirement in order to preserve their health insurance and applied for unemployment benefits because they were involuntarily unemployed. The Board of Review disqualified the claimants, the decision was affirmed by the trial court, but was reversed on appeal. The Ohio Appeals Court concluded that "in no sense is a loss of a health benefit package an insignificant factor for a person aged 55 or older."

Despite all this, Trupo's request for unemployment compensation benefits was denied, mostly because she presented no evidence supporting her claims. Also, once the unemployment benefits she would have received were reduced by the amount of her early retirement pension, the benefits would have given her little or no economic benefit, anyway.

Making Informed Decisions

There is a growing movement in this country for more involvement in and control over health care costs and how health care dollars are spent. It is particularly important for seniors to make informed decisions regarding their own health care costs, coverages, and benefits.

A competent insurance agent can help you determine how much additional coverage, if any, you might need. Among your most critical considerations are the kinds of health insurance you have in force, whether these policies are individual or group policies, how long they are effective, and what the major exclusions and limitations are.

Remember, group policies you have through your employment are "rented" insurance, with coverage ending when you retire or your employment otherwise ends. You may have options for converting these group coverages into individual insurance, so it is important to check with your benefits administrator or read the group contract language and find out for sure.

Determining what your current health insurance needs are is similar to identifying your life insurance requirements. First, consider the types of health insurance already available to you. These might include:

- workers compensation benefits for job-related disabilities;
- Social Security disability benefits;
- medicare, if you are eligible
- work-related benefits through employer-sponsored plans;
- health coverage under any statutory plans.

In this section we will discuss the different types of health care providers, types of health insurance available, common benefits, policy provisions, exclusions, limitations, and underwriting practices. It is critical that you understand the coverages you have now, so you might want to have a copy of your policy or group certificate at hand as you read through this section. This should also help you identify additional riders or new policies you may need for the future. We will also talk about government health insurance, Medicare and Medicaid, Medicare supplement insurance, and long-term care insurance.

Health insurance varies according to the methods of underwriting, the injury or illness covered, the types of insurers, the types and amounts of benefits and services provided, and the types of losses covered. There are health policies that cover losses from specific or limited causes, such as accidents only or cancer only. And there are policies which are much more comprehensive.

Health insurance is unusual in that it is almost as important to know who is providing your coverage as it is to understand the coverage you have. So first we will discuss the various types of insurers and health care plans that are available.

Health Care Plans

The insurers of health care are not only the traditional stock and mutual companies, and Blue Cross and Blue Shield, but also the health maintenance organizations and preferred provider organizations formed by hospitals and physicians to deliver health care directly to enrollees in their plans.

The traditional broad health coverage provided by commercial insurance plans provides little incentive for efficient, cost-effective health care delivery. One response from insurers and providers has been to reorganize the health care delivery system into a form of managed care. Managed care imposes controls on the use of health care services, the providers of health care services, and the amount charged for these services, usually through health maintenance organizations or preferred provider arrangements, all discussed below.

Commercial insurers are stock and mutual life insurers, and sometimes casualty companies. Commercial insurers have traditionally provided coverage on a reimbursement basis but have also begun to embrace alternative approaches. Reimbursement plans pay benefits directly to you, usually after you've already paid the provider.

Commercial insurers offer both individual and group health insurance products. These products include basic medical expense coverage, major medical plans, comprehensive medical plans, disability income policies and other types of health products.

When considering purchasing health coverage from a commercial carrier, you should not only consider the extent and types of coverage available for the premium charged, but also the insurer's financial health and ability to pay claims. There are a number of rating companies which provide financial analysis of an insurer's creditworthiness. The ratings are based on the company's assets, surplus, premiums, revenue and investment performance, and other relevant information.

Prepaid Plans

The 69 Blue Cross and Blue Shield plans nationwide provide coverage to 66 million people. When considered in combination, they are the dominant health insurer of the United States.

Blue Cross and Blue Shield are different from traditional commercial insurers in several important areas. They provide the majority of benefits on a service basis rather than on a reimbursement basis. This means that the insurer pays the provider directly for the medical treatment given, instead of reimbursing you. Also, Blue Cross and Blue Shield have contractual relationships with the hospitals and doctors. As participating providers, the doctors and hospitals contractually agree to accept specific costs for the medical services provided to subscribers.

Blue Cross is a hospital service plan and Blue Shield is a physicians service plan. Under the hospital plan the contract is between Blue Cross and the hospital providing the hospital care. Under the medical plan the contract is between Blue Shield and the physicians providing the service.

Blue Cross and Blue Shield plans are called prepaid plans because the plan subscribers pay a set fee, usually each month, for medical services covered under the plan.

How Blue Cross Works

Blue Cross offers broad coverages and pays claims on a service basis. The plan covers hospital daily room and board, outpatient services for minor surgery, or accidental injury, medical emergencies, diagnostic testing, physical therapy, kidney dialysis, chemotherapy, and in some cases preadmission testing. Family plans may also include coverage for dependent handicapped children. Maternity benefits are also made available the "same as for any other disability."

Blue Cross also has a supplemental coverage, for catastrophic loss, which is similar to commercial major medical plans.

Blue Shield offers medical coverage to cover the physician expenses incurred by plan subscribers. Again, through the contractual arrangement with the providers, Blue Shield will normally pay the participating physician a predetermined amount for the specific service provided. Usually, this amount will be based on a usual, customary and reasonable (UCR) basis depending on the charges made by other physicians in the same geographical area for the same or similar medical procedure.

Jointly-operated (consolidated) Blue Cross/Blue Shield plans are often so comprehensive that supplementing them with major medical coverage is not necessary. Plan provisions applying to consolidated Blue Cross/Blue Shield plans are similar to plan provisions applying to comprehensive major medical plans.

Health Maintenance Organizations

Health maintenance organizations (HMOs) provide pre-paid doctor and hospital care. Their growth has been encouraged by rising health care costs and federal legislation. HMOs are sometimes owned and controlled by commercial insurers, however, many are independently owned.

The majority of HMOs are organized as for-profit corporations although they may also be nonprofit. HMOs must operate within a specified geographical area known as the service area. The service area must be approved by the state Department of Insurance and all members of the HMO must reside in the prescribed service area. The service area is usually a city, or part of a city and occasionally an entire state. HMOs may be state qualified (able to provide services within a single state or states) and/or federally qualified (able to provide services in specified areas throughout the nation for national contracts like the United Auto Workers, Teamsters, or government employees). If an HMO is federally qualified, it must also be state qualified in the states where it serves members obtained through a national contract.

The HMO Act of 1973 required that employers with at least 25 employees, who are paying at least minimum wage, and who offer a health plan to their employees to offer coverage by a federally qualified HMO as an alternative to an indemnity plan.

HMO benefits are not limited to treatment resulting from illness or injury, but include preventive health care measures like routine physical examinations. HMO members pay a set fee, usually on a monthly basis, which entitles them to all necessary health care.

Health maintenance organizations are required to provide a wide range of health care services. These required services are referred to as basic health care services. Any services or benefits provided by the HMO to members in excess of the basic health care services are

referred to as supplemental health care services. A basic menu of health care services must be provided:

- inpatient hospital and physician services for at least 90 days per calendar year for treatment of illness or injury (If inpatient treatment is for mental, emotional or nervous disorders—including alcohol and drug rehabilitation and treatment—services may be limited to 30 days per calendar year. Treatment for alcohol and drug rehabilitation and treatment may be restricted to a 90-day lifetime limit.);

- outpatient medical services when prescribed or supervised by a physician and rendered in a non-hospital based health care facility (i.e. physician's office, member's home, etc.), including diagnostic services, treatment services, short term physical therapy and rehabilitation services, laboratory and X-ray services and outpatient surgery;

- preventive health services, including well child care from birth, eye and ear examinations for children under age 18 and periodic health evaluations and immunizations;

- in- and out-of-area emergency services, including medically necessary ambulance services, available on an inpatient or an outpatient basis 24 hours per day, seven days per week.

Many HMOs and other managed-care plans require members to make a copayment when they get treatment. A copayment is a specific dollar amount, or percentage of the cost of a service that must be paid by the HMO member in order to receive a basic health care service. For example, a $5 copayment might be required for an office visit to a member's physician, or a member might be required to pay a 30 percent copayment (30 percent of the cost of the services) for alcohol and drug rehabilitation. Copayments are usually less than $10.

HMO Exclusions

Exclusions and limitations are used to either limit a benefit provided or specifically exclude a type of coverage, benefit, medical procedure etc. HMOs may not exclude and limit benefits as readily as commercial insurers. This is because the rationale of an HMO is to provide comprehensive health care coverage. Some of the benefits an HMO

may exclude from coverage, and often do, include: eye examinations and refractions for persons over age 17, eyeglasses or contact lenses resulting from an eye examination, dental services, prescription drugs (other than those administered in a hospital), long term physical therapy (over 90 days) and out-of-area benefits (other than emergency services).

HMOs must provide evidence of coverage to members within 60 days of their enrollment. In it, the member's coverages and benefits (including required copayments), benefit limits, exclusions, and conversion privileges are specified. The evidence of coverage will also include the name, address, and telephone number of the HMO, the effective date and term of coverage, a list of providers and a description of the service area, terms and conditions for termination, a complaint system, a 31-day grace period for premium payment provision, a coordination of benefits provision, incontestability clause, and a provision on eligibility requirements for membership in the HMO. Other provisions may also be found in the evidence of coverage, but those outlined above must be included.

HMOs, like traditional commercial insurers, are not allowed to engage in certain types of business practices, policies, etc. Specifically, HMOs are prohibited from excluding a member's preexisting conditions from coverage, from unfairly discriminating against a member based on age, sex, health status, race, color, creed, national origin, or marital status. HMOs are also prohibited from terminating a member's coverage for reasons other than: nonpayment of premiums or copayments, fraud or deception in the member's use of services, a violation of the terms of the contract, failure to meet or continue to meet eligibility requirements prescribed by the HMO, or a termination of the group contract under which the member was covered.

Preferred Provider Organizations (PPOs)

Preferred Provider Organizations developed as a compromise between the benefits of an HMO and a traditional reimbursement insurance plan offered by commercial insurers. A PPO is made up of various hospitals and private physicians in an area, who agree to provide services to the insurer's clients at a predetermined price. In return, the insurer designates these doctors and hospitals as preferred providers.

If you seek treatment from a preferred provider the coverage for the services rendered is 100 percent minus a nominal copayment for each office visit or hospital stay. If you elect to receive treatment from a nonpreferred provider then the reimbursement benefits will be reduced to the usual 80 percent. This type of plan allows you to choose between cost savings and freedom of choice in selecting a health care professional.

Other Managed Care Plans

Exclusive provider organizations are a type of PPO in which individual members use particular preferred providers, instead of having a choice of a variety of pre-ferred providers. Providers are not paid a salary, but are paid on a fee-for-service basis.

EPOs are characterized by a primary physician who monitors care and makes referrals to a network of providers (this is known as the gatekeeper concept), strong utilization management, experience rating, and simplified claims processing. EPOs can serve as an alter-native to or companion to HMOs and PPOs.

With a self-funded plan an employer, not an insurance company, provides the funds to make claim payments for company employees and their dependents. In the event that claims are higher than predicted, a self-funded health insurance plan can be backed-up by a "stop-loss" contract, which limits the employer's total liability to a specified amount in case claims payments go too high. The back-up insurer then pays all claims once the spec-ified amount is reached.

If your employer self-funds its health insurance plan, you may be more at risk than you think. The main disadvan-tages of self-insurance are:

- actual losses may be higher than predicted, causing the employer to experience financial difficulty or dis-continue the plan;

- contracts are usually not regulated by the state Insurance Department, and therefore the Depart-ment cannot assist consumers with problems;

- contracts are not subject to mandated benefits laws, and can be modified by the employer more easily.

Small employers (usually defined as those with fewer than 20 to 25 employees) have been especially hard hit by increases in health care insurance premiums. Because many group plans are "experience rated", small employers see an immediate premium increase whenever claims are high. If the average age of the participants is particularly high, or if claims experience is high, or if there has been even one long or catastrophic illness in a small employer plan, it can have a devastating effect, making health insurance unaffordable for the whole group. Recent surveys by the Health Insurance Association of America (HIAA) indicate a substantial decline in the number of small firms that are able to offer health coverage to their employees.

Group vs. Individual Health Insurance

Although group and individual health insurance policies share many of the same policy provisions, there are a few significant differences.

There are usually fewer limitations for group coverage. You may not have to prove insurability. For an individual policy, the contract is between the insurer and the covered individual. For a group policy, the contract is between the insurer and the employer, union, trust or other sponsoring organization. This gives you much less input when changes are made to the policy, or when coverage is moved to a different carrier.

While group policies may have fewer limitations, they do have one important drawback. If you change jobs or retire, you probably will lose your coverage under the group policy. Individual health insurance contracts continue regardless of changes of employment.

The federal law COBRA (Consolidated Omnibus Budget Reconciliation Act)[1] provides for continuation of group coverage for employees whose coverage ends because of a "qualifying event." When you retire from a company with 20 or more employees that provides medical coverage, you have the right to continue your coverage for 18 months, but you will be responsible for paying your own premiums.

[1]For more on COBRA and related laws, see page 247.

You must clearly understand in advance how your coverage may change after you retire. If your employer offers you retiree coverage, it is required to offer you COBRA coverage, as well. You will be asked to elect one and reject the other. Most of the time it is a better idea to reject the COBRA coverage and take a retiree plan or group conversion privelege. The COBRA coverage will continue only for 18 months (or 36 months, with a surviving spouse extension). A conversion plan is generally designed to last until age 65. Retiree coverage, even if it is less comprehensive, is generally designed to continue indefinitely. However, most employers preserve the right to unilaterally make changes to the group health insurance plan, and it is possible that your coverage could end.

Master Policies

The group insurance policy is called a master policy and is issued to the policyowner—usually the employer, association, union, or trust, etc. The individuals covered under the group policy are issued certificates of insurance. The certificate lists what the policy covers, and explains to you such things as how to file a claim, the term of insurance, and the rights to convert from group coverage to an individual policy. Many of the group health insurance contracts features are similar to the contract features of group life insurance.

The Age Discrimination in Employment Act provides that employers with 20 or more employees that provide medical coverage to employees must provide the same coverage to older employees (and their spouses) as younger employees. There is no upper age limit on this protection. When you become entitled to Medicare benefits, the employer must allow you to choose which coverage will be primary: your group health coverage or Medicare. Also, your employer may not in any way encourage you to make Medicare your primary coverage, such as by offering to pay for Part B coverage on your behalf, or by offering to pay for a Medicare supplement policy for you.

In the 1992 decision *James Maxa v. John Alden Life Insurance Co.*, the U.S. Court of Appeals for the eighth circuit considered a denial of group coverage for an insured who was eligible for Medicare. (As a note, the Age Discrimination in Employment Act did not apply here because the employer had fewer than 20 employees.)

In July 1984, at the request of Neil Maxa, president of H.R. Peterson Co., John Alden Life Insurance Company ("John Alden") instituted a group health benefit plan. Maxa, then 62 years old, was accepted by John Alden for group health insurance coverage as an employee of Peterson and received a certificate of group insurance and a brochure, each of which outlined in some detail Maxa's rights and responsibilities under the group plan. When Maxa turned 65, his insurance premium was reduced from $210 to $134. At that time, Maxa did not apply for Medicare benefits.

The Boss Didn't Enroll in Medicare

In early 1989, while still employed by Peterson, Maxa underwent a lengthy hospitalization and then died in June. John Alden paid only some of the hospital bills, claiming that Maxa should have enrolled in Medicare, and that John Alden was not liable under the terms of the plan for the bills which Medicare would have covered if Maxa had enrolled for Medicare.

Maxa's son, James, as personal representative of his father's estate, sued John Alden in September, 1990, alleging that the summary plan description was faulty, that John Alden breached its fiduciary duty by failing to notify Maxa upon his 65th birthday that his plan benefits would be reduced by the amount of the Medicare coverage he would receive if he were to apply for Medicare, and that the reduction of plan benefits was unlawful.

The district court wasn't persuaded, concluding that although the summary plan description may not have met the requirements of ERISA, there was not enough evidence that Maxa relied to his detriment upon that description.

The estate appealed, maintaining that none of the three sets of documents which Maxa received from John Alden could be considered a summary plan description. However, even though none of the documents was entitled "summary plan description," at least one, the certificate of group insurance, provided a benefits summary.

The estate also contended that the certificate of group insurance failed to meet the requirements of federal law, because its description of the Coordination of Benefits

provision was ambiguous. The COB provision read: "We will coordinate your Medical and Dental Benefits (if applicable) with benefits payable under other plans. The other plans are those which provide benefits or services in connection with medical or dental care or treatment through:Medicare (Parts A & B) when you are eligible for Medicare coverage. For purposes of determining your Medicare benefits, you will be deemed to have enrolled for all coverages for which you are eligible under Medicare (Parts A and B), whether or not you actually enroll.

The court found that while the COB provision wasn't crystal clear, it could reasonably be read to imply that benefit coverage would be reduced by the amount of Medicare coverage for which one is eligible. On the other hand, the court doubted that the summary plan description met the requirements of ERISA.

A Lack of Significant Reliance

Nevertheless, that was not enough to provide coverage. While Maxa's estate certainly appeared to have suffered a loss because he failed to enroll in Medicare, the estate would have to prove that the plan description caused him not to apply for Medicare. And the estate did not provide any direct evidence that Maxa failed to enroll in Medicare because of the language of the plan summary.

Even though the language of the group certificate did not state that applying for Medicare was absolutely necessary to assure total coverage—a reasonable person would conclude that he or she might have to enroll in Medicare in order to avoid a reduction of overall benefits, and, at the very least, there was no suggestion that there was no need to apply for Medicare.

Moreover, the reduction of Neil Maxa's premiums from $210 to $134 undercut the estate's argument because it should have brought to his attention the possibility that his benefits had been reduced.

With regard to the argument that John Alden breached its fiduciary duty by failing to notify Maxa on his sixty-fifth birthday that his benefits would be reduced and that he needed to enroll in Medicare in order to have full medical coverage, it was observed that most courts have not imposed upon an ERISA plan fiduciary any additional duty to notify participants and/or beneficiaries of the specific impact of the general terms of the plan upon

them, beyond providing the summary plan description. So the district court found in favor of John Alden.

Types of Groups

Group policies usually are issued to employers, where insurance is secured for the benefit of the employees. The employer is the policyowner, and establishes the eligible class of employees to be covered under the group policy. Usually this includes all full-time employees, but the eligible class of employees may also include retired employees (this is becoming less and less common).

Group policies may be issued to other groups such as labor unions or fraternal benefit societies. The usual requirements are that the group must have a constitution and bylaws, and be organized and maintained in good faith for purposes other than obtaining insurance.

Medical Expense Insurance

Medical expense insurance, commonly referred to as hospitalization insurance, provides benefits for expenses incurred due to in-hospital medical treatment and surgery as well as certain outpatient expenses such as doctor's visits, lab tests and diagnostic services. Hospitalization insurance may be issued as an individual or group policy. Benefits provided cover the individual and eligible dependents.

Contracts may provide for payment of medical expenses incurred on a reimbursement basis (by paying benefits to the policyowner), on a service basis (by paying those who provide the services directly), or a contract may provide for payment of an indemnity (by paying a set amount regardless of the amount charged for medical expenses).

Although there are many types of benefits available, medical expense insurance can generally be categorized as basic medical expense insurance, major medical insurance, comprehensive medical insurance and special policies.

Basic Medical Expense

Basic coverages provided by an individual medical expense policy include hospital expense, surgical expense and medical expense. These three basic coverages may be sold together or separately. Frequently

this is written as "first dollar" coverage, which means it does not have a deductible.

Hospital Expense

Hospital expense coverage provides benefits for daily hospital room and board and miscellaneous hospital expenses (not including telephone and television) while you are confined to the hospital. The policy may provide for a certain dollar amount for the daily hospital room and board benefit, although the trend is toward coverage of not more than the semi-private room rate unless a private room is medically necessary.

Room and board (R&B) rates will vary by geographical location but it is not unusual to find R&B rates ranging from $300—$500 per day or more. The hospital expense part of a basic medical expense policy accordingly would provide a R&B daily rate of a specified amount which may or may not be equal to the actual R&B expenses incurred.

For example, if your R&B benefit was $400 per day and the hospital actually charged $500 per day, you are liable for the $100 per day not covered by the policy.

In addition, there are normally time limitations associated with a basic medical expense policy. For example, benefits may be provided for only 30, 60 or 90 days, after which no further benefits would be provided unless you were subsequently hospitalized at a later date with a different ailment.

If you are confined to an intensive care unit of a hospital, then the R&B benefits will be increased. Normally, benefits for intensive care are at least twice the regular R&B benefit.

The miscellaneous hospital expense part of the basic hospitalization policy includes benefits for such things as surgical dressings, in-hospital drugs, charges for operating rooms, anesthetics, lab work, in-hospital diagnostic tests, etc. Except for the R&B charges and surgery, most other hospital expenses could be identified as miscellaneous expenses or hospital extras.

Usually miscellaneous benefits are limited to specific dollar amount ($2,000, $3,000, $5,000, etc). Most often the benefit is limited to a multiple of the plan's daily R&B benefit. For example, if the basic medical expense policy provides for a daily R&B benefit of $500, the miscellaneous benefit might be expressed as an amount

equal to ten or 20 times the R&B benefit or $5,000 or $10,000. Again, it should be noted that this is a limitation of the basic hospitalization plan in that only a specified amount may be paid for miscellaneous hospital expenses.

Generally, in-hospital miscellaneous expenses are very high. Depending on the reason for admittance to the hospital, you could exhaust a modest miscellaneous benefit of $5,000 in a matter of a couple of days.

Surgical Expense

Surgical expense coverage provides benefits for the surgical services of a physician performed in or out of the hospital. Surgical expense benefits are usually limited to a dollar amount, although they may be expressed as multiples of the hospital benefit maximum. Usually a schedule of operations is attached to the policy and the maximum amount payable for each operation is listed. The more serious and complicated the surgery the higher the benefit. Operations that are not listed on the schedule are covered and the limit that applies to them is determined by the insurer on a basis consistent with comparably listed operations.

Some surgical schedules do not list dollar amounts but assign a relative value unit to each procedure. For example, a schedule may be identified as a $1,000 schedule which basically means that the maximum benefit for a surgical procedure will be $1,000. Naturally, this maximum amount of $1,000 would be paid for the most serious types of surgery such as open heart surgery. All other surgical procedures would have a relative value in relation to this $1,000 schedule. This relative value would be expressed by a number and then multiplied by a conversion factor to arrive at the benefit to be paid.

To illustrate this point, let's assume that Stephanie is about to have her gall bladder removed. Her basic hospitalization policy has a $1,000 surgical schedule and gall bladder surgery has a relative value of 40. The schedule's conversion factor (which remains constant) is 20. Multiplying 40 by 20, results in a benefit of $800 for the gall bladder surgery.

Other Medical Expense

Hospital R&B, miscellaneous and surgical expenses incurred as an inpatient represent the major benefits

provided by a basic plan. Thus, if you were hospitalized due to a sickness or an accident, daily R&B charges, miscellaneous hospital expenses and surgical charges would be paid in accordance with the policy and its limitations.

Other medical expense benefits may be included as part of the policy or as options added to the policy. Following is a description of some of the more common policy benefits or options.

In-Hospital Physician Visits

Frequently, a basic hospitalization policy will include a daily benefit for expenses incurred when your physician visits him or her in the hospital. This benefit is limited to a dollar amount such as $25 or $30 per day. This amount would be paid for any charges made by the doctor for visiting the patient.

Emergency Accident Benefits

A basic plan may include a specific benefit for expenses incurred due to an accident when you are taken to the emergency room of a hospital as an outpatient. Typically, this benefit is stated as $300 or possibly, $500. The benefit is to cover the cost of treatment in the emergency room including physician expenses, X-rays, stitches, etc.

Maternity Benefits

Most often, maternity benefits are optional benefits which may be elected by you. As a benefit, maternity coverage is very expensive and to keep the cost of this benefit reasonable, the benefit amount is frequently very limited. For example, for an additional premium, you may add a maternity benefit of $1,000. This amount is the total benefit paid for prenatal care, delivery of the baby and the hospital confinement for mother and child due to the delivery.

Mental and Nervous Disorders

This benefit is usually part of the policy and covers expenses for outpatient mental and nervous disorders. Normally, this would include out-of-the-hospital therapy provided by a psychiatrist or clinical psychologist. The benefit is usually limited to a specific dollar amount per visit, such as $50. There is normally a lifetime maximum of $10,000 or possibly as high as $25,000.

Hospice Care

Most states require that any hospitalization policy (individual or group) include benefits for hospice expenses. The hospice is a facility designed to control pain and suffering of terminally ill patients until their death. It does not treat diseases nor does it attempt to cure. In addition, the hospice also provides counseling for the patient and the family of the terminally ill. Expenses covered include R&B, medication as well as outpatient services and expenses.

Home Health Care

This is usually an optional benefit which provides for reimbursement of expenses incurred by you for the services of a visiting nurse, a therapist or some other support-type person who due to a medical necessity, visits you in your home and provides necessary medical services.

Outpatient Care

Outpatient care refers to expenses incurred by you for doctor's office visits, out-of-the-hospital diagnostic services such as lab work and X-rays. Often a basic medical expense policy only covers in-hospital expenses (inpatient) whereby treatment is provided to the patient who has been assigned a room and a bed and is staying in the hospital for some period of time. Basic plans may add coverage for certain medical services provided to you as an outpatient.

In summary, it is clear that basic medical expense plans have time and/or benefit amount limitations. Thus, you may well expect to have to pay a considerable amount out of pocket for medical expenses. The solution to this problem is another type of hospitalization coverage referred to as major medical insurance.

Major Medical Insurance

Unlike basic medical expense policies with benefit amount limitations, major medical coverage is designed to provide a large sum of money from which to pay covered medical expenses. Sometimes, major medical insurance is referred to as catastrophic health insurance because its focus is on large, catastrophic medical expenses. Major medical policies may be issued as individual coverage or as a group hospitalization plan. Major medi-

cal is characterized by deductibles, coinsurance and large benefit maximums.

Deductibles

Major medical benefits begin to be paid after the deductible is satisfied. The policy's deductible is usually between $100 and $500; although higher deductibles are not that uncommon. The deductible is considered satisfied as long as you can show evidence of having incurred the necessary expense.

For example, let's assume that a major medical policy contains a $500 deductible. You have no other medical expenses and are hospitalized for surgery. Your total hospital bill is $7,500. Of this amount, $7,000 would be eligible for major medical benefits and $500 would be identified as the deductible amount. Thus, you have incurred an expense equal to the deductible. Notice that payment of the deductible is not necessary; only incurring the expense is required to satisfy the deductible.

The deductible may be identified as a per cause deductible or a calendar year deductible. Each of these applies to each covered person. The per cause deductible requires that a deductible be satisfied for each separate claim. The calendar year (all cause) deductible specifies that one deductible needs to be satisfied for a calendar year period regardless of the number of claims.

Most policies provide that if a family is insured, a maximum of two or three deductibles will satisfy the deductible requirement for the entire family for a year.

Also related to the family situation is the common accident provision which states that if members of a family are injured in a common accident, only one deductible applies.

Most major medical policies will contain a carry over provision. This provision usually stipulates that if you had no claims during the year but incur medical expenses in the last three months of the year, these late year expenses may be carried over to a new calendar year and applied to the new year's deductible.

Coinsurance (Percentage Participation)

Most policies have a coinsurance provision. Under its terms, all expenses in excess of the deductible are shared on some basis between the insurance company and you.

In a great many policies expenses are shared on an 80/20 basis. The insurer pays 80 percent, you pay 20 percent. Other coinsurance percentages encountered are 75/25 and 85/15.

Out of Pocket Limit

The out of pocket limit is the maximum amount you will be required to pay during a policy year. After you have paid out a predetermined amount the insurer will pay 100 percent of covered expenses for the remainder of the year, up to the policy limit.

A major medical policy may reflect a $500 deductible followed by 80/20 coinsurance on the first $5,000 of covered expenses. If expenses exceed $5,000, the insurer pays 100 percent, because your out of pocket limit will have been reached. Basically, this means that you would be expected to incur the $500 deductible and 20 percent of $5,000 of medical expenses or an additional $1,000. Thus, you would be liable for a maximum expense of $1,500—regardless of how large the claim might be.

If a major medical claim was exactly $5,500, you would be liable for $1,500 or approximately 27 percent of the entire amount. On the other hand, if the claim totaled $105,500, you are still responsible for $1,500 which represents only a little more than 1 percent of the entire claim.

Frequently, this out of pocket limit is also referred to as your stop loss, which is the point at which your loss (coinsuring the claim) stops and the insurer assumes responsibility for 100 percent of the claim. Thus, in the previous example, the stop loss limit is $1,500.

Maximum Benefit

Major medical plans include a maximum benefit which applies on a "lifetime" basis, "per person." The maximum benefit is usually substantial, such as $500,000 or $1 million. Each member of an insured family is separately insured for the maximum benefit amount.

Restoration of Benefits

Most major medical policies have a restoration of benefits provision. If a claim is paid, the total amount of insurance is reduced by the amount of the claim. A policy with a $250,000 limit and a $10,000 claim, would only have $240,000 of coverage after that claim had been paid. The restoration of benefits feature restores a certain amount

of coverage, such as $2,500 or $3,000 each year to replace, in effect, the coverage lost as a result of the claim.

Covered Medical Expenses

The coverage provisions of major medical policies are very broad. One way of looking at a major medical policy is to consider that the insurer has opened a bank account in your name and almost all of your medical expenses pass through this account. The term, "covered expenses", usually includes doctors' fees, nursing fees, hospital R&B charges, miscellaneous expenses, surgical expenses, out of the hospital expenses such as doctor's office calls, prescription medication, diagnostic services, etc. These expenses are covered in accordance with the policy's deductible and coinsurance provisions up to the policy's maximum benefit.

Limits of Coverage

The limits of coverage are also established by the concept of reasonable and customary charges (also referred to as usual, customary and reasonable—UCR). These charge or expense factors represent the average charge in a given geographical area for the medical service provided. These factors are adjusted periodically to reflect changes. A major medical policy might specify that it will pay the reasonable and customary charges for various covered medical expenses up to the policy's lifetime maximum of $1 million.

This does not imply that the policy will pay all of your medical expenses. It states it will pay what is reasonable and customary, and there may be inside limits; limits which apply to particular types of expense such as hospital room and board and surgery. The inside limit may be expressed as a maximum dollar amount. Inside limit amounts are higher than the amounts allowed under basic medical expense policies.

For example, David has his tonsils removed. The surgeon's fee is $750. However, upon review by the insurer, it is determined that the reasonable and customary charge for a tonsillectomy is $550. Thus the covered expense is $550 subject to the policy's deductible and coinsurance provisions. If the policy also had an inside limit of $500 for a tonsillectomy, that would be the most it would pay.

Supplemental Major Medical

In the past, major medical policies were frequently sold as supplemental coverage. The insured person had a basic medical expense plan which paid specific dollar amounts for various medical services. These amounts were often referred to as "first dollar" benefits because there were no deductibles or coinsurance features and the basic plan covered expenses up to these first dollar limits.

However, as medical expenses soared, the basic medical expense plan quickly exhausted its benefit limits and the insured was in need of additional coverage. These additional benefits were often provided by a major medical policy which was initially designed to supplement the basic plan so that when basic benefits were reduced or used up, the supplemental benefits would pick up where the basic plan left off.

Today, due to the high cost of health care and the high cost of hospitalization insurance, most employers and individuals will carry major medical plans as their main source of health care insurance. Because of the deductibles, coinsurance features and lack of first dollar benefits, major medical plans are typically less expensive. The higher the plan's deductible, the lower the premium. The higher the stop loss point with regard to coinsurance, the lower the premium.

For example, a major medical plan with a $500 all cause deductible and 70/30 coinsurance on the first $10,000 of covered medical expenses will be less costly than a first dollar plan or a major medical plan with a $100 deductible and 80/20 coinsurance on the first $2,500 of covered medical expenses.

Comprehensive Medical Expense

Comprehensive medical expense insurance is a combination of basic medical expense coverage (first dollar coverage) plus a major medical plan. Both major plans are simply combined into one policy. The basic part of the plan provides first dollar coverage, usually without any deductibles or coinsurance features. Once the basic benefits are exhausted, the major medical portion of the plan kicks in subject to a corridor deductible and coinsurance provisions.

For example, assume that Keith has a comprehensive medical policy which provides 100 percent coverage of the

first $10,000 of medical expenses followed by a deductible of $100 and a $1 million major medical plan with 80/20 coinsurance on the next $5,000 of medical expenses with 100 percent paid thereafter. Keith incurs medical expenses totaling $11,100. His plan would pay as follows:

Keith's plan would cover $10,800 of the total expenses. It pays the first $10,000. Keith then pays the $100 deductible. The plan then pays 80 percent of the $1,000 balance and Keith pays 20 percent, or $200. Thus, Keith pays a total of $300.

Comprehensive plans will pay considerably more benefits in a typical situation than a basic hospitalization policy and slightly more benefits than a major medical plan. However, the inclusion of the block of first dollar benefits under the basic part of the comprehensive plan is expensive. This premium difference is often large enough to motivate many people to simply purchase a major medical plan with a reasonable deductible and a more reasonable premium.

Medical Expense Limitations

Medical expense policies frequently provide limited coverage or benefits for certain medical conditions, as outlined below.

- *Mental or Emotional Disorders.* Lifetime benefit amounts are limited for outpatient treatment of these disorders. For example, a major medical policy may have a lifetime maximum of $1 million but the policy may limit coverage for outpatient treatment of mental or emotional disorders to a lifetime benefit of $25,000. In addition, frequently there may be a limitation with regard to the number of outpatient psychiatric visits per calendar year (such as a maximum of 26 visits per year) and/or the benefit amount paid per visit (such as a maximum benefit of $50 per visit or coverage for no more than 50 percent of the actual charges). These limits would not apply to inpatient treatment of mental or emotional disorders.

- *Substance Abuse.* Outpatient treatment for drug or alcohol problems is usually limited in much the same way that nervous or emotional disorders are covered. Usually, if you are hospitalized as an inpatient for treatment of the substance abuse problem, then regular medical expense benefits would be payable.

- *Chiropractic Services.* The treatment rendered by a chiropractor is normally a covered expense subject to a limitation with regard to total benefits (ie. $10,000 lifetime) or a limitation with regard to the number of visits that will be covered in a given year and/or the amount that may be paid per visit.

- *Preexisting Conditions.* Generally, a preexisting condition is any condition for which you sought treatment or advice prior to the effective date of coverage. Many policies contain a preexisting conditions limitation which excludes coverage for unspecified conditions for a period of time (usually six months). If an insurer wants to permanently exclude a preexisting condition, it usually has to specify the condition by name in the issued policy. Depending on the severity of the condition, it may be permanently excluded or temporarily excluded (ie., the first 12 months following the effective date of coverage). Seldom is a preexisting condition covered by means of limited benefit amounts. Generally, it is either excluded or covered in full as any other condition.

Other Limitations

In past years, many health insurance contracts placed limitations on the kind of provider who could perform covered treatments and services. In many cases, coverage was limited to treatment rendered by a "physician." In effect, this eliminated coverage for treatments rendered by chiropractors, midwives, and other nontraditional healers.

In recent years, many alternative providers who are subject to state licensing or standards of conduct have been recognized as qualified health care providers. Use of alternative providers can help to minimize health care costs and reduce the demand on hospitals and doctors. Under current laws in many states, policies must provide benefits for services given by various providers if benefits would be payable for the same services when given by a physician. These include:

- chiropractors,
- optometrists,
- opticians,
- psychologists,

- podiatrists,
- clinical social workers,
- dentists,
- physical therapists, and
- professional counselors.

Medical Expense Exclusions

Medical expense policies contain many exclusions that are found in all health and disability policies: preexisting conditions, war, intentionally self-inflicted injuries, and active military duty. Exclusions which are common in medical expense policies include:

- workers compensation,
- government plans (care in government facilities),
- well-baby care,
- cosmetic surgery,
- dental care,
- eyeglasses,
- hearing aids,
- routine physicals and medical care.

Optional Features & Benefits

Prescription Drugs

The prescription drug benefit is most often found in group health insurance policies. Some individual health insurance policies offer this benefit as a rider. Usually prescription drug coverage requires a small deductible of typically $2, $3 or $5.

A prescription drug benefit generally works one of two ways. Either insureds can be reimbursed for their prescription drug expenses using standard claim forms, or a prescription drug card can be issued. A prescription drug card allows prescriptions to be paid for by paying only the deductible with each prescription purchase. The pharmacy bills the insurer issuing the card directly for the prescription.

For example, Sally has a prescription drug card as part of her group medical plan which has a $5 deductible per pre-

scription. Her doctor prescribes two medications for a serious cold. Each of these medications would cost Sally $5. The balance of the prescription cost will be billed to the insurer by the pharmacy.

Vision Care

Vision care includes eye examinations (refractions) and eyeglasses. Although not a very common benefit, it occasionally is offered as an optional benefit under group health insurance. Generally, this option will pay a specific amount or the entire cost of an annual eye examination. It normally also covers all or part of the cost of prescribed eyeglasses once in every two-year period.

Hospital Indemnity Rider

A hospital indemnity benefit provides for the payment of a daily benefit for each day that you are hospitalized as an inpatient. Available amounts are usually $50 to $100 per day or possibly slightly higher. In addition to any other medical benefits paid to you, the hospital indemnity benefit will pay the daily amount as long as you are hospitalized, usually for a benefit period of one or two years.

Nursing/Convalescent Home

Under this benefit, a daily maximum amount is paid for each day you are confined to a nursing or convalescent home after a hospital stay. Benefits are paid generally for as short as one month or up to one year.

Organ Transplants

More and more insurers are offering this coverage as it becomes less experimental and more commonplace. To provide coverage, many insurers require that a transplant must only be performed for life-threatening situations. Some of the more commonly covered transplants include bone marrow and kidney.

Dental Expense

Dental insurance usually is offered only under group plans. It is most often excluded from medical expense insurance. Under group insurance it is usually offered as optional coverage.

Expenses Covered

Dental insurance may be covered under the benefits of a major medical plan on a scheduled or nonscheduled

basis, in which case the dental coverage and medical coverage would be an integrated plan. The deductible amount can be met by either dental or medical expenses.

Dental expenses offered as an optional benefit (nonintegrated plan) may also be either scheduled or nonscheduled. A nonscheduled plan is paid on a usual, customary and reasonable basis (UCR). A scheduled plan has specific categories of dental treatment and dollar amounts are set for each category of dental care. The scheduled plan reimburses dental charges only up to the maximum amount specified on the schedule as to each covered service. A schedule would list the following categories:

- preventive care,
- diagnostic care,
- restoration (which includes fillings, inlays, and crowns),
- prosthodontics (which concerns bridgework),
- oral surgery,
- periodontics (treatment of gum problems),
- endodontics (treatment of problems with dental pulp, or root canals),
- orthodontics.

The scheduled maximum amounts differ from one part of the country to another. This difference in the amount of benefit payable on a particular procedure is based on the difference in dental costs throughout the nation. Dental costs in New York City, New York would be higher than dental costs in Des Moines, Iowa. There are many reasons for this, including, the higher office rents in New York than in Iowa.

Limits

Limitations usually apply to prophylaxis (preventive care), no more than two, and only one fluoride treatment during any 12-month period. A bridge or denture will not be replaced within the first five years, except under special conditions. A kind of preexisting condition for dental coverage is the fact that teeth missing prior to the effective date of coverage will not be covered, or, if covered, your copayment will increase.

Coinsurance and Deductible Provisions

Most dental plans have a deductible amount (e.g., $25, $50, $100) which must be met each calendar year. If the plan also covers the cost of preventive care, the deductible often does not apply to treatment for prevention (e.g., cleaning and routine examinations).

Most dental plans, as with most medical plans, have a coinsurance feature. That is, you pay some percentage of the dentist's charge, and the plan pays a percentage.

The plan will generally pay a maximum amount per calendar year (e.g., $500, $1,000, $5,000).

Dental services which are for cosmetic purposes, or are not considered to be standard procedure are usually not covered, except in rare instances, as when such benefits are offered to key employees or company executives.

Prepaid Dental Plans

Prepaid dental plans operate in much the same way as health maintenance organizations. Subscribers must have the right to select any participating dentist as a provider. The dentists are paid (other than the copayment or deductible) by the prepaid dental plan. Provider contracts are subject to state laws designed to protect enrollees from becoming liable for services the prepaid dental plan fails to pay because of insolvency.

All enrollees must receive an evidence of coverage describing the dental services covered, limitations on those services (including deductibles and copayments), how to obtain services and information, and methods for resolving complaints.

Health Insurance Policy Provisions

All 50 states have enacted the provisions of the Uniform Policy Provisions Law, developed by the National Association of Insurance Commissioners. The law includes 12 mandatory provisions that must be included in individual health insurance policies and 11 optional provisions. The optional provisions are not required to be included in the policy, but if the subject of any of them is contained in the policy, it must be worded in accordance with the wording of the appropriate optional provision. An insurer may reword any of the mandatory or optional provisions so long as the new wording is not less favorable to you or to

the beneficiary. You can usually find the mandatory provisions in your policy under a section entitled Mandatory or Required Provisions.

Mandatory Provisions

Entire Contract

This provision states that the policy, including riders and attached papers (such as the application) constitutes the entire contract. This is to ensure that you (the policyowner) have a copy of the entire contract and can't be surprised by changes made later. The provision also states that the contract cannot be modified unless the change is authorized by an officer of the insurance company and attached to the contract. Just as in life insurance, your agent cannot change any of the policy provisions.

Time Limit on Certain Defenses

The purpose of the time limit on certain defenses provision is to limit the period of time in which an insurer may challenge the contract or deny a claim on grounds of material misrepresentation in the application. This provision is similar to an incontestable provision in an individual life insurance contract.

Your health insurance policy may not be contested regarding any statement on the application, nor may a claim be denied, after the contract has been in force for two years (three years in some states). No material misrepresentation can void the health insurance contract after it has been in force for two years except for fraud. Fraud can void the health insurance contract whenever it can be proven by the health insurer.

The insurer cannot deny a claim on the basis of preexisting conditions after expiration of a two-year time limit, unless the condition was excluded from coverage under the policy by name or specific description. A preexisting condition is one that existed before the effective date of the policy, such as heart disease.

Grace Period

The grace period provision gives you additional time in which to pay the premium, keeping the insurance in force for a certain period of time after the premium is due but unpaid, protecting you from unintentionally lapsing your

coverage. The extra time allowed is seven days for weekly premium policies, ten days for monthly premium policies and 30 or 31 days for all other policies.

If a policy contains a cancellation provision, a reference to the cancellation provision may be made in the grace period provision. If a policy provides that the insurer reserves the right to refuse renewal of a policy, an additional provision allows the insurer to avoid the grace period provision by giving notice of its intention not to renew.

Reinstatement

Similar to life insurance, the reinstatement provision allows you to put a policy that has lapsed for nonpayment of premiums back in force. If no application for reinstatement is required, usually acceptance of the past due premium by the insurer will reinstate the policy.

If an application for reinstatement is required, you must prove insurability and pay all past due premiums plus interest and submit the application and premiums to the insurer. Reinstatement is effective when the insurer notifies you. However, if you haven't received approval or disapproval from the insurer within 45 days of the date you apply for reinstatement, the policy will be automatically reinstated after the forty-fifth day. A reinstated policy covers accidents immediately. However, there is a ten day probationary (waiting) period for coverage of any sickness under a reinstated policy. This means that any sickness must begin after the policy has been in force for ten days.

Notice of Claim

You must must give written notice of a claim to your insurer or agent within 20 days of the loss or as soon as reasonably possible. In the case of a disability income benefit payable for at least two years, notice of claim regarding the continuance of the disability may be required every six months. If the nature of the disability is such that you are legally incapacitated, that is, unable to satisfy this requirement due to physical or mental disability, then the continued notice of claim requirement would be waived.

Claim Forms

This provision requires the insurer, after it has been notified of the claim, to furnish claim forms to you within 15 days. If the forms are not furnished, then you should submit written proof of the occurrence, character, and extent

of the loss and you will be deemed to have complied with the requirements of filing proof of loss.

Proof of Loss

The proof of loss provision limits the time within which you may file a written proof of loss. A proof of loss is a formal statement given to the insurer regarding a loss. It may include a doctor's statement or death certificate. Proof of loss must be filed within 90 days of loss or, in the case of a continuing loss, within 90 days after the end of a period for which the insurer is liable. If you cannot comply with these requirements, proof of loss must be filed within a reasonable time not exceeding one year. In the event of legal incapacity there is no time limit on filing a proof of loss.

Time of Payment of Claims

Claims must be paid immediately upon receipt of proof of loss except for periodic payments, which are to be made as specified in the policy or made at least monthly. Balances unpaid when the claim terminates shall be paid immediately upon receipt of due proof of loss.

Some states have substituted a specific number of days in place of the word, "immediately." In some states, immediately means within 30 or 60 days of receipt of the proof of loss.

Payment of Claims

The payment of claims provision specifies to whom the policy's benefits will be paid. Benefits may be paid to a named beneficiary or to your estate if there is a death benefit to be paid under the health insurance policy, such as an accidental death benefit.

Normally, the health insurance benefits are paid to you (or to the loss payee; that is, the person who has experienced the loss). Often medical expense benefits payable under a health insurance policy may be paid to the provider of the medical care if you have executed an assignment form. The assignment authorizes the insurer to pay benefits directly to the provider of the medical services, such as a physician or a hospital.

Insurers may add either or both of two optional provisions. The first optional provision provides that if no beneficiary is named or if the named beneficiary is legally incapable of signing a valid release (such as a minor or

legally incompetent person), the insurer may pay an amount specified in the provision not to exceed $1,000 to any relative by blood or marriage of you or to the beneficiary who is deemed by the insurer to be equitably entitled thereto. This is usually referred to as a facility of payment clause.

The second optional provision gives the insurer the option of making payments for medical, surgical and nursing expenses to the person or hospital rendering the services.

Physical Examination and Autopsy

The physical examination and autopsy provision allows the insurer, at its own expense, to examine you while a claim is pending, and in the event of death to perform an autopsy, at its own expense, where not prohibited by law.

Legal Actions

The legal actions provision restricts the time period during which you may bring legal action against your own insurance company. This provision requires that no legal action to collect benefits may be started sooner than 60 days after the proof of loss is filed with the insurer. This waiting period allows the insurer time to evaluate the claim. The insurer may also not be sued later than three years after the time that the proof of loss is required to be filed.

Change of Beneficiary

If an individual health insurance policy provides a death benefit, it must also provide a change of beneficiary provision. This provision gives the policyowner, unless he or she has made an irrevocable designation of a beneficiary, the right to change beneficiaries or make any other change without the consent of the beneficiary or beneficiaries.

Optional Provisions

There are "optional" provisions that, if covered by the policy, must be worded in accordance with the wording specified in the law. An insurer may use other wording not less favorable to the policyowner, subject to approval by the state Insurance Department.

Change of Occupation

Your occupation is important underwriting factor especially as it would pertain to disability income insurance. Disability income policies are partially rated on the degree of risk inherent in your occupation. For example, a police officer would pay a higher premium than a doctor because of the more hazardous nature of the police officer's occupation.

If this provision is contained in the policy it allows the insurer to adjust policy benefits if you have changed to a more hazardous occupation.

Conversely, this provision will also allow you to notify the insurer if you change to a less hazardous occupation in which case your premium would be reduced.

Misstatement of Age

If you have misstated your age on the application for health insurance, this provision allows for an adjustment of the benefit payable. All amounts payable under the policy will be adjusted to the amount that the premium would have purchased at your correct age.

Other Insurance

This provision is designed to limit problems of overinsurance with the same insurer, and is most often found in disability income policies in order to discourage a person from purchasing several disability income policies (with the same insurer) which could make a disability very profitable! Remember most insurers limit the amount of disability income which may be purchased to 60 to 70 percent of your gross earned income, as an encouragement to return to work.

There are two versions of this provision. The first enables the insurer to place a cap on benefits received from all similar policies with the same insurer.

The second version of this option allows you (or your estate) to select which policy or policies are to be kept in force. The remaining policies will be voided and the premium refunded.

There is also the possibility of overinsurance when you have similar coverage with more than one insurer. If you have other valid policies with other insurers, and the other insurers are unaware of the other policies before a claim occurs, benefits may be limited to a proportion of

the total loss or claim. This is designed to keep insureds from profiting from an insurance claim.

Relation of Earnings to Insurance

The relation of earnings to insurance provision is concerned with overinsurance for disability benefits, so that an insured will not receive more money from disability insurance than he or she would receive from working. The provision may only be used in noncancellable and guaranteed renewable contracts. The provision states that if at the time the disability begins, your total disability income exceeds your earned income, or average earned income for the preceding two years, the disability income benefits will be reduced proportionally. Premiums for any excess coverage will be refunded to you.

Unpaid Premium

This provision allows deduction of unpaid premiums from claim payments. Upon the payment of a claim, any premium then due and unpaid may be deducted.

Cancellation

This provision allows the insurer or you to cancel the policy with proper written notice. If the insurer cancels the policy, the notice of cancellation cannot take effect until at least five days from receipt of the notice. In reality, most insurers will provide for cancellation of the policy 30 days after receipt of the cancellation notice. If the insurer cancels the policy, you are entitled to a pro rata return of the unearned premium. Since premiums are paid in advance, the actual premium earned by the insurer may be retained but any unearned premium must be returned to you.

You may also cancel the policy with proper written notice. The effective date of such cancellation will be the date the notice is received by the company or the date specified in the cancellation notice. When you cancel a policy, the insurer may keep any earned premium plus a portion of unearned premium. Since the insurer can keep part of the unearned premium, the refund to you is referred to as a short rate return.

Conformity with State Statutes

This provision amends the policy to conform to minimum requirements of state law, if necessary. Any provision of a policy which, on its effective date, is in conflict with the

statutes of the state in which you reside, is amended to conform to the minimum requirement of the statutes.

Illegal Occupations

Under this provision, liability is denied if loss results from your committing or attempting to commit a felony or from your engaging in an illegal occupation.

Intoxicants and Narcotics

This provision states that the insurer is not liable for any loss resulting from your being intoxicated or under the influence of any narcotic unless administered on the advice of a physician.

It should be noted that treatment for substance abuse is a covered expense under a health insurance policy. The optional exclusion only relieves the insurer of responsibility for a loss caused by drug or alcohol use.

Other Health Insurance Provisions

The Policy Face

The face of the policy is a standard printed form containing the name of the insurance company and providing enough information to give you a capsule summary of what type of policy and what type of coverage is provided by the contract. The policy face identifies you and states the term of the policy (when it goes into effect and when coverage expires). It also states how the policy can be renewed.

The policy face usually gives a brief statement of the type or types of benefits. However, it is essential to examine the benefit provisions within the body of the contract to obtain a complete understanding of the coverage provided.

Free Look

Many states now require that health policies contain a clause allowing the policyholder a period of ten days (or even 30 days) from date of receipt of the issued policy in which to inspect it and, if dissatisfied for any reason, return it for a full refund. If you do cancel, the company is not liable for any claims originating during the free-look period.

Insuring Clause

The insuring clause represents the insurer's promise to pay benefits and the conditions under which these benefits will be paid. This clause further identifies the insurer and the insured, and states what kind of loss is covered. An example of an insuring clause would be:

The insurer, ABC Mutual, agrees to pay disability income benefits to the insured upon receipt of proof of loss and the timely payment of premiums by the insured. All benefits will be paid in accordance with the policy's provisions contained herein.

Consideration Clause

Consideration means giving something of value as part of a contractual agreement. The insurer agrees to provide something of value (policy benefits) in exchange for value received from you; this value being the premium and the statements on the health insurance application.

Renewability Clause

The renewal provision, which contains the terms and conditions for renewal of the policy, must appear on the first page of the policy. Renewal provisions vary, but they can be categorized into five types.

Cancellable. A health insurance policy which is cancellable may be canceled at any time with proper written notice from the insurer and a refund of any unearned premium. Cancellation of the policy does not relieve the insurer of any claim's responsibility. If you are in the midst of a claim at the time the policy is cancelled, the insurer must continue to honor the claim. (This type of renewability is not very common.)

Optionally Renewable. The insurer may elect not to renew the policy for any reason or no reason at all. If the election of nonrenewal is made, it can only be exercised on the policy's premium due date or the policy's anniversary. The policy's anniversary date is the "birthday" of the policy; that is, the anniversary of the policy's effective date. The insurer can also elect to renew the policy on the anniversary and it may also increase the policy's premium.

Conditionally Renewable. This provision is very similar to the optionally renewable provision. The primary difference is that a conditionally renewable policy may be cancelled for specific conditions contained in the policy.

Optionally renewable policies basically do not require a policy condition or any reason for cancellation. Premiums may also be increased on the policy's anniversary date if the policy is to be renewed.

Guaranteed Renewable. This type of renewability guarantees that you have the right to continue the policy in force until a specified age by timely payment of the premiums. The insurer cannot refuse to renew the policy. What is not guaranteed is the premium. The insurer has the right to increase the premium on each policy anniversary. However, premiums may be increased but only for the entire class of insureds, not for an individual. This is a very common form of renewability, especially in hospitalization policies.

Noncancellable. A noncancellable policy is one which provides for the guarantee of both renewability and the premium. The insurer cannot cancel the policy or increase the premium. This type of renewability is most common with some forms of disability income policies.

Thus, there are two types of renewability which guarantee that the policy cannot be cancelled by the insurer— guaranteed renewable and noncancellable. However, under either type of renewability, the guarantee not to cancel typically only applies until age 65. At age 65, if you own a medical expense policy, you become eligible for Medicare and normally, the medical expense policy will not be renewed. If you own a disability income policy, the policy will only be renewed beyond age 65 if you provide evidence that he you are still working at a full time job. In this situation, the policy may be renewed for one year periods from age 65 to age 70 or 72.

Finally, it should be noted that the only the noncancellable type guarantees that its premium cannot be increased. All other renewability provisions allow the insurer to increase premiums on the policy's anniversary.

In any type of health insurance, when renewal is denied, you must be given a written explanation for nonrenewal or be notified that the explanation is available upon written request.

Benefit Payment Clause

This clause describes the type of benefits provided by the policy and the circumstances under which they will be paid. Often information on the specific benefit amounts,

duration of the benefit and elimination periods is contained in a benefit schedule, which is a detachable page appended to the policy.

Certain benefits, referred to as mandated benefits, are required by state law to be included in certain types of policies. Examples of mandated benefits include coverage of newborn children, and coverages for mental, emotional or nervous disorders. Some benefits must be provided as options, such as optional coverage for obstetrical services or for alcohol and drug dependence.

Exclusions and Reductions

An exclusion or exception is a provision that entirely eliminates coverage for a specified risk. A reduction is a decrease in benefits as a result of specified conditions.

Most health insurance policies exclude war and act of war, self inflicted injuries, aviation, military service and overseas residence. Benefits will not be provided if the cause of a loss is due to military service, a war or civil disorder, a self inflicted injury such as an attempted suicide, or if the loss is due to aviation as a pilot. If you expect to live overseas, or if you fly your own private plane, you will need to talk to your insurance agent and purchase additional insurance coverages or riders.

Generally, coverage is temporarily suspended if an individual resides in a foreign country for a specified period of time or if the individual is serving in the military. Coverage is reinstated or reactivated when you return to the United States or are no longer serving in the military.

Preexisting Conditions

Preexisting conditions can be excluded from coverage under a health insurance policy. This exclusion may be permanent or temporary. A preexisting condition is usually defined as any condition for which the insured (you) sought treatment or advice prior to the effective date of the policy.

Further, a preexisting condition can also be defined as any symptom that would cause a reasonable and prudent person to seek diagnosis and medical treatment. This concept prevents an applicant who suspects that he or she may have a serious medical problem from buying health insurance and then going to a doctor for diagnosis and treatment.

Preexisting conditions may be covered by the insurer if they are indicated on the application. The insurer will then review the medical information and depending on the condition may elect to cover the problem or exclude it. Usually, only serious or chronic conditions will be excluded.

A Preexisting Condition Dispute

In its 1990 decision *Janet Fuglsang v. Blue Cross of Western Iowa and South Dakota, et al.,* the Supreme Court of Nebraska offered a good explanation of how preexisting conditions exclusions work in group health insurance policies.

Janet Fuglsang was diagnosed on July 1, 1986, as suffering from myasthenia gravis, a disease which affects different muscle groups of the body and results in weakness, but not in sensory loss or pain.

Earlier in the year, in January, Fuglsang had seen Dr. Tom Surber, a family physician in Norfolk, Nebraska. She complained of difficulty with swallowing, chewing, and moving her tongue, and weakness of the muscles of the arms and legs. Surber knew that Fuglsang was taking a thyroid medication. A series of tests indicated that there was not enough thyroid medication in her body, so Surber adjusted her medication and advised Fuglsang to let him know if she did not feel better.

Fuglsang felt fine from February through May, but the symptoms returned sometime in June. She contacted Surber again and he referred her to a Dr. Simons, who hospitalized her and referred her to a neurologist. When he noted her symptoms, the neurologist's diagnosis was that she had myasthenia gravis.

At trial Blue Cross asked several questions of the neurologist designed to find out whether Fuglsang's myasthenia gravis existed or could have been diagnosed in January 1986. The central issue in the trial was whether the myasthenia gravis was in fact a preexisting condition which relieved Blue Cross from liability under the terms of the policy. The trial court sustained several of Fuglsang's objections to these questions, and, thus, the neurologist was not allowed to answer them.

Blue Cross contended that Fuglsang's condition existed prior to her effective coverage date, and it therefore denied coverage under policy provisions that restricted

her coverage for preexisting conditions until she had been a member for 11 consecutive months. Preexisting condition was defined as "any illness or injury or other condition for which medical or surgical treatment or advice was rendered within one year prior to said person becoming a Member."

Suing Over When the Policy Took Effect

Fuglsang sued Blue Cross, arguing that coverage—which she'd obtained through her employer—had begun in February 1986. Blue Cross argued that the policy became effective in June 1986. The trial court ruled in favor of Fuglsang and ordered coverage plus damages and attorney fees. The entire award totalled a little over $40,000.

Blue Cross appealed, arguing that the trial court had made a number of mistakes; among them excluding expert medical testimony of whether Fuglsang suffered from myasthenia gravis prior to the effective coverage date of the policy and whether the condition could have been diagnosed prior to the coverage date,

But the Nebraska Supreme Court ruled that: "Whether coverage commenced in February or June makes little difference in this case, for Blue Cross argues that Fuglsang's condition existed and was capable of diagnosis as early as January 1986, prior to both of the asserted coverage dates."

The neurologist would have testified, if allowed, that myasthenia gravis possibly could have been diagnosed in January 1986; that there was a possibility that Fuglsang's condition was related to her thyroid problem, which could, to some extent, mimic symptoms of myasthenia gravis; and that Fuglsang probably did have myasthenia gravis then, but one could not be certain and could also suspect other things such as hypothyroidism.

Blue Cross argued that the law in Nebraska is that a disease exists not when it becomes known to the insured, but when it becomes manifest. The court declared that those terms are actually synonymous. This serves the dual purpose of protecting insurers from fraudulent applicants seeking coverage for known diseases while protecting innocent premium-paying insureds from being deprived of benefits for preexisting conditions of which they have no knowledge.

Not only did Fulglsang get to keep her original award, she was awarded another $2,500 for attorneys fees incurred by Blue Cross's appeal.

Waiver of Premium

Under this provision, the insurer waives premium payments after you have been totally disabled (as defined in the policy) for a specified period of time, usually three or six months. If you remain totally disabled, no further premium payments will be required. The insurer will pay the premiums until you reach age 65 and become eligible for Medicare. If you recover from the disability, then you resume paying the premiums.

Case Management Provisions

In order to control the costs associated with medical care, many insurers are instituting methods to reduce costs while giving you options for health care. The second surgical opinion is a provision that can be included in policies that offer surgical expense benefits. This coverage allows you to consult a doctor, other than the attending physician, to determine alternative methods of treatment. While the use of this provision is sometimes optional, it is more often mandatory for certain procedures, such as tonsillectomy, cataract surgery, coronary bypass, mastectomy, and varicose veins. Some insurance companies have medical examiners review claims, and the examiner's decision to approve or deny a claim is considered the required second opinion.

One cost control mechanism being used by insurers and employers is utilization review. Utilization review consists of an evaluation of the appropriateness, necessity, and quality of health care, and may include preadmission certification and concurrent review.

Under the precertification provision (or precertification authorization) the physician can submit claim information prior to providing treatment to know in advance if the procedure is covered under your plan and at what rate it will be paid. This way both the physician and you know in advance what the benefit will be and can plan accordingly. This provision allows the insurance company to evaluate the appropriateness of the procedure and the length of the hospital stay.

Under the concurrent review process the insurer will monitor your hospital stay to make sure that everything is

proceeding according to schedule and that you will be released from the hospital as planned.

Recent evidence has shown that many treatments can be satisfactorily provided without the need for a hospital stay. Ambulatory outpatient care is the alternative to the costly inpatient diagnostic testing and treatment, and is usually offered through hospital outpatient departments. However, this care can be provided by special ambulatory care health centers, group medical services, hospital emergency rooms, multi-specialty group medical practices, and health care corporations. These ambulatory facilities provide, in addition to diagnosis and treatment, preventive care, health education, family planning, and dental and vision care.

Group Insurance Policy Provisions

Conversion Privilege

The conversion privilege allows you to convert your group coverage to individual coverage without having to provide evidence of insurability. This privilege goes into effect only when you are no longer eligible for group coverage when:

- your employment is terminated, or

- you become ineligible for coverage because the "class" you were insured under is no longer eligible for coverage.

(For example, to save expenses, a company that formerly provided coverage for all employees may decide to only provide coverage to the "class" of full-time employees)

Usually, you have 31 days from the time of ineligibility to convert to the new plan of insurance. The new insurance will usually be an individual plan—normally a hospitalization policy—which will not provide the same benefits that the group plan did. Usually, the group medical expense benefits are more liberal than the converted policy's benefits. Often, those who elect to exercise this conversion privilege do so because they have insurability problems.

Certificates of Insurance

Insureds must be issued a certificate summarizing the coverage they have under the group policy. Information is usually provided on benefits, age limits, notice of loss and proof of loss requirements, the insurer's right of examina-

tion, and conversion. Certificates are sometimes issued in booklet form.

Dependent Coverage

Life or health insurance benefits may be extended to the primary insured's dependents. Dependents may be any of the following individuals:

- your spouse,
- your children,
- your dependent parents, and
- any other person for whom dependency can be proved.

Your children can be stepchildren, foster children or adopted children. Dependent children must be under a specified age, usually to age 19, or to age 21 if attending school full time. The law further requires that any other person dependent on you must be eligible for coverage. Such dependency is proved by the relationship to you, residency in the home, or the person being listed on your income tax return as a dependent.

A child may be a dependent beyond the ages of 19 or 21 if that child is permanently mentally or physically disabled prior to the specified age. Also, a dependent child may be offered coverage beyond the limiting age of 19 if he or she is a full time college student in an accredited college. Usually, dependent coverage will be extended until age 21 or even to age 25.

Coordination of Benefits

A coordination of benefits (COB) provision is included in group health insurance policies to reduce overinsurance. Under this provision, when a person is covered under more than one plan, total benefits payable cannot exceed total medical expenses incurred. Without a COB provision, all plans could pay the full benefits of each plan. you would make money to the extent that the benefits exceeded medical expenses or loss of wages.

Records and Recordkeeping

This provision contains information as to whether the insurer or the policyholder will maintain records on you. It provides for the policyholder to furnish the insurance company with necessary information to determine premiums and administer coverage.

A clerical error provision provides that if there is an error or omission in the administration of a group policy, the person's insurance is considered to be what it would be if there had been no error or omission.

For example, an employer has the responsibility to send group enrollment forms for newly hired employees to the insurer. Sean is a new employee and through an administrative error, his enrollment form is never forwarded to the insurance company. A few months later he submits a medical expense claim to the insurer and is told that they have no record of his coverage.

This recordkeeping and clerical error provision protects the new employee in this type of situation. Usually, the insurer would accept an enrollment form and all of the past due premium and proceed to pay the medical claim.

Regulations Affecting Group Policies

A number of federal regulations enacted over the past 20 years affect group life and health insurance policies. These are known by the acronyms COBRA, OBRA, TEFRA, and ERISA.

Continuation of Benefits (COBRA)

The Consolidated Omnibus Budget Reconciliation Act (COBRA) is a federal law that requires employers with 20 or more employees to provide for a continuation of benefits under the employer's group health insurance plan, for former employees and their families. Coverage may be continued for 18 to 36 months. Employees and other qualified family members, who would otherwise lose their coverage because of a qualifying event are allowed by COBRA to continue their coverage at their own expense at specified group rates. COBRA specifies the rates, coverage, qualifying events, qualifying beneficiaries, notification of eligibility procedures, and time of payment requirements for the continuation of insurance. Below are the terms and concepts most important to the understanding of COBRA and its limitations.

Qualifying Event. A qualifying event is an occurrence that triggers an insured's protection under COBRA. Qualifying events include: the death of a covered employee, termination or reduction of work hours of a covered employee, Medicare eligibility for the covered employee, divorce or legal separation of the covered employee from

the covered employee's spouse, the termination of a child's dependent status under the terms of the group insurance plan, and the bankruptcy of the employer. Termination of employment is not a qualifying event if it is the result of gross misconduct by the covered employee. In short, a qualifying event occurs when the employee, spouse, or dependent child becomes ineligible for coverage under the group insurance contract.

Qualified Beneficiary. A qualified beneficiary is any individual covered under an employer-maintained group health plan on the day before a qualifying event. Usually this includes the covered employee, the spouse of the covered employee and/or dependent children of the employee.

Notification Statements. Employers are obligated to provide notification statements to individuals eligible for COBRA continuation. This notification must be provided under the following circumstances:

- when a plan becomes subject to COBRA;
- when an employee is covered by a plan subject to COBRA;
- when a qualifying event occurs.

In addition to notifying current employees, the company must also notify new employees when they are informed of other employee benefits. Initial notification made to the spouse of an employee, or to his or her dependents must be made in writing and sent to the last known address of the spouse or dependent.

Following the notification of eligibility for continuation of benefits an individual has 60 days in which to elect such continuation. If continued coverage is not elected within 60 days the option to do so is forfeited.

Duration of Coverage. An employer is not required to make continuation coverage available indefinitely. The rationale behind COBRA is to provide transitional health care coverage until the employee or family member can obtain coverage or employment elsewhere. The maximum period of coverage continuation for termination of employment or a reduction in hours of employment is 18 months. For all other qualifying events the maximum period of coverage continuation is 36 months. There are also certain disqualifying events that can result in a ter-

mination of coverage before the time periods specified above. The dates of these events are as follows:

- the first day for which timely payment is not made;
- the date the employer ceases to maintain any group health plan;
- the first date on which the individual is covered by another group plan (even if coverage is less comprehensive);
- the date the individual becomes eligible for Medicare.

It should be remembered that COBRA deals with continuation of the exact same group coverage that the employee had as a covered employee. This distinction is important so as not to confuse this provision with the conversion of group coverage to a lesser amount of insurance as part of an individual plan.

Not only is the type of coverage the same that the insured had while employed, the premium is also the same except now the terminated employee will pay the entire premium to the employer for the privilege of continuing the group benefits. To cover any administrative expense that the employer may incur, the terminated individual may also pay an additional amount each month not to exceed 2 percent of the premium. It should also be noted that only the health benefits can be continued under COBRA. Any group life insurance under the plan may not be continued. It can, of course, be converted.

Recent amendments to COBRA require the continuation of coverage if a preexisting condition limitation is included in the new group health coverage. However, the new group health coverage is primary and the continuation coverage is secondary.

OBRA

The Omnibus Budget Reconciliation Act of 1989 (OBRA) extended the minimum COBRA continuation of coverage period from 18 to 29 months for qualified beneficiaries disabled at the time of termination or reduction in hours. The disability must meet the Social Security definition of disability, and the covered employee's termination must not have been for gross misconduct.

Under OBRA '89, an employer may terminate COBRA coverage because of coverage under another health plan

provided the other plan does not limit or exclude benefits for a beneficiary's preexisting conditions.

OBRA '89 also clarifies that COBRA coverage may be terminated only because of Medicare entitlement, not merely eligibility. Before terminating COBRA coverage for beneficiaries at age 65, an employer must first be certain that the individual has actually enrolled under Medicare. Also, 36 months of COBRA coverage must be provided for the spouse and dependent children of a covered employee who becomes entitled to Medicare.

TEFRA

TEFRA (the Tax Equity and Fiscal Responsibility Act of 1982) is intended to prevent group term life insurance plans (usually always part of group health insurance programs) from discriminating in favor of "key employees." Key employees include officers, the top ten interestholders in the employer, individuals owning five percent or more of the employer, or owning more than one percent who are compensated annually at $150,000 or more.

TEFRA also amends the Social Security Act to make Medicare secondary to group health plans. TEFRA applies to employers of 20 or more employees, and to active employees and their spouses between ages 65 and 69. TEFRA also amends the Age Discrimination in Employment Act (ADEA) to require employers to offer these employees and their dependents the same coverage available to younger employees.

ERISA

The Employee Retirement Income Security Act of 1974 (ERISA) was intended to accomplish pension equality, but it also protects group insurance plan participants. ERISA includes stringent reporting and disclosure requirements for establishing and maintaining group health insurance and other qualified plans. Summary plan descriptions must be filed with the Department of Labor and an annual financial report must be filed with the IRS. For other qualified plans, legal documentation of the trust agreement, plan instrument, plan description, plan amendments, claim and benefit denials, enrollment forms, certificates of participation, annual statements, plan funding, and administrative records must all be maintained.

A Big ERISA Problem

Perhaps the most important federal lawsuit involving heath care plans designed for pensioners: the U.S. District Court for the middle district of Tennessee's 1985 ruling in *Robert Musto, et al. v. American General Corp., et al.*

This case considered whether an employer (or its successor) could "unilaterally terminate or materially alter retirement benefits after employees have provided years of service and have left active employment with the company." And ERISA requirements came into play, in the former employees' favor.

In 1939, The National Life and Accident Insurance Company established an annuity and life insurance program for its employees and future retirees. In 1945, National Life established a health insurance plan for its employees and future retirees. In 1968 NLT Corporation was formed to be a holding company for National Life and other affiliated subsidiaries. NLT assumed plan sponsorship for the employee benefit plans established by National Life. All subsidiaries of NLT were thereafter covered by the NLT plans. The named plaintiffs are all retirees of National Life, NLT or its subsidiaries who receive or were eligible to receive pension and welfare benefits as a result of their service to their former employer.

The employee benefit plans provided by National Life and NLT were collectively known as the Security Program. The Security Program offered retirees a pension, paid-up life insurance and lifetime medical insurance. National Life and NLT used the Security Program as a recruiting device to solicit new agents and also as a bargaining point in attempting to convince its own agents to continue on with the corporation. Some individual retirees had received promises that all benefits recieved upon retirement would be fully funded.

Over the years, the National Life/NLT Security Program underwent changes, including those necessitated by ERISA, resulting in overall improvements in retirement benefits under the program. Until January 1984, life and medical insurance coverage which continued after retirement required no payment of premiums.

NLT and National Life utilized the Security Program as a major inducement to attract employees. The promise of

continued benefits at no cost to the individual after retirement was a material part of the presentation to prospective employees. Potential employees were advised that the Security Program was one of the most liberal benefit packages in the country. National Life and NLT aggressively promoted the protection it would give its employees and retirees. The promise of continued benefits at no cost after retirement was continually reaffirmed in various ways.

American General Corporation, a Texas corporation which owns a number of other insurance companies, acquired NLT in November 1982, and began to administer the plaintiffs' pension and welfare plans. In the merger agreement and elsewhere, American General agreed to maintain existing NLT employee benefits, including the Security Program, at the time of the merger, and promised that if it integrated NLT's benefit programs with its own programs, overall benefits would compare to those in effect at the time of the merger.

Until December 1983, the retirees' and their spouses received medical insurance having a lifetime maximum benefit of $100,000 per person and an annual deductible of $100 per person. It paid 100 percent of surgical fees, 100 percent of the first $3,000 of hospital expenses, and 80 percent of hospital expenses over that amount. A retiree and his spouse or dependents had a maximum annual cost of $500 per calendar year, in addition to the per person deductible. Finally, the retiree was not required to make any further contributions to be eligible to receive this insurance.

A Sneaky Shift

In November 1983, American General held numerous meetings across the country for active employees of NLT or its subsidiaries. Individuals who had already retired were not invited. At the meetings as well as in documents and other communications, employees were informed that changes would be made in future retirement benefits effective January 1984. After that date, employees would fall under the American General plan.

By coming under the American General plan, the former NLT/NLA employees received an increased lifetime maximum benefit to $750,000 per person. The "up front" costs for a future retiree, his spouse and depend-

ents, however, were increased. The annual deductible per person was $275, $200 or $125. The maximum annual cost was $1,500, $1,000, or $1,000 per person and $2,500, $2,000, or $1,500 per family respectively. Additionally, surgical and hospital costs were reduced from 100 to 80 percent.

Retirees leaving employment after January 1984, also were required to make contributions to receive medical insurance. The dollar amount of monthly contributions varied depending upon the retiree's age, whether he elected to have coverage for dependents, and which of the three plans was chosen. Contributions for those retirees over age 65 were lower since their benefits were coordinated with Medicare. All retirees contributed approximately 20 percent of the cost of their chosen insurance.

Neither during these meetings nor at any other time were plaintiffs advised that the insurance benefits would or could be reduced. As with NLT, the express reservation was made only in the plan documents. Testimony indicated that company agents advised employees of the termination clause only if directly asked a specific question on the policy term. Paraphrasing the words of one such agent "you do not emphasize the negative."

A number of the still actively employed plaintiffs relied on American General's representations regarding planned future changes in benefits. Some retired prior to January 1984, so that they could receive the benefits under the NLT Security Program. Others decided not to retire but to remain as active employees and retire under the promised benefits plan.

In May 1984 American General notified all former employees who had retired before May 1984 (both pre- and post-January 1984) that certain retirement benefits would be changed effective July 1, 1984. Six months after the January changes were put into effect, American General changed the plan again.

The New Program

The July 1984 medical insurance program applied to all retirees, regardless of their retirement date. The plan provided a lifetime maximum benefit of $200,000 per person, an annual deductible of $200 per person and a maximum annual cost of $1,000 per person and $2,000 per family.

All were required to make contributions for continued insurance coverage or permanently forfeit any and all retirement medical insurance benefits. Retirees under age 65 were required to contribute 25 percent of the cost of the insurance. Retirees 65 and older were required to contribute 50 percent of the cost. (Because of the coordination with Medicare for those over 65, the costs for all retirees was roughly the same. Then American General announced it would increase the contribution of retirees under age 65 to 50 percent on July 1, 1985; but they were restrained by the court from doing so.

Of 1800 retirees or spouse survivors, 230 "chose" not to enroll, probably because the cost was prohibitive.

Another feature of the July 1984, modifications was that if any retiree or spouse was eligible as an employee for another employer's group medical insurance, then American General would permanently cancel all medical insurance for that person, even if they had elected not to be covered by the other insurance. This termination of coverage applied immediately to eight people.

The plaintiffs sued under ERISA and the applicable federal common law. The district court, setting certain conditions, allowed the lawsuit to proceed as a class action. The court's conclusions:

"Unlike medical insurance benefits, spousal survivor benefits constitute a form of pension benefit and are therefore covered by the comprehensive vesting and participation provisions and the funding provisions under ERISA. Under the terms of the Security Program, retirees who left active employment with NLT/NLA prior to age 65 were given a window period during they could decide whether to elect to enter the spousal survivor program. The election was not required to be made until age 65....If American General can modify the plan at will, the retirees have no assurance as to the future level of benefits, the premiums, or the deductible they must meet."

It ruled with the pensioners.

Health Insurance Underwriting

Like life insurance, health insurance underwriting is the process of selection, classification, and rating of risks. Most companies offering health policies have a variety of

policies available and underwriting standards for each policy are usually well established.

Underwriting is extremely more restrictive for individual than for group policies. The underwriter's principal functions are to review applications to eliminate those that do not meet underwriting standards, thus reducing adverse selection, and to classify risks to establish benefits and corresponding premium.

You can benefit from understanding how insurance companies underwrite their policies. Knowing their guidelines helps you make more informed buying decisions.

The Application

The insurance company relies on the information in the application when deciding whether to issue a policy or not. Application forms vary as to the type and amount of information required. Usually the application asks for personal information such as your name, address, Social Security number, dependent status, date of birth, work address and specific occupational duties. In addition, questions regarding your earned and unearned income may be included.

Applications also usually request information regarding other health insurance coverage that you may own — the type of coverage, benefit amounts and the name of the insurer(s).

You will also probably have to supply specific medical information regarding yourself and any family members to be covered, including your past medical history, current physical condition, moral habits and hobbies. This part of the application is usually completed by the agent, or by medical personnel if a physical exam is required.

The application must be signed by the proposed insured and the policyowner (usually this is the same person), as well as by the insurance company's agent.

Remember that your responses to questions on the application are considered representations, that is, statements you believe to be true to the best of your knowledge.

Other Sources of Information

It is the responsibility of the agent taking your application to be sure to ask clear and precise questions and to record

your answers accurately. State law usually requires the agent and the applicant to certify in writing that the applicant has read the completed application and realizes that any false statement or misrepresentation may result in loss of coverage.

As with the life insurance contract, the agent may be your sole personal contact in the insurance process. It is the agent's job to explain all aspects of coverage. Also, on any matters pertaining to the insurance contract, notice to the agent is the same as notice to the company.

Just like when you apply for life insurance, the insurer may conduct investigative reports and gather information about you. You should receive a "Notice of Information Practices" when you apply which explain the information that will be collected about you and who will have access to that information. If you are rejected based on the information contained in an investigative report, you have the right to access the information, challenge it, and request that corrections be made. An "investigative consumer report" includes information on your character, general reputation, personal habits, and mode of living obtained through interviews with associates, friends and neighbors.

Insurers can obtain more information about your insurance history from the Medical Information Bureau (MIB). Insurers can request a report that tells them whether you have applied for insurance with any other MIB member insurers, and what your responses were to questions on those applciations. MIB information cannot be used as the sole reason to decline a risk.

Underwriting Criteria

The insurance company underwriter selects those risks which are acceptable to the insurer, and at an acceptable premium. But the selection criteria used in this process, by law, must be only those items which are based on sound actuarial principles or expected experience. The underwriter cannot decline a risk based on sex, blindness or deafness, genetic characteristics (such as sickle cell trait), marital status, or sexual preference.

Age is a factor in health insurance because older people are more likely to have accidents and become sick, and they do not recover as quickly as younger people.

Statistically, females offer a higher health insurance risk as they usually have more health problems than males. Accordingly, more health problems means more insurance usage and increased claims. Typically, this results in higher health insurance premiums for females.

Ironically, it could be that as a result of more frequent health care, the female's life expectancy is longer than males. Accordingly, female life insurance rates are typically lower than a male of comparable age. It is not that unusual for a male, age 35, to suddenly drop dead from a heart attack. It is unusual for a female, age 35, to die suddenly as the result of a heart attack. This fact could be the result of more frequent health care by females and less by males.

Some insurers have unisex rates for health insurance which results in both male and female insureds paying the same premium. In these cases, the sex of the applicant is not an important underwriting factor.

Your Job as a Risk Factor

A person's occupation has a greater impact on his or her health. Occupations are classified into broad groups having approximately the same claims experience. Classifications are based on frequency and severity of injury, exposure to hazards, moral hazards, nature of work, and length of disability by occupation. For example, a factory worker is more likely to injure his back than an office worker.

Most companies have accident insurance manuals which list hundreds of different occupations and a grading is assigned to each occupation depending on how hazardous it is. A clerical office worker (with a minimal occupational hazard) might be Class 1 and the rates would be low. On the other hand a deep sea diver might be assigned to Class 10 (severe occupational hazard) and the rates would be high.

Physical condition refers to the applicant's current state of health and past medical history. Applicants who are in good physical health and have had few, if any, health problems in the past, present the best risk to the underwriter.

Conversely, applicants who are currently being treated for health problems such as high blood pressure, ulcers,

heart problems, and chronic back conditions, present a serious risk factor for the underwriter.

Chronic medical conditions which reflect a history of treatment and medical advice, reflect negatively on a health insurance applicant. Underwriting considerations are based on what has been, what is and what is expected to be the medical condition of the applicant in the future.

Habits, including personal avocations are of particular interest to the underwriter. The underwriter would like to know about personal habits, such as the use of drugs and alcohol, and whether or not you smoke. Avocations would be your interest and participation in hazardous activities, such as sky diving, motorcycle racing, or mountain climbing.

The major function of an insurance company's underwriting department is to select risks that will fall into the "normal range" of expected losses. Once a company underwriter has all of the information on an applicant, one of four underwriting actions will be taken — accept the applicant on a standard basis, reject the applicant, accept the applicant at a higher premium charge, or accept the applicant by issuing the policy with a restrictive rider attached.

A rider is an amendment attached to the policy contract which modifies the conditions of the policy by decreasing (or expanding) its benefits or excluding certain conditions from coverage.

Group Underwriting

Group underwriting is different from individual underwriting in that usually there is no medical information required regarding plan participants. No proof of insurability is required. The underwriter focuses on the group as a whole, rather than individual members.

There are statutory requirements imposed on group underwriting. For example, a group may not discriminate in favor of individuals in a manner that increases the opportunity for adverse selection against the insurance company. For instance, if an employer has five typists in the same job classification (job title and salary range) the employer cannot single out one typist to receive benefits greater than the other four typists. Therefore, employees

will be grouped under "classifications," such as, "all eligible full-time employees," "all clerical workers," "all hourly employees," "all salaried employees," "all executives," "employees working one year or more," or "employees earning not less than $10,000 but not more than $15,000."

The employer is in charge of enrollment, premium payment, benefit selection and all other areas of administration that are not an insurance company function.

Most insurers require a minimum number of employees or plan participants before a group health insurance plan may be written. This requirement may vary depending on state laws. Typically, the minimum group size for health insurance is ten but it could be as low as five or some other number. The larger the group, the more predictable will be the loss experience.

Small Groups Have to Work Harder

Relatively small groups (25 employees or less) may require some form of individual underwriting whereby each plan participant may be required to prove insurability. Generally, larger groups do not need to prove insurability.

The insurance company requires that a majority of eligible individuals be members of the group of insureds. For example, under a plan of insurance where an employer pays the entire premium, and the employee does not contribute to the premium payment (noncontributory plan) 100 percent of all eligible employees must be covered. Under a plan where both the employer and the employee contribute toward the premium payment (contributory plan) 75 percent of all eligible employees must be covered.

Also a new insurer may establish a preexisting condition provision in the group contract which excludes coverage for any condition which exists before the effective date of coverage. This provision will normally exclude these conditions for a period of six or 12 months after the effective date of coverage.

Although there have been changes to underwriting standards due to the passing of unisex laws, there are still instances where a group composed largely of women in general, young women, or older employees pay higher premiums.

Pensions and Group Plans

In a William M. Mercer Inc. survey conducted in 1992, 44 percent of employers questioned had increased the amount retirees must pay for health-care coverage. On average, retirees with spouses in the plan had to pay $1,719 a year, a ten percent annual increase.The Mercer survey found that 22 percent of the companies are dropping all health-care coverage for future retirees. And a separate Mercer study last year found that three percent of the 216 companies surveyed have suspended health-care coverage for current retirees.

For many early retirees, the bitterest pill comes when they try to re-enter the deteriorating job market. Data from the University of Massachusetts Gerontology Institute in Boston indicates that only 48 percent of unemployed workers age 55 and older can expect to find work.

In 1993, General Motors Corp. forced many retirees to pay part of their own health-care premiums for the first time. Some 102,000 retirees from salaried jobs now will have to shell out premiums running as much as $107 a month for family coverage at a health-maintenance organization.

Leaving a company's group plan can mean paying premiums for yourself until you qualify for Medicare at 65. For a married couple, that can run $3,000 or $4,000 a year.

By law, your employer must let you continue the company's insurance for 18 months, with you footing the cost. A company eager to trim its ranks may offer a longer span, perhaps to 65, and pick up some or all of the expense.

Looking Back

These are the major issues considered in this chapter:

- Having adequate health insurance is perhaps the greatest insurance concern we have as we age. It is important to understand the coverages you have in force now, how long they are effective, and what their major exclusions and limitations are.

- If you have group health insurance, find out what your conversion options upon retirement might be, so you understand in advance how your coverage will change. Find out how much time you will have

(for example, 30 days) to convert to the new insurance plan.

- Remember that a group insurance provider (your former employer) usually reserves the right to makes changes in the coverage, or even the right to cancel the coverage altogether. So there's no guarantee you won't have some unpleasant surprises after retirement.

- If you are buying new, individual health insurance, you may be subject to medical underwriting and may face being rated as a "substandard" risk because of medical conditions you have. Still, it is important to answer health-related questions on the insurance application honestly and accurately. You also will be subject to a waiting period until preexisting conditions are covered by the new policy. Take advantage of your free look period and read through the coverage to make sure it's what you want.

- You might consider purchasing your coverage through a managed care plan, such as a health maintenance organization or preferred provider organization, to keep your health care premiums and costs down. Also look into self-help programs for the elderly which offer health care discounts.

- Replacing a health insurance policy you already have is generally not a good idea, especially the older you are, unless the new policy provides substantially better benefits. An agent that convinces you to change your coverage to your disadvantage can lose his or her license to sell insurance and be subject to fines and penalties.

CHAPTER 9
DISABILITY INCOME INSURANCE

If you're in your early fifties, you probably have ten to 15 working years ahead of you. The pressure on these years: Your financial needs for retirement. The advantage: These are probably your peak earning years. A disability that would prevent you from working through this period is a considerable risk.

Although the risk of disability decreases with age, the average duration of a disability increases with age. The older you are at the onset of a disability, the longer the recovery period. Also, the older you are, the less likely it is that you'll recover completely.

The *Journal of the American Society of Certified Life Underwriters* did a study of the average duration of a disability that lasts over 90 days. It analyzed these by the age at which the disability occurred:

AGE	DURATION
25	4.3 years
30	4.7 years
35	5.1 years
40	5.5 years
45	5.8 years
50	6.2 years
55	6.6 years

In the United States, more mortgage foreclosures happen not because of death but because of disability. We tend to insure "things," purchasing protection against premature death but too often we overlook our most important asset, the ability to earn an income.

When you suffer a serious disability, life insurance is of no value. Benefits related to your pension plan are not readily available and, if you can qualify for Social Security disability benefits (this is a big *if,* as we'll show later), actual receipt of the money is at least one year after the disability strikes. Your earned income stops, but all of your normal expenses continue and you have the added medical and

related expenses of the disability. Although there are certain statutory disability benefits available, you are probably best protected by having some amount of disability income insurance.

Disability income insurance is basically paycheck insurance. If you are totally disabled due to accident or sickness, the policy will provide income to replace part of your lost income, which is defined as salary, wages, commissions, fees, or other earned remuneration. It excludes rents, royalties, interest, dividends, and other forms of unearned income. Further, most insurers will limit the amount of disability income insurance which they will issue to 70 or 75 percent of your gross earned income. The reason for this limitation is to encourage you to return to work by providing benefits which are no greater than your net pay. If you could insure 100 percent of your gross income, there would be little incentive to return to work, because you would be receiving an income (usually tax free) greater than your take-home pay.

Your net worth may also serve as a limiting factor. If your net worth is very high, say several hundred thousand dollars or more, the insurer may decline to provide any disability income coverage.

Statutory Protections

There are two primary statutory programs available in the event of a disability: Social Security and workers compensation insurance.

To be eligible for Social Security disability benefits, you must be fully insured, which means that you have at least 40 calendar quarters of coverage during which you have paid Social Security taxes. In essence, this means that you have to have paid Social Security taxes for at least ten years.

You also have to satisfy the Social Security definition of total disability: "the inability to engage in any substantial gainful activity by reason of any physical or mental impairment which is expected to last for at least 12 months and/or end in death."

For Social Security benefits to kick in, the disability must be so severe that you are unable to work in any gainful employment which exists in the national economy regardless of whether such work exists in the immediate

area where you live or whether a specific job vacancy exists.

In addition, a five-month waiting period must be satisfied before you qualify for benefits. Once a claim is filed following the elimination period, it will take several months for the claim to be processed. In reality, if you can qualify for Social Security benefits, you won't receive the first check until nearly the end of the first year of disability.

The disability benefit received from Social Security is equal to your Primary Insurance Amount (PIA). The PIA is based on your average earnings history under Social Security. Depending on your average earnings, age at the onset of the disability and dependent status, the monthly benefit generally can range from a low of $400 to a high of $1,500 or more.

The key factor however, is whether or not you can qualify for benefits under the rigid definition of total disability used by the Social Security Administration.

Workers compensation (regulated at the state level) provides benefits to workers who have occupational or job-related disabilities. Workers compensation benefits are usually expressed as a percentage of the worker's wage before disability—usually 67 percent.

Workers compensation and Social Security are the two principal statutory disability programs which cover most people. You may also be eligible for other disability benefits. Most federal Civil Service workers who began working for the government prior to 1984 are not covered by Social Security. They have their own Civil Service program which provides disability benefits. The Veteran's Administration (VA) provides disability benefits for disabilities incurred while on duty with any of the military branches. The VA benefits are paid so long as the veteran remains totally or partially disabled even after discharge from the military service.

If You Don't Have Insurance. . .

Without adequate disability income insurance, the only resources available to offset the devastating effects of a disability are:

- savings,
- business assets,

- borrowing,
- other personal assets, and
- government programs.

You may have health insurance provided by your employer, and you may even have coverage at work under a group disability income plan, which provides for continuation of your compensation at a percentage of your salary (such as 60 or 70 percent). Most often disability income benefits are provided to age 65.

When group disability income insurance is provided by the employer, the employer enjoys a tax-deductible premium, but your benefits will be taxable as income. One advantage of group coverage is that usually you will not have to prove insurability by answering health history questions or undergoing a medical examination. This enables a person who is a substandard risk to acquire disability income protection regardless of his or her health history or current physical condition.

When you pay for your own group disability income insurance through payroll deductions, the insurer will normally issue you an individual policy, and you would probably have to show evidence of insurability. An advantage to this type of coverage is that it is generally less costly than individual coverage.

Group Disability Policies

However, under a group policy your coverage is basically rented coverage. You do not own the policy. Your employer is the policy owner, and could terminate the policy. If you terminate employment, the disability coverage is also terminated. Working for your employer is a condition of having the coverage.

Related to the concept of group coverage is the association plan. Professional associations such as the American Medical Association or the American Bar Association offer association or group-type disability income coverage to association members. Basically, association coverage is individual coverage. As a member of a professional association, you would complete an application for insurance and an individual policy would be issued through the association. Association plans are "packaged plans" in that only certain elimination periods, benefit periods, and benefit amounts are offered to members.

Premiums for association coverage are usually banded, or grouped based on increments of age. For example, everyone ages 25-30 pays the same premium; ages banded between 31 and 35 would pay the same premium and other bands of five years would continue to age 55 or possibly age 60. Typically, the amounts of coverage are also predetermined such as a $1,000 benefit or a $2,000 plan. This packaging of the product is facilitated by the fact that all members have the same occupational classification and job duties, ie., physicians, lawyers, etc.

Association plans may offer a minimum guaranteed issue policy without regard to the insurability of the member. This of course, is an advantage for the uninsurable individual. Through an association plan, you could acquire disability income insurance regardless of your health history.

Disadvantages of association coverage include the fact that the policy may be canceled by the insurer or the association. In essence, the association members are "renting" the coverage much like the participant in an employer-employee group plan. In addition, you can lose the coverage if you fail to maintain membership in the association.

A final disadvantage is the fact that the premiums are not guaranteed. The insurer can raise the premium for the entire plan. Also, you will pay higher premiums whenever you move into a new age band.

Conditional Disability Riders

The Supreme Court of Connecticut considered the language of a standard disability income policy in the 1990 decision *Jagdish Sanghavi v. The Paul Revere Life Insurance Co.*

Paul Revere issued a disability policy to Sanghavi in July 1976, that provided indemnity benefits of $600 per month during the period of disability. For an additional premium, Paul Revere issued a rider to the policy that provided for seven future income options, each in the amount of $100 per month, that could be exercised by Sanghavi until July 1990. Specifically, the rider stated that monthly payments would be increased, regardless of the status of Sanghavi's health, provided that he met four conditions:

"1. That the insured submit a written request and pay an additional premium, unless the premium is waived, within prescribed time limits.

"2. The requested increase cannot exceed the maximum disability income coverage then being offered by the company to new applicants of the same classification of risk as is the insured, according to the company's then published underwriting and participation limits.

"3. The insured's monthly earned income is sufficient to qualify for an increase on the anniversary option date according to the company's then published income limits.

"4. The insured may exercise only one increase during each period of the continuous disability regardless of the number of anniversary options which become due during such disability."

In July 1978, Sanghavi completed and forwarded an application to exercise the first option pursuant to the rider. His application was approved and his monthly benefit was increased by $100 to $700 per month.

In February 1979, Sanghavi was declared to be totally disabled. In accordance with the policy, Paul Revere paid Sanghavi $700 per month.

Exercising Income Options

By correspondence dated May 1982, Sanghavi attempted to exercise two options to purchase additional monthly benefits which would have increased his monthly benefits to $900.

Paul Revere refused to honor Sanghavi's request, claiming, under the third condition: "that Sanghavi failed to provide adequate information concerning his income and other sources of disability insurance; and that Sanghavi's income was insufficient to warrant such an increase in monthly benefits."

Sanghavi sued Paul Revere in June 1983, claiming that Paul Revere breached its contract with him by not increasing his monthly benefits in accordance with the rider. He also alleged that Paul Revere had violated the Connecticut Unfair Trade Practices Act (CUTPA), and he sought retroactive payment of the additional benefits due since the suit was filed.

Five years later, in June 1988, a state trial judge found in favor of Sanghavi that Paul Revere had breached its contract and owed him retroactive benefits, but disagreed that the company had violated fair trade practices.

In particular, the court found that conditions three and four of the rider were invalid and retroactively awarded Sanghavi the two increase options that he attempted to exercise in May 1982. The trial court also held that Sanghavi was entitled to all future increase options as they became due.

The trial court ruled that condition three was invalid because it violated Connecticut insurance law, which required that the policy, application and endorsements constitute the entire insurance contract.

Condition three based the determination of whether an increase in benefits will be granted by reference to "the company's then published income limits." But the limits were not appended to Sanghavi's policy, and at no time were such limits made available to him.

The trial court ruled that by not providing income limits, the insurance company failed to present the entire contract to Sanghavi and enumerate all of his rights. Rather, the company had drafted its policy in such a way that it could modify the benefits it chose.

Condition four limited the policyholder to only one increase during each period of disability. The trial court held that this condition was invalid "because it was in conflict with the rider itself, creating an ambiguity in the contract that must be resolved against the insurance company [or] because it was inconspicuous and unenforceable."

Paul Revere appealed the court's decision that conditions three and four of the rider were invalid. The supreme court agreed with the lower court on condition three but found condition four valid. It "clearly and unambiguously state[d] that the policyholder bargained for only one increase in monthly benefits during a period of disability....As a result, Sanghavi is entitled only to one increase in benefits," the high court concluded.

"On appeal...the discussion of the issues boiled down to one statement—'there is a distinction between health and disability.' Which is wrong, because if you are disabled, you would necessarily then have a problem with

your health," said one of several attorneys who represented Sanghavi. "Plus, this was sold as a guaranteed insurability policy...you wouldn't have to take a physical later to keep your coverage if you buy now, despite your future health. The policy said if you become disabled, you can't buy additional increments of coverage anymore, but this is in contradiction to the language that says guaranteed insurability despite future health. The language is inconsistent, and we argued that the ambiguity goes in favor of the insured."

An attorney who represented Paul Revere focused more on the language of the policy rider than the facts of the case: "This income option rider...permitted higher benefits with extra premium. This type of rider is not standard, but not unusual. It protects from changes in the person's health in the future. An older person would probably buy this."

Definitions and Concepts

To fully understand disability income insurance, you first need to understand the language of the product. Following are some basic definitions and concepts.

Disability income insurance is a contract which pays a monthly benefit, following the elimination period, for total disabilities due to accident or sickness. Disability income policies are also called "loss of time" policies.

The *elimination period* (EP) is the period of time the policyholder must be totally disabled before benefits are payable. The elimination period is also known as the "waiting period" (WP). The elimination period is usually measured in days or months, such as 30, 60, or 90 days; or one month, three months, six months, etc.

The elimination period can be thought of as a "time deductible" in much the same way as a automobile policy or a major medical policy is subject to a deductible. For example, if you are involved in an auto accident, you must first satisfy the policy's deductible and then the insurer pays your claim. With a disability income policy, you must first satisfy the deductible in terms of time (the elimination period) and then the insurer begins to pay you a monthly benefit.

The *benefit period* (BP) is the length of time benefits will be paid for each disability following the elimination period.

The benefit period is usually expressed in years, ie., one year, two years, five years or to age 65.

For example, when an applicant elects a five-year benefit period, total disability benefits will be paid for up to five years for each claim or disability sustained by the policyholder. It should also be noted that benefits are paid for each day of a disability after the elimination period has been satisfied. For example if an policyholder had a 30-day EP and was totally disabled for 35 days, he or she would receive five 30ths of the monthly benefit for the five days of total disability following the EP.

Evidence of insurability is sometimes required by the insurer before a policy will be issued. This is especially important for seniors, since it becomes more and more difficult to prove you are insurable as you get older. Insurers may require detailed answers to medical questions or even a physical examination, and may increase standard rates or even decline to issue your policy depending on the answers to those questions or the results of the examination.

The *free look provision* gives the policyholder the opportunity to review the policy upon receipt and return it to the insurer within ten days for a refund of all premium paid if not satisfied for any reason. This provision must be included by law in almost all individual life and health insurance policies so that consumers can have time to review the entire policy after it is delivered and decide whether or not it is the right policy for them.

A disability income policy may be issued as cancelable, optionally renewable, guaranteed renewable, or noncancellable.

You may have noticed in reading through this section that most provisions are applicable only until the policyholder's 65th birthday. Most often, the policy will not be renewed past the policyholder's 65th birthday regardless of the type of renewability. It is assumed that the policyholder will retire and no longer be employed or have any earned income to protect.

However, in the event that the policyholder does not retire at age 65 and continues to work and earn an income, the disability income policy may be conditionally renewable past age 65. The policy may be continued for subsequent one year periods on the condition that the policyholder continues to work full time, or a certain number of hours

per week, and earn an income. This period of conditional renewability will continue to age 70 or 72. On each annual renewal date, the premium will be increased. Additional riders, especially riders like residual disability benefits, are usually not allowed.

A *Future Increase Option* may also be referred to as the Guaranteed Insurability Option, since it enables the policyholder to purchase additional disability income protection, regardless of his or her insurability, at specified future dates.

The future increase option is more important to applicants who are under 40 years of age as it protects future insurability by providing the guaranteed right to purchase additional amounts of disability income insurance in subsequent years. Normally, the rider is not available past age 40 although some insurers may offer it up to age 50.

The *Cost of Living Benefit* adjusts benefits over time. The purchasing power of fixed disability benefits may be eroded due to inflation and increases in the cost of living. To protect against these trends, most insurers will offer an optional cost of living benefit.

The *Lifetime Benefits Option* extends the benefit period from age 65 to lifetime. This extension may apply to accident only benefits or to accident and sickness benefits. Normally, if the total disability is due to an accident occurring before age 65, benefits will be paid for the lifetime of the policyholder provided he or she remains totally disabled.

Most companies will place some time limitations on the lifetime sickness benefit. That is, the disabling sickness must begin prior to a specified age such as 50, 55 or 60. A policy providing lifetime sickness benefits may stipulate that if the sickness begins at age 55 or earlier, then 100 percent of the total disability benefit will be provided for the lifetime of the policyholder. However, if the disability begins after age 55, but before age 65, a reduced benefit will be paid for life.

For example, a policy might state the following: If total disability, due to sickness, begins at age 55 or earlier, total disability benefits will be paid for the lifetime of the policyholder. If total disability benefits begin at age:

- 56, total benefits are paid to age 65; then 90 percent of the benefit for the lifetime of the policyholder;

- 57, total benefits are paid to age 65; then 80 percent of the benefit for the lifetime of the policyholder;

- 58, total benefits are paid to age 65; then 70 percent of the benefit for the lifetime of the policyholder;

- 59, total benefits are paid to age 65; then 60 percent of the benefit for the lifetime of the policyholder;

- 60, total benefits are paid to age 65; then 50 percent of the benefit for the lifetime of the policyholder.

This progression of benefits would continue until age 65. If the total disability began at age 65 (normally the policy is not renewed past age 65), then the payment of total disability benefits would be limited to one or two years.

Buying Disability Income Coverage

A broker or agent should conduct a fact finding interview to determine your specific needs and concerns so he or she can make a competent and professional recommendation. The essential elements of the interview should include:

- personal information—name, address, occupation, dependent status, etc.;

- individual insurance—individually owned life, health, and disability income insurance including names of insurers, amounts of coverage, and beneficiary designations;

- statutory benefits—eligibility for workers compensation, social security or other similar benefits;

- business information—business address, earned income, specific occupational duties, employee benefits (group health, group life, pension, sick days);

- liabilities—fixed monthly expenses (rent, food, shelter, clothing, insurance premiums, etc.) and variable monthly expenses (medical, dental, home or auto repair, etc.);

- other assets—savings, investments and unearned income.

In addition to this factual type of information, you should discuss your goals, objectives or special needs, such as

educational objectives for dependent children, business objectives, retirement goals, etc. Upon completion, your agent should be able to generate a proposal for an individual program of disability income coverage.

You may have to have a physical examination performed by a doctor or paramedical facility in lieu of simply answering medical questions posed by the agent. Depending on the medical problem, an applicant's personal physician may be requested to complete an Attending Physician's Statement (APS). The purpose of this report is to provide more detailed information about an applicant's medical history or current physical condition.

Normally, the amount at risk, age of the applicant, occupational class and the benefit period elected are the factors which determine whether or not a physical exam is necessary.

Non-Medical Limits

Benefit Period and Amount

Occupational Class	Age	5 Years or Less	More Than 5 Years
1 and 2	18-40	$3,500	$2,000
	41-50	$2,500	$1,500
	51-60	$1,000	$1,000
3 and 4	18-40	$2,000	$1,500
	41-50	$1,500	$1,000
	51-60	$ 500	0

A dentist, age 45 and in a class 1 occupational, could purchase up to $2,500 with a benefit period not to exceed five years, non-medically. That is, no physical exam would be required.

A bartender, age 30 and in class 3, could purchase up to $1,500, payable to age 65, non-medically. A truck driver, age 54, class 4, could purchase nothing, non-medically.

The chart above reflects the relationship between occupational class and the amount at risk. The lower the occupation class, the lower the amount of disability income which may be purchased. Conversely, the better the occupational class, the higher the amount of disability income which can be purchased. This relationship is due to the degree of risk involved in the lower occupational classes. Accordingly, the insurer will limit its exposure to

that risk by limiting the amount of coverage and/or the benefit periods.

Disability income premiums are based on age, sex, and occupation of the policyholder. The application is the principal tool of the underwriter as it will contain important information about the risk which will include:

- the age, sex and occupation of the applicant;
- past medical history and current physical condition;
- moral habits;
- information regarding other insurance owned;
- family history information;
- unusual hobbies or avocations.

Statistically, females become disabled more frequently than do males. Therefore, females present a higher risk. Accordingly, the disability income premium for females will be higher than for males. The opposite is true with regard to females and life insurance underwriting. Ironically, women tend to take care of themselves better than men. Consequently, they use health insurance more frequently than their male counterparts. This contributes to their longer life expectancy and lower life insurance rates but due to more usage of the health insurance policy, the females pay higher rates.

Occupation is an underwriting factor for both life and health insurance. A policeman applying for life insurance is normally a standard risk and does not present any unusual hazard with regard to mortality. However, due to the nature of the work, a police officer applying for disability income insurance is a different matter. The officer is more likely to be injured and thus disabled due to the occupational risks involved. Therefore, as an underwriting factor, occupation is more heavily weighted in terms of disability income coverage.

Dangerous Avocations

Related to hazardous occupations is the hazardous avocation factor. Hobbies, such as skin diving, scuba diving, sky diving, and auto racing are certainly more hazardous than golf or tennis. As such, the underwriter must be made aware of these high risk hobbies when considering the applicant for disability income.

Your medical profile will normally consist of past medical history and current physical condition. To a degree, family medical history may also be a factor.

To prevent overinsurance, it is necessary for the insurer to be aware of any other disability income coverage in force. The agent has to obtain accurate information regarding the amount of other coverage, elimination and benefit periods.

The insurance company may have specific issue and participation limits which are based on the applicant's earned income. As a general rule, most insurers will offer coverage equal to 60 or 70 percent of earned income. This limitation may also be adjusted (decreased) due to the occupational class of the applicant. Most insurers will offer smaller amounts of disability income protection to those in the more hazardous occupations.

Another financial underwriting factor is other disability income coverage which the applicant may have. Any amount of coverage applied for may be reduced by the amount of coverage in any other insurer.

In discussing the guidelines that allow a plan under ERISA to incorporate the Social Security benefits paid, the Supreme Court has said:

> It is particularly pertinent for our purposes that Congress did not prohibit "integration," a calculation practice under which benefit levels are determined by combining pension funds with other income streams available to the retired employees. Through integration, each income stream contributes for calculation purposes to the total benefit pool to be distributed to all the retired employees, even if the non-pension funds are available only to a subgroup of the employees. Under this practice, an individual employee's eligibility for Social Security would advantage all participants in his private pension plan, for the addition of his anticipated Social Security payments to the total benefit pool would permit a higher average pension pay out for each participant.

Income Influences Disability Payments

In the 1992 decision *Harvey Wallace v. Transport Life Insurance Co. et al.*, the Oklahoma Court of Appeals considered the other benefits and income streams that influenced disability payments.

Harvey Wallace was employed by Oklahoma Farmers Union Mutual company. In August, 1984, at the age of 46, he became disabled due to heart disease and was unable to work. Farmers provided a group disability insurance plan through Transport Life Insurance Company. In essence, the plan provided that 90 days after disability, it would pay 60 percent of Wallace's salary until he reached 65 years of age.

The Plan contained the qualifying provision:

"If an insured employee is entitled to other income benefits...or if such income benefits become payable to the insured employee for the same period of disability for which a monthly benefit is payable, then the amount of the monthly benefit payable will be reduced by the amount of the following other income benefits...."

Partial Payment

Transport Life paid 60 percent of Wallace's salary from December 1984 to March 1987. In April 1987, the company didn't make the payment. Instead, it demanded that Wallace sign a letter agreeing to apply for Social Security benefits as an offset against the amounts payable under the plan.

Wallace signed the letter, applied for and began to receive Social Security benefits. Payments also began for his wife and child. Transport Life also notified Wallace that his prior lengthy delay in seeking Social Security benefits had created an offset against the future plan payments.

Wallace sued his employer and Transport Life, seeking disability payments not made since April 1987, damages for emotional distress, mental suffering and bad faith. He argued that he'd been coerced into seeking Social Security benefits. Transport Life countersued for the amount of its alleged overpayment.

The trial court held the plan to be within the scope of ERISA. (State courts have been granted concurrent jurisdiction with federal courts to determine and enforce rights under an insurance plan covered by ERISA.)

The trial court held that Transport Life was entitled to the difference between the plan payments actually made and those that would have been due if Wallace had applied for Social Security benefits when eligible, as required by the plan provisions.

The trial court also found the plan provisions requiring Wallace to apply for Social Security or other benefits were clear, unambiguous and not in violation of public policy.

The Oklahoma supreme court upheld the lower court's ruling.

Standard vs. Substandard Risks

Once all the underwriting information on an applicant has been reviewed, a decision is made as to acceptance of the risk. Most applicants are classified as standard risks, which basically means they fit the norm. They are an average risk and the policy will be issued as applied for by the applicant. The rate or premium charged will be the standard premium relative to the individual's age, sex, occupation, benefit amount, elimination and benefit periods selected.

While an estimated 90 percent of life insurance risks are accepted, only about 75 percent of disability income risks are accepted. Sometimes an applicant for disability income is classified as substandard due to some underwriting reasons such as a past or current medical problem. Remember that the risk being insured is disability and not death. Thus, if an applicant has a history of a bad back, this medical problem would not affect the underwriting of life insurance, but very definitely would affect the underwriting of disability income. An applicant will not die due to a backache, but certainly could become totally and even permanently disabled.

When an applicant is classified as substandard due to medical history or current physical condition, the insurer has several alternatives available for issuance of a substandard disability income policy.

- An extra premium may be charged to compensate for the higher risk involved.

- A rider may be attached to the policy modifying the coverage. A full exclusion rider is used when the nature of the condition is likely to result in recurrent disabilities. For example, a full back exclusion rider may be used for chronic back disorders.

- A qualified condition exclusion rider may be used to exclude coverage for a specified medical problem for a specified period of time. This is normally accom-

plished by altering the elimination period or benefit period for the particular medical condition.

- Depending on the medical condition, the insurer may increase the elimination period or shorten the benefit period to compensate for the medical disorder.

- A final alternative available to the underwriter and the insurer is simply to deny coverage due to the medical condition.

How Your Net Worth Comes into Play

Your net worth may serve as a limiting factor for the amount of disability income insurance you can purchase. In fact, the financial underwriting process is said to be a rigid as the medical underwriting in disability income insurance. An extremely wealthy person with a net worth of several hundred thousand dollars or more may have the amount of insurance limited, or the insurer may decline to provide any disability income coverage. Of course, if you are very wealthy you probably do not need disability income insurance.

The amount of total net worth and the liquidity of such assets will determine whether a reduced amount of disability income will be issued (or even no coverage at all). If a person's assets are easily marketable and/or if the total net worth reflects a large amount of unearned income, then the underwriter may decide that the applicant is not eligible for any coverage.

A plan with a 60 day elimination period costs about 20 percent less than a plan with a 30 day EP. Longer elimination periods will reduce the premium even more. Most companies will offer elimination periods from 30 days to as long as two years, but the longer EP may not be to your best advantage.

For example, if you elect a 90-day elimination period, this means that you will not begin to accrue a benefit until the 91st day of a disability. Then, the insurer will probably issue your first claim check at the end of the month. Therefore, you will wait nearly 120 days or four months from the onset of the disability before you receive any benefit.

When determining which elimination period to elect, ask yourself "How long can I go without any income from my disability income plan?" Your answer will depend on your:

- fixed obligations such as mortgage or rent payments, car payments, utilities, food, installment purchases, insurance premiums, etc.;

- other expenses: your unexpected, non-fixed expenses which occur from month-to-month, such as the automobile repair, medical expenses, prescriptions, home repairs, the dreaded miscellaneous expenses, etc. Make some rough estimation of these unexpected monthly obligations.

In addition, you will have the added expense of your disability, such as medications, doctor's bills, medical equipment (such as wheelchairs) and hospital bills which are not fully covered by hospitalization insurance.

Be careful of assuming that because you earn a high income that you can live with a six-month or even 90-day elimination period. Usually the more income you earn, the more you spend and the higher your expenses. An executive earning $250,000 may not have any more liquidity than a worker earning $25,000.

When selecting your benefit period (the maximum period of time benefits will be paid), remember that the most common benefit periods are one, two or five years and "to age 65." A lifetime accident and/or sickness option may be included in the policy which extends the benefit period for lifetime. Naturally, the longer the benefit period, the higher the cost of the policy.

When purchasing individual disability income protection, your most important considerations are the elimination period, benefit period, the amount of the monthly benefit and any optional benefits which may be added to the contract, as well as the relative premium and cost of these elements. For example, the shorter the elimination period, the higher the premium, and the longer the benefit period, the higher the premium.

You should estimate your current expenses, as well as other insurance in force and other financial assets. An adequate program of disability income coverage can contribute to your total financial security.

Aggressive Resistence

Disability income insurers will sometimes fight claims too aggressively. The Supreme Court of Alabama dealt with

this kind of situation in the 1994 decision *Victoria Ragsdale v. Life Insurance Co. of North America.*

In March 1988, Ragsdale experienced heart arrhythmia and atrial fibrillation, which were later diagnosed as symptoms of a connective tissue disease, polymyositis. In July 1990, she was hospitalized because of blood clots, another symptom or complication of the disease. She did not return to work again. Instead, she retired on November 2, 1990. She had been an employee of the City of Opelika's Revenue Department for about 12 years.

Upon her retirement, Ragsdale submitted a claim for disability income benefits in the city's personnel office. Five months later, in April 1991, Life Insurance Company of North America (LINA) denied Ragsdale's claim for disability benefits, based on a "preexisting condition limitation."

Ragsdale sued LINA in January 1992. Specifically, she charged that the city, through its employees, misrepresented to her that upon her retirement she would receive disability payments from LINA, the city's group long-term disability insurance carrier. She alleged that at least three city employees were agents of LINA.

Ragsdale stated that in August 1990 she spoke with Doris Strickland, the city's assistant personnel technician, about what benefits she would receive if she were to retire. Strickland said that Ragsdale would receive long-term disability payments of about $860 a month.

Strickland stated in deposition that she had never represented to Ragsdale that if she retired she would be entitled to disability benefits from LINA.

Ragsdale requested a letter from the city detailing exactly what her benefits would be if she retired. She introduced as evidence a letter signed by the mayor of the City of Opelika, dated October 1990, listing the insurance benefits "that the City of Opelika provides to employees that separate from City employment due to a medical disability." The letter includes "Long Term Disability Insurance."

Ragsdale stated in her deposition that she called the regional sales manager for LINA, Martin Steele and that he told her "that it was up to the City of Opelika to explain [the policy] to [her]."

Steele testified in his deposition that he did not remember any specifics of his conversation with Ragsdale. Steele testified that LINA alone had the authority to determine whether an individual was entitled to receive benefits under the policy. He also testified that the city would answer some questions about benefits. The distinction between questions LINA would answer and ones the city would answer was unclear.

At trial, LINA argued—and the circuit court held—that there was no question of fact to be decided because the long-term disability income policy issued by LINA to the city stated that the city was not an agent of LINA. The company cited a "Miscellaneous Provision" from the policy as support for that argument:

"The Insurance Company will deal solely with the Policyholder who will be deemed the representative of each Employee. Any action taken by the Policyholder will be binding on the Employees."

The Alabama supreme court didn't buy the argument. "It is arguable whether the logical implication of this provision would make the City the employees' agent and not LINA's agent. Even if it would, that implication would not be conclusive," it wrote, "...because in Alabama agency is determined by the facts, and not by how the parties may characterize the relationship."

Which Side Does the Agent Serve?

Several Alabama cases had been decided on the question of whether an employer was an agent of an insurer in administering group policies insuring employees. In *Harrison v. Insurance Co. of North America* (1975), the Court held that the employer was the agent of the insurer for purposes of notifying the employees of changes in the policy. The insurer had notified the employer of a change, but the employer had not notified the employees. The Court held that the change in the policy was not effective to the employees, because they hadn't received notice of the change.

"We hold, after carefully reviewing the record, that Ragsdale did present substantial evidence that an agency relationship existed between LINA and the City," the high court concluded. "Two of the City's employees bore the full burden of explaining the insurance policy to the other City employees. LINA cannot give the City the full

power of explaining the benefits available under the policy and then claim to be exempt from responsibility when the City misrepresents the coverage available to an employee."

It reversed the earlier judgment for LINA and remanded the case for trial. LINA took the hint and settled with Ragsdale.

Looking Back

These are the major issues considered in this chapter:

- Disability income insurance is paycheck insurance. Depending on how much you rely on your employment income, you may need disability income insurance. And it's dangerous to rely on Social Security or the workers compensation program to provide disability benefits.

- If you have a very high net worth, or have large amounts of unearned income (such as rents from properties you own), you probably do not need this insurance, and insurance companies will most likely refuse to provide you with this coverage.

- You should understand the policy mechanics, including the elimination period and benefit period and how they affect your premiums and coverage.

- Buying an individual disability income policy will probably subject you to medical underwriting. Expect to be able to insure only 60-70 percent of your earned income. If you are classified as substandard because of medical problems you have, you may be able to modify the policy benefits and still receive coverage.

CHAPTER 10
MEDICARE AND MEDICARE SUPPLEMENTS

Medicare is a federal health insurance program for people 65 or older, people of any age with permanent kidney failure, and certain disabled people. Medicare is part of the Social Security System and is administered by the Health Care Financing Administration, part of the Department of Health and Human Services.

The basic medical care needed by the older citizen and covered by Medicare includes, but is not limited to: necessary day-to-day outpatient medical care; occasional hospitalization for care of chronic or acute ailments or accidents and possibly skilled nursing care in a nursing home. Medicare is designed to provide some benefits for each of these major needs.

Medicare provides benefits for over 50 million people and has an annual budget in excess of $100 billion. Needless to say, it is important that the Medicare program and the Social Security System to be financially sound as the number of people covered under the program increases annually and those entering the program will be covered for increasingly longer and longer periods of time.

There probably are aspects of Medicare coverage that you do not fully understand. You may be unclear about what Medicare covers, what it excludes, how much of your medical expenses you will be responsible for, and whether you need additional health insurance.

Limits to the Coverage

Medicare pays for some health care expenses; it by no means pays for them all. There are limits on covered services and the program includes both deductibles and coinsurance provisions. Doctors often charge more for services than Medicare will pay. To fill the gaps in protection left by Medicare, insurance companies have developed special policies known as Medicare supplement policies.

Insurers and retiree associations deluge the senior population with advertisements for Medicare supplement policies. Agents selling Medicare supplements don't always practice the professionalism and ethical conduct they should. Often, this bombardment of literature and sales pressure results in the individual making poor decisions regarding supplemental coverage: buying too much coverage, or the wrong kind, or none at all. Many, many marketing abuses have occurred, and as a result Medicare supplement policies are heavily regulated by the government, and purchasers have been assured by law of certain important legal rights.

Social Security offices provide written information about Medicare benefits. Depending on the individual office and the expertise of the employees, some discussion of benefits may also be offered. However, quite often the written information provided is not current, fully relevant to your individual needs, or very clear.

Friends, relatives and associations are another source of information. The American Association of Retired Persons and similar groups often provide group insurance programs for their membership including group Medicare supplement coverage. Normally, the information and enrollment procedures are done by mail. The major disadvantage is there isn't anyone to help answer questions or explain the policy benefits in detail.

Using Your Agent as a Resource

You can sometimes get good one-on-one information from a knowledgeable insurance agent, insurance counselor or financial planner who specializes in Medicare and Medicare supplements. Bear in mind that even though agents are by law required to exercise great care in recommending and selling Medicare supplement policies, they are paid commissions on the policies they sell and may be motivated to sell you higher cost policies you may not need. Whoever you work with should be able to provide specific information regarding Medicare—how it functions, types of benefits, the claims process, etc., and should be able to clearly explain the Medicare supplement policy or policies he or she can offer.

Senior counseling programs are available at the state government level, either through the insurance department, department of aging, department of human resources, or

department of health services. Trained volunteers are available to answer your questions regarding coverage, and to help you with your insurance decisions. (A list of available senior counseling programs appears in the Resources Directory appendix.)

The first step in determining whether you need a Medicare supplement policy is clearly understanding what types of health care costs are and are not covered by Medicare. Medicare pays only for services determined to be medically necessary and only to the extent that Medicare determines the charge to be reasonable. Medicare does not pay for custodial care or outpatient prescription medication.

Medicare Part A

Medicare has two parts: Part A Hospital Insurance and Part B Medical Insurance (also known as Supplementary Medical Insurance). Hospital insurance helps pay for inpatient hospital care and certain follow-up care. Medical insurance helps pay for doctors' services and many other medical services and items.

Hospital insurance is financed through part of the payroll (FICA) tax that also pays for Social Security. Medical insurance is financed from the monthly premiums paid by people who have enrolled for it and from general federal revenues.

Private insurance companies are used as fiscal intermediaries for the purpose of processing Part A claims. Private insurers are also used to process Part B claims. These insurance companies are referred to as carriers. Social Security offices throughout the country are used for administrative support. Peer Review Organizations (PROs) are groups of doctors in each state who serve as a review committee to evaluate the need for and quality of care provided under Medicare.

Just about every working person will receive Medicare at age 65. Under Part A of Medicare, any person entitled to Social Security benefits is automatically eligible for hospital insurance at no charge. The processing of the person's Social Security retirement benefits triggers enrollment in Part A of Medicare.

Coverage begins on the first day of the month in which the person attains age 65. Part A coverage is "automatic"

unless you continue to work past age 65, in which case you will have to file an application for hospital insurance in order for the protection to begin. Filing for coverage is accomplished through a Social Security office.

The following people are also eligible for Part A benefits:

- a disabled person who has been receiving Social Security disability benefits for at least 24 months;

- a person who is diagnosed as having permanent kidney failure which requires dialysis or a kidney transplant;

- an individual born prior to 1909 who has no quarters of coverage under Social Security;

- a retired railroad worker.

In addition to those who automatically qualify for Medicare, certain individuals who don't qualify for Medicare hospital insurance (such as those who do not have the required work credits) may be covered if they pay monthly premiums for the coverage. The monthly premium in 1993 was about $200. These persons must also enroll in Part B of Medicare, be residents of the United States and either citizens or lawfully admitted aliens.

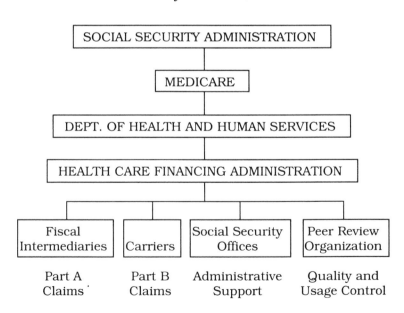

Primary and Secondary Payors

If a worker decides to continue to work after age 65, he or she will still be covered by Medicare. However, such coverage may be secondary. If an employer has at least 20 employees, employees over 65 must be offered the same health benefits as the younger employees. Medicare becomes a secondary payor of benefits and the employer's health plan is primary. Accordingly, any health claim made by an age 65 or older employee, will first be paid by the group health insurance carrier. If any part of the claim is not satisfied by the employer's plan, that portion of the claim would then be submitted to Medicare. You may reject your employer's plan and elect Medicare as the primary payor but your employer may not in any way encourage you to make Medicare your primary coverage, such as by offering to pay for Part B coverage on your behalf, or by offering to purchase a Medicare supplement policy for you.

Medicare also becomes the secondary insurer in cases where medical care is to be provided under the provisions of a liability policy, including automobile policies. But this can create some confusion.

In the 1991 decision *United States of America v. Pilot Life Insurance Co.*, the U.S. District Court for the middle district of North Carolina dealt with charges from a law firm that insurance companies were colluding to defraud the government.

The law firm of Stinson, Lyons, Gerlin & Bustamante brought a lawsuit under the federal False Claims Act. It sought damages and penalties pursuant arising from alleged false statements and claims made by Pilot Life Insurance Company.

This lawsuit was one of several similar ones filed by Stinson Lyons pending in other federal district courts against other insurance companies, including Blue Cross (in Georgia), Prudential (in New Jersey) and Provident Life (in Florida).

All of the claims arose out of a common set of facts relating to alleged violations by the insurance companies of federal legislation involving reimbursement of Medicare insurance claims. The essential claim: that they defrauded the government by shifting the primary responsibility for the payment of insurance claims to

Medicare, when in fact primary responsibility for payment was the insurance company's.

Congress Makes Employers Primary

The North Carolina court laid out some background:

"At first, Medicare provided the primary insurance payments for medical expenses for almost all of its beneficiaries. However, medical expenditures began to rise dramatically and Congress became concerned over being able to fund the program. Starting in 1980, Congress began to look to private insurance carriers to help share the burden. It did this by shifting the responsibility for making primary insurance payments to the employer health plans for those workers also covered by Medicare. In a series of enactments, Congress intended to make the private carriers pay the costs of medical care which they were otherwise responsible for paying under the private insurance contract for those employees also covered by Medicare.

"Consequently, in the Tax Equity and Fiscal Responsibility Act of 1982 (TEFRA), Congress prohibited employers from having Medicare carve out provisions in their health plan whereby the insurer would not pay for benefits paid for by Medicare. The Medicare Act was further amended by TEFRA to provide that Medicare was to be the secondary payor for employer group health plans where the beneficiary was between the ages of 65 and 69. Later enactments extended these provisions to include all employees and their spouses who were 65 years of age and older."

Stinson Lyons alleged that one insurance company— and possibly a number of others—engaged in a scheme to defraud the government by having Medicare carve out provisions in their group health policies, by responding to health claims in a manner so as to make Medicare the primary payor, or by otherwise avoiding or decreasing their obligation to reimburse Medicare.

The firm's first knowledge originally grew out of its representation of a Mr. Leonard in a state court action in Florida to recover for injuries he sustained in an automobile accident.

In processing Mr. Leonard's claims for group health benefits in 1983-1985, Louis Bustamante of Stinson Lyons

discovered that Provident Life and Accident Insurance Company, through its claims handling procedures, was violating federal law by treating Mr. Leonard's health expenses as secondary to Medicare.

Improper Behavior

Bustamante also found that the Provident policy which covered Mr. Leonard did not conform with the requirements of TEFRA. He notified Medicare officials.

Internal documents indicated that Provident was processing the claims of Medicare covered employees on a secondary rather than a primary basis in instances where benefits had not been assigned to the provider. Provident's analysts had contacted other insurance carriers to determine their method of processing claims and prepared a list if 24 insurance carriers. Next to the names of seven carriers were handwritten annotations, three of which indicated that the carriers handled the claims "same as us."

The note for Pilot indicated as follows: "If assigned, pay regular liability to provider. If no assignment, pay as secondary and wait for refund request." Stinson Lyons claimed to have other information which related to Pilot's allegedly filing false Medicare claims.

The federal court ultimately rejected the claims because Stinson Lyons's evidence was "extremely general and does not have a specific time frame other than that of the telephone call, or identify specific policies or claims."

How Medicare Pays Benefits

Medicare claims are usually paid on a reimbursement basis, meaning directly to you, the patient, usually after you've already paid the provider. Benefit payments may also be made directly to a participating provider. Participating health care providers are certified and approved by Medicare for payment of benefits, and have agreed to accept the amount reimbursed by Medicare as payment in full.

Under Part A of Medicare, when a patient is admitted to the hospital, it is because the person is under the care of a physician who has made a diagnosis. The diagnosis identifies the patient's Diagnosis-Related-Group (DRG). Each of several hundred DRGs has a prospective price which

represents the outside limit or maximum payment that Medicare will pay to the participating provider. When the provider is approved by Medicare, it agrees to accept the amount reimbursed by Medicare as payment in full.

The DRG and prospective pricing concepts were implemented by Medicare in an effort to better control expenses and fees charged by medical providers. However, if a hospital is a non-participating provider, it may bill you for excess expenses which are not paid by Medicare.

Medicare hospital insurance can help pay for inpatient hospital care, inpatient care in a skilled nursing facility, home health care, and hospice care.

Inpatient Hospital Care

Inpatient hospital care is limited by the amount of time you are hospitalized. Your benefit period begins the day that you are admitted to the hospital as an inpatient. It ends when you have not been a patient in a hospital or a skilled nursing facility for 60 consecutive days. The maximum length of time for which benefits will be paid in any benefit period is 90 days. There is no limit to the number of benefit periods a person can have (except for hospitalization due to mental illness).

During the first 60 days of a hospitalization, you satisfy a deductible (this amount was $696 in 1994) and then Medicare pays for all covered inpatient expenses. During the next 30 days of a hospitalization, you incur a daily copayment (or coinsurance) expense (this amount was $174 per day in 1994).

If you are still hospitalized after 90 days, you have a lifetime reserve of 60 additional days of coverage. These days may be drawn on, provided there are any left. Each of these reserve days also results in a daily copayment (this amount was $348 per day in 1994).

The deductible and copayment amounts usually increase each year. Normally, the copayment for the 60 reserve days is twice the copayment for days 61 to 90. It is also equal to one-half of the Part A deductible.

The following inpatient services are covered under Part A:

- room and board services in a semi-private room or ward;
- nursing services provided by licensed registered nurses;

- services of medical social workers;

- miscellaneous hospital services and supplies;

- use of hospital equipment, supplies and appliances such as wheel chairs, crutches, dressings and splints;

- prescription drugs furnished·by the hospital;

- diagnostic or therapeutic services;

- costs of operating rooms and recovery rooms;

- services of interns or residents who are in training in an approved teaching program;

- blood transfusions after the first three pints;

- X-rays, lab tests and radiation therapy;

- expenses incurred in an intensive care unit;

- rehabilitation services such as physical therapy.

With regard to room and board services, if you need a private room for medical reasons, then Medicare will pay for it. If you elect a private room just because you prefer one, Medicare will pay the semi-private rate and you pay the difference.

Inpatient services and benefits are also provided for care in a psychiatric hospital. However, psychiatric benefits are limited to a lifetime maximum of 190 days. If the patient is already hospitalized in a psychiatric hospital when he or she turns age 65, the limitation is 150 days and the time spent prior to obtaining Medicare eligibility will be counted as part of the 150-day limitation.

HOSPITAL INSURANCE BENEFITS (1995)

Expense	Medicare Pays		Patient Expense	Total Patient Expense
Inpatient Hospital Care	Days 1-60	All but $716	$716	$716
	Days 61-90	All but $179 a day	$179	$5,370
	Days 91-150	All but $358 a day	$358	$21,480
	After 150 Days	Nothing	All expenses paid by the patient	
Skilled Nursing Care	First 20 Days	All	Nothing	
	Days 21-100	All but $89.50 a day	$89.50	$7,160
Home Health Care	Full cost for an unlimited number of days		Nothing 20% of approved amt. for durable med. eq.	
Hospice Care	Total of 210 days paid in full except for some prescription medication and respite care.		5% limited copay for drugs and respite care	
Blood	Pays all except for the first 3 pints		Pays for 3 pints of blood	

Skilled Nursing Facility Care

A *Skilled Nursing Facility* is an organization which is eligible for reimbursement under Part A. A skilled nursing facility may be a nursing home or part of a general hospital which provides skilled nursing care only.

Under Medicare, a nursing home will not be approved if it provides custodial care only. The home must primarily provide nursing care under the supervision of licensed physicians and registered nurses. In addition, the nursing home must be approved or certified by the state. A nursing home must comply with the following requirements in order to be Medicare approved:

- all patients must be under the care of a physician;
- a doctor must be available for emergency care;
- care must be provided on a 24-hour basis;
- coverage is for patients in need of skilled care or rehabilitative services on a daily basis.

In order to be eligible to receive extended care benefits under Part A, the patient must have been hospitalized for a least three days in a general hospital and admission to the nursing home must occur within 30 days of discharge from the hospital. In addition, the nursing home must be Medicare approved and a participating provider, and the reason for admission to the nursing facility must be to receive skilled nursing care. Most nursing homes are not certified or approved by Medicare, because they provide custodial care only.

The following services are covered in a skilled nursing facility under Part A:

- room and board in a semi-private room;
- nursing care;
- prescriptions, supplies and equipment for use in the nursing home;
- medical, diagnostic, therapeutic and rehabilitative services.

The patient receives 20 days of covered services in each benefit period for skilled nursing care without incurring any expense. However, from the twenty-first to the hundredth day, the patient is responsible for a copayment ($87 per day in 1994). No benefits are provided after 100 days but each benefit period will consist of a new total of 100 days.

Home Health Care

Often, a person who is discharged from a general hospital needs some continued care which can be provided in the

home. Part A of Medicare covers expenses for *Home Health Care* provided certain requirements are met:

- the care must be "intermittent" or part-time, defined as not more than 35 hours per week or six days per week and not for more than three consecutive weeks;

- the person must be confined to the home based on a doctor's orders which also includes a formal home health care plan;

- the home health care organization must be approved by Medicare as a participating agency.

Specific types of home health services include:

- skilled nursing care;

- physical, speech and occupational therapy;

- part-time services of a home health aide;

- medical social services;

- the use of certain medical equipment.

Medicare covers an unlimited number of days of care as long as the above requirements are satisfied. There is no charge to the patient except for a 20 percent copayment for certain medical equipment such as wheelchairs or hospital beds. Benefits are not provided for custodial care, full-time nursing care, prescription medication or blood transfusions.

Hospice Care

Part A also provides benefits for *hospice care.* Hospice care is primarily for control of pain and supportive counseling and services for the terminally ill and their families. A hospice does not treat a sickness or employ life support systems. It simply enables the terminally ill patient to "die with dignity."

In addition to meeting the normal eligibility for Medicare benefits, the patient must be certified as terminally ill by a doctor (having a life expectancy of not more than six months). Hospice services can be provided both at home and in a hospice. Hospice benefits include:

- nursing and physician's services;

- medical social services for the patient and the family;

- necessary medical supplies and drugs for the control of pain;

- services of a home health aide;
- short-term care, such as respite care.

The benefit period for hospice care consists of two 90-day periods plus one 30-day period for a total of 210 days (approximately seven months). If additional time or days are necessary, the patient must be re-certified as terminally ill.

The cost of the hospice care is covered in full except for a five percent copayment for prescription medication (maximum payment is $5 per prescription) and a five percent copayment for respite care which is limited to the current Part A deductible ($716 in 1995).

Respite Care

Respite care is a "break" for the family of the terminally ill patient. Part A will provide benefits and cover expenses incurred when the patient is removed from the home and admitted to a hospice for a short term to enable the family to have a respite from the ordeal of caring for the individual, limited to a maximum of five consecutive days.

If respite care is required for the family and the daily hospice charge is $200, the family would be responsible for $200 x 5 percent = $10 per day copayment.

What Part A Does Not Cover

Hospital insurance under Medicare does not cover:

- private duty nursing;
- charges for a private room, unless medically necessary;
- conveniences, such as a telephone or television in a policyholder's room;
- the first three pints of blood received during a calendar year (unless replaced by a blood plan).

A Key Medicare Part A Dispute

The 1992 U.S. District Court decision *Folland (on Behalf of Smith) v. Sullivan* dealt with Medicare Part A.

Priscilla Smith was 66 years old when, in October 1987, she suffered a left-sided cardiovascular accident (CVA)

and was consequently hospitalized from October 16 through October 27. On October 29, she was placed under the care of the Orleans and Northern Essex Home Health Agency (ONEHHA).

In December, Smith's physician, Dr. Michael Sterling, completed a home health certification and plan of treatment form covering December 28, 1987 through February 26, 1988. The certification noted that Smith suffered from the left-sided CVA, hypertension, adult onset diabetes melitus, and hemorrhoids. During that period, Smith also had problems with "blood pressure regulation, right lower extremity weakness, obesity and a recent weight gain, and a knowledge deficit."

An Order for Home Care

In the December 28 plan of treatment, Sterling ordered skilled nursing visits once a week for 60 days to instruct Smith on the effects of medications and her diabetic diet, to monitor her vital signs, activity, tolerance, weight, skin condition, and diabetic status, to provide foot and nail care, to reinforce her exercise program, and to supervise home health aide visits once every two weeks.

Sterling also ordered home health aide visits three times a week to bathe Smith, assist her in walking, and reinforce her exercise program and diet instruction.

The goals of this plan were to improve Smith's knowledge of her medications and diet, assure early detection and treatment of complications in her existing problems, and ultimately for Smith to gain optimal independent function.

On January 7, 1988, Smith was visited by Donna Heath, R.N. Heath's report indicated that Smith's diet was going well, her blood pressure was under control but warranted rechecking to assure continued stability, and she had no pedal edema. Heath noted that she would return the next week to assess vital signs and medications.

On January 12, 1988, Smith reported that her blood pressure had been high on a recent visit to her doctor—but when measured on January 12, it was only slightly higher than on January 7. Smith's vital signs and symptoms had not otherwise changed. Heath noted that she would return the next week to monitor Smith's blood sugar, bowel function, breath sounds, and perform a general assessment.

On January 20, 1988, ONEHHA informed Smith of its determination that the services provided no longer met Medicare coverage requirements, and that Medicare would thereafter not be billed. Smith acknowledged receipt of this notice.

The Trouble Begins

The nursing visit of January 20 was the first visit in dispute. Other disputed nursing visits occurred on January 27, February 26, March 3 and March 23, 1988. The coverage of 36 related home health aide visits that occurred from January 20, 1988 through April of 1988 was also in dispute.

On January 22, 1988, Sterling decreased nursing visits to one a month. Sterling completed a new certification form on February 26, 1988 which reflected the decrease in nursing visits to one per month and otherwise ordered the same plan of treatment as before.

On March 3, 1988, Smith requested an unscheduled nursing visit because she was experiencing new symptoms of abdominal and lower back pain. Sterling was contacted; he advised Smith to take pain medication and call him if the symptoms persisted or worsened.

On April 18, 1988, Smith was discharged from ONEHHA and admitted to North Country Hospital. Smith thereafter received inpatient treatment and undisputed home health care for treatment of cancer of the colon. Smith died of that cancer on September 5, 1989.

Smith had requested an initial determination and reconsideration of the disputed claim. Medicare's fiscal intermediary denied both requests and, on review, an administrative law judge also denied coverage.

Having exhausted her administrative remedies, Smith's daughter Nancy Folland filed a lawsuit to challenge the denial of Medicare Part A home health care benefits.

In a physician's report filed after Smith's death, Sterling stated that home health treatment was necessary for Smith because she had "diabetes [with an] ongoing need for diabetic foot care," and the provision of such care by a nurse was necessary to manage her condition.

Benefits were granted by the district court, which found "the ALJ's conclusion was not based upon substantial evidence or in accordance with correct legal principles."

Medicare Part B

Part B benefits provide coverage for most of the medical expenses not covered by Part A. To have adequate coverage, you really must have both Part A and Part B benefits.

While Part A is financed through part of the Social Security tax, Part B is paid for by the individuals who enroll in it.

Eligibility for Part B of Medicare is the same as it is for Part A except that coverage is not automatic. Part B is optional and requires the payment of a monthly premium, which increases each year. The 1995 monthly premium is $46.10.

Part B coverage is subject to a specific enrollment period of seven months, beginning three months before the person's sixty-fifth birthday, and ending three months after the month the person turns 65.

At the time the person is eligible for Part A benefits, he or she is sent an enrollment form for Part B. If Part B coverage is to be rejected, the individual must submit the form indicating rejection of coverage within two months.

Once the person enrolls in Part B, coverage is effective on the first day of the month following submission of the enrollment form. If a person enrolls in the seventh month of the initial enrollment period, coverage will be effective on the first day of the seventh month.

A seven-month enrollment period is also provided to employees who continue to work past age 65 and for whom Medicare is the secondary coverage. When these employees retire, they may enroll at any time during the seven months following the date on which the private insurance is canceled.

If an individual declines coverage during the initial enrollment period, that person may subsequently enroll in Part B during any general enrollment period, held from January 1 to March 31 each year. For those who enroll during the general enrollment period, coverage is effective July 1.

However, if you do not enroll during your initial enrollment period and subsequently enroll in a general period, Part B premiums are increased by ten percent for each full 12-month period you were not enrolled in Part B.

Generally, individual premiums are deducted directly from the person's Social Security, government or railroad retirement checks each month. Individuals who are not receiving these retirement benefits may pay their premiums on a quarterly basis. Social service agencies may enroll and pay the premiums for those on public assistance.

The administration of Part B coverage is similar to that of Part A. The Department of Health and Human Services has overall responsibility for the program. It uses the services of The Health Care Financing Administration and various local Social Security offices for processing of Part B enrollments. The Department of Health and Human Services contracts with commercial insurers referred to as "carriers" for purposes of administering and processing claim payments.

After the annual medical insurance deductible ($100) is met, Part B generally will pay 80 percent of the approved charges for covered services received during the rest of the year.

The deductible amount is subject to change. However, it is not adjusted as often as the Part A deductible. For many years the Part B deductible was $75. In 1991, it was increased to $100. Thus, the patient is responsible for the payment of the calendar year deductible and 20 percent copayment of Part B expenses.

Part B Services

Following is a list of services covered by Part B:

- doctors services provided on an inpatient or outpatient basis, no matter where received in the United States, and including surgical services, diagnostic tests and X-rays, medical supplies furnished in a doctor's office, and services of the office nurse;
- services of clinical psychologists, chiropractors, podiatrists, and optometrists;
- outpatient diagnostic services and medical lab fees, such as care in an emergency room or outpatient clinic of a hospital;
- outpatient physical and speech therapy;

- certified nurse-midwife services for pregnancies (needless to say, this benefit isn't used much by those over 65);

- dental work which is required due to accident or disease;

- the use of outpatient medical equipment such as iron lungs, braces, colostomy bags, and prosthetic devices such as artificial heart valves;

- ambulance service, if the patient's condition requires it;

- outpatient psychiatric care (there is a 50 percent copayment instead of 20 percent);

- the cost of certain vaccines and antigens. Only medicines which are administered at the hospital or at a doctor's office are covered by Medicare. Drugs which can be self-administered (taken at home) are not covered, even if prescribed by a doctor;

- an unlimited number of home health care visits, if all required conditions are met and you do not have Medicare hospital (Part A) coverage;

- preventive health care expenses such as pap smears and mammography (however, mammograms are covered only when performed in a Medicare-approved facility);

- one pair of eyeglasses following cataract surgery.

Blood is a covered expense under Part B (also Part A). In essence, there is a "3-pint deductible" for blood. The patient is responsible for either paying for the first 3 pints of blood or replacing the blood. The blood deductible for Part B can be used to satisfy the blood deductible for Part A. Thus, only one 3-pint deductible is required. However, any blood provided under Part B is still subject to the 20 percent copayment.

Services Not Requiring a Deductible

There are certain Part B services which do not require a deductible or a 20 percent copayment. These services include:

- the cost of a second opinion required by Medicare for surgery;

- home health services (except the 20 percent copayment applies to the use of certain medical equipment);

- pneumococcal vaccine (flu shots);

- outpatient clinical diagnostic lab tests conducted by Medicare-certified facilities or doctors who accept assignments.

Under Part B, the allowable charge is the charge on which Medicare will base its benefit payment. Medicare will compare the amount actually charged for the medical service, the customary charge for the service rendered (generally, the average fee charged in the area during the previous year), and the prevailing charge in the area where the patient lives. Medicare will then base its benefit payment on the smallest of these three figures.

Also, under Part B of Medicare, there is a deductible ($100) and a 20 percent copayment. Medicare pays 80 percent, the patient, 20 percent.

How Part B Payments Are Made

Part B payments may be paid directly to the provider under the assignment method. The patient agrees in writing to assign the benefit payment to the physician. Under the assignment method, the provider agrees to accept the amount paid by Medicare and thus any excess charge will not be billed to the patient.

Once the patient or the participating provider submits a claim to Medicare, the patient receives an Explanation of Medicare Benefits notice to explain how the claim will be paid. This form will indicate what the covered services and expenses are, the allowable charges and how much, if any, of the patient's deductible remains to be satisfied.

Part B Exclusions

Although Part B benefits are relatively comprehensive, there are several exclusions to be considered. These include:

- prescription drugs;

- routine exams and testing which are not due to a medical reason such as routine hearing aid tests, routine foot care and dental care;

- private duty nursing (unless prescribed by a doctor);

- medical services which Medicare feels are not necessary;

- medical services performed by relatives or for which the patient is not legally obligated to pay;

- personal convenience items;

- medical care outside the United States (except for emergency care);

- custodial care such as meal preparation;

- acupuncture or experimental medical treatment and procedures;

- cosmetic surgery (except if the need is due to an accident).

Choose the Right Physician

About half of the doctors in the country will accept the amounts paid by Medicare as payment in full. This is referred to as accepting the Medicare assignment. As an exception, if a pathologist or radiologist who performs services on an inpatient basis will accept a Medicare assignment, Medicare will pay 100 percent of what it calls "reasonable charges." Medicare will also pay the cost of a Medicare-required second opinion for surgery with no 20 percent copayment. Medicare will also pay for services of other specialists on the same 80 percent of reasonable charges basis.

Physicians who do not accept assignment are prohibited by law from charging more than 140 percent of the Medicare prevailing charge for office and hospital visits. For other services, such as surgery, the limit is further reduced to 125 percent.

Physicians have been trying to circumvent these limiting charges by requiring patients to contract to pay the doctor's full charges. The Health Care Financing Administration has cautioned that these contracts are not valid.

Doctors, suppliers, and other providers must submit claims for covered Part B services directly to Medicare, regardless of whether they are participating or nonparticipating providers. Some doctors ask patients to waive the right to have doctors submit Medicare claims and obligate the patient to pay privately for Medicare-covered ser-

vices. These waivers are also invalid, according to the HCFA, and could subject physicians to civil penalties.

If a doctor has not accepted a Medicare assignment, the doctor sends the bill for Part A services directly to the patient. The patient fills out a Medicare claim form, and attaches itemized bills from the doctor including date of treatment, place of treatment, description of treatment, doctor's name, and charge for service. The form and accompanying documents are sent to the Medicare "carrier" (private insurance company) in the patient's area. Upon receiving the claim, the carrier will send the Explanation of Medicare Benefits. This form shows which services are covered and the amounts approved for each service.

The Appeals Process

If your Medicare claims are denied, there is an appeal process you can go through. Within six months of receiving the Explanation of Medicare Benefits notice, you must file a written request for review. The carrier will check for miscalculations or other clerical errors. If the carrier, after review, declines to make a change, an appeal can be made to the Social Security office (but only if the amount disputed is $100 or more). You must appear in person to attend a hearing and present evidence, such as a doctor's letter, to support your point. A written notice of the decision will be sent to you after the hearing.

Health Maintenance Organizations are available to individuals on Medicare, just as they are through private insurance contracts. A growing number of HMOs have contracted with the federal government to provide managed care services to Medicare recipients. Qualified HMOs offer services covered by both Part A and Part B of Medicare. Medicare makes a monthly payment to the HMO on behalf of the recipient. This payment will not cover Medicare deductibles and copayments, so additional payments from the recipient to the HMO may be required.

The advantages of an HMO for a Medicare recipient may be:

- no claim forms required;

- almost any medical problem is covered for a set fee so health care costs can be budgeted.

As with any HMO, all medical services must be received through the plan, except in emergencies. Also, HMOs may not be available in your area. "We have all these people coming into the area from California where they have wonderful HMOs," an AARP volunteer told a local newspaper in Coeur D'Alene, Idaho, in 1994. "They want the same coverage here and we don't have it."

Medicare Supplements

Medicare supplement policies pay some or all of Medicare's deductibles and copayments. Some policies also pay for health services not covered by Medicare. An estimated 80 percent of the nation's 30 million Medicare beneficiaries have purchased such plans, with annual premiums ranging from $150 to $1,070 or more.

As with most other health insurance policies, Medicare supplement policies are sold on both an individual and group basis. Medicare supplement policies are neither sold nor serviced by the state or federal government. Insurance agents and companies may not claim that they represent the Medicare program or any government agency, or that the policy they are selling is guaranteed, approved, or otherwise backed up by the government. An agent is nothing more than an agent for an insurer.

You only need one Medicare supplement policy, because only one policy will pay benefits. Although it is unethical and illegal to duplicate existing coverage for the sake of generating a premium and commission, agents have been known to do so. There are serious penalties for agents who duplicate or "pile on" supplemental coverage, including the loss of their license to sell insurance, jail terms for up to two years, and fines of up to $10,000.

Insurance is regulated at the state level, so it is the state insurance departments for the most part that impose regulations on the Medicare supplement industry. State insurance departments approve the policies sold by insurance companies, but only to the extent that the company and policy meet the requirements of state law. The state insurance department also oversees the licensing of agents who sell Medicare supplements. Some states require additional instruction in ethics for agents who serve the senior market.

An organization which influences insurance laws passed by both the federal and state government is the National

Association of Insurance Commissioners (NAIC). The NAIC passes model legislation to help regulate the insurance industry as well as its products. However, the NAIC cannot force a state to adopt specific legislation. The issue, i.e., Medicare supplements, is investigated and studied by the NAIC. After much deliberation, some model (or sample) legislation is produced. Each state may elect to adopt such legislation in whole or in part. Each state is also free to reject the legislation and develop its own statutes and guidelines.

The NAIC model laws on Medicare supplement insurance that have been adopted by most states regulate areas such as disclosure, renewability, your right to return the policy (the free look period), replacement, marketing standards, and loss ratios.

OBRA 1990

The Omnibus Budget Reconciliation Act of 1990 (OBRA 1990), a federal law which took effect on November 5, 1991, enhanced the protections for Medicare supplement consumers. Under this law, Medicare supplement insurance may not be denied on the basis of an applicant's health status, claims experience, or medical condition during the first six months a Medicare beneficiary age 65 or older first enrolls in Part B of Medicare. This is known as the open enrollment requirement.

In early 1994, Connecticut insurance regulators, citing unfair sales practices, ordered three insurance companies to lift restrictions they'd put on sales of supplemental insurance for certain people on Medicare.

The companies under scrutiny: Blue Cross & Blue Shield of Connecticut, Mutual of Omaha and Prudential Insurance Company of America's program marketing in conjunction with the AARP.

Specifically, the insurance department cited:

- Blue Cross for limiting sales of one Medicare supplemental policy only to people who seek it within six months of turning 65. The plan included home health care benefits. Blue Cross didn't want to sell it to anyone beyond the six-month period, fearing that people would wait to buy the policy until they're sure to need the benefits—especially the home health care coverage. "If such a situation was allowed to

develop," Blue Cross said in a prepared statement, "it would dramatically increase claims costs, thus hurting those already in the plan."

- Mutual of Omaha for only selling the most basic Medigap policy to disabled people under age 65 on Medicare switching from another insurer. The company offered four different plans to such applicants if they were not replacing another company's policy.

- Prudential Insurance for halting sales in a way that regulators warned could bar the company from re-entering the Medicare supplement market in the state for up to five years.

Prudential stopped most Medigap sales because regulators, citing a new state law, insisted the company sell at least one policy to any disabled person on Medicare. Prudential's practice had been to sell supplemental coverage only to AARP members. Connecticut Insurance Commissioner Robert Googins called the position taken by Prudential and AARP "unseemly....they should not be hiding behind some artificial membership rule."

The state Department of Insurance sent letters to the three insurers, requiring them to report within 15 days on how they were complying with the order. The insurers each said they would work with state officials to resolve the disputes. None admitted any wrongdoing.

Redundant Coverage is Prohibited

OBRA prohibits the sale of Medicare supplement insurance to a person who already has another health insurance policy that provides coverage for the same benefits. Likewise, a health insurance policy may not be sold if it duplicates coverage by an existing Medicare supplement policy. Insurers must ask applicants about their existing coverage when taking applications.

Insurers must suspend insurance benefits upon request of a policyholder during any period of time the policyholder is entitled to benefits under Medicaid.

All Medicare supplement policies must cover preexisting conditions after the policy has been in force for six months.

If a Medicare supplement policy replaces another Medicare supplement policy which has been in effect for at

least six months, the new policy must waive any time periods applicable to preexisting conditions, waiting periods, elimination periods, and probationary periods.

For determining order of benefits, OBRA 1990 requires that employer benefits are primary to Medicare benefits until October 1, 1995 (except for retirees and people with end-stage renal disease). Employers may not offer incentives to employees who are eligible for Medicare to terminate their group health coverage in order to avoid having the group health coverage be primary. Violators may be subject to a $5,000 penalty for each violation.

Standardizing the Options

Perhaps most importantly, OBRA required that Medicare supplement policies be standardized. This was done because the staggering number of different Medicare supplement policies available from different insurance companies in different states was confusing to anyone in the market for a Medicare supplement policy, and it was felt that standardizing the policies would be the best way to improve consumer protection.

The NAIC developed ten standard Medicare supplement policies, one of which is a core benefit or no frills policy with basic benefits that must be included in all Medicare supplement policies. No more than these ten standard Medicare supplement policies may be offered for sale.

The ten Medicare supplement policies developed by the NAIC are identified by letters "A" through "J". Insurers may not change the letter designations assigned to the ten policy forms, but they may add other names or titles.

Plan A is the basic policy offering just the set of core benefits. The other nine policy forms (Forms B through J) contain the core benefits plus various additional benefits. A state may limit the number of plans available within the state to fewer than ten, but Plan A must be approved for sale. Insurers are not required to offer all ten plans but each must offer the basic plan.

MEDICARE SUPPLEMENT PLANS

MEDICARE SUPPLEMENT INSURANCE CAN BE SOLD IN ONLY TEN STANDARD PLANS. THIS CHART SHOWS THE BENEFITS INCLUDED IN EACH PLAN.
EVERY COMPANY MUST MAKE AVAILABLE PLAN "A". SOME PLANS MAY NOT BE AVAILABLE IN ALL STATES.

BASIC BENEFITS: INCLUDED IN ALL PLANS

HOSPITALIZATION: PART A COINSURANCE PLUS COVERAGE FOR 365 ADDITIONAL DAYS AFTER MEDICARE BENEFITS END.
MEDICAL EXPENSES: PART B COINSURANCE (20% OF MEDICARE-APPROVED EXPENSES).
BLOOD: FIRST THREE PINTS OF BLOOD EACH YEAR.

A	B	C	D	E	F	G	H	I	J
BASIC BENEFITS	BASIC BENEFITS	BASIC BENEFITS	BASIC BENEFITS	BASIC BENEFITS	BASIC BENEFITS	BASIC BENEFITS	BASIC BENEFITS	BASIC BENEFITS	BASIC BENEFITS
		SKILLED NURSING CO-INSURANCE	SKILLED NURSING CO-INSURANCE	SKILLED NURSING CO-INSURANCE	SKILLED NURSING CO-INSURANCE	SKILLED NURSING CO-INSURANCE	SKILLED NURSING CO-INSURANCE	SKILLED NURSING CO-INSURANCE	SKILLED NURSING CO-INSURANCE
	PART A DEDUCTIBLE	PART A DEDUCTIBLE	PART A DEDUCTIBLE	PART A DEDUCTIBLE	PART A DEDUCTIBLE	PART A DEDUCTIBLE	PART A DEDUCTIBLE	PART A DEDUCTIBLE	PART A DEDUCTIBLE
		PART B DEDUCTIBLE			PART B DEDUCTIBLE				PART B DEDUCTIBLE
					PART B EXCESS (100%)	PART B EXCESS (100%)		PART B EXCESS (100%)	PART B EXCESS (100%)
		FOREIGN TRAVEL EMERGENCY	FOREIGN TRAVEL EMERGENCY	FOREIGN TRAVEL EMERGENCY	FOREIGN TRAVEL EMERGENCY	FOREIGN TRAVEL EMERGENCY	FOREIGN TRAVEL EMERGENCY	FOREIGN TRAVEL EMERGENCY	FOREIGN TRAVEL EMERGENCY
			AT HOME RECOVERY			AT HOME RECOVERY		AT HOME RECOVERY	AT HOME RECOVERY
							BASIC DRUGS ($1,250 LIMIT)	BASIC DRUGS ($1,250 LIMIT)	EXTENDED DRUGS ($3,000 LIMIT)
				PREVENTIVE CARE					PREVENTIVE CARE

Exceptions: Delaware does not permit plans C,F,G, and H. Pennsylvania and Vermont do not permit Plans F,G, and I. Waivers were granted to Minnesota, Massachusetts, and Wisconsin because they already had standardized Medicare supplement policies. In these three states, the benefit packages are different than the ten standard plans.

The Basic Package

The benefits which make up Plan A and form the basis for all the other plans include coverage for:

- the Part A coinsurance amount for days 61 through 90 of hospitalization in each Medicare benefit period;

- the Part A coinsurance amount for each of the lifetime reserve days;

- 100 percent of Part A eligible hospital expenses, limited to a maximum of 365 days, after all Medicare Hospital benefits have been exhausted;

- Parts A and B for the reasonable cost of the first 3 pints of blood;

- the 20 percent copayments for Part B services.

Again, all ten standard plans must contain the core benefit package described above.

All Medicare supplement policies must cover losses resulting from sickness and accidents on the same basis. Also, they must cover inpatient and outpatient care for substance abuse. No Medicare supplement policy may contain benefits which duplicate the benefits provided by Medicare.

Medicare supplement policies may not use waivers to exclude, limit or reduce coverage or benefits for specifically named or described preexisting diseases or physical conditions.

HOSPITAL INSURANCE BENEFITS (1993)
WITH
MEDICARE SUPPLEMENT

AFTER MEDICARE, PATIENT PAYS	SUPPLEMENT PAYS	BALANCE
Inpatient Hospital Care $676 deductible	$676	0
$169 copayment, days 61-90	$169 per day	0
$338 copayment, days 91-150	$338 per day	0
	100% of cost for 365 days	0
All expenses after 150 days		
Skilled Nursing Care Nothing for the first 20 days	Nothing	0
$84.50 copayment, days 21-100	$84.50 per day	0
Home Health Care Nothing	Nothing	0
Hospice Care Nothing except 5% copayment for medication and respite care	Nothing	$5 maximum for medication and 5% copay for respite care

Medicare supplements must be automatically adjusted each year for the increased deductibles and copayments which occur annually in Medicare. Most Medicare supplements follow the same guidelines and pay nothing for services Medicare finds unnecessary, such as cosmetic surgery.

If you have health insurance coverage before you are eligible for Medicare, your insurer must send you a notice of the availability of a Medicare supplement. If you have coverage under a group Medicare supplement policy, and the policy is terminated and not replaced, the insurer must offer you an individual policy and a choice between a policy that continues the same benefits provided by the group policy or a policy that provides only the benefits required to satisfy the minimum benefit standards required by your state.

Managed Care Options

Medicare Select plans are supplement policies which provide managed care or HMO-type care. The individual makes a monthly premium payment to the HMO. Medicare Select plans conform to the ten standardized plans in terms of benefits provided.

As with any HMO, all medical services must be received through the plan, except in emergencies. This means that you may be required to receive inpatient hospital care in specific hospitals. Other restrictions on where you can obtain health services may also apply. Because of the managed care aspect, premiums are expected to be lower for Medicare Select plans.

Medicare Select plans are not available in all states, and are being evaluated to see if they should be made available nationwide.

Standard Policy Provisions

As health insurance policies, Medicare supplements must contain the standard provisions found in any health insurance contract. Of the various provisions found in Medicare supplement policies, there are a number which are of special importance to the policyholder. These include:

- premium payment and renewability;
- preexisting conditions;
- benefit provisions;
- the claims process;
- exclusions and limitations.

It's important to understand the premium amount and the frequency with which it is to be paid. Related to the premium is the concept of renewability. Most Medicare supplements are issued as guaranteed renewable, which means the insurer guarantees to renew (and cannot cancel the policy) but does not guarantee the premium. The premium will be increased at certain ages or on the policy's anniversary.

Most insurers will band premiums by age. That is, all applicants ages 65 to 70 pay the same premium, ages 71 to 75 pay the same premium, etc. Most insurers do not make any distinction regarding male or female rates. The premium is the same for both sexes.

Actual premiums may vary widely from one company to another depending on the insurer's loss experience. Naturally, a basic Medicare supplement will be less costly than a more comprehensive policy. Thus the quantity and quality of the benefits will also determine premium.

BASIC MEDICARE SUPPLEMENT ANNUAL PREMIUMS

AGES	COMPANY A	COMPANY B	COMPANY C
65-70	$450	$568	$701
71-75	535	$638	$771
76-80	620*	$796	$945

COMPREHENSIVE MEDICARE SUPPLEMENT ANNUAL PREMIUMS

65-70	$555	655	800
71-75	620	744	905
76-80	705	812	990
80+	705*	880	1,050

* Company A's premium remains the same for ages 76 and above.

A caveat: Always find out whether or not your premium is guaranteed, and ask to see a schedule or scale of the increasing premium payments.

Medicare supplement policies must be issued as guaranteed renewable, and cannot be canceled or nonrenewed solely because your health has deteriorated or because of your age. Termination of a Medicare supplement policy cannot reduce the benefits for any continuous loss or claim which began before the policy was terminated. If your coverage is canceled or nonrenewed for any reason, except for nonpayment of premium, it will not serve to terminate coverage for your spouse if he or she is covered under the same policy

Preexisting Conditions

Many older people are being treated for some medical problems. These conditions may be significant (high blood pressure, heart conditions, etc.) or minor (such as allergies). In any event, for insurance purposes these problems are defined as preexisting conditions.

In any health insurance policy, you should investigate the coverage limitations for preexisting conditions. First, read through the definition of a preexisting condition in the policy, and ask your agent for an explanation. Most Medicare supplement contracts will define a preexisting condition as any condition for which the policyholder sought treatment or advice in the six months prior to the effective date of the policy.

Treatment generally consists of actual medical treatment provided by a doctor, nurse, hospital, etc. Advice consists of consultations, but could even include a telephone conversation regarding the medical condition.

Once you understand what a preexisting condition is, you should know that most Medicare supplements will exclude benefits for that condition until the policy has been in force for six months. In other words, there is a six month waiting period for coverage of preexisting conditions. Some companies have no preexisting condition exclusion, some impose a 90 day or 3 month exclusion, but none can be greater than six months.

Claims and Exclusions

It is important to understand the benefit provisions of the policy. This includes how the deductibles and copayments under Part A and Part B of Medicare are reimbursed, how the policy treats allowable Medicare charges and excess charges, and how important it is for you to use participating providers.

Any optional benefits you have elected also need to be discussed, such as private hospital rooms, coverage for blood and coverage of outpatient prescription medication.

It is equally essential that you understand the claims process under both Medicare and the Medicare supplement policy. The mandatory provisions in your policy will define the steps for filing and processing a claim.

Generally, Medicare supplements exclude the same services that Parts A and B do, but some supplements offer coverage for some Medicare exclusions. These additional benefits (which are available for an additional premium) might include a benefit for private hospital rooms or prescription drugs. In addition, the Medicare supplement will normally exclude those conditions common to most health insurance policies. These would include losses from war or act of war and self-inflicted injuries.

Due to the high cost of providing outpatient prescription coverage, most Medicare supplements will exclude this benefit. And of course, while a senior citizen may be relatively free from the need for inpatient hospitalization, few are free from the need for prescription medication, which can run hundreds of dollars per month.

How Underwriting Works

Underwriting Medicare supplement policies is similar to underwriting other health insurance policies. The important underwriting factors include the age and sex of the applicant, past medical history, current physical condition, morals and avocations.

Everyone has the right to buy a Medicare supplement policy if they apply within six months of becoming eligible for Medicare (age 65) and have enrolled in Part B. During this "open enrollment" period, the insurance company must offer you a supplement without any restrictions. If you apply for coverage after this period, you can be declined

for coverage or have exclusionary riders added to your policy.

Insurers may base Medicare supplement premiums on two age-rating methods, or may charge everyone the same premium regardless of age (this is rare). With attained age rating, your premium is adjusted every year according to your age. With issue age, your premium is always based on the age you were when you purchased the policy. These are initially more expensive, but the premium amount never goes up.

Premiums also may be affected by where you live. Sometimes, higher premiums are charged for men than women. Check with your insurance company or agent to find out your exact premium.

Beware of policies that are advertised as "guaranteed issue" contracts. These are the type that say "no medical questionnaire needed to apply." No underwriting takes place but most often, the policies will have limited benefits and/or more exclusions than a policy which is underwritten. While there are companies that take all applicants regardless of health status, if your health is relatively good, it is usually a better idea to go through the underwriting process.

Consumer Protection Provisions

To help protect the consumer, states have passed laws requiring insurance policies to "disclose" your rights and responsibilities, right from the time of application.

States usually require that the application include the following statements:

- You do not need more than one Medicare supplement policy.

- If you are 65 or older, you may be eligible for benefits under Medicaid and may not need a Medicare supplement policy.

- Counseling services may be available in your state to provide advice concerning the purchase of Medicare supplement insurance and concerning Medicaid.

All applicants for Medicare supplement coverage must receive a Medicare supplement Buyers Guide, in the form developed jointly by the National Association of Insurance

Commissioners (NAIC) and the federal Health Care Financing Administration (HCFA).

You must receive the Buyers Guide at the time you apply for coverage, and the insurer must obtain written proof of receipt (usually the agent will ask you to sign a form that you have received the Buyers Guide). If you are applying for coverage by mail (known as a direct-response solicitation), the Buyers Guide must be delivered to you no later than at the time the policy is delivered to you.

Outline of Coverage

Each insurer, except direct-response insurers, must also provide an Outline of Coverage to you at the time of application, and obtain written acknowledgement that you have received it. Outlines of Coverage describe whether the insurance covers or does not cover private duty nursing, skilled nursing home care (beyond what is covered by Medicare), custodial nursing home care, intermediate nursing home care, home health care (above the number of visits covered by Medicare), physician charges (above Medicare's "reasonable charges"), drugs, care received outside of the United States, dental care, routine foot care, cosmetic surgery, and examinations for and the cost of eyeglasses and hearing aids.

The Outline of Coverage must also describe the policy provisions that exclude, eliminate, resist, reduce, limit, delay, or in any other way qualify the payment of benefits. There must be a conspicuous statement that the chart summarizing Medicare benefits only briefly describes the benefits, and that the Health Care Financing Administration or its Medicare publications should be consulted for further details.

Policy provisions which restrict renewability or continuation of coverage, especially if the insurer has reserved its right to change your premium, must be explained. The amount of the policy premium to be charged must also be given.

A Medicare supplement policy which provides for the payment of benefits based on standards described as "usual and customary" "reasonable and customary" or similar words must define and explain those terms in the Outline of Coverage.

Many of the most important policy features such as renewability and significant exclusions or limitations must appear on the first page of the policy, and not be buried in the fine print at the end of the policy booklet. Policy forms that do not meet these requirements usually will not be approved for sale.

For example, the renewal, continuation or nonrenewal provision which describes the ways in which the policy may be renewed or continued, and whether the insurer has reserved the right to nonrenew the policy, must be appropriately captioned and appear on the first page of the policy.

Adding Riders and Endorsements

Riders or endorsements added to a Medicare supplement policy after date of issue or at reinstatement or renewal which reduce or eliminate benefits or coverage in the policy require your signed acceptance. This does not apply to riders or endorsements you have requested or instances where the insurer exercises a specifically reserved right under the policy, or if the rider or endorsement is required by law. If you are to be charged a separate additional premium for benefits provided in connection with riders or endorsements, the premium charge must be disclosed in the policy.

Any limitations regarding preexisting conditions must appear as a separate paragraph of the policy and be clearly labeled "Preexisting Condition Limitations."

No later than 30 days prior to the annual effective date of any Medicare benefit changes, insurers must notify policyholders of any modifications made in Medicare supplement coverage. The notice must describe the revisions in the Medicare program, describe the modifications of the Medicare supplement insurance, and inform each covered person as to when any premium adjustment will be made due to the changes in Medicare.

Free Look Language

Medicare supplement policies and certificates must have a notice prominently printed on the first page, or attached to the first page, informing every applicant of the right to return the policy or certificate within 30 days of delivery and have the premium refunded if not satisfied for any

reason. Any refund must be paid directly to the applicant in a timely manner.

Marketing Rules

The terms "Medicare supplement," "Medicare Wrap-Around," or similar words may not be used in marketing a policy unless the coverage and forms are approved as Medicare supplement policies by the state insurance department. Many states prohibit the use of the term Medigap because it implies that all health care costs not covered by Medicare will be covered by the supplement.

Other marketing materials will emphasize benefits that may have little real value. An example: A brochure from Union Fidelity Life Insurance Co., a unit of Illinois-based Combined International Corp., warned that "Medicare pays nothing" after 150 days of hospitalization. The Union Fidelity plan supplemented hospital charges for up to 365 days. Senior-citizen groups, though, pointed out that few people need such a benefit, since the average Medicare hospital stay is 7.5 days.

States usually require insurers marketing Medicare supplement insurance coverage to establish marketing procedures to assure that any comparison of policies done by its agents will be fair and accurate. Also, insurers must have written, established procedures to assure that excessive insurance is not sold or issued.

The first page of the policy must include the statement "Notice to Buyer: This policy may not cover all of your medical expenses. The buyer is thus informed that the policy may not cover all medical care costs during the period of coverage, and should review all policy limitations."

Advertisements that produce leads by using a coupon or request to write must disclose that an agent may contact the applicant. Advertisements and solicitations may not use a true or fictitious name which is deceptive or misleading. Ads may not imply connection to a government agency, nonprofit or charitable institution, or senior organization to imply the policy is endorsed by governmental agencies. Advertisements must not imply that policyholders will become members of a special class or group and enjoy group privileges, unless such is the case. Ads used by agents or brokers must have prior written approval of the insurer before being used.

Copies of Medicare supplement insurance advertisements are usually required to be submitted to the insurance department for review at least 30 days before being used.

Replacing Supplemental Policies

Because the elderly are often victimized insurance prospects, and are most susceptible to being penalized by pre-existing conditions limitations, there are often very restrictive government regulations for replacing Medicare supplement policies.

Application forms must include questions on whether the insurance will replace existing Medicare supplement insurance and whether the policy or contract being applied for is intended to replace any other policy or contract currently in force.

You may be asked to respond to the following questions:

- Do you have another Medicare supplement insurance policy, subscriber contract, or certificate in force (including health care service contract or health maintenance organization contract)?

- Did you have another Medicare supplement insurance policy, subscriber contract, or certificate in force during the last 12 months? If so, with which company? If the policy lapsed, when did it lapse?

- Are you covered by Medicaid?

- Do you intend to replace any of your medical or health insurance coverage with this policy, subscriber contract, or certificate?

Some states require agents to list any other health insurance policies or contracts they have sold to you, including those that are still in force and those sold during the last five years which are no longer in force.

If you already have a policy and want better benefits, you can replace your policy with a new one. Be sure the old policy doesn't expire before the new policy takes effect.

If you are replacing Medicare supplement insurance, the insurer or its agent must give you a Notice Regarding Replacement. The notice will inform you that your preexisting conditions may not be covered by the new policy, which could result in delay or denial of a claim for benefits.

The notice must also inform you that failure to include all material medical information on the application may result in denial of claims, and you may want to consult your present insurer and agent. You must receive a copy of the notice before the policy is issued or delivered, and a copy signed by both you and agent is retained by the insurer. If you purchase a Medicare supplement policy through the mail, the insurer must give you the notice when the policy is issued.

Insurance companies must show that they have established procedures for determining whether a replacement policy contains clearly and substantially greater benefits to the policyholder than the replaced coverage in order to trigger first-year commissions for the agent.

In the 1990 Alabama Supreme Court decision *Lucile Guinn v. American Integrity Insurance Co., et al.*, the court considered the questionable sales of Medicare supplement coverage, and the practice of replacing good coverage with bad.

Guy Martin and Roger McCollough, who did business as Southern Insurance Service, were general agents for American Integrity Insurance Co. and Providers Fidelity Insurance Co. They visited Guinn at her home in an attempt to sell her Medicare supplement insurance. Guinn informed them that she already had coverage; she had approximately five months of coverage remaining before a renewal premium of $594 was due, and had met all of the required waiting periods under those policies.

Guinn, who was 88 years old, informed Martin and McCollough that she was especially interested in obtaining the best nursing home coverage she could. However, she emphasized that she did not want to be overinsured. Guinn also told the agents that she was not knowledgeable about insurance policies and the different kinds of benefits they provided, and would rely on them to tell her what she needed to do to get the coverage that she desired.

Martin and McCollough reviewed Guinn's current policies and then offered her a "package" of an American Integrity policy and a Providers Fidelity policy. Guinn said the agents told her that the nursing home benefits available under that package were superior to those available under her existing coverage. They advised her to buy their package and allow her other policies to lapse.

The agents also told Guinn that she would be able to cancel the American Integrity policy within ten days of its effective date, and the Providers Fidelity policy within 30 days of its effective date, if she was not satisfied with them. Guinn agreed to make the purchase and gave the agents a single check for the initial premiums of $808.70 for the American Integrity policy and $107.50 for the Providers Fidelity policy, a total of $916.20.

Soon after the purchase, but before she received her policies, Guinn made three unsuccessful attempts to cancel the policies. She then consulted another insurance agent, who reviewed both the old and new policies and told her that her new policies not only did not provide better coverage than her old policies, but were more expensive.

Guinn filed a lawsuit alleging that Martin and McCollough had made fraudulent misrepresentations of material facts concerning her previous policies and the policies they sold her, especially regarding the benefits available under the new package and the necessity of buying both of the policies in that package.

The trial court ruled in favor of Martin and McCollough, because Guinn had not shown any damage as a result of Martin and McCollough's alleged misrepresentations. Guinn appealed.

On appeal, additional testimony was provided by Marvin Watkins, Providers Fidelity's agency director. Watkins stated that the American Integrity policy did not provide Guinn with any coverage that she did not already have and that it was not in her best interests to replace her existing coverage by buying both of the policies offered to her by Martin and McCollough. Watkins also stated that a person who told Guinn that such a purchase would be in her best financial interests would not be telling her the truth.

This court concluded there was "evidence that Martin and McCollough misrepresented to Guinn the necessity of buying the American Integrity policy. The testimony of those two agents, standing alone, indicates that that policy simply replaced, at a cost of $808.70, coverage that Guinn already had and that had all of its waiting periods served," the court ruled. "Such misrepresentations, if made, would involve a material fact and would appear to have been relied upon by Guinn to her detriment."

Guinn alleged that Martin and McCullough made false representations and comparisons regarding her existing policies and the policies that they wanted to sell her, thus violating an Alabama statute prohibiting twisting. But, because Guinn failed to present evidence of a relationship between herself and Martin and McCollough that gave rise to a fiduciary duty, the supreme court ruled that lower court had not erred in dismissing the claim. The court reversed the summary judgment for the fraud claims, and sent the case back to trial.

"This covered a Medicare supplement policy. [The opposing counsel] wanted a new cause of action on the theory of twisting. The jury trial went $300,000 for the plaintiff on the agent and American," said Mark Fuller, an attorney for Providers Fidelity. "Here, there was no fiduciary duty. You need superior knowledge, along with other factors. There are differences between agents: general, special and soliciting agents. Here, they were general, and not captive agents. So, the agent is the agent of the [consumer] at the time of purchase, and thus no fiduciary duty comes from us."

Agents' Commissions

Agent compensation on a replaced policy may be limited to just the renewal compensation payable, rather than first year commission amounts, unless the benefits of the new policy are substantially greater than those provided under the replaced policy.

The 1991 Oregon Appeals Court decision *Associated Agents, Inc. v. Department of Insurance and Finance* dealt with the manner in which insurance agents are compensated for selling Medicare supplemental policies.

An insurance agents association filed an action challenging a rule adopted by the Director of the Department of Insurance and Finance, providing for a "leveling" of commissions and other compensation that insurers could pay agents.

The effect of the rule was to reduce the first year's commission for a Medicare supplement policy and spread it over a period of not less than seven years.

The Director of Insurance explained that the rule was necessary in order to eliminate the practice whereby large commissions are paid to agents for the first year of

Medicare supplement policy coverage. That form of payment sometimes results in agents encouraging senior citizens to replace existing policies simply to generate commissions, a practice known as "rolling" or "churning" policies. The Director found "rolling" to be unfair and deceptive.

The association challenged the rule as impairing contracts between agents and insurance companies. "Even assuming that the rule effects a change in existing contractual arrangements, there is no constitutional violation. The rule adjusts the form of compensation by spreading it out more evenly over time; it does not deny compensation," the appeals court ruled, and held the rule valid.

Prohibited Sales Practices

Most states prohibit agents and insurance companies from engaging in any of the following practices in the sale and marketing of Medicare supplement policies:

- *Twisting.* Knowingly making any misleading representation or incomplete or fraudulent comparison of insurance policies or insurers in order to induce a person to lapse, forfeit, surrender, terminate, retain, pledge, assign, borrow on, or convert any existing insurance policy or to take out a new policy.

- *High pressure tactics.* Employing any method of marketing having the effect of or tending to induce the purchase of insurance through force, fright, threat (explicit or implied), or undue pressure.

- *Cold lead advertising.* Using any method of marketing which fails to conspicuously disclose that the purpose of the marketing effort is to solicit insurance, and that the prospect will be contacted by an insurance agent or insurer.

The Missouri court of appeals, in its 1992 decision *Ronnie Brown, et al. v. Lewis Melahn,* looked at Medicare supplement insurance in a useful way.

A group of licensed insurance agents who sold Medicare supplement policies sued the Director of the Division of Insurance, alleging that he exceeded his authority in promulgating certain rules.

After the federal government imposed the ten standard-policy requirement, the NAIC revised its model law on Medicare supplement insurance in relation to permissible compensation arrangements.

It stated: "[t]he commissioner shall issue reasonable regulations to establish minimum standards for benefits, claims payment, marketing practices and compensation arrangements and reporting practices, for Medicare supplement policies."

Soon after, the Missouri General Assembly amended its law relating to Medicare supplement insurance to include language substantially similar to the NAIC model regulation.

Brown filed a lawsuit challenging the validity of the changes to Missouri law which related to compensation arrangements for insurance agents or representatives for the sale or servicing of Medicare supplement policies. Those sections limited the first year commission or other first year compensation is no more than 200 percent of the commission or other compensation paid for selling or servicing the policy or certificate in the second year or period. It also limited subsequent renewal commissions to those provided in the second year. No additional compensation for replacement policies was allowed, unless benefits of the new policy were clearly and substantially greater than the benefits under the replaced policy.

Brown argued that the state insurance director was only empowered to set minimum standards for compensation arrangements, not maximum limits. The trial court agreed.

The Court of Appeals didn't. It held that: "The prospective purchasers of Medicare supplement insurance policies are senior citizens, many living on fixed incomes with considerable concern about medical costs. The field is one particularly subject to abuse by unscrupulous agents."

Trying to Control Abuses

Evidence at the hearing established that first year commissions prior to the regulations ran in the area of 55 to 70 percent of the premium. Renewal commissions standardly ran approximately ten to 15 percent of the pre-

mium. Clearly such a large difference in the return gives a substantial incentive to unscrupulous agents to "twist."

"The regulations of the Director and NAIC do not restrict the amount of the first year commission that the agent can earn. They establish only a ratio between the first year commission and the subsequent renewal commissions," the court of appeals wrote. "The renewal commissions must be at least 50 percent of the first year commission, and must remain at that level for at least three renewal years. Companies are free to provide larger renewal commissions if they choose. To the extent the compensation of the agent is restricted it is because of the market conditions not the language of the regulations."

John Lichtenegger, the attorney for the agents, was obviously unhappy with the conclusion. "This changes the amount of commissions an agent can earn, but it goes much further. The government is writing the insurance. Basically, the government is taking over the health care industry, influencing who will continue to sell and who can do it legally. I'll tell you another thing...AARP, one of the largest sellers, is exempt from these regulations. That shows the influence of the special interests...they are cornering the market. That's what makes this such an interesting case...very political."

Should You Buy Med Sup Insurance?

Most states also try to regulate the counseling that agents give to applicants for Medicare supplement insurance, by requiring agents to identify whether a person is a "suitable purchaser" of insurance. We have mentioned that purchasing Medicare supplement insurance isn't appropriate for everyone. If your sole source of income is a relatively small pension and you have no substantial assets at risk, you don't need to buy a Medicare supplement policy and probably couldn't afford one, anyway. Instead, you could be eligible for Medicaid reimbursement of your health care expenses. In recommending the purchase or replacement of Medicare supplement insurance, the agent must make reasonable efforts to determine whether the purchase is appropriate for the client.

State Regulation

"Standardization of Medigap policies should go a long way toward helping people understand how this type of insurance works," Lisa Joyce told an Oregon newspaper in 1994. "But many seniors still need assistance in this area."

The Senior Health Insurance Benefit Assistance program (SHIBA), which Joyce coordinated out of the Oregon Department of Insurance and Finance, had recently received a $144,000 federal grant to do just that. Joyce said the money will be used to help set up training and provide support for a core of volunteers who provide counseling to seniors across the state.

Many states require insurance companies to file an annual report which lists every state resident for which the insurer has more than one Medicare supplement policy or certificate in force. The report must show each policy and certificate number and the date of issue. This helps the government and insurance companies to keep duplication of coverage from happening.

Medicare supplement policies are expected to return benefits which are reasonable in relation to the premiums charged. This means that state insurance departments watch insurance companies to see that they are not grossly overcharging policyholders for Medicare supplement coverage. The loss ratios are regulated, so that group policies must return at least 75 percent of the aggregate premiums earned, and individual policies at least 65 percent of aggregate premiums earned to policyholders in the form of benefits. In other words, for every $100 in premiums collected from policyholders who own individual Medicare supplement contracts, the insurance company is expected to pay out at least 65 percent in benefits.

Protecting Yourself from Scammers

There are agents and companies selling Medicare supplement policies whose lack of professionalism and ethics can cost consumers dearly. But there are also ways for you to protect yourself. Knowledge is power, and being aware of your coverages as well as your legal rights and responsibilities will help you avoid being taken advantage of in this market.

There are definite warning signs to watch out for when shopping for a Medicare supplement insurance policy.

Insurance agents and companies may not claim that they represent the Medicare program, the Social Security Administration, the Health Care Financing Administration or any government agency. They may not imply that the policy they are selling is guaranteed, approved, or otherwise backed up by the government. If someone calls you claiming to have been authorized by the government to contact you in order to review, modify, or discuss your existing insurance program don't make an appointment with him or her.

Anyone who tells you that he or she is a "counselor" or "adviser" for any association of senior citizens, may in fact just be a licensed insurance agent trying to sell you a Medicare supplement insurance policy. Ask for credentials, the licenses they hold, and what kinds of products they are authorized to sell. A business card is not a license.

Never let an agent talk you into signing any form, application, or document in blank. When you are buying a policy, never pay your policy premium in cash or make out a check to the agent's personal account. The agent should make it clear that you have the option of paying your premiums directly to the insurer.

Be careful of any description of benefits that sounds too good to be true. It probably is. Agents give inaccurate, exaggerated, and misleading descriptions of the benefits provided by both Medicare and Medicare supplement policies in order to convince you to purchase a policy from them.

"I think a big problem is that seniors will continue to purchase too much insurance," says Susan Polniaszek, director of national services for the United Seniors Health Cooperative, a consumer-information group based in Washington, D.C. "When people get older, they become fearful that something like medical costs will wipe them out financially, so they overcompensate."

You only need one Medicare supplement policy, because only one policy will pay benefits. If you have purchased several Medicare supplement policies, and you have a claim, only one policy will pay and you will receive a refund of the premiums paid on the other policies.

Any agent who tries to sell you a number of identical policies is ripping you off.

Complaints reached the Insurance Department in Virginia about an agent who was intimidating older people to buy insurance. This agent was selling two, three, or four of the same kinds of policies from different insurance companies to the same person, falsifying the part of the application that asks whether the person already has similar insurance coverage.

The Insurance Department investigated, and found that the agent had backdated policies, told applicants there were complications in the insurer's underwriting procedures that were delaying response, whatever it took to keep the scam going. "He would apply premiums from one person's application to another person's policy," says Warren Spruill, Supervisor of the Agent Licensing Section for Virginia's State Corporation Commission's Bureau of Insurance. "Eventually, he couldn't keep up with his own system."

"You can't prevent bad agents from falsifying applications, and the insurance companies do not communicate with each other," says Spruill. This agent was ultimately prosecuted in six jurisdictions for larceny, and received an 18 year prison sentence.

"Loading Up" Seniors

Another Virginia case involved a husband and wife team who routinely "loaded up" seniors with policies they didn't need. The Department of Insurance received a complaint from a person who had bought two Medicare supplement policies after being told she would be paid twice upon submitting a claim.

Upon investigation, the Insurance Department found that among numerous other violations, the couple had sold over 40 duplicative policies to two elderly sisters, who eventually couldn't keep track of their own premium payments and the number of contracts they held. The couple had even sold them whole life policies where the premiums paid far exceeded the face amount of the policy. The couple surrendered their licenses in lieu of disciplinary action, and subsequently the wife was prosecuted by the U.S. attorney for continued activities involving insurance.

Similarly, agents sometimes try to get you to surrender insurance you already own and replace your coverage

with a policy they are selling by misrepresenting the policy they are selling, or making an incomplete comparison of the policies, or even by telling you that your current insurer is in financial trouble.

As with all insurance policies, it pays to compare the costs of similar policies available from different insurers. The ten standardized plans make it easier: Plan A is always a company's lowest priced Medicare supplement policy, and is identical in coverage to other Plan A's from other companies. A 1994 study by the Missouri Department of insurance showed the annual premiums for Plan A ranged between $347 to $785 (for the same coverage!) while annual premiums for Plan F (the most commonly purchased plan) ranged from $732 to $1,436.

Shop aggressively when you first buy a policy; after that, change insurers or policies only when you desire to make substantial changes to your coverage. If you cancel one policy to purchase another, there is generally no refund of premium, and you may be subject to new policy limitations and restrictions.

A last note: Federal law guarantees people enrolling in Medicare that they can buy any Medigap policy for the first six months they're enrolled, regardless of health problems.

Looking Back

The following are the major issues considered in this chapter. Review them before talking with any agent, broker or company selling Medicare supplement insurance.

- In order to know whether you need to purchase health insurance which is supplemental to Medicare, you must first understand what Medicare pays for—and does not pay for, as well as how you become eligible for Medicare coverage, and how much it will cost you in terms of deductibles, coinsurance, and Part B premiums.

- When you are covered by Medicare, it becomes important to know whether your health care provider will accept payment from Medicare as payment in full. You need to know how to submit claims and how to appeal a claim denial.

- The ten standardized Medicare supplement plans have helped cut through the confusion and provide a clear basis for comparison when you are shopping for the best Medicare supplement policy. Be sure to read through the Buyers Guide and Outline of Coverage, and take advantage of your free look period.

- If you purchase Medicare supplement insurance other than at the time of open enrollment, you will be subject to medical underwriting and preexisting conditions restrictions.

- You should be especially careful if you are being asked to replace Medicare supplement coverage you already have. It is very rarely a good idea to do so.

- Your state insurance department or state office on aging can provide you with information and counseling regarding your decision to purchase or not purchase Medicare supplement insurance.

CHAPTER 11
LONG TERM CARE

Better medical care means more of us will be living into our eighties, nineties and beyond. But even though life expectancy has increased, many older individuals have serious health problems that keep them from living on their own or completely caring for themselves.

There are over 31 million people over the age of 65, accounting for 11 percent of the population. Of that number, about 50 percent will suffer from a cognitive impairment or have limitations requiring long-term care services.

The fear of running out of money in your old age and becoming a burden to your children and family is a powerful incentive to shop around for long-term care (LTC) insurance. (It's also an incentive agents often use to sell their LTC products.) But don't let that fear control your decisions. The fact is that relatively few people spend more than a year in a nursing or convalescent facility.

The costs of those facilities do run high, though. Insurance industry experts have estimated that the cost of long-term care will financially ruin 70 percent of all single people admitted to a nursing home within three months and 50 percent of all couples within six months after one spouse is admitted.

Given population trends, by 2040 as many as 5.9 million people may reside in nursing homes. Currently, over 3.5 million senior citizens receive LTC services in their homes, and more than 1.5 million live in licensed nursing homes. Medicaid pays for over 70 percent of nursing home costs.

By 2011, those over 65 will number 38 million and represent 14 percent of the population. Thus, the number of people potentially requiring LTC will increase as will the "dependency ratio" or the relationship between retired and nonworking people to FICA-taxpaying workers. By 2011, over 6 million elders will need LTC services.

Statistically, the likelihood of a person requiring confinement in a nursing home after age 65 is about one in three. At age 75, this likelihood is about one in two. In 1990, the average annual cost for a person confined to a nursing home was $28,000.

The Myths that Color Many Decisions

Half-truths and myths about LTC and its financing persist:

- The belief that the person will never need LTC services;

- The highly questionable generalization that home care costs much less than nursing home care;

- The fear that all nursing homes are terrible and abuse the residents;

- The myth of no difference in quality among nursing homes;

- The hope that retirement income, savings, and real estate assets will be adequate, and will not be depleted by LTC costs;

- The myth that Medicare and Medicare Supplementary (Medigap) insurance are significant LTC payers. Too few people understand that Medicare coverage covers only two percent of LTC services and—more importantly—that uncovered LTC costs often exceed the costs of acute medical care;

- The hope that the government will pay for LTC, whether through Medicaid or through creation of some new comprehensive program. Yet it is unlikely that any expensive new government programs will be created in the near future—at least until budget deficits can be reduced; and ·

- The myth that private LTC insurance is not affordable and the related assumption, that since it is not affordable, it offers poor value.

One thing's true: The longer you wait to purchase a long-term health care policy, the more expensive the coverage and greater the chance that a preexisting condition will disqualify you for coverage or reduce your potential benefits.

The skilled nursing care provided by Medicare and Medicare supplements is extremely limited. Medicare pays less than five percent of the United States annual nursing home expenses. To be eligible, a person must be admitted to a nursing home within 30 days of a hospital stay that lasted at least three days; coverage for skilled nursing care is limited to 100 days per calendar year, and there is a copayment of $87 (1994 figures) per day after the first 20 days.

Many times, the person is admitted to a nursing home because he or she needs custodial care, in which case Medicare pays nothing. Also, the patient copayments of $87 per day represent the average daily cost of a nursing home, so the coverage provided by Medicare is nominal.

The primary methods available for meeting the costs incurred due to a nursing home confinement include:

- personal income and assets;
- gifts and financial support from family members;
- some local government or social service programs;
- Medicaid;
- Medicare;
- Long Term Care insurance.

Although there are about 100 insurers nationwide now offering long-term nursing care policies, most have been criticized by consumer activists for offering an expensive coverage that has little chance of paying for what seniors will eventually need in nursing home care.

In June 1991, *Consumer Reports* magazine surveyed the 90 most widely-marketed LTC policies:

- an Atlantic & Pacific policy placed first;
- Prudential/AARP placed second (and cost about $1,000 more a year than other policies at the top of the ranking); and
- a CNA policy placed third.

At the bottom of the Consumer Reports heap: policies from Pioneer Life and American Integrity.

What LTC Insurance Covers

LTC insurance pays for the kind of care needed for individuals who have a chronic illness or disability. It often covers the cost of custodial nursing care (nursing homes), but also provides coverage for home-based care—visiting nurses, chore services, and respite care for daily care givers who need time away from these difficult duties.

LTC insurance usually provides coverage for at least 12 consecutive months for medically necessary diagnostic, preventive, therapeutic, rehabilitative, maintenance, or personal care services, provided in a setting other than an acute care unit of a hospital, and includes group and individual policies.

This kind of insurance normally provides a daily benefit (usually $50 to $250) following an elimination period (EP). The elimination period is usually expressed as 30, 60 or 90 days, and serves as a "time deductible" during which no benefits are provided. Once the EP is satisfied and the daily benefit begins to accrue, it will usually be paid for the benefit period selected by the policyholder. Typical benefit periods range from one to five years.

Regulatory Uncertainty Poses Risks

LTC insurance is still in an evolutionary stage. In 1980, there were a few standard products offered. By 1990, a wide variety of products had emerged. There are literally hundreds of individual contracts (they have not been standardized like Medicare supplement policies).

While it might seem logical for federal regulation of LTC to follow hard upon its Medicare supplement regulation, experts feel the move would be premature. There are two reasons for the hesitation: fewer people buy LTC insurance and the insurance industry is still experimenting with different versions. Product revisions and changes occur with such rapidity that last year's LTC policy is quickly replaced by a new version.

For example, early LTC policies excluded Alzheimer's disease. Today, most policies cover this ailment. In addition, early policies usually required a period of prior hospitalization before benefits were triggered. Many of today's policies do not have such a requirement.

In the early years, the LTC policy was a contract sold only to individuals. Today LTC coverage is also marketed on a

group basis, as an employer-sponsored benefit, and as a rider to life insurance policies.

Probably the most important advantage to ownership of LTC insurance is protection of personal assets. There is protection against the risk of liquidating assets and exhausting personal financial resources to pay for a nursing home stay.

Dangerous Manipulations

Many older people resort to complicated financial acrobatics to qualify for Medicaid support for their long-term care needs. This can be an extremely risky process. The 1993 Connecticut decision *Alice Wroblew v. Shirley Thompson* shows just how risky this can be.

Alice Wroblew was an 85-year-old woman who had been widowed for the second time. Although Mrs. Wroblew had no children of her own, she had spent 14 years raising her sister's daughter, Shirley Thompson, giving up her job to do so. She treated Shirley like a daughter and, when Shirley married William Thompson and had children, she treated Shirley's children like grandchildren. Indeed, Shirley Thompson testified that she and Wroblew were as close as a mother and daughter. Likewise, William Thompson, all the children and their spouses testified to having a close personal relationship with Wroblew.

The Thompsons lived in a house that Wroblew and her husband had purchased for them, paying nominal rent at first until Wroblew gave the house outright to Shirley. Over the years, Wroblew gave gifts to Shirley and her family, mostly in cash. On one occasion, she gave the Thompsons $9,000 for a driveway and on another occasion she gave Shirley $12,000 to divide evenly among the children. None of these gifts came with any conditions.

In 1988, a year after her husband died, Mrs. Wroblew returned to Connecticut from Florida where she had lived since 1976. During the next year she moved frequently, finally settling in an apartment in Hamden in June 1989. She enjoyed a good relationship with the Thompsons and their children during this time and saw them frequently.

In June 1990, Wroblew decided to try to get a place in a senior citizen's home in North Haven and devised a plan

that she believed would help her get into the home without waiting several years. At the time, Wroblew made her own decisions about her money but Shirley's husband William helped her with her taxes. She discussed her plan with him and he both agreed with it and approved it.

The King Lear Plan

Wroblew had $100,000 in maturing certificates of deposit which listed the Thompsons and their children as beneficiaries in the event of her death. Mrs. Wroblew decided to divide the $100,000 by ten, giving $10,000 to Shirley, William, their five children and three daughters-in-law with the understanding that they were to invest the money in their own names in six month certificates of deposit and name her as beneficiary on the account in the event of death.

Furthermore, while they could use any interest earned they were not to touch the principal and they were to return the money to Wroblew when she needed it.

Wroblew discussed these terms with Shirley and William Thompson and told them to tell the others what she wanted done. Shirley assured Wroblew that she shouldn't worry and if she needed the money she could get it back at any time. Likewise, William told Wroblew that he would follow her instructions and pass them on to the children. Wroblew withdrew the funds and distributed them to the Thompsons.

Sometime in August 1990, Wroblew changed her mind about the senior citizen's home and decided to move to Florida with Bill Thompson and his wife Susan. The three of them left for Florida at the end of September. Shortly thereafter, Bill and Susan returned to Connecticut for a visit and told the other family members that Wroblew would be asking for her money back to use to purchase a house in Florida in which they would all live.

When Wroblew telephoned, asking the Thompsons to return her money, they refused.

Bryan Thompson testified that he originally agreed to give the money back to Wroblew but changed his mind when he learned that she was going to use the money to buy a house for Bill and Susan. Shirley Thompson testified that she didn't feel that Wroblew was treating all her children evenly because the money would benefit Bill

and Susan. Shirley and William, Sr. testified that they felt Wroblew was asking for "our money" back.

When all the certificates of deposit matured, instead of returning the money, Shirley and William took the funds and placed them in their joint account. David put the money in a certificate of deposit in his own name. Patricia rolled the funds over into a certificate in her own name and later loaned some of the money to her sister. James took $5,000 and used it to buy a used car and put the balance in a joint savings account with his wife. Cheryl put the funds in a certificate in the name of herself and her husband. Kathleen put the funds in her own savings account. Bryan put the funds in a certificate in his own name which he has continued to roll over.

Bill and Susan Thompson testified that Wroblew spent time crying in her room, was despondent, wouldn't eat, and threatened suicide over the refusal to return her money.

The court had to decide whether Wroblew made a gift of her money to the defendants. "Wroblew's intentions can be ascertained from her words and her actions," the court ruled. "Clearly, Wroblew intended that if any of the Thompsons died during the time they held her money the funds were to revert to her rather than belong to their individual estates. Just as clearly, she intended for the Thompsons to return her money upon her request."

By refusing to return her funds, the Thompsons engaged in unauthorized acts over Wroblew's money with the intention of permanently depriving her of the property and to her clear harm.

Violating a Confidence

In summary, the court found that "there was a special relationship of confidence between Wroblew and the defendants, that Wroblew did not intend to give her money to the defendants but rather for them to hold it for her and return it upon her request, that the defendants failed to honor Wroblew's request for the return of the money, that the defendants then used Wroblew's money for their own benefit and that they were thereby unjustly enriched."

The Thompsons suggested that Wroblew was equally at fault because her efforts to divest herself of her savings

were an attempt to defraud the senior citizen's home where she thought she wished to live. The court found two problems with this argument. First, there was no indication that Wroblew intended to perpetuate a fraud upon the court. Second, she never actually applied for admission to the senior citizen's home; therefore no fraud was perpetrated on it.

The Thompsons were each directed to pay to the plaintiff the amount of $10,000 plus interest at ten percent a year from December 1990 until the certificates of deposit became due. Further, the court awarded $40,000 in damages to Wroblew for negligent infliction of emotional distress, for which the defendants were held jointly and severally liable.

Wroblew got her money back. But she probably should have bought LTC insurance and avoided the whole problem.

Benefit Schedules

LTC policies, even though they are not standardized, contain similar benefits and provisions. Occasionally, some of these policies will offer newer or unique benefits or features. We will attempt to draw a composite of the common benefit features and provisions found in most individual contracts.

Most LTC policies provide a daily benefit during confinement. Benefit amounts range from $50 per day up to $200 or $250 per day. Some insurers may pay the actual charges incurred by you.

To illustrate these points, let's use the example of Kim who has a LTC policy with a 30 day elimination period, a daily benefit of $75 per day and a two-year benefit period. Kim is confined to a nursing home for a total of seven months. Her benefit calculation would be as follows:

First 30 days: No benefit paid (elimination period)

Next six months: $75 per day (assumes 30-day month)

$75 x 180 = $13,500

If Kim's actual charges were more than $75 per day, this amount would have to be paid by her.

Most individual LTC policies are guaranteed renewable. That is, the insurance company guarantees to renew the

policy but reserves the right to increase the premium. A small number of individual LTC policies are optionally renewable. The insurer has the option to renew, cancel, or increase the premium by class. Eventually, there may be noncancellable LTC contracts where renewability and premium are guaranteed for the life of the policy.

If the premiums are to be increased, they will be changed on the policy anniversary and the increased premium will apply to an entire class of policyholders, not just a single individual. For example, all policyholders in a given state will have their premiums increased on their respective policy anniversaries.

LTC Preexisting Conditions

All policies will contain a preexisting condition provision of some kind. Most will contain a six month preexisting condition provision which basically will not provide benefits for any preexisting condition during the first six months that the policy is in force. More liberal policies may state that all preexisting conditions are covered as of the effective date of the policy if the condition is stated on the application.

A preexisting condition is usually defined as any medical treatment or advice received or recommended within a certain period of time prior to the effective date of coverage. The specified period of time is most often six months. The definition of preexisting condition does not prohibit an insurer from using an application form that elicits the applicant's complete health history, or underwriting based on the applicant's answers. No long-term care insurance policy may exclude, limit, or reduce coverage or benefits for specifically named or described preexisting conditions or diseases beyond the waiting period.

One way to limit the insurer's risk with regard to preexisting or impaired conditions is by means of reduced benefit amounts.

Marie applies for a LTC policy with a daily benefit amount of $150, following a 30-day elimination period. Benefits are payable for up to five years. Marie indicates on the application that she has several medical problems—high blood pressure, arthritis, borderline diabetes, and hardening of the arteries.

Marie's medical history presents underwriting problems. One recourse will be to limit the daily benefit for this impaired risk. For example, the underwriter may approve the policy issue but only for $50 per day in benefits. In essence, the policy is reduced from a total benefit of $273,750 (five years x $150 per day) to $91,250.

Another underwriting device which can be used with Marie's case is to increase the elimination period from 30 days to possibly 90 or 100 days.

Finally, the underwriter could approve the policy with a shorter benefit period to reduce the dollar amount of the potential loss to the insurer.

Prior Hospitalization

Early LTC policies normally required a period of prior hospitalization before the policyholder would be eligible for benefits. Most of the newer versions of LTC policies no longer require prior hospitalization as a condition for receipt of benefits. Admission to the nursing home must be because of an accident or sickness and the elimination period must be satisfied. Some insurers may offer prior hospitalization as an optional provision to be elected or rejected by the policyholder.

When elected, the cost of the LTC policy will be slightly less than a policy without the prior hospitalization provision. However, many states require that when benefits are only provided following institutionalization, they cannot be conditioned upon admission to a facility for the same or related conditions within a period of less than 30 days from date of discharge.

Some of the newer LTC policies base eligibility for admission to a nursing home on the inability to perform some of the activities of daily living in lieu of sickness or injury. These contracts do not require prior hospitalization nor that the policyholder be admitted to a nursing facility as a result of sickness or injury.

The event which triggers admission to the skilled nursing facility is the inability to perform one or more of so-called "activities of daily living" (ADLs). For example, if an individual is unable to perform personal hygiene or is unable to walk or "get around," he or she would be eligible for admission to a nursing home and payment of policy benefits.

If claims experience is favorable with this type of policy, more policies of this type may be issued by insurers. This is a very liberal policy and approach to the needs for LTC protection due to the fact that it does not require that the policyholder's admission to the nursing home be related to a sickness or injury.

The recurring provision found in LTC policies is similar to relapse provisions found in other forms of health insurance. Under this provision, if the policyholder is released from a nursing home and is re-admitted within 180 days of the discharge due to the same or a related condition, the second admission (the relapse) will be considered a continuation of the previous nursing home stay. If 180 days has elapsed since the individual was released from the nursing home facility, a subsequent admission for the same or a related cause will result in a new elimination and benefit period.

Spousal Coverage

Often one spouse is confined to a nursing home and the other spouse remains at home. Since the income and assets of both spouses are considered when determining eligibility for Medicaid, the process of income and asset depletion could, and often did, reduce the stay-at-home spouse to the point of poverty as well as the confined spouse. To remedy the situation, Congress passed the Spousal Impoverishment Act which protects a portion of the income and assets that a stay-at-home spouse may retain without terminating Medicaid eligibility for a confined spouse.

Before coverage would begin, the healthy spouse would either be driven in poverty or have to divorce the ill spouse so that he or she could qualify as a single person. This created a generation of so-called "nursing home widows," who had to take drastic measures to make sure their mates received decent care.

Under rules which took effect in 1989, the healthy spouse was allowed to keep some of the couple's joint monthly income (a minimum consisting of the first $815 of monthly income, up to a maximum of $1,565 of joint monthly income) and joint assets (a minimum of the first $12,000 of assets, not to exceed to maximum of $60,000 of assets). These amounts are indexed for inflation and increase annually.

The federal law provides a degree of protection for a healthy spouse, but it is designed to be a safety net and is not a substitute for insurance. Without long term care insurance, most middle- and upper-class families would still be exposed to a considerable reduction in family resources if an extended stay in a nursing home became necessary.

Underwriting LTC Insurance

LTC policies will contain some exclusions or limitations. Common exclusions include: war or act of war, intentionally self-inflicted injuries, losses covered by workers compensation or other government programs and losses due to personality disorders which are not subject to a physical or organic disease. Mental or personality disorders resulting from an illness or accident are covered, including Alzheimer's disease.

Long term care underwriting is concerned with the same factors as health insurance underwriting, with the major emphasis on the likelihood of prolonged confinement in a nursing home.

For example, a person who has a heart condition that could require surgery might not be a good candidate for health insurance, but might be accepted for LTC insurance because the condition would probably not result in a nursing home stay.

You will probably be asked questions about your health in the application for coverage. Some companies use "short form" which only asks if you have been hospitalized in the last 12 months or if you are confined to a wheelchair. If "no," the policy will usually be issued on the spot.

It is important to answer these health questions truthfully. If the company later finds out you have lied about your health, and the company relied on your statements to grant coverage, it can cancel your policy and return the premiums you've paid, leaving you with no coverage. They can usually do this within two years after you buy the policy.

Medical information is extremely important to the underwriter. Much of this information will be found on the application. Additional medical information may be obtained from the applicant by means of an investigative report or directly from the applicant's doctor through the

use of an Attending Physician's Statement. Applicants for LTC insurance are rarely required to take a physical exam.

Once all of the underwriting information is gathered, the underwriter will basically classify the person as a standard or substandard risk. Accordingly, if the applicant is a standard risk, he or she will pay the standard rate or premium for the policy. Substandard risks may have to pay an extra premium for the policy, have a policy issued with a rider omitting some element of the coverage or they may be declined.

Better Information Means Better Rates

Affordability is often cited as an issue and reason not to buy LTC insurance. This argument is often made politically to advocate universal LTC coverage. However, it also has to be acknowledged that LTC often costs less than private medical insurance. The amount of coverage may be geared to a person's budget and strategy. The younger a person is, the more affordable the coverage. As a financial planning benchmark, not more than ten percent of after tax income should be devoted for health and LTC insurance purposes.

The pricing of LTC products depends on the following actuarial assumptions:

- mortality;
- persistency (the length of time a policy remains in force without lapsing);
- investment return earned by the insurance company;
- expenses of marketing, compliance with government regulations, and operations,
- morbidity (i.e., the length of time benefits are paid);
- a state required minimum loss-reserve ratio;
- a company's underwriting standards and experience; and
- product profitability.

During the 1980s, standard LTC premiums decreased as a result of better and more reliable risk information. Following are some representative annual premiums for four

different insurers offering LTC coverage with a $50 daily benefit, payable for up to four years, with a 20-day elimination period.

COMPANY	AGE 55	AGE 60	AGE 65
A	$401	$609	$919
B	290	290	441
C	140	240	356
D	470	610	610

Considering these actuarial factors, it is possible to understand the favorable cost benefit values and pricing of LTC. A high percentage of individuals will either die or lapse their policies. With LTC services required on average at about the age of 80 and an estimated payment period of four years at home and two years in a nursing home, it is understandable that the premiums paid increase with age.

Policy Restrictions

Many of the recent second generation of policies have been greatly improved with standard provisions, home care benefits, and valuable, affordable coverage. However, possibly only 50 percent of elders may qualify or be able to afford more than a minimum level for Medicaid strategy purposes. After the age of 79, LTC policies, if available, are so limited and restricted that the coverage is often not cost effective.

A study by the United Seniors Health Cooperative showed that 82 percent of long-term-care policies contained clauses that seriously restricted coverage.

"Most of the [long-term care] policies out there are not great," said Susan Polniaszek, executive director of the Cooperative. "But it's getting better. All of these policies should cover skilled, intermediate and custodial care. If you're going into a nursing home because you've gotten old, not because of an illness or injury, we're not sure the policy will pay off.

"There are so many policy restrictions," she said. "Those that require a hospitalization or require a skilled level of care before they pay for custodial care won't work for most people. Most people will not meet those conditions."

In recent years group LTC contracts have slowly begun to appear as well as LTC benefits attached to new or existing life insurance in the form of policy riders.

Typically, group health insurance is written for employer-employee situations, professional associations and trade unions. Eligibility for participation in these group health plans typically is restricted to employees and their dependents.

Many employer group LTC contracts marketed today provide the following participation eligibility:

- the employee and spouse;
- parents of both the employee and the spouse;
- retired employees and their spouses.

This is very liberal in that it not only covers the employee and his spouse but reaches out to provide coverage for a second generation as well as retired workers and their spouses.

Standard Group Benefits

The standard benefits offered under group contracts are very similar to those offered as individual policies. These benefits include:

- skilled nursing care;
- intermediate care;
- custodial care;
- home health care;
- certain optional benefits.

Hospice care may also be provided by the group policy as a standard or optional benefit. Another optional policy benefit is adult day care which provides the functionally impaired adult with a day-time environment of social as well as certain functional activities. Adult day care usually includes transportation to the day care facility, at least one meal and certain vocational or recreational activities.

Most group contracts provide that benefits will be paid based on one or more of the following criteria:

- the policyholder has been hospitalized for a minimum period of time (usually three days) due to an

accident or illness and, due to the accident or illness, it is necessary to confine the individual to a nursing home;

- the policyholder is forced into a nursing home due to an accident or illness without the need for prior hospitalization;

- confinement is due to the fact that the person is unable to perform some of the activities of daily living (ADLs).

Most group contracts are on an indemnity basis as opposed to an expense incurred concept. Daily benefits range from $50 to $150.

Elimination periods under group contracts range from ten to 100 days and the benefit periods are usually three to five years in length. Typically, the group elimination period seems to fall between 30 and 90 days with at least a three year benefit period.

LTC Riders

In recent years, some insurers have begun to offer long term care coverage in the form of a rider attached to a new issue of life insurance or possibly some other policy form, such as a disability income policy. With this marketing approach, there are two sales, the life sale and the LTC sale which should be beneficial to the insurer, the policyholder and the agent.

LTC rider benefits are very similar to those found in a LTC policy. The benefit structure includes the following:

- elimination periods in the range of ten to 100 days;

- benefit periods of three to five years or longer;

- prior hospitalization of at least three days may be required;

- benefits may be triggered by impaired activities of daily living;

- levels of care include: skilled, intermediate, custodial and home health care.

In addition, certain optional benefits may also be provided such as adult day care, cost of living protection, hospice care, etc.

One difference with this "LTC package" is the method of determining LTC benefits. The benefits may be expressed as a specific daily amount; $50, $100 or $150 per day for example. They may also be expressed as a factor of the face amount of the life policy. For example, two percent of the face amount of the policy may be paid monthly as a LTC benefit up to a specified maximum.

This combination of life insurance and LTC benefits is marketed as a "Living Benefit" or "Living Needs" rider. This approach draws on the life insurance benefits to generate LTC benefits. Thus, the LTC rider is attached to the life policy "at no charge." In a sense, it's like borrowing from the life insurance to pay LTC benefits.

Generally the "Living Needs" rider provides funds for LTC expenses or for expenses incurred with a terminal illness. Under this rider, the policyholder may be advanced life insurance dollars to cover these expenses. There are usually two options associated with this rider.

The first is the LTC Option which typically may provide up to 70 to 80 percent of the policy's death benefit to offset nursing home expenses.

Terminal Illness Option

The second option is the Terminal Illness Option which can provide 90 to 95 percent of the death benefit as a pre-death benefit to be used to offset medical expenses.

One obvious difference of course is that the payment of LTC benefits reduces the face amount of the life policy.

Two unique concepts have begun to appear involving the use of annuities and disability income insurance. An annuity, designed to be a retirement vehicle, may be issued with a LTC rider in much the same way that the LTC rider may be attached to a life policy. With this arrangement, the annuity provides necessary funds to help with LTC expenses. It might be said that the annuity and the LTC policy are cousins in that annuities provide retirement income and LTC needs normally occur after retirement. Thus, one of the newer approaches involves adding the LTC rider to the annuity.

When and if needed, annuity funds will be paid to cover LTC expenses. This of course will have the effect of reducing the amount of money in the annuity and conse-

quently, the monthly retirement income may be reduced as well.

One final use of a LTC rider is in combination with a disability income policy. Disability income insurance is designed to protect a person's most important asset—the ability to earn an income. However, the disability income need normally ends at age 65 or retirement since the policyholder no longer has earned income.

Like Medicare supplement insurance, long term care policies are heavily regulated by the state insurance departments. Consumer protections that have been implemented at the state level include rules for full and fair disclosure of long-term care insurance terms and benefits, including disclosure for sale, terms of renewability, conditions of eligibility, nonduplication of coverage, preexisting conditions, termination of insurance, probationary periods, limitations, exceptions, and reductions, elimination periods, requirements for replacement, recurrent conditions, and definitions of terms.

Prohibited Provisions

Many states have passed laws, based on NAIC model laws, which prohibit certain provisions from being included in long-term care insurance policies. Although the provisions differ slightly from state to state, we have summarized the most common consumer protections below.

Cancellation

LTC policies may not be canceled, nonrenewed, or otherwise terminated on grounds of age or deterioration of your mental or physical health.

Benefits

Policies may not provide coverage for skilled nursing care only, or provide more coverage for skilled care in a facility than for lower levels of care.

No long-term care insurance benefits may be reduced because of out-of-pocket expenditures made by you or on your behalf.

Termination of Benefits

If long-term care insurance is terminated, it shall be without prejudice to any benefits payable for institutionalization which began while the insurance was in force. Benefits must continue without interruption after termination. This extension of benefits may be limited to the duration of the benefit period, if any, or to payment of a maximum benefit, and may be subject to any policy waiting period and all other applicable provisions of the policy.

Post Claims Underwriting

Applications for long-term care insurance usually contain clear questions designed to determine your health status. You may be asked whether you have had medication prescribed by a physician, and to list the medication. If the medications listed are directly related to a medical condition for which coverage would otherwise be denied, and the policy or certificate is issued, it may not be later rescinded for that condition. However, a policy is issued based upon your responses to questions on the application. If the answers are incorrect or untrue, the company has the right to deny benefits or rescind the policy. Companies are generally prohibited from "post-claims underwriting," which means they investigate your medical record only when you file a claim—or after you enter the nursing home—and then attempt to deny benefits based on inconsistencies in your application. If they reject your claim, you get your premiums back—but by then it's too late to get coverage elsewhere.

Of course, the best time to clear up any questions is before a claim arises.

In one of the most egregious cases of abuse in selling LTC insurance, the Supreme Court of South Dakota had to settle the 1990 case *Floyd McKinney and Una McKinney v. Pioneer Life Insurance Co.*

Floyd had been a patient of Dr. James Monfore for over 20 years. He had enjoyed fairly good health over those years, except for minor back troubles. Between June 1982 and February 1987, Floyd began to suffer episodes of gross confusion which culminated in a diagnosis of Alzheimer's disease.

He was treated with various drugs. In February 1987, Floyd was admitted to the hospital and hospital records note that he suffered from Alzheimer's disease (this was

the first time doctors' records make that diagnosis explicitly).

In March 1987, Floyd was admitted to nursing home care at the hospital. On that same day, Pioneer agent Michael R. Johnson sold a "long-term care" insurance policy to Floyd and Una, his wife. Johnson had traveled that Sunday afternoon to Miller, South Dakota, from his home in Sioux Falls, after receiving a phone call from Una asking him to come to Miller to write a "nursing home" policy for Floyd.

The application for insurance was written and signed by Una in their home. Floyd, who was in the hospital, was not present. Una signed his name for him. Johnson, who completed the application form, was aware that Floyd was hospitalized.

Johnson, who had previously sold health insurance to the McKinneys, was generally familiar with Floyd's condition. On prior occasions, he and Una had discussed the fact that Una believed Floyd had Alzheimer's disease.

The insurance application, completed by Johnson, merely notes that on February 19, 1987, the applicant (Floyd) had a sickness or injury, the nature of which was "unknown," and that he had been in the hospital or nursing home since February 1987. Johnson accepted Una's check for the premium and submitted the application to Pioneer. The policy which Pioneer issued contained a preexisting condition limitation.

Una ultimately filed a claim with Pioneer for expenses which arose from Floyd's long-term care in the nursing home. Subsequently, Pioneer notified the McKinneys that the claim was denied based on the preexisting condition limitation in the policy. Pioneer rescinded the policy and sent a check to the McKinneys representing the amount of the initial premium of $1,316.00.

The McKinneys sued. In their complaint, they alleged breach of contract, fraudulent inducement and bad faith refusal to pay insurance proceeds. They sought $15,853.50 for policy benefits due, $50,000 for "severe emotional strain," and $100,000 in punitive damages.

Una claimed that Johnson had explained the "six-month waiting period" to mean that she could not submit a claim to Pioneer for benefits until six months after the date the policy was issued. That, she explained, was

why she did not file a claim for benefits until September of 1987, six months after Floyd had been admitted to the hospital/nursing home. The trial court supported Pioneer's position.

Agent Lied on Application

But, on appeal, the McKinneys' claimed that they had been fraudulently induced to purchase the insurance through a scheme executed by Johnson. He filled out the application for the McKinneys, including answers which he knew were untrue and were designed to lead to the approval of the application by Pioneer.

They also said were unaware that Johnson had written false answers to questions on the application and were unaware that later, given the correct answers to those questions, Pioneer would attempt to rescind the policy.

Finally, they argued Pioneer, having failed to reasonably investigate the application for insurance, was responsible as a principal for Johnson's actions.

Una testified that she had previously purchased a different health insurance policy from Johnson through Pioneer. Pioneer terminated the policy for nonpayment of premium. She had paid the premium to Johnson, but he did not remit it to Pioneer. She then contacted Pioneer, sending them a copy of the check. Pioneer called her, informing her that they had "straightened it out" by charging Johnson's account for the amount of the premium.Soon after this episode, Pioneer fired Johnson because he evidently had a problem selling insurance policies due to his frequent use of marijuana and other drugs. Desperate for money, he had exploited the trust of his clients.

When Johnson sold the McKinneys the long-term care policy, he had already been fired by Pioneer. When the McKinneys sued Pioneer, Johnson was an inmate in the South Dakota State Penitentiary, having pleaded guilty and received a five-year sentence for grand theft. (He'd pocketed checks from several other clients after he'd been fired from Pioneer.)

It was through Johnson's status as an agent that he obtained the information which Una claimed was falsely related in the application.

The state supreme court concluded that "the jury could determine, considering Johnson's drug usage, his dire need for money, and his alleged theft of the McKinneys' health insurance premium on a prior occasion, that he had, in fact, made the representations to the McKinneys; that Pioneer could or should have anticipated such conduct because of their awareness of his problems; and that as a result Pioneer could be held liable."

So, it reversed the lower court's summary judgment and sent the case back for trial.

Charges of Post-Claim Underwriting

"The summary judgment was reversed, and then the case settled," says Brian W. Jones, the attorney for the McKinneys. "This was a crooked agent, this guy was not a good person....I think that [Pioneer] used procedures for post-claim underwriting, where they would only look at the application when a claim came in and then try to get out of it based on the application."

Jones calls many long-term care policies "notoriously bad." For future situations, a person looking to buy long-term care policies should take it to their attorney, he says. "These long-term care policies had glaring loopholes that anybody could spot, but most people buy a policy, stick it in a drawer and just pay the premiums when they are due. I think that especially seniors, they would be embarrassed. Although most people may be familiar with what's in an auto policy, long-term care is a lot different. In hindsight, too, verify the agent's status. I would have never thought of doing this until this case."

Robert B. Anderson, who represented Pioneer, took a much different stance. "The term 'insurance agent' means something different from the legal term 'agent,' but most people don't recognize this. But here, we were held liable....[besides] I don't believe the insureds were completely innocent. They called an agent who was over 100 miles away. I think they wanted someone who they didn't know, and who would be eager to sell a policy. The man was already hospitalized when they bought the policy."

Disclosure Requirements

An *Outline of Coverage* must be delivered at the time you apply for LTC insurance. For direct-response solicita-

tions, the Outline of Coverage must be delivered at your request, but no later than at the time of policy delivery. The Outline of Coverage must include a description of the principal benefits and coverage provided, a statement of the principal exclusions, reductions, and limitations of the policy, its renewal provisions, including any reservation of a right to change premiums, and a description of your rights regarding continuation, conversion, and replacement.

The Outline of Coverage must state that it is a summary of the policy only, and the policy should be consulted to determine governing contractual provisions.

Certificates

A certificate issued under a group long-term care insurance policy must include a description of the principal benefits and coverage provided, a statement of the principal exclusions, reductions, and limitations, a statement that the group master policy determines governing contractual provisions.

Life Insurance

When an individual life insurance policy provides long-term care benefits, it must be accompanied by a policy summary that includes an explanation of how the long-term care benefits interact with other components of the policy, an explanation of the amount of benefits, the length of benefits, and the guaranteed lifetime benefits, if any, for each covered person, any exclusions, reductions, or limitations on long-term care coverage If applicable, disclosure of effects of exercising other rights under the policy, of guarantees related to long-term care costs, and current and projected lifetime benefits.

LTC Applications

Applications for long-term care insurance (except guaranteed issue LTC insurance) must contain clear, simple questions designed to ascertain your health condition. Questions must contain only one inquiry each and require only a "yes" or "no" answer (except for names of physicians and prescribed medications).

Many times, states require the application to include the warning:

Caution: If your answers on this application are misstated or untrue, the insurer may have the right to deny benefits or rescind your coverage.

If the insurer does not complete medical underwriting and resolve all reasonable questions on the application before issuing the policy, the insurer may only rescind the policy or deny a claim on clear evidence of fraud or material misrepresentation. The fraud must pertain to the condition for which benefits are sought, involve a chronic condition or involve dates of treatment before the date of application, and must be material to the acceptance for coverage.

The contestability period is usually two years. Some states require insurers to maintain records of all policy rescissions and annually report them to the insurance department.

Consumer Protections

Riders or endorsements which reduce or eliminate benefits usually require your signed acceptance (unless you request the change in the first place). Riders or endorsements which increase benefits and increase the premium must be agreed to in writing by the policyholder unless the change is required by law.

Limitations on preexisting conditions must be set forth in a separate paragraph on the first page of the policy and clearly labeled. Any limitations or conditions for eligibility must also be set forth as a separate paragraph and labeled "Limitations or Conditions on Eligibility for Benefits."

Some states set loss ratio standards for LTC policies as well as Medicare supplement policies. Usually, for individual LTC policies, benefits are considered reasonable in relation to premiums if the expected loss ratio is at least 60 percent.

Copies of long-term care insurance policy advertisements intended for use must usually be filed with the state insurance department at least 30 days before they are used. Copies of the advertisements used must be retained by the insurer for a period of time, usually at least two or three years.

Ads designed to produce leads must disclose that "an insurance agent will contact you." Agents, brokers, or others who contact consumers as a result of receiving

information generated by a "cold lead" must immediately disclose that fact to the consumer.

Insurers offering LTC insurance must establish marketing procedures to assure comparisons of policies will be fair and accurate, and to assure that excessive insurance is not sold or issued.

Insurers must display prominently on the policy and the Outline of Coverage Notice to buyer: This policy may not cover all of the costs associated with long-term care incurred by the buyer during the period of coverage. The buyer is advised to review carefully all policy limitations.

"Every Reasonable Effort"

Insurers must make every reasonable effort to discover whether an applicant already has accident and sickness or LTC insurance, and the types and amounts of such insurance.

In recommending the purchase or replacement of a LTC policy, an agent must make reasonable efforts to determine the appropriateness of the recommended purchase or replacement. Many states have incorporated language to this effect in their insurance laws, and the NAIC Senior Issues Task Force is working to finalize suitability proposals for long-term care insurance policies.

If you already have a long-term care policy and want better benefits, you might try to enhance your existing policy with additional riders (it might be cheaper to do this than to buy a new policy). Or, you can replace your policy with a new one. This might make sense if you have an older policy with requirements for prior institutionalization, and if you are in good enough health to qualify for another policy. Be sure your application for the new policy is accepted before you cancel the old policy. However, when you switch policies, preexisting condition restrictions will apply and you may not have coverage for a period of time.

Controlling Agents and Brokers

Laws prohibit insurers, brokers, and agents from persuading anyone to replace a long-term care insurance policy unnecessarily, especially when the replacement causes a decrease in benefits and increase in premium. Some insurance departments will set a limit, such as

three or more policies sold to a policyholder in a 12-month period, as being presumed unnecessary.

Long-term care insurance application forms must include a question about whether the proposed insurance is intended to replace any other long-term care insurance presently in force. Upon determining that a sale will involve replacement, the insurer is required to furnish the applicant with a Notice to Applicant Regarding Replacement of Accident and Sickness or Long-Term Care Insurance.

Insurers using agents must furnish this notice prior to issuance or delivery of the policy or certificate. One copy is retained by the applicant, and an additional copy signed by the applicant shall be returned to and retained by the insurer.

Except when the replacement coverage is group insurance, the replacement notice must include a statement to be signed by the agent documenting that, to the best of the agent's knowledge, the replacement coverage materially improves the policyholder's position. The notice must also include the specific reasons the agent is making this recommendation.

Insurers making a direct-response solicitation through the mail must furnish this notice upon issuance of the policy or certificate. Separate notice forms have been prescribed by the Insurance Department for use by direct-response insurers and by other insurers.

If a group LTC policy is replaced by another group LTC policy, the replacing insurer must:

- provide benefits identical or substantially equivalent to the terminating coverage;

- calculate premiums based on the policyholder's age at the time of issue of the group certificate for the coverage being replaced (If the coverage being replaced itself replaced previous group coverage, the premium must be based on the original policy). However, if the replacement coverage offers new or increased benefits, the premium for those benefits may be calculated on the policyholder's age at the time of replacement;

- offer coverage to all persons covered under the replaced policy;

- not exclude coverage for preexisting conditions that would have been covered under the terminating coverage;

- not require new waiting periods, elimination periods, probationary periods, or similar preconditions;

- not vary the benefits or premiums based on the policyholder's health, disability status, claims experience, or use of LTC services.

If existing coverage is converted to or replaced by a new form of LTC insurance with the same company (except for an increase in benefits voluntarily selected by the policyholder) the insurance company may not establish any new waiting periods.

Sometimes agent commissions on replacement policies are regulated. In California, if a LTC insurance policy is replaced, the sales commission must be calculated based on the difference between the annual premium of the replacement coverage and that of the original coverage. The insurer must declare that the replacement policy materially improves the policyholder's position.

Continuation and Conversion Rights

Group LTC certificates must provide for continuation/conversion coverage for certificate holders if the group coverage terminates for any reason except:

- failure to make premium payment or contribution;

- when the group coverage is replaced within 31 days by identical or substantially equivalent benefits, and the premium for the replacement coverage is calculated on the policyholder's age at the time of the original policy issue date.

Continuation means you can maintain your coverage under an existing group policy provided you keep paying your premium.

Conversion means the insurer will issue you an individual LTC policy without considering insurability, containing identical or equivalent benefits. The premium for the converted policy must be calculated based on your age at the time the group certificate was issued.

The insurer may require that you were continuously insured under the group policy for at least six months pri-

ʳmination in order to be entitled to conversion
ʳe. You must apply for the converted policy within a
able period after termination of the group
ʳage.

Should You Buy LTC Insurance?

Not everyone who is approaching retirement is necessarily a candidate for LTC insurance. Insurers and insurance agents have been roundly criticized for selling long-term care insurance to people who do not need it; either because they cannot afford it or because they do not have enough assets to protect. Buying LTC insurance should not cause you financial hardship or make you neglect more important financial needs. If you have trouble meeting your other financial obligations such as utilities, food, and medicine, you should not purchase LTC insurance.

"The way long term care policies are sold is a disservice to people who are going to end up on Medicaid anyway," says Mary Griffin of Consumers Union. "Let's stop using Medicaid to sell long term care insurance. We are not telling people enough about the private and public alternatives available to them."

If a senior's sole source of income is a relatively small pension and he or she has minimal financial assets then this person may already be eligible for Medicaid reimbursement of LTC expenses. Occasionally, the retiree may receive financial assistance from friends and relatives to help cover nursing home expenses.

But assume that a person aged 65 buys an LTC policy, paying a level premium of $1,900 for 15 years. At age 80, which is the average age at which LTC services are required, the purchaser will have paid $28,500 in premiums for $500,000 worth of home-care and nursing-home benefits. This results in a 17.5-to-1 value ratio.

Of course, a person may purchase as much or as little coverage for as many years as are deemed at risk. However, the financial risk is greater for LTC services above the average required time, and it is made economically attractive to purchase more coverage rather than a lesser amount on a conservative basis. What other investment might an elder consider with a potential return of better than 10-to-1? And no one would be disappointed if, at the age of 80 because of good health, LTC services were not yet required and the value ratio ended up being lower.

Options for the Average Person

Margaret, age 66, has limited assets and a small retirement income. She would like to purchase a LTC policy with a $100 per day benefit, a ten-day EP and a five year benefit period. However, she cannot afford the premium. What options are available to her?

Any of the following or any combination of the following will permit Margaret to purchase a LTC policy at a premium she can possibly afford:

- she can naturally reduce the daily benefit to a lesser amount, ie., $50;

- she can increase the elimination period to 60 days, 90 days or longer;

- she can reduce the benefit period to two or three years.

In addition to these obvious alternatives, another factor which would enable Margaret to purchase the LTC care policy of her choice is age. Most insurers offer policies beginning at age 50 (a few, as low as age 40). As loss experience and underwriting data are accumulated, possibly this minimum age of 50 will be reduced to a much lower entry level and consequently, lower premiums.

However, to date, no insurer appears to offer a non-cancelable contract—meaning one in which both renewability and the premium are guaranteed. The vast majority of policies are guaranteed renewable but the premium is not guaranteed. Thus, even if Margaret had purchased a LTC policy at a much younger age, she still might find difficulty paying the premium at her present age of 66. She would have had the advantage of paying this increasing premium over a period of time which would have possibly enabled her to "budget" for this periodic premium increase.

Special Provisions

Each LTC insurance company has its own special contract provisions. An educated buyer must review contracts to understand these differences before making a LTC commitment:

- The amount of daily/annual benefit coverage, years of coverage, amount of home care coverage, waiting

period before benefit begins, and inflation rider options vary by contract.

- Home care coverage is usually available at the 50 percent, 80 percent, or 100 percent level of the base nursing home-care coverage. This is the most important variable area. If home care is a priority, it is important to factor the different level of home care coverage into any comparison of premiums between different company proposals. A home-care rider has an incremental cost for the extra years purchased for this purpose which amounts to about 30 percent of the base nursing-home cost.

- Claims can be paid on either a reimbursement or an indemnity basis. In a reimbursement policy, an insurance company reimburses a licensed agency for custodial aid services or a nursing home up to but not more than a policy benefit limit. In an indemnity policy, the full coverage is paid directly to the policyholder.

- While a disability income approach recently introduced allows the policyholder to use the benefits paid for any purpose, this approach is relatively expensive. Disability policies also include LTC riders. As LTC costs are likely to be greater than the amount of coverage purchased, the three different payment approaches are not an important contractual, financial issue.

- The definition of activities of daily living varies, but inability to perform two or more ADLs is the usual qualification for LTC benefit payments.

- Contracts also vary slightly on extra areas such as respite care or day care, reimbursement for certain home equipment, starting time period for a waiver of premium payments, and waiting time periods after an interruption in LTC services.

Nonforfeiture Provisions

An issue currently being debated in the industry is whether or not the incorporation of nonforfeiture benefits and inflation protection in LTC policies should be mandatory.

Nonforfeiture provisions, which return some of your investment if you drop your coverage, will probably be required eventually in LTC policies. Without nonforfeiture provisions, LTC insurance provides no recovery for the policyholder who lapses the policy, or who dies without ever having needed LTC benefits. If the policyholder surrenders the policy, all value and all premiums paid are lost. If you cancel coverage after ten or 20 years and have never used any of the policy benefits, your loss could be significant.

The standard nonforfeiture options which would apply to LTC insurance include:

- *Cash Surrender Value.* A guaranteed sum is paid to the policyholder upon surrender or lapsing of the policy. This sum is generally equal to some portion or percentage of the insurer's policy reserve at the time premiums cease.

- *Reduced Paid Up.* A lesser or reduced amount of daily benefit payable for the maximum length of the policy's benefit period with no further premium payments required.

- *Extended Term.* A limited extension of insurance coverage for the full amount of the policy benefits without any further premium payments, for a limited period of time only.

The reduced paid up and extended term options are paid from the policy's cash value. These are fairly standard and are very similar to the nonforfeiture options found in permanent life insurance policies.

Another form of nonforfeiture option which has been considered is a Return of Premium option. Under this option, a lump sum cash payment equal to some percentage (60 percent, 80 percent, etc.) of the total premiums paid would be paid to the policyholder upon lapsing or surrendering the policy. Normally, any claims previously paid to the policyholder, would be deducted from the return.

Consumer advocates argue that, unlike life insurance, when LTC policyholders lapse their LTC policies by halting premium payments (and without ever having made a claim on the policy), they lose their accumulated equity in the product (all the premiums they've paid in).

Because of the lack of nonforfeiture benefits, insurers have been charged with "predatory pricing" in which ini-

tial premiums are low but increase dramatically, "squeezing out" policyholders who cannot afford the premium payments and allow the policies to lapse.

Similarly, policies sold without an inflation protection provision could leave the insured with inadequate coverage at claim time.

But the insurance industry maintains that the inclusion of these benefits could more than double the already high cost of LTC insurance, pricing it out of the reach of most people.

Some insurers argue that nonforfeiture values were not contemplated when premium rates were developed, and that adding nonforfeiture provisions to long-term care policies will increase the premium up to 100 percent. Others have already started offering them.

The issues remain unresolved. Even though its Long Term Care Task Force has taken a position in favor of requiring nonforfeiture benefits in all new LTC policies, the NAIC is holding off suggesting that the benefits be mandatory, pending further study. There is, however, support for the mandatory *offer* of these benefits.

Shopping for LTC Insurance

If you decide to shop for a long-term care policy, a good way to begin is to assemble information on the types of long-term care services and facilities you might use and find out how much they charge. Shopping for long-term care insurance is more difficult because the plans have not been standardized like Medicare supplement policies. Review several different policies and compare the benefits they provide, the premiums they charge, the limitations and exclusions on coverage, and the types of facilities you have to be in to receive coverage.

Make sure you know what the policy covers and what it does not. Know your rights and responsibilities, and ask for the information you are entitled to. If the agent does not provide you with a Buyers Guide and Outline of Coverage, or tells you it will be provided later, switch to a different agent.

Don't be pressured into making a quick decision. John Davidson, Director of Consumer Services for the West Virginia Insurance Department, says, "We always recommend that you should not buy a policy on the first

interview, even if the agent says it's best to have the policy issued more quickly, says it's the only day he'll be in your area, or claims the policy can only be offered once." Davidson also recommends "Always read over a form before you sign. If the agent fills out the form for you, read it carefully before you sign. Don't sign a form with incorrect information on it, and never sign blank forms."

Take your time, read through the Outline of Coverage, and ask questions. If the agent can't answer your questions, try the insurance company's home office. You may also want to contact your state insurance department or state insurance counseling program if it has one.

Never pay the agent in cash. Write a check payable to the insurance company, write the policy number on the check, and get a receipt. The agent could keep your money and not even submit your application, claiming you've given him a personal loan, not a premium payment, and you will have to go to court to get your money back. Be sure you get the name, address, and telephone number of both the agent and the insurance company. You should receive your policy within 30 to 60 days. When you do, put it in a safe place and tell someone you trust where it can be found when needed.

Remember, you have 30 days after purchasing a long-term care policy to make sure it is what you want. If you decide you do not want it, you can cancel it and get your money back. Send the policy and a letter asking for your refund by certified mail within 30 days of receiving the policy.

As newer and more improved LTC products evolve in the future, nonforfeiture options would provide an equitable way for you to surrender an inferior product and upgrade to a better policy without forfeiting all values in the existing policy. It is conceivable that at some time in the future, the government may usurp the need for LTC insurance. If this were to happen, with nonforfeiture values, you would be guaranteed a fair escape from the private plan to the government program.

LTC Partnership Programs

The Robert Wood Johnson Foundation, a private foundation affiliated with the Center on Aging at the University of Maryland, has assisted several states (California, Connecticut, Indiana, Illinois, and New York) in developing

public/private long-term care insurance programs which help safeguard against the total depletion of assets before a person qualifies for Medicaid.

The overall goal of the partnership is to offer an LTC product that coordinates with state public assistance programs and is affordable and attractive to consumers. Partnership policies are endorsed by the state but are marketed by private licensed insurance companies.

Partnership programs define formulas for asset protection, identify those eligible for coverage, and provide minimum coverages and standards. Individuals who purchase partnership policies are allowed to retain more assets and still qualify for Medicaid assistance.

Agents tend to "get into grooves" and become self-proclaimed experts in some facet of the insurance business. One agent may write nothing but life insurance; another becomes an expert in producing pension plans and a third becomes a big producer by selling health insurance.

LTC Needs Careful Explanation

Due to the type of product LTC insurance is, and its unique market, insurance just can't announce the existence of a new feature and tell the field force to read a rate manual to learn more about the policy. To fully understand the LTC product requires formal training sessions where the market is identified and the policy studied in detail. In addition, because of the complexity of the coverage, it is essential that agents have the ability to explain the product to the senior citizen.

The state of North Carolina has recognized the importance of properly trained agents who work in the long term care marketplace. Effective January 1, 1991, North Carolina implemented a new prelicensing education law for any agent who sells LTC insurance or Medicare supplement policies. Any agent who intends to sell these products must satisfy a ten hour prelicensing education requirement and pass a separate licensing exam for these lines of insurance. In addition, North Carolina has also implemented a two hour continuing education requirement to maintain this license.

California has recently implemented a similar law, requiring agents who sell long-term care policies to com-

plete 8 hours of LTC-related continuing education each license renewal period.

Today, major companies offer LTC policies with many standard contractual terms and some provisions which differ between contracts. While there is no uniform nationwide standard for LTC policies, the National Association of Insurance Commissioners has recommended standards that have influenced most state regulations.

Looking Back

Finally, here are some of the hazards lurking in long-term care policies:

- The most restrictive policies cover only "skilled" care—that is, care ordered by a doctor and given by a registered or practical nurse—and only if you spend three days in the hospital before going into a nursing home. The effect of this limitation is to exclude the typical nursing home patient, who doesn't need constant medical attention, yet is unable to take care of himself. The three-day prior hospital stay requirement has been outlawed in most states.

- More liberal policies require only that the policyholder be unable to perform certain daily activities— eating, dressing or moving from a bed to a chair— before claims will be paid. But be warned: Companies can define living activities in a way to make collecting difficult. Make sure your policy covers cognitive as well as physical impairments. And try to buy a policy that covers care at home as well as in an institution.

- The policy may not keep up with inflation. Say you are 60 and will go into a nursing home at age 80. If costs keep climbing at 7 percent a year, today's $45,000-a-year home will be billing $175,000 a year when you enter. A policy allowing for up to five percent a year in cost escalation is typical. It would cost only a little more for an older buyer, a lot more for a young one.

- The policy may not be guaranteed renewable— meaning that the insurer in effect has the right to confiscate your savings. How so? Long-term care insurance premiums are designed to stay the same every year as you age. That means you pay much more in the early years than is statistically necessary

to cover your risk of immediately entering a nursing home; the excess is supposed to be put aside in reserve to keep your rate low in later years. But in 23 states insurers may cancel a nursing home policy at any time, thus robbing the policyholder of the equity he thought he was building up with his early-year premiums. The premium, which is supposed to stay constant, may shoot skyward. If your policy is guaranteed renewable over your lifetime, an insurer cannot single you out and raise your rate selectively. But it can raise rates across the board for all policyholders, or even for everyone in a single state or single age group. So far Conserv, a Blue Cross of Western Pennsylvania subsidiary, appears to be the only company willing to guarantee level premiums for life.

- The insurer may take your money for years, then decide after you enter a nursing home that you didn't qualify for coverage after all—probably because of some medical problem you failed to disclose on your application, or that the company forgot to ask you about. An older person may forget to tell the agent about a certain health problem. Or the agent, worried about making a sale, will intentionally leave the condition off the application. You may get your premiums back, probably without interest, but of course then find it is too late to buy a policy elsewhere. Outrageous? This "post-claims underwriting" is being challenged in several states. You should choose an insurer that will thoroughly investigate your medical history, says Jerie Charnow, a social worker in New York specializing in long-term care for the elderly.

- The policy you invest in today may become irrelevant or uncompetitive, and you may not be permitted to upgrade. Insurers are constantly improving upon old products and, in many cases, lowering their rates. Travelers allowed everyone who bought its original long-term care policy back in 1987 to trade it in for its new, cheaper policy when it was introduced earlier this year. The upgrades were made without additional evidence of good health, and the new rates were based on policyholders' original issue ages. In October John Hancock introduced the third version of its nursing home insurance product in five years, which allows all existing ProtectCare Plus policy-

holders under age 80 to upgrade, without ev_
health, with certain provisos. Rates will be
lated at today's ages.

Among the most important things to remember wh_
picking long-term-care insurance is the reputation of th_
company that's backing it. Since long-term-care policies
haven't been around for very long, the insurance industry
underwriting is being done on what amounts to a wing
and a prayer. For that reason, planners recommend pol-
icies from the bigger carriers with good credit ratings.

An LTC Checklist

For many older citizens in need of LTC insurance, how
comprehensive or costly a policy is may not be as impor-
tant as which benefits and provisions are contained in the
contract. Following is a checklist of policy features which
the average buyer of LTC insurance should consider and
the agent should be prepared to offer and explain to you.

Type of Policy Benefits:

Does the policy provide benefits for the following and

how long will benefits be provided?

Skilled Nursing Care_____

Intermediate Care_____

Custodial Care_____

Home Health Care_____

Does the policy have a maximum benefit amount
expressed in dollars or time? What is the maximum bene-
fit?_____

Does the policy contain nonforfeiture provisions?_____

Does the policy contain any optional policy benefits?___

Adult Day Care_____

Hospice Care_____

Inflation Protection_____

Amount of Benefits:_____

Are policy benefits paid on an expense incurred basis?__

What is the percentage?_____

How long will benefits be provided?_____

Are policy benefits paid on an indemnity basis?_____

What is the daily benefit for each level of care?_____

How long will benefits be provided?_____

Policy Provisions:

How long is the elimination period?_____

How long is the benefit period for each level of care?____

Does the policy require prior hospitalization? If so, how long?_____

Does the policy base benefits on the ability to perform the activities of daily living? If so, how many activities?____

Does the policy provide purely custodial care?_____

Is there a waiver of premium provision?_____

Policy Exclusions or Limitations:

What are the policy's exclusions?_____

Does the policy cover Alzheimer's disease?_____

Does the policy cover preexisting conditions? If so, when?

These elements and policy conditions appear to be the more important factors of consideration. The buyer of LTC insurance is entitled to know these considerations. This in turn requires that the agent be well educated in the various policy provisions and benefits, and able to explain these policy provisions to the buyer of LTC insurance.

CONCLUSION

Once you've done your homework, analyzed your insurance needs and familiarized yourself with the different options available to you, you should be ready to decide whether to keep the policies you have, surrender them, change them, add endorsements, convert to a different kind of insurance, replace the policies with better coverage, or purchase additional, new insurance coverage.

Don't keep a policy just because you've had it for many years. Even if you decide to keep a policy you should be sure your coverage is updated to meet your current circumstances. All of your insurance coverages should be reviewed every one to two years, especially if you or your family goes through death, divorce, marriage, the birth of children, or changes in income and/or health status.

It's important to go over your homeowners policy since a fire, theft, or other residential loss can have devastating financial (and emotional) consequences, especially when you are living on a fixed income. Without adequate coverage, you may be unable to replace what you have lost. It is often a good idea to increase your homeowners coverage, assuming the additional costs are within your means.

With juries routinely awarding seven-figure judgements in personal injury cases, you should analyze the adequacy of your current liability coverage to be sure that a loss would not cause financial hardship. You may want to consider obtaining an umbrella or excess liability coverage to provide a cushion against large negligence awards.

When you retire, you probably won't be driving as much as you were when you were working. Therefore, the probability of an accident will decrease, and increasing your deductibles may be a relatively risk-free way to lower premiums. You might want to get rid of the extras, such as riders for multiple drivers and business use. And be sure

you take advantage of mature driver discounts offered by insurance companies.

If you purchased life insurance to provide financial security for children who are now in their 30s or 40s, they may not need the protection anymore and you should think about how much it is costing you to continue to provide it. Beneficiary designations are key review points. Merely changing your will is not enough, especially since life insurance proceeds do not go through probate. Designations made years ago may not necessarily reflect your current desires, and you might accidentally disinherit someone.

If you purchased life insurance as a safe investment to build cash value, now is the time to think about when you will use those funds, or whether you would like to borrow from the cash value or cash in the policy altogether and invest the money differently.

As for health insurance, consider the coverages you have in effect now, including whether you will be able to convert any coverage you have at work to individual coverage after you retire. It is important to check with your benefits administrator or read the group contract language and find out for sure.

Look for a Knowledgeable Agent

At least for now, the insurance agent is key to the marketing, underwriting and delivery of insurance policies. Few lawyers and accountants, or even financial planners, understand insurance well enough to make sensible recommendations. In fact, after reading this book, you may well know more about your insurance policies than your lawyer or accountant.

You will need a knowledgeable and professional insurance agent to help solve your post-retirement problems and help you meet the financial challenges of aging. Your agent should be well versed in the policies available on the market, not just the policies he or she offers, and must keep current in many areas: government programs, insurance products, taxation, estate planning, and employee benefits. Your agent's advice should mesh with that of the other experts you use to help establish a comprehensive financial plan, such as attorneys, accountants, and financial planners.

As a marketing representative of the insurer, the agent is legally responsible for representing, explaining, and marketing the insurer's products ethically and professionally. During the underwriting process (especially for life and health insurance), the agent is the primary source of information for the insurance company. It is the agent's duty to accurately and thoroughly complete insurance applications, collect initial premiums, give you a receipt, and promptly submit the money to the company. The agent must provide you with privacy notices and information such as the Notice of Insurance Information Practices.

By law, insurance agents act in a fiduciary capacity, which means they are bound to act in good faith with regard to the insured person. A fiduciary is a person who holds a position of trust and confidence with the insured. This means giving you good advice, selling you the policies that best suit your needs, and collecting and remitting your premiums in accordance with insurance company guidelines and state law. Agents attempting to replace your current insurance policies with a new policy need to take special care not to mislead you or provide coverage which is to your detriment.

Remember: Agents Work on Commission

Never forget that your insurance agent is striving to earn a commission. No matter how much you may like your agent as a person, or how well you feel you know and trust your agent, understand that one of the basic conflicts confronting agents is the desire to provide good service when there is pressure to sell and make high commissions. The agent may be earning a 30 to 50 percent commission from your first year's premium payment.

John Davidson, Director of Consumer Services for the West Virginia Insurance Department, cautions that "at the same time the agent is doing your CNA (cash needs analysis), he is doing his own CNA (commission needs analysis)." Insurance companies protest that they require their field force to comply with all insurance laws and provide a careful needs analysis but, in fact, the reward system for agents is based on sales—not service. The company wants the agent to make several sales a week. Commission structures also encourage agents to sell "higher commission" products instead of policies which better serve the client's needs.

If you are comfortable with your current insurance agent, you can ask his or her advice on different types of policies. Ask for brochures and other information on the types of insurance you are considering, and ask for a quote.

If you don't already have an insurance agent whom you trust, rather than making a random selection from the yellow pages, you might want to ask the advice of a financial planner or employee benefit specialist. Your credit union, retirement center, local fraternal association, chamber of commerce, and other trusted organization may also be able to give you a referral.

Consider Professional Designations

Ask about your insurance agent's educational credentials. All insurance agents must pass a state examination to become licensed, and many states require professional continuing education, but some agents go the extra step and take advanced courses and designations. The most common professional designations are:

- CLU, Chartered Life Underwriter;
- CPCU, Chartered Property/Casualty Underwriter;
- FLMI, Fellow, Life Management Institute;
- CIC, Certified Insurance Counselor;
- CFP, Certified Financial Planner;
- CFC, Chartered Financial Consultant.

An agent who has taken any of these advanced courses and earned these designations indicates that he or she is capable of understanding advanced insurance theory, and is committed to being informed and qualified to serve in the insurance industry.

Prepare for any visit with an insurance agent by reviewing the policies you will be discussing, and have a list of questions prepared.

If you feel like you aren't getting the full story from your agent, don't hesitate to ask questions. If your agent can't answer the questions you have, or skips over them to continue with the sales pitch, call the insurance company, or your state insurance department.

As we have mentioned throughout this book, there are agents and companies selling insurance policies whose

lack of professionalism and ethics can cost consumers dearly. Don't leave your important insurance decisions up to a stranger. There are ways to protect yourself. Knowledge is power, and being aware of your coverages as well as your legal rights and responsibilities will help you avoid being taken advantage of in this market.

No agent should try to pressure you to make a purchase on the spot. A professional agent will work with you, doing a needs analysis, and conduct one or more follow-up visits to answer your questions, customize your program, and help you feel comfortable with the decisions you reach. Anyone who seems in a hurry to "close" you, or who suggests that the policy is a "one-time" or "limited time" offer, is probably more interested in the sale and the commission than in meeting your insurance needs.

Remember, it is illegal for an agent to make derogatory or malicious statements about other insurance companies (the competition). If an agent tells you that your current insurer is in financial trouble, or legal trouble, or is known for ripping people off, the agent is guilty of an unfair trade practice known as defamation. (If you point this out to the agent, you'll probably make him or her nervous enough to stop.)

When you are making an installment purchase, such as a new car, the lender may require you to provide adequate amounts of life insurance to provide security for the loan, and may even tell you that your existing insurance is not adequate. However, the lender may not require you to purchase insurance from a specific agent or company. And to suggest that the loan will not be granted unless you buy insurance from a particular company or agent is an unethical business practice for which they can be fined and lose their license to sell insurance.

Rebating is generally considered to be an unethical practice although in a few states rebating is not illegal. By definition, rebating is any inducement in the sale of insurance which is not specified in the insurance contract. This could include both "cash" rebates and services, so if your agent offers to split his or her commission with you or even tune up your car in return for you buying a policy, he or she is behaving unethically, and probably illegally.

Beware False Guarantees

Remember that life insurance policy dividends are never guaranteed, may not be advertised as guaranteed, and agents are not allowed to suggest that dividends are guaranteed. But overly optimistic projections make impressive sales presentations. If your agent says "even though we have to say that dividends aren't guaranteed, just look at our returns over the past few years! You just know that returns like these will come in every single year, and your investment will grow and grow," you should show him or her the door, and inform your state insurance department.

Disclosing your medical history when applying for life and health insurance is very important. Don't be misled by an agent who says your medical history does not need to be accurate. If the agent fills out your application for you, be sure to read it over carefully before you sign. Never let an agent talk you into signing any form, application, or document in blank.

Anyone who tells you that he or she is a "counselor" or "advisor" for any association of senior citizens, may in fact just be a licensed insurance agent trying to sell you a Medicare supplement insurance policy. Ask for credentials, the licenses they hold, and what kinds of products they are authorized to sell. A business card is not a license.

Remember that even though your state, or the state your insurer does business in, may have a guaranty association, your protections are limited. Any guarantees made in your policy are contingent on your insurance company staying in business. If it goes out of business, you may be left without coverage. Your agent may not use the existence of a guaranty association to imply that your coverage and benefits are guaranteed.

Carefully Evaluate Any Sales Pitch

Never, ever pay your policy premium in cash or make out a check to the agent's personal account. The agent should make it clear that you have the option of paying your premiums directly to the insurer.

An elderly Tennessee couple, both of whom had arthritis and trouble writing, allowed their agent to fill out their check for Medicare supplement insurance. The agent made it payable to himself, signed it, and cashed it with-

out ever submitting it to the insurance company. After submitting a claim for medical expenses when the wife had eye surgery, they were notified that the policy had lapsed because the insurance company never received their premium. The agent's license was revoked, but they were left without coverage.

Another mistake is to send money on the basis of a telephone investment sales pitch—no matter how friendly and smooth the salesperson sounds, never give your checking account number, credit card number, or any other personal information, to people over the telephone unless you made the call and you're certain with whom you're dealing and that that person has a legitimate need for the information.

Insurance agents and companies may not claim that they represent any government agency, including Medicare, Social Security, and the Health Care Financing Administration. Agents and insurers may not imply that the policy they are selling is guaranteed, approved, or otherwise backed up by the government. If someone calls you claiming to have been authorized by the government to contact you in order to review, modify, or discuss your existing insurance program don't make an appointment with him or her. If you receive cards in the mail that look as if they were sent by the government and ask questions about your insurance coverage, they are probably from insurers looking to sell you insurance policies.

Don't Be Sold by Celebrities

It is common for companies to use celebrities for advertising insurance policies. Most of the time, these people are being paid to advertise, or may even have a financial interest in the company. Celebrities are not insurance experts, so you should be careful to not let what they say have too much influence on your decision making.

Replacement is not illegal, but agents who convince you to replace current insurance policies with new coverage need to take special care not to mislead you or provide coverage which is to your detriment. Health conditions covered under a current policy may be excluded as preexisting conditions, or new waiting periods may be established. An agent should not talk you into replacing your coverage unless the amounts of coverage and benefits to you are substantially increased. If your agent talks you

into buying a new policy every year or every other year, even if it's from the same insurer, he or she is more interested in earning the first year commission than in protecting your interests.

Always Shop Around

The importance of comparison shopping when buying insurance cannot be overstressed. Many people just renew their existing coverages, or write new coverages with their current agent, without shopping around. Prices for similar policies can vary substantially from company to company. You should compare benefits, limitations of coverage, exclusions, and premiums. Be sure to check with different companies before you buy to get the best rates and services for your needs. It pays to shop for the right policy at the right price, but don't base your decision on price alone, and don't buy more insurance than you can afford. Take your time and be patient. These are important decisions, and it takes a lot of homework to get the best kinds and amounts of insurance for the lowest cost.

Shop aggressively when you first buy a policy; after that, change insurers or policies only when you desire to make substantial changes to your coverage. If you cancel one policy to purchase another, there is generally no refund of premium, and you may be subject to new policy limitations and restrictions.

When you are purchasing insurance from a commercial carrier, you should not only consider the extent and types of coverage available for the premium charged, but also the insurer's financial health, reputation, level of service, and ability to pay claims. Several private companies conduct financial analysis of insurance companies and assign "grades." The ratings are based on the company's assets, surplus, premiums, revenue and investment performance, and other relevant information. Different rating organizations use different rating scales, so ask for an explanation.

Also, it is usually better to purchase insurance through a company that is authorized to transact insurance in your state. In case you have problems, your state insurance department will have more authority over the company, and the company will be sure to be covered by your state's guaranty association, if there is one (most of the time, out

of state companies are not covered by the guaranty association). Call your insurance department to find out if a company or agent is authorized in your state.

Always Read Your Policy

Take your time and read through the policy and the Outline of Coverage (if applicable). Read through "danger" areas in the policy like preexisting conditions exclusions, waiting periods, coverage limitations, and age restrictions (such as when coverage expires). Find out how you renew the policy and whether your premiums can go up. Beware of any insurance program that seems too good to be true. It probably is. Never let yourself be pressured into a hasty decision.

Make use of the consumer assistance available to you. Your state insurance department can send you consumer guides for most of the policies you are looking into, including automobile and homeowners insurance. There are hotlines to help seniors make coverage decisions.

Use your free look provision, as provided in life and health policies. If you decide you don't want the policy after all, you can get your money back provided you notify the company within the time period allowed by the policy.

If you are declined coverage, you have the right to write and request a written explanation of why your application was declined. If you feel the insurer has unfairly refused to issue you a policy, you may file a written complaint with the insurer, agent, and the insurance department. The insurance department can investigate the complaint and help correct misunderstandings, but does not provide legal services.

Remember, you are in charge of your insurance coverages, and you are in the best position to make insurance decisions that make the most sense for your current and future plans. Use this book as your road map to achieving insurance security.

Directory of State Insurance Departments and Agencies on Aging

Following is an alphabetical listing of state insurance departments and departments of aging, as well as each state's insurance counseling hotline. Contact these agencies when you are having trouble resolving a problem with your agent or your insurance company, or when you have a complaint against an agent or company. The hotline numbers are staffed by volunteers who can help you determine which coverages you need, and can help you understand the coverages you may want to purchase.

It is a federal offense for an insurance agent to indicate that he or she represents the Medicare program in order to sell an insurance policy. The federal toll free number to register a complaint about an agent who does so is 1-800-638-6833.

ALABAMA

INSURANCE COUNSELING
1-800-243-5463

INSURANCE DEPARTMENT
135 South Union St., Ste. 150
Montgomery, AL 36130-3401
(205) 269-3550

COMMISSION ON AGING
770 Washington Ave., Suite 470
Montgomery, AL 36130
(205) 242-5743

ALASKA

INSURANCE COUNSELING
1-800-478-6065
(907) 562-7249

DIVISION OF INSURANCE
State Office Building, 9th Floor
333 Willoughby Ave.
Juneau, AK 99801
(907) 465-2515

OLDER ALASKANS COMMISSION
P.O. Box 110209
Juneau, AK 99811-0209
(907) 465-3250

ARIZONA

INSURANCE COUNSELING
1-800-432-4040

INSURANCE DEPARTMENT
Consumer Affairs and Investigation Div.
2910 N. 44th St., Ste. 210
Phoenix, AZ 85018
(602) 912-8400

DEPT. OF ECONOMIC SECURITY
Aging & Adult Administration
1789 W. Jefferson St.
Phoenix, AZ 85007
(602) 542-4446

ARKANSAS

INSURANCE COUNSELING
1-800-852-5494
(501) 686-2939

INSURANCE DEPARTMENT
Seniors Insurance Network
1123 S. University Avenue
400 University Tower Bldg.
Little Rock, AR 72204-1699
(501) 686-2900

DIVISION OF AGING AND ADULT SERVICES
1417 Donaghey Plaza South
P.O. Box 1437/Slot 1412
Little Rock, AR 72203-1437
(501) 682-2441

CALIFORNIA

INSURANCE COUNSELING
1-800-927-4357
(916) 323-7315

INSURANCE DEPARTMENT
Consumer Services Div.
Ronald Reagan Building
300 S. Spring Street
Los Angeles, CA 90013
(213) 897-8921

DEPARTMENT OF AGING
1600 K Street
Sacramento, CA 95814
(916) 322-3887

COLORADO

INSURANCE COUNSELING
(303) 894-7499

INSURANCE DIVISION
1560 Broadway
Suite 850
Denver, CO 80202
(303) 894-7499

AGING AND ADULT SERVICES
Dept. of Social Services
1575 Sherman St., 4th Fl.
Denver, CO 80203-1714
(303) 866-3851

CONNECTICUT

INSURANCE COUNSELING
(203) 566-7772

INSURANCE DEPARTMENT
153 Market Street
P.O. Box 816
Hartford, CT 06142-0816
(203) 297-3802

DEPARTMENT ON AGING
175 Main Street
Hartford, CT 06106
(203) 566-7772

DELAWARE

INSURANCE COUNSELING
1-800-336-9500

INSURANCE DEPARTMENT
Rodney Building
841 Silver Lake Bldg.
Dover, DE 19904
(302) 739-4251
1-800-282-8611

DIVISION OF AGING
Dept. of Health & Social Services
1901 N. DuPont Highway
2nd Fl. Annex Admin. Bldg.
New Castle, DE 19720
(302) 577-4791

DISTRICT OF COLUMBIA

INSURANCE COUNSELING
(202) 724-5626

INSURANCE DEPARTMENT
613 G Street, NW
Room 638
P.O. Box 37200
Washington, D.C. 20001-7200
(202) 727-8009

OFFICE ON AGING
1424 K Street, NW
2nd Floor
Washington, D.C. 20005
(202) 724-5622

FLORIDA
INSURANCE COUNSELING
1-800-96 ELDER
1-800-963-5337
(904) 922-2073

DEPARTMENT OF INSURANCE
202 E. Gaines St., Larson Bldg.
Tallahassee, FL 32399-0300
1-800-342-2762
(904) 922-3100

DEPARTMENT OF ELDER AFFAIRS
1317 Winewood Blvd.
Building 1, Room 317
Tallahassee, FL 32301
(904) 922-5297

GEORGIA
INSURANCE COUNSELING
1-800-669-8387

INSURANCE DEPARTMENT
2 Martin L. King Jr., Dr.
716 West Tower
Atlanta, GA 30334
(404) 656-2056

OFFICE OF AGING
Dept. of Human Resources
878 Peachtree St., NE, Rm 632
Atlanta, GA 30309
(404) 657-5258

HAWAII
INSURANCE COUNSELING
(808) 586-2790

DEPARTMENT OF COMMERCE AND CONSUMER AFFAIRS
Insurance Division
250 S. King St., 5th Floor
Honolulu, HI 96813
(808) 586-2790

EXECUTIVE OFFICE ON AGING
335 Merchant Street
Room 241
Honolulu, HI 96813
(808) 586-0100

IDAHO

INSURANCE COUNSELING
(208) 334-3833

INSURANCE DEPARTMENT
Public Service Dept.
700 W. State St., 3rd Fl.
Boise, ID 83720
(208) 334-4350

OFFICE ON AGING
Statehouse, Room 108
Boise, ID 83720
(208) 334-3833

ILLINOIS

INSURANCE COUNSELING
1-800-548-9034

INSURANCE DEPARTMENT
320 W. Washington St.
4th Floor
Springfield, IL 62767
(217) 782-4515

DEPARTMENT ON AGING
421 E. Capitol Avenue
Springfield, IL 62701
(217) 785-3356

INDIANA

INSURANCE COUNSELING
1-800-452-4800

INSURANCE DEPARTMENT
311 W. Washington St.
Suite 300
Indianapolis, IN 46204
1-800-622-4461
(317) 232-2385

DIV. OF AGING & HOME SERVICES
402 W. Washington St.
P.O. Box 7083
Indianapolis, IN 46207-7083
1-800-545-7763
(317) 232-7020

IOWA

INSURANCE COUNSELING
(515) 281-5705

INSURANCE DIVISION
Lucas State Office Bldg.
E. 12th & Grand Sts.
6th Floor
Des Moines, IA 50319
(515) 281-5705

DEPT. OF ELDER AFFAIRS
Jewett Bldg., Suite 236
914 Grand Avenue
Des Moines, IA 50319
(515) 281-5187

KANSAS

INSURANCE COUNSELING
1-800-432-3535

INSURANCE DEPARTMENT
420 S. W. 9th Street
Topeka, KS 66612
(913) 296-3071
1-800-432-2484

DEPARTMENT OF AGING
122-S. Docking State Office Building
915 S. W. Harrison
Topeka, KS 66612-1500
(913) 296-4986

KENTUCKY

INSURANCE COUNSELING
1-800-372-2973

INSURANCE DEPARTMENT
215 W. Main Street
P.O. Box 517
Frankfort, KY 40601
(502) 564-3630

DIVISION OF AGING SERVICES
Cabinet for Human Resources
275 E. Main Street
Frankfort, KY 40621
(502) 564-6930

LOUISIANA

INSURANCE COUNSELING
1-800-259-5301

INSURANCE DEPARTMENT
P.O. Box 94214
Baton Rouge, LA 70804-9214
(504) 342-0895
1-800-259-5301

GOVERNOR'S OFFICE OF ELDERLY AFFAIRS
4550 N. Blvd.
P.O. Box 80374
Baton Rouge, LA 70898-0374
(504) 925-1700

MAINE

INSURANCE COUNSELING
1-800-300-5000
(207) 624-5335

BUREAU OF INSURANCE
Consumer Division
State House, Station 34
Augusta, ME 04333
(207) 582-8707

BUREAU OF ELDER AND ADULT SERVICES
State House, Station 11
Augusta, ME 04333
(207) 624-5335

MARYLAND

INSURANCE COUNSELING
1-800-492-7521

INSURANCE DEPARTMENT
Complaints and Investigation Unit
501 St. Paul Place
Baltimore, MD 21202-2272
(410) 333-6180

OFFICE ON AGING
301 W. Preston Street
Room 1004
Baltimore, MD 21201
(410) 255-1100

MASSACHUSETTS

INSURANCE COUNSELING
(617) 727-7750

INSURANCE DEPARTMENT
Consumer Services Section
470 Atlantic Ave., 6th Floor
Boston, MA 02114
(617) 521-7794

EXECUTIVE OFFICE OF ELDER AFFAIRS
1 Ashburton Place, 5th Floor
Boston, MA 02108
1-800-882-2003
(617) 727-7750

MICHIGAN

INSURANCE COUNSELING
1-800-347-5297

INSURANCE BUREAU
611 W. Ottawa St., 2nd Floor
Lansing, MI 48933-1020
(517) 373-9273

OFFICE OF SERVICES TO THE AGING
611 W. Ottawa Street
P.O. Box 30026
Lansing, MI 48909
(517) 373-8230

MINNESOTA

INSURANCE COUNSELING
1-800-882-6262

INSURANCE DEPARTMENT
Department of Commerce
133 E. 7th Street
St. Paul, MN 55101-2362
(612) 296-2488

BOARD ON AGING
Human Services Building
4th Floor
444 Lafayette Road
St. Paul, MN 55155-3843
(612) 296-2770

MISSISSIPPI
INSURANCE COUNSELING
Counseling services not provided at this time.

INSURANCE DEPARTMENT
Consumer Assistance Division
P.O. Box 79
Jackson, MS 39205
(601) 359-3585

DIV. OF AGING & ADULT SERVICES
455 N. Lamar Street
Jackson, MS 39202
1-800-345-6347
(601) 359-6770

MISSOURI
INSURANCE COUNSELING
1-800-726-7390

DEPARTMENT OF INSURANCE
Consumer Services Section
301 W. High St., 6 North
Jefferson City, MO 65102-0690
1-800-726-7390
(314) 751-4126

DIVISION OF AGING
Dept. of Social Services
P.O. Box 1337
615 Howerton Court
Jefferson City, MO 65102-1337
(314) 751-3082

MONTANA
INSURANCE COUNSELING
1-800-332-2272

INSURANCE DEPARTMENT
126 N. Sanders
Mitchell Bldg., Rm. 270
P.O. Box 4009
Helena, MT 59601
(406) 444-2040

GOVERNOR'S OFFICE ON AGING
State Capitol Building
Room 219
Helena, MT 59620
1-800-332-2272
(406) 444-3111

NEBRASKA
INSURANCE COUNSELING
(402) 471-4506

INSURANCE DEPARTMENT
Terminal Building
941 "O" St., Suite 400
Lincoln, NE 68508
(402) 471-2201

DEPARTMENT ON AGING
State Office Building
301 Centennial Mall South
Lincoln, NE 68509-5044
(402) 471-2306

NEVADA
INSURANCE COUNSELING
(702) 687-4270

DEPARTMENT OF INSURANCE
Consumer Services
1665 Hot Springs Road
Carson City, NV 89710
(702) 687-4270
1-800-992-0900

DEPT. OF HUMAN RESOURCES
Division for Aging Services
340 N. 11th St., Suite 114
Las Vegas, NV 89101
(702) 486-3545

NEW HAMPSHIRE
INSURANCE COUNSELING
1-800-351-1888 Ex. 4642
24 Hour Helpline 1-800-852-3388
(603) 271-4642

INSURANCE DEPARTMENT
Life and Health Division
169 Manchester St.
Concord, NH 03301
(603) 271-2261
1-800-852-3416

NEW HAMPSHIRE (Cont.)

DEPT. OF HEALTH & HUMAN SERVICES
Div. of Elderly & Adult Services
State Office Park South
115 Pleasant Street
Annex Building No. 1
Concord, NH 03301
(603) 271-4680

NEW JERSEY

INSURANCE COUNSELING
1-800-792-8820

INSURANCE DEPARTMENT
20 West State Street
Roebling Building
CN 329
Trenton, NJ 08625
(609) 292-5363

DEPT. OF COMMUNITY AFFAIRS
Division on Aging
101 S. Broad and Front Sts.
CN 807
Trenton, NJ 08625-0807
(609) 984-3951

NEW MEXICO

INSURANCE COUNSELING
1-800-432-2080

INSURANCE DEPARTMENT
P.O. Box 1269
Santa Fe, NM 87504-1269
(505) 827-4500

STATE AGENCY ON AGING
La Villa Rivera Bldg.
224 E. Palace Ave.
Santa Fe, NM 87501
(505) 827-7640

NEW YORK

INSURANCE COUNSELING
1-800-342-9871

INSURANCE DEPARTMENT
160 West Broadway
New York, NY 10013
(212) 602-0967
Outside of New York City
1-800-342-3736

STATE OFFICE FOR THE AGING
2 Empire State Plaza
Albany, NY 12223-0001
(518) 474-5731

NORTH CAROLINA

INSURANCE COUNSELING
1-800-443-9354

INSURANCE DEPARTMENT
Seniors Health Insurance Information Program (SHIIP)
P.O. Box 26387
Raleigh, NC 27611
(919) 733-0111
1-800-662-7777

DIVISION OF AGING
693 Palmer Drive
Raleigh, NC 27626-0531
(919) 733-3983

NORTH DAKOTA

INSURANCE COUNSELING
1-800-247-0560

INSURANCE DEPARTMENT
Capitol Bldg., 5th Fl.
600 E. Boulevard Av.
Bismarck, ND 58505-0320
1-800-247-0560
(701) 328-2440

DEPT. OF HUMAN SERVICES
Aging Services Division
P.O. Box 7070
Bismarck, ND 58507-7070
(701) 328-2577

OHIO

INSURANCE COUNSELING
1-800-686-1578

INSURANCE DEPARTMENT
Consumer Services Division
2100 Stella Court
Columbus, OH 43266-0566
1-800-686-1526
(614) 644-2658

DEPARTMENT OF AGING
50 W. Broad Street
8th Floor
Columbus, OH 43266-0501
(614) 466-1221

OKLAHOMA

INSURANCE COUNSELING
(405) 521-6628

INSURANCE DEPARTMENT
P.O. Box 53408
Oklahoma City, OK 73152-3408
(405) 521-2828

DEPT. OF HUMAN SERVICES
Aging Services Division
312 NE 28th Street
Oklahoma City, OK 73125
(405) 521-2327

OREGON

INSURANCE COUNSELING
1-800-722-4134(503) 378-4484

DEPARTMENT OF INSURANCE AND FINANCE
Insurance Division
Consumer Advocacy
200 Labor & Industries Bldg.
Salem, OR 97310
(503) 378-4484

DEPT. OF HUMAN RESOURCES
Senior & Disabled Services Div.
500 Summer St., NE, 2nd. Fl.
Salem, OR 97310-1015
1-800-232-8096
(503) 378-4728

PENNSYLVANIA

INSURANCE COUNSELING
(717) 783-8975

INSURANCE DEPARTMENT
Consumer Services Bureau
1321 Strawberry Square
Harrisburg, PA 17120
(717) 787-2317

DEPARTMENT OF AGING
231 State Street
Barto Building
Harrisburg, PA 17101
(717) 783-1550

PUERTO RICO

INSURANCE COUNSELING
(809) 721-8590
(809) 721-5710

INSURANCE DEPARTMENT
Fernandez Juncos Station
P.O. Box 8330
Santurce, PR 00910
(809) 722-8686

GOVERNORS OFFICE OF ELDERLY AFFAIRS
Gericulture Commission
P.O. Box 11398
Santurce, PR 00910
(809) 722-2429

RHODE ISLAND

INSURANCE COUNSELING
(401) 277-2858

INSURANCE DEPARTMENT
233 Richmond St., Suite 233
Providence, RI 02903-4233
(401) 277-2223

DEPT. OF ELDERLY AFFAIRS
160 Pine Street
Providence, RI 02903
(401) 277-2858

SOUTH CAROLINA

INSURANCE COUNSELING
1-800-868-9095

INSURANCE DEPARTMENT
Consumer Assistance Section
P.O. Box 100105
Columbia, SC 29202-3105
(803) 737-6160
1-800-768-3467

COMMISSION ON AGING
400 Arbor Lake Drive
Suite B-500
Columbia, SC 29223
1-800-868-9095

SOUTH DAKOTA

INSURANCE COUNSELING
(605) 773-3656

INSURANCE DEPARTMENT
500 E. Capitol Avenue
Pierre, SD 57501-3940
(605) 773-3563

OFFICE OF ADULT SERVICES AND AGING
700 Governors Drive
Pierre, SD 57501-2291
(605) 773-3656

TENNESSEE

INSURANCE COUNSELING
1-800-525-2816

INSURANCE DEPARTMENT
Dept. of Commerce & Insurance
Insurance Assistance Office
4th Floor
500 James Robertson Pkwy.
Nashville, TN 37243
(615) 741-2241

COMMISSION ON AGING
706 Church Street
Suite 201
Nashville, TN 37243-0860
(615) 741-2056

TEXAS

INSURANCE COUNSELING
1-800-252-9240

INSURANCE DEPARTMENT
Complaints Resolution, MC 111-1A
333 Guadalupe St., P.O. Box 149091
Austin, TX 78714-9091
(512) 463-6515
1-800-252-3439

DEPARTMENT ON AGING
P.O. Box 12786
Austin, TX 78711
(512) 444-2727

UTAH

INSURANCE COUNSELING
(801) 538-3910

INSURANCE DEPARTMENT
Consumer Services
3110 State Office Bldg.
Salt Lake City, UT 84114-1201
1-800-439-3805
(801) 538-3805

DIVISION OF AGING AND ADULT SERVICES
120 North 200 West, Rm. 401
P.O. Box 45500
Salt Lake City, UT 84103
(801) 538-3910

VERMONT

INSURANCE COUNSELING
1-800-642-5119

DEPT. OF BANKING & INSURANCE
Consumer Complaint Division
89 Main Street, Drawer 20
Montpelier, VT 05620-3101
(802) 828-3301

DEPT. OF AGING & DISABILITIES
Waterbury Complex
103 S. Main Street
Watebury, VT 05671-2301
(802) 241-2400

VIRGINIA

INSURANCE COUNSELING
1-800-552-7945

BUREAU OF INSURANCE
Consumer Services Division
1300 E. Main Street
P.O. Box 1157
Richmond, VA 23209
(804) 371-9694

DEPT. FOR THE AGING
700 Centre, 10th Fl.
700 E. Franklin Street
Richmond, VA 23219-2327
(804) 225-2271

VIRGIN ISLANDS

INSURANCE COUNSELING
(809) 774-2991

INSURANCE DEPARTMENT
Kongens Gade No. 18
St. Thomas, VI 00802
(809) 774-2991

SENIOR CITIZEN AFFAIRS DIV.
Dept. of Human Services
19 Estate Diamond
Fredericksted
St. Croix, VI 00840
(809) 774-0930

WASHINGTON

INSURANCE COUNSELING
1-800-562-6900
(206) 407-0383

INSURANCE DEPARTMENT
Insurance Bldg. AQ21
P.O. Box 40255
Olympia, WA 98504-0255
1-800-562-6900
(206) 753-7301

AGING & ADULT SERVICES ADMIN.
Dept. of Social & Health Services
P.O. Box 45050
Olympia, WA 98504-5050
(206) 586-3768

WEST VIRGINIA
INSURANCE COUNSELING
(304) 558-3317
INSURANCE DEPARTMENT
2019 Washington St., E.
Charleston, WV 25305
(304) 558-3354
1-800-642-9004
1-800-435-7381 (hearing impaired)
COMMISSION ON AGING
State Capitol Complex
Holly Grove
1900 Kanawha Blvd., East
Charleston, WV 25305-0160
(304) 558-3317

WISCONSIN
INSURANCE COUNSELING
1-800-242-1060
INSURANCE DEPARTMENT
Complaints Department
P.O. Box 7873
Madison, WI 53707
1-800-236-8517
(608) 266-0103
BUREAU ON AGING
Department of Health and Social Services
P.O. Box 7851
One W. Wilson Street
Madison, WI 53707-7851
(608) 266-2536

WYOMING
INSURANCE COUNSELING
1-800-438-5768
INSURANCE DEPARTMENT
Herschler Building
122 W. 25th Steet
Cheyenne, WY 82002
(307) 777-7401
COMMISSION OF AGING
Hathaway Building
2300 Capitol Ave., Room 139
Cheyenne, WY 82002
1-800-442-2766
(307) 777-7986

PUBLICATIONS

The following publications have been produced either by government agencies or nonprofit organizations, and are available either free or for a nominal charge.

The Medicare Handbook
The Guide to Health Insurance for People with Medicare
Available from any Social Security office or by writing
MEDICARE PUBLICATIONS
HEALTH CARE FINANCING ADMINISTRATION
6325 Security Boulevard
Baltimore, MD 221207

The Consumer's Guide to Long-Term Care Insurance (C101)
The Consumer's Guide to Medicare Supplement Insurance (C102)
The Consumer's Guide to Health Insurance (C103)
HEALTH INSURANCE ASSOCIATION OF AMERICA
P.O. Box 41455
Washington, D.C. 20018

Shopper's Guide to Long-Term Care Insurance
Shopper's Guide to Cancer Insurance
Health Insurance Shoppers Guide for Senior Citizens
Health Insurance Shoppers Guide
Buyers Guide to Annuities
Life Insurance Buyers Guide
Guide to Buying Life Insurance After Age 60
NATIONAL ASSOCIATION OF INSURANCE COMMISSIONERS
NAIC Publications
120 W. 12th Street, Suite 1100
Kansas City, MO 64105

Appendix

Long-Term Care: A Dollar and Sense Guide
UNITED SENIORS HEALTH COOPERATIVE
1331 H Street N.W., Suite 500
Washington, D.C. 20005

Long-Term Living
Managing Your Healthcare Finances
Susan Polniaszek, MPH
United Seniors Health Cooperative
1331 H Street N.W., Suite 500
Washington, D.C. 20005

Planning for Incapacity: A Self-Help
A Matter of Choice: Planning Ahead for Health Care Decisions (D12776)
Tomorrow's Choices: Preparing Now for Future Legal, Financial and Health Care Decisions (D13479)
Health Care Powers of Attorney (D13895)
Living Trusts and Wills (D14535)
Older Driver Skill Assessment and Resource Guide: Creating Mobility Choices (C48)
AMERICAN ASSOCIATION FOR RETIRED PERSONS **(AARP)**
601 E. Street, N.W.
Washington, D.C. 20049

"Looking Ahead to Your Financial Future"
NATIONAL CENTER FOR WOMEN AND RETIREMENT RESEARCH
Long Island University
Southampton, N.Y. 11968

The Social Security Administration provides a free projected estimate of your future benefits. Request form No. 7004 (Earnings and Benefit Estimate Statement).

ORGANIZATIONS

The danger posed by some organizations that offer services to people over 50 is that they're direct-mail marketers in disguise. Their true goal—rather than providing any service—is to get your name one a mailing list. The following organizations do the best job of offering real information and service to older Americans.

A caveat: Even some of these—like the giant AARP—have things they'll try to sell you. And insurance is among those things.

AMERICAN ASSOCIATION OF HOMES FOR THE AGING
901 E Street N.W.
Washington D.C. 20004
(202) 783-2242

AMERICAN ASSOCIATION FOR RETIRED PERSONS (AARP)
601 E Street, N.W.
Washington, D.C. 20049
(202) 434-2277

CONSUMERS UNION
1666 Connecticut NW Ste. 310
Washington, D.C. 20009
(202) 462-6262

HEALTH CARE FINANCING ADMINISTRATION
6325 Security Boulevard
Baltimore, MD 221207
(410) 966-3000

NATIONAL ASSOCIATION OF INSURANCE COMMISSIONERS
120 W. 12th Street, Suite 1100
Kansas City, MO 64105
(816) 374-7259

NATIONAL CENTER FOR WOMEN AND RETIREMENT RESEARCH
Long Island University
Southampton, N.Y. 11968
(800) 426-7386

NATIONAL COUNCIL OF SENIOR CITIZENS
1331 F St. NW

Washington, D.C. 20004
(202) 347-8800

OLDER WOMEN'S LEAGUE
666 11th St. NW, Suite 700
Washington, D.C. 20001
(800) 825-3695

PENSION RIGHTS CENTER
918 16th St. NW, Suite 704
Washington, D.C. 20006
(202) 296-3776

THE SOCIAL SECURITY ADMINISTRATION
(800) 772-1213

UNITED SENIORS HEALTH COOPERATIVE
1331 H Street N.W., Suite 500
Washington, D.C. 20005
(202) 393-6226

Index

BUSINESS REPLY CARD

FIRST CLASS MAIL PERMIT NO. 243 SANTA MONICA, CA

POSTAGE WILL BE PAID BY ADDRESSEE

 THE MERRITT COMPANY
POST OFFICE BOX 955
SANTA MONICA, CA 90406-9875

SWAF

NO POSTAGE
NECESSARY
IF MAILED
IN THE
UNITED STATES

BUSINESS REPLY CARD

FIRST CLASS MAIL PERMIT NO. 243 SANTA MONICA, CA

POSTAGE WILL BE PAID BY ADDRESSEE

THE MERRITT COMPANY
POST OFFICE BOX 955
SANTA MONICA, CA 90406-9875

SWAF